REMBRANDT

BOOK CLUB ASSOCIATES - LONDON

J. BOLTEN - H. BOLTEN REMPT

REMBRANDT

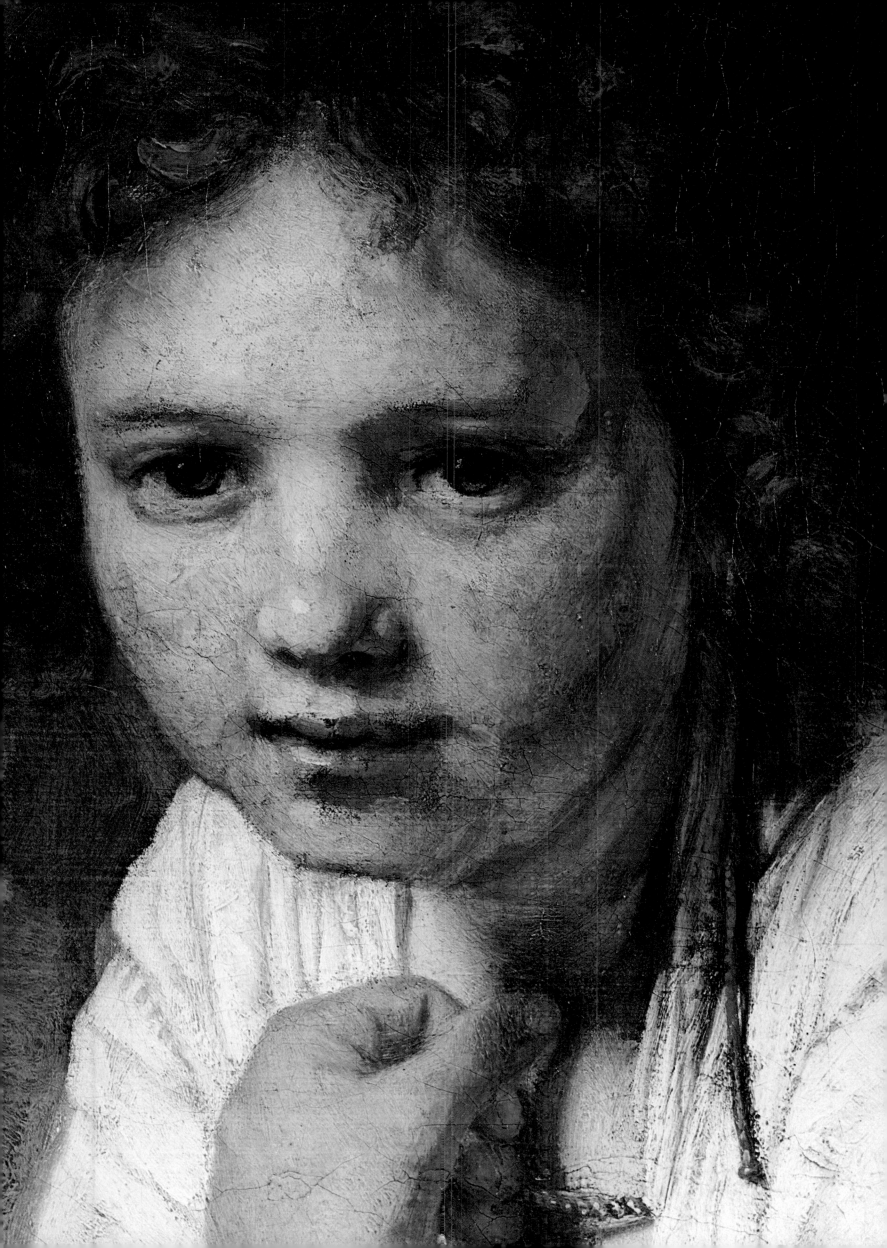

Frontispiece illustration:
A YOUNG GIRL LEANING ON
A WINDOWSILL
Detail
Oil on canvas; $32\frac{1}{8} \times 26$ in
(81.5×66 cm)
Signed and dated: Rembrandt ft. 1645
London, Dulwich College Gallery

REMBRANDT

BY J. BOLTEN AND H. BOLTEN-REMPT

EDITORS: MARIELLA DE BATTISTI, MARISA MELIS
EDITORIAL COLLABORATION: GIORGIO FAGGIN,
PAOLA LOVATO
GRAPHIC DESIGN: ENRICO SEGRÈ
TRANSLATED FROM THE DUTCH BY DANIELLE ADKINSON

This edition published 1977 by
Book Club Associates
By Arrangement with Bay Books Ltd.,

Printed in Italy by Officine Grafiche di
Arnoldo Mondadori Editore, Verona

Filmset by Keyspools Ltd, Golborne, Lancashire

Contents

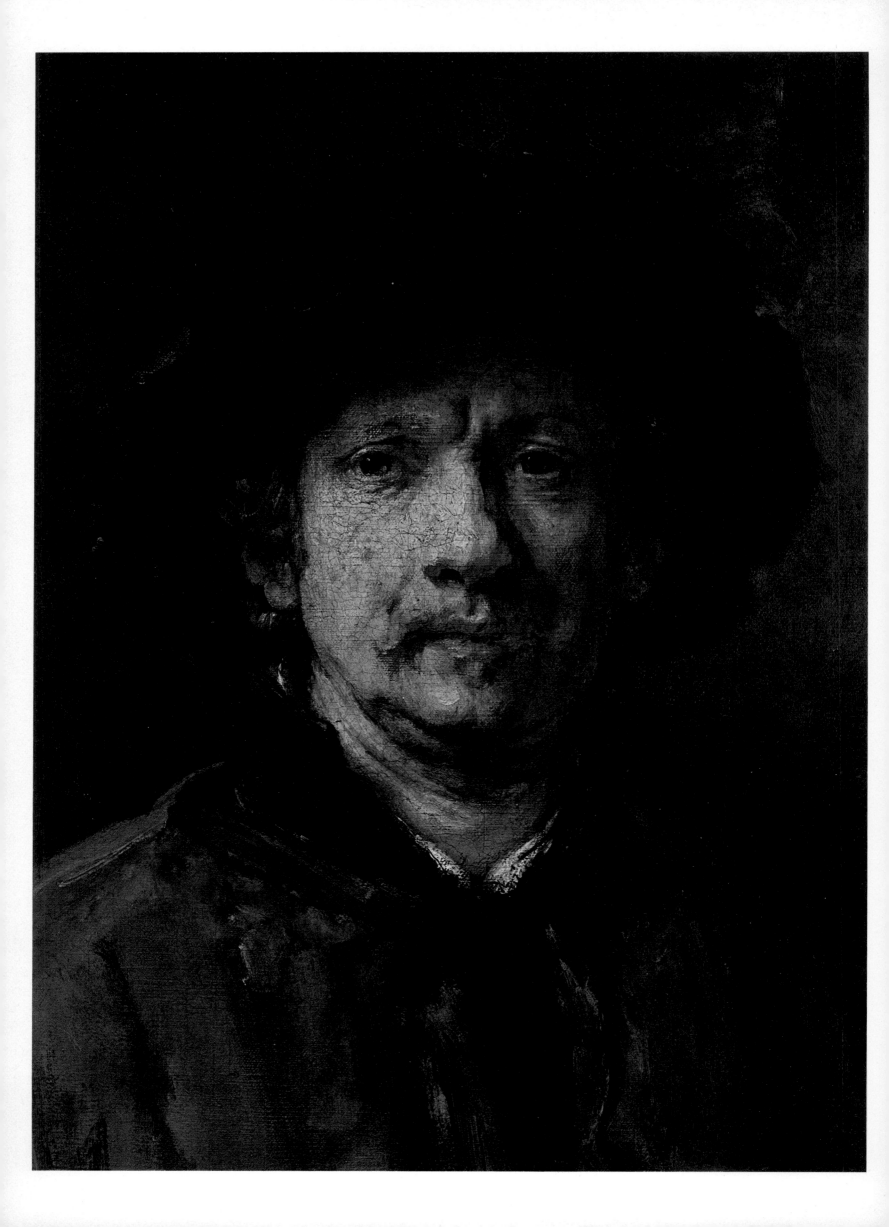

Foreword

The appearance of yet another book on Rembrandt, to add to the many publications already in existence about the most famous artists of the finest period of Dutch art, does perhaps need some explanation.

It is a fact, however, that the specialized critical study of Rembrandt's work from time to time reveals new aspects which remain inaccessible to the general reader, principally because the new views are usually published in specialized reviews not normally read by the public at large.

The aim of this book is to provide a straightforward summary of the more permanent findings of Rembrandt criticism, both past and present. We have emphasized the importance of the role played by Rembrandt in the context of the times in which he lived, and we have discussed his work with reference to the paintings which are reproduced in this book, only occasionally drawing on other visual evidence. We have also tried to give a picture of the socio-economic and political developments which took place during the life of the artist. Although we also discuss the personal life of the artist, it should be added that, no matter how much the life and work of a painter seem to be interdependent, the works of a seventeenth-century artist should not necessarily be taken as illustrative of his personal fortunes. The consideration of art as autobiography cannot be meaningfully applied to the seventeenth century; this is a phenomenon which only dates from the advent of Expressionism.

Our intention, then, is two-fold: to construct a picture of Rembrandt's life, based on contemporary documentation and its most recent interpretation, and to analyze the paintings, etchings and drawings reproduced here in terms of their style and within the broader framework of the art criticism of Rembrandt's own time and later.

We have devoted a considerable amount of attention to the question of space in Rembrandt's paintings, or more specifically, the relationship between the representation of a subject on the flat area of the canvas and the conveyance of the idea of space; this seems to us a particularly fruitful way of looking at the way in which a painting works.

To make the text more immediately readable, we have decided to do without footnotes and critical apparatus. With few exceptions, the personal views of the authors are only expressed in their choice of their sources of information and in the extent and manner in which they have interpreted these. A list of the works most frequently consulted is given at the end of the book. Of these, two titles are worthy of particular mention: Emmens' *Rembrandt en de regels van de Kunst* (Rembrandt and the Rules of Art) and van de Waal's *Steps Towards Rembrandt*. The latter book is a posthumous collection of articles from various publications which have appeared since 1937. These articles, which have been particularly well chosen, do provide an invaluable contribution to our understanding of Rembrandt's work, his methods and artistic ambitions. Emmens' book in itself brought about a revolution in Rembrandt's studies. In the course of three centuries several layers of cultural sediment had been deposited on those works which are generally considered to be the finest flowering of Dutch painting, so that the paintings, and even Rembrandt himself, had come to be seen through a series of distorting lenses: Classicism and Romanticism had each added its own particular way of looking at the works. Emmens' study, however, went beyond this accumulated, though various, body of criticism and returned to an examination of the artistic theory current in Rembrandt's own times.

Both these authors have opened up entirely new fields of study, or have given proper emphasis to aspects which were hitherto considered unimportant; their work represents a very genuine advance in our understanding of Rembrandt. Rembrandt was one of those rare artists, whose whole ability, intelligence and activity were directed towards visual expression. His inborn talent was outstanding; the function of his intelligence can be seen in terms of an indefatigable search for knowledge so

SELF-PORTRAIT
Detail
Oil on canvas; 44 × 32 in
(112 × 81.5 cm)
Signed and dated: . . . dt f. 1652
Vienna, Kunsthistorisches Museum,
Gemäldegalerie (Br. 42)

intense to be termed scientific. The constant development of his talents and his application of them to his creative work have created a body of visual experiences which has never ceased to fascinate the world.

Historical introduction

The year of Rembrandt's birth, 1606, falls roughly in the middle of the period of Dutch history which was to become known as the Eighty Years' War – the revolt of the Netherlands against Spain. The Netherlands, Northern and Southern, were part of the empire of Charles V, which comprised a substantial part of Europe. In 1555 Charles abdicated in favor of his son, Philip II. Philip then left the court in Brussels and established himself in Spain, where he chose Madrid as the seat of his government. The interests of the Hapsburg empire as a whole and those of the Netherlands, which depended on trade and industry, slowly began to diverge. The problems first began to become apparent when the high costs of the economically unprofitable wars led to an increasingly heavy burden of taxation. The low countries near the sea enjoyed a relatively high standard of living, compared to the surrounding territories. This led to unavoidable social differences: in contrast to a prosperous bourgeoisie, the mass of people was very badly off. Spanish measures aimed at the centralization of power and the strengthening of the influence of the Catholic Church were also unpopular in a country where the form of government was still based on the old medieval system of Privileges. Nor was the strengthening of the Inquisition in accordance with the religious traditions of the Dutch. Indeed, the country enjoyed a relatively high degree of tolerance; the clergy had never wielded much political power, and this had disappeared entirely with the coming of the Reformation. The other traditionally strong group, the aristocracy, also enjoyed little influence, since large estates had been slow to develop in the Netherlands: the provinces of Holland and Westfriesland were maritime provinces, with a few important towns which were centers of trade and industry; and it was precisely these provinces which were to determine the image of the new Republic.

The revolt against Spain began in 1567 with attacks on church images which were to have far-reaching cultural consequences. The chief political aim of the rebellion was the retention of the old medieval freedoms and privileges, thus opposing the modern tendency towards centralization which had led to absolute monarchies in the neighboring countries of England, France and Spain. This aim, however, which was fundamentally backward-looking, was backed by a system of beliefs which must have seemed super-modern at the time: the burgeoning capitalism which was so effectively stimulated by the values of Calvinism. The North was thus gradually conquered from the provinces of Holland and Zeeland, and Calvinism became the official religion in the conquered areas, although the large majority of the population remained Roman Catholic. In 1573, only five per cent of the population was officially Protestant. A shift of power and property had taken place, but the vital interests remained the same.

The final separation between the Northern, Protestant provinces and the Southern, Roman Catholic and Spanish orientated, Netherlands became fact in 1579 with the treaties of Atrecht and Utrecht which closely followed each other. Although official recognition of the new state was only to come much later, the Northern Provinces, from then onwards, formed *de facto* an independent nation. As the United Provinces, this nation was shortly to know a period of unprecedented prosperity and cultural achievement.

Although regents, like Matthias, Anjou and Leicester, were still recognized as stadholders until the truce of 1609, ultimate and decisive power lay in the hands of the trade aristocracy which began to form a new ruling class. Their political power was effectively based on their control over

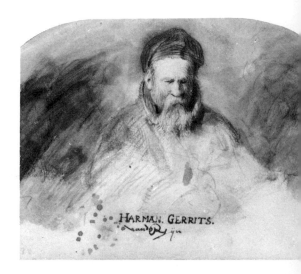

"REMBRANDT'S FATHER"
Drawing in charcoal, red crayon and watercolor
$9\frac{1}{2} \times 7\frac{1}{4}$ in (24 × 18.9 cm)
Circa 1630
Oxford, Ashmolean Museum
(Benesch 56)

Pieter Lastman
CORIOLANUS RECEIVING THE EMISSARIES
Oil on panel
1622
Dublin, Trinity College

financial matters. Their famous tolerance in matters of religion also served their ends in trade, since they paid little regard to the persuasion of their trading partners. This spirit of independence and religious tolerance came to be recognized as one of the outstanding characteristics of Dutch society at this period. One contemporary Spanish historian noted "the many superstitions" which the regents allowed the people to entertain, adding that this was done so that the will and soul of the people remained in the control of the ruling class. Attracted by the reputation of the young Republic of the United Netherlands, which had just wrenched itself free from Spanish domination, many Portuguese Jews, the Sephardim, came to the Netherlands from the end of the sixteenth century onwards and settled chiefly in Amsterdam. Their presence there was to have a deep influence on Rembrandt's life and work.

The Jews in Portugal had originally come from Spain, where they had had a long tradition of involvement in science and in the occult. From the end of the fifteenth century the increasing power of the Inquisition had made life impossible for them in Spain, and large numbers had moved to Portugal. It did not take long for persecution to become rife there too, as the Catholic Church intensified its struggle against all forms of heresy – Protestant and Jewish – and the choice offered to the Jews was usually conversion or death. Many chose the latter alternative. Those who allowed themselves to be baptized as Christians to save their lives were officially known as "new Christians," although they were still considered as second-class citizens and were commonly known as *Marranos* (pigs). No restrictions were imposed on their activities, however, so that it was at least possible for them to achieve considerable material prosperity and wealth. Nevertheless, their traditional religious beliefs could hardly be totally eradicated.

These prosperous Portuguese Jews were very welcome in the young Republic of the Netherlands. In addition to their wealth, they also brought with them new overseas trade connections. There was little reason, therefore, for them to be subjected to further persecution for their beliefs. By 1642, in fact, a visit to the synagogue was already one of the attractions of Amsterdam. And between 1670 and 1675, the imposing Portuguese synagogue, which still stands today, was built with the permission of the Amsterdam city council. No restrictions were placed on the trading activities of the Jews, and they were also allowed to practice their, usually liberal, professions. That, however, was the extent of tolerance. Limitations were imposed on direct social contacts with Christians; as far as admission to schools, the guilds and public office was concerned, they were no more welcome in the Netherlands than anywhere else. Indeed, the holding of public office was something which was generally thought should be reserved to the Protestant community; that at least was the intention of the official Church although this aim was only fully realized in 1795. It would be true to say, however, that the essential conditions for the existence of a Jewish community were there: freedom of expression and of the press. After all the bitter years of oppression a flood of Jewish books in Hebrew, Spanish and other languages appeared, and Amsterdam became a center of Jewish book publishing during the seventeenth and eighteenth centuries.

The Sephardic Jews were held in high regard, not only for their economic expertise, but also for the richness of their cultural life. This was not the case where the German or Polish Jews, the Askenasim, were concerned, who had fled to the Netherlands in the 'thirties to begin a new life. As destitute refugees they were looked down on by the respectable and educated Sephardic Jews. The Askenasim frequently became small street traders or even went into domestic service in Sephardic households. As we shall see later, both groups were to figure importantly in the work of Rembrandt.

By the beginning of the new century, the military phase of the struggle with Spain was largely over. A truce was signed in 1609, although this was to last for only twelve years. In the religious and political spheres, the internal affairs of the republic were characterized by continual struggle, which took

SCENE FROM THE LIFE OF PYRRHUS
Pen and watercolor drawing
London, British Museum
(Benesch 104a)

9

place between the powerful, mainly Dutch regents, the holders of power, and the stadholders of the royal house of Orange, who were supported by the aristocracy, the army, the Calvinist preachers and the burgher class; in other words their support was popular. In addition to the political differences between the party in power and the party which wished to attain power, there was also a conflict within the Church concerning the doctrine of predestination, which was also closely linked to the events taking place on the political scene. The question of man's ability or lack of ability to influence his after-life, which had been so closely argued by two Leyden theologians, Arminius and Gomarus, soon led to the formation of parties within the Church; the supporters of Arminius were called Arminians or Remonstrants and those of Gomarus Counter-remonstrants. The chief protagonists in this politico-religious battle were Johan van Oldenbarnevelt, solicitor for the government and Grand Pensionary of Holland, the most powerful province, and Prince Maurice, who finally chose the side of the Counter-remonstrants. The final judgement of the national synod of Dordrecht on the matter favored the supporters of Gomarus. This decision very much favored Maurice at the expense of Oldenbarnevelt, who was a supporter of Arminius; on May 13, 1619, the seventy-two-year-old Oldenbarnevelt, who had been considered the personification of the power of the regents, was executed for high treason.

Maurice's victory, however, did not produce any real changes in the political system. But Frederick Henry, his brother and successor, did manage to acquire greater power and an enhanced status, surrounding

THE JUSTICE OF BRUTUS
Panel; $35\frac{1}{4} \times 47\frac{1}{2}$ in (91 × 121 cm)
Leyden, Municipal Museum (Br. 460)

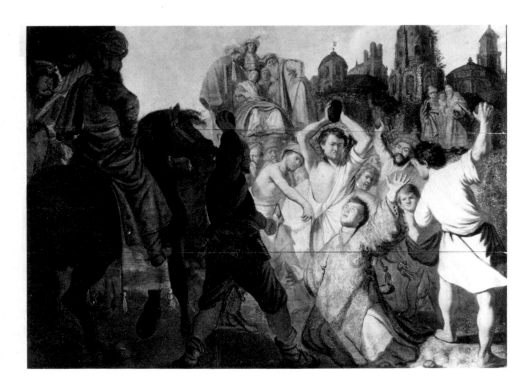

THE MARTYRDOM OF ST. STEPHEN
Oil on panel; $35\frac{1}{2} \times 48\frac{1}{2}$ in (89.5 × 123.5 cm)
Signed and dated: R f. 1625
Lyons, Musée des Beaux-Arts (Br. 531a)
The two men seen to the right and left of the man who is lifting the stone with both hands are self-portraits of Rembrandt and of Jan Lievens, the Dutch painter, who was Rembrandt's friend and colleague in Leyden.

himself by what was almost a royal court. For the decoration of his summer residence of Honselaarsdijk, near the residence of 'sGravenhage in Westland, he commissioned a number of artists, including Rembrandt, although it would be misleading to conclude that this was royal patronage on the same scale as elsewhere. Moves were certainly made towards the formation of a monarchy, but the oligarchic system of government of the regents still remained. Official recognition of the Republic finally came in 1648 with the signing of the Treaty of Münster. The prosperity of the nation was now growing considerably. The flourishing East Indian trade brought prosperity to the ports, the fishing industry, and the cloth trade, while encouraging the growth of maritime power. The great material acquisitions which made the Republic the richest country in Europe were accompanied by an equally great cultural revival.

THE BAPTISM OF THE EUNUCH
Oil on panel; $25\frac{1}{4} \times 18\frac{3}{4}$ in (64 × 47.5 cm)
Signed and dated 1626
Utrecht, Aartsbisschoppelijk Museum
This work, discovered in 1976, depicts the scene of the baptism of the black eunuch by the apostle Philip (Acts of the Apostles 8: 26–40).

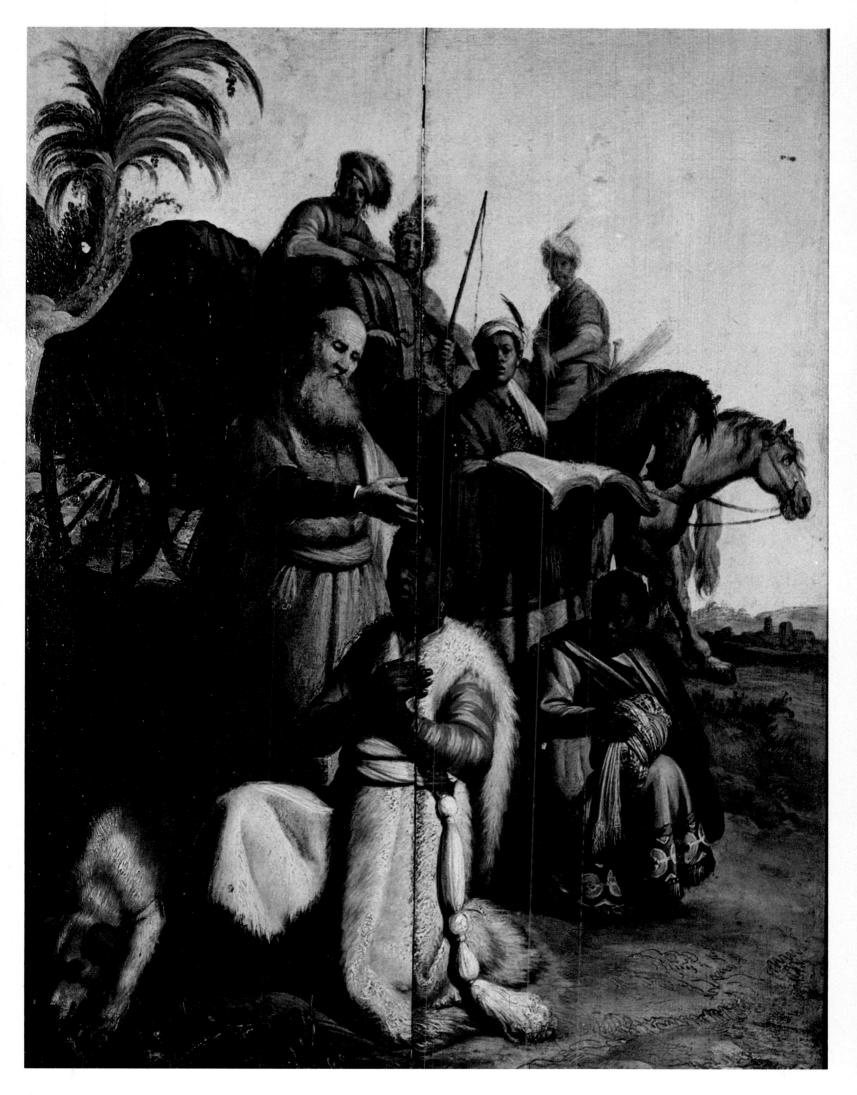

The Life of Rembrandt

Rembrandt's life, then, can be set against the historical background described above. This life began in the town of Leyden, one of the most important towns of the province of Holland. The town had particularly distinguished itself during the rebellion of 1574 by resisting a lengthy siege by the Spaniards. As a reward for the courage and tenacity of the burghers and the magistrates, Prince William of Orange – William the Silent – granted a university to the town. Its founding further stimulated the growth of the population's self-consciousness and its spirit of independence.

Rembrandt's childhood and youth was spent among the industrious, reformed lower burgher class. His father, Harmen Gerritsz., was a miller, while his mother, Neeltie Willemsdr. van Zuytbrouck, was the daughter of a

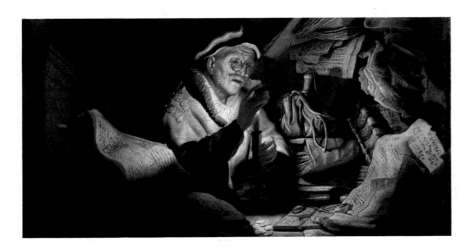

"THE MONEY CHANGER"
Detail
Oil on panel; $12\frac{1}{2} \times 16\frac{1}{2}$ in
(32×42 cm)
Signed and dated: RHL 1627
Berlin, Staatliche Museen Preussischer Kulturbesitz, Gemäldegalerie (Br. 420)

TWO SCHOLARS DISPUTING
Oil on panel; $28\frac{7}{8} \times 23\frac{1}{2}$ in
(71×58.5 cm)
Signed and dated: RHL 1628
Melbourne, National Gallery of Victoria (Br. 423)
Mentioned in the inventory of Jacob de Gheyn of 1641.

Leyden baker. The couple were married in 1589, first civilly and then at St. Peter's Church, which had by then become Protestant. That same year Harmen Gerritsz bought a half share of his stepfather's maltings, which were situated near the town walls to the north of the white gate, and the houses in the Weddesteeg which went with them. It was there that Rembrandt Harmensz. van Rijn was born on July 15, 1606, the sixth child of the family. The name "van Rijn" was an addition to the family name and refers to the siting of the town of Leyden on a branch of the Rhine. The parents were sufficiently well-off to bring up their children in relative material comfort and to give them – as was usual at the time – a religious upbringing.

The chosen professions of some of Rembrandt's brothers are in fact known: Adriaen became a shoemaker; Willem chose the same trade as his maternal grandfather and became a baker. The young Rembrandt, however, was obviously possessed of other talents, and seemed destined for a career in public life. He first attended the Leyden grammar school, essential for anyone wishing to hold public office. On May 20, 1620 – at the age of fourteen – he enrolled in the Faculty of Arts at the University of Leyden, his native town, so that "when he came of age, he could serve the town and municipality and help to further its interests," as his first biographer, J. Orlers, wrote in his *Beschrijvinge der Stadt Leijden* (Descriptions of the Town of Leyden). Rembrandt himself, however, seems to have had other plans for his career, and did not remain enrolled long at the university. At some time he must have told his parents about his wish to study the arts of painting and drawing. His parents obviously acceded to their son's demands, for we find him apprenticed to the Leyden master, Jacob Isaacsz. van Swanenburgh. Rembrandt was taught the basic principles of painting by this little-known, conservative master. During the three years he remained apprenticed to van Swanenburgh, in whose house he was also boarded and lodged, Rembrandt made such progress that, with his father's permission, he became apprenticed in 1624 to the famous historical painter, Pieter Lastman, in Amsterdam. This choice does help to explain some of the ambitions of the

THE APOSTLE PAUL IN PRISON
Oil on panel; $28\frac{3}{4} \times 23\frac{3}{4}$ in
(73×60 cm)
Stuttgart, Staatsgalerie (Br. 601)
Signed and dated: R f. 1627.
On the leaf which hangs over the book can be read *"Rembrandt fecit."*

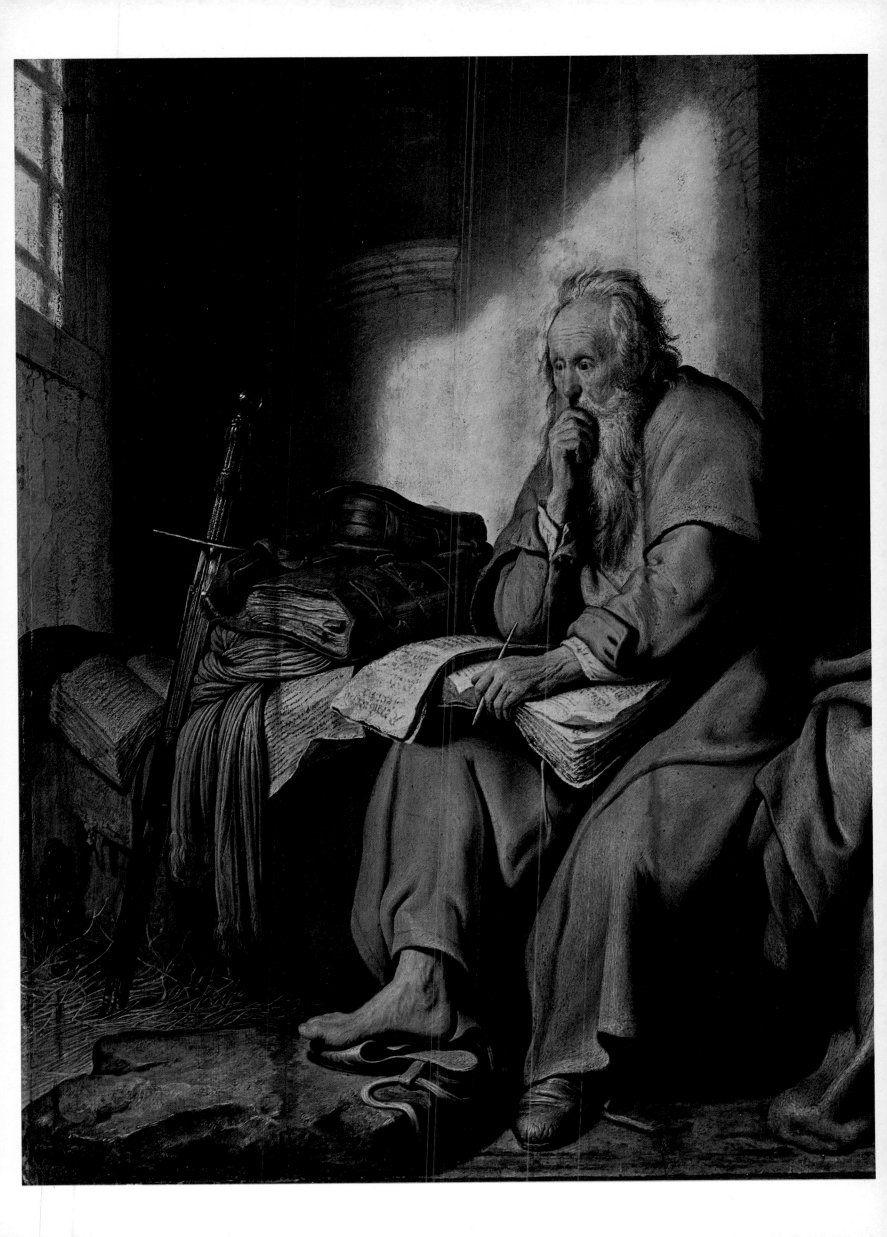

young Rembrandt. Of all the genres open to the seventeenth-century painter, such as landscape, portrait or still-life, the painting of historical subjects was the most respected, at least by the official theorists; this could include both religious and secular subjects and also subjects drawn from classical mythology. To be a successful painter in the historical genre, an artist had to possess a combination of artistic ability and scholarly erudition not required for the other genres. After spending a period in Rome during the first years of the seventeenth century, Lastman returned to Amsterdam already a famous painter and the bringer of new ideas from the Eternal City to a northern Europe hungry for them. During his stay in Italy he had come under the influence of the famous Frankfurt painter, Adam Elsheimer, and had become closely acquainted with all the new trends in painting.

Rembrandt was only to remain with Lastman for six months. But short though this apprenticeship was, the influence of Lastman on the young, impressionable Rembrandt was such that it can still be traced in the latter's late work. Thus, the drawing which depicts a scene from the life of Pyrrhus (p. 9) is closely related to Lastman's painting of Coriolanus receiving the envoys (p. 8). In 1625 Rembrandt returned to Leyden as an independent master and soon took on apprentices himself. One of these was Gerrit Dou who joined Rembrandt in 1628 and later founded the Leyden School.

The fame of Rembrandt soon began to reach beyond Leyden. In the unfinished autobiography of Constantin Huygens, which dates from about 1631, we come across an interesting assessment of Rembrandt. Huygens first discusses other contemporary artists, such as Rubens, Mierevelt and Ravesteyn, and finally mentions two young painters from Leyden, Rembrandt and Jan Lievens, who are included among the first rank of artists. They are already seen to be the equal of their contemporaries and likely to surpass them, although it is noted that they both came from a modest background and have little or no education. Huygens further finds that Rembrandt surpasses Jan Lievens in judiciousness (*iudicio*) and the liveliness of his emotions. On the other hand, he finds that Lievens excels in artistic inventiveness (*inventio*), audacity of narrative style and richness of form. Referring to one painting by Rembrandt, *Judas Returning the Pieces of Silver*, Huygens even went as far as to say that he thought the Rembrandt could be favorably compared to any Italian painting or to anything done in classical antiquity. This was certainly no small praise, especially since it came from someone who was not known for using words lightly. From the same source we learn why Rembrandt – like Lievens – deliberately refused to make the almost obligatory journey to the Holy Land of painting, the Italy of Leonardo, Michelangelo and Raphael. We find them both declaring that they could not afford the time in the prime of their lives, and that it was possible to study and admire the best of Italian art outside Italy, and indeed the very dispersal of that art made it difficult to find in Italy itself!

It should also be remembered that a new-found self-confidence led these young and ambitious artists to the belief that Dutch art could produce something worthwhile which was not simply an imitation of the Italian; indeed, there was a strong feeling that it was preferable that the Italians should not be imitated.

The observations of Rembrandt and Lievens, which reach us by way of Huygens, point to the sudden growth of the graphic art "industry" at the end of the fifteenth century and the beginning of the sixteenth. Etched or engraved reproductions of all the latest Italian works were widely available. And such reproductions had many advantages over the originals as far as the study of works of art was concerned: multiple reproduction made them cheap; they could be sent anywhere easily or taken on a journey. They could be handled much more easily for close study, in contrast to the originals, which might be hanging in some dark church. Reproductions, then, performed an important function in the dissemination of artistic information, a role now filled by photography. The works of Raphael, often in detail, were thus reproduced in the prints of Marc Antonio Raimondi,

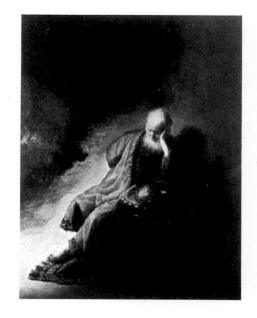

THE PROPHET JEREMIAH MOURNING OVER THE DESTRUCTION OF JERUSALEM
Oil on oak panel; 22¾ × 18 in (58 × 46 cm)
Signed with monogram and dated: RHL 1630.
Amsterdam, Rijksmuseum (Br. 604)
This painting was part of the collection of Cesar of Berlin about 1760, after which it passed into the Sergei Stroganoff Collection, Leningrad, and then into that of H. Rasch, Stockholm. It was bought in 1939 for the Rijksmuseum by the Rembrandt Society and private subscription.
Opposite page and pages 16–17: Two details

14

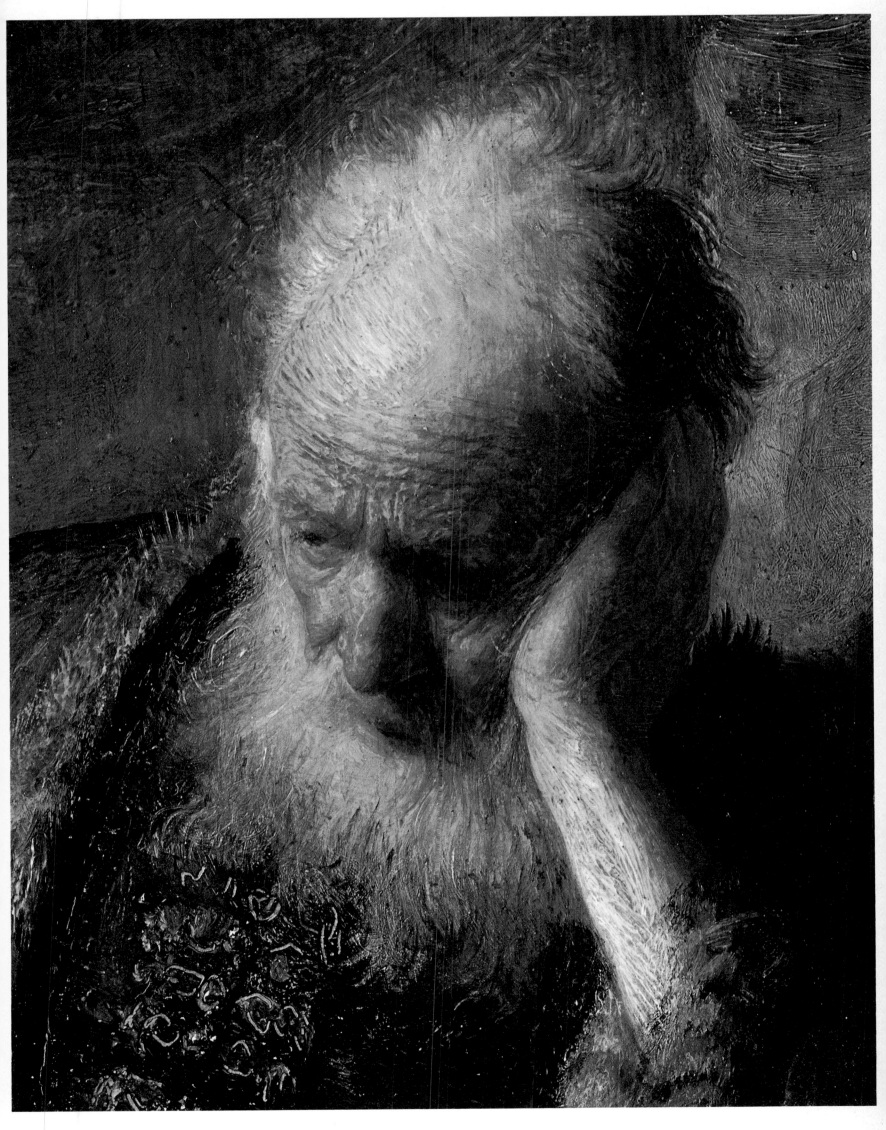

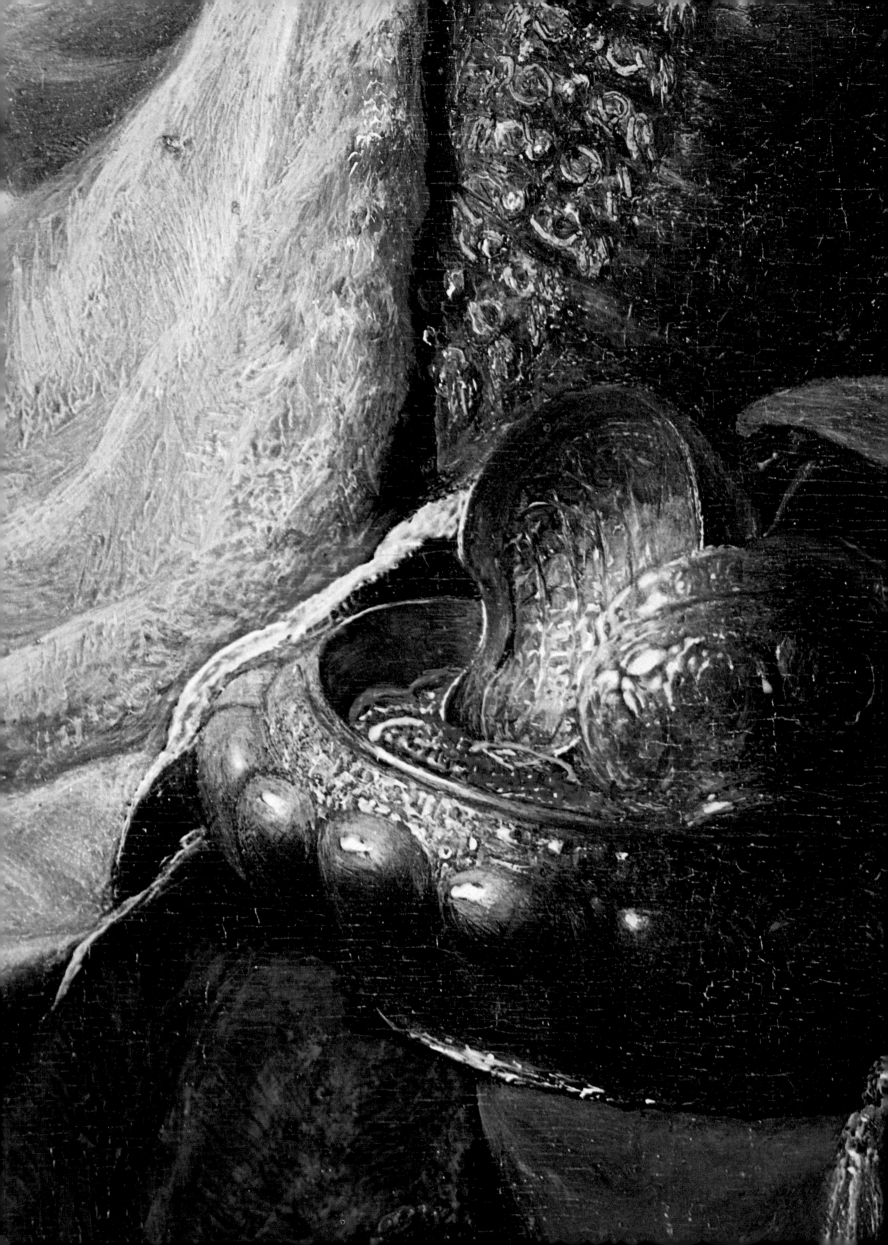

making them especially widely known. Nor were prints the only way in which Italian art became known in northern Europe; Amsterdam itself was the center of a vigorous art trade and many important paintings passed through the city before finding a permanent home.

Rembrandt himself was very interested in the art trade; so much so, that various sources suggest that he did in fact participate in this lucrative business. A legal document of 1631 states that H. Uylenburch, painter and art dealer, records that he is indebted to Rembrandt, then still resident in Leyden, for the sum of 1000 florins. The precise reason for his indebtedness is not clear, but it is probable that Rembrandt had bought a share in Uylenburch's fine art business for that sum. It was in fact quite common for the professions of painter and art dealer to be combined. Rembrandt remained on good terms with Hendrick Uylenburch, and it was at the art dealer's house that he was to meet his future wife, Saskia van Uylenburch, Uylenburch's niece from Friesland. When he first moved to Amsterdam, Rembrandt lived alone at Uylenburch's house. Later, after their marriage, Saskia joined him. Uylenburch also supervized the production of a number of editions of prints and etchings by Rembrandt.

In addition to auction records, there is also a more immediate source which indicates that Rembrandt frequently participated at auctions, that he there became acquainted with the works of the Italian masters and masters of other nationalities, and that he often also bought works. On a rapid sketch after Raphael's portrait of Count Baldassare Castiglione, Rembrandt wrote: "Count Baldassare Castiglione by Raphael, sold for 3500 florins," a small fortune in those days. On the back of the sketch Rembrandt noted that the whole auction of Italian paintings, which had been brought to Amsterdam by the art dealer Lucas van Uffelen, made 59,456 florins in 1639.

The scope of Rembrandt's activities in Amsterdam then became increasingly wide. As the center of trade and artistic life of the country, the town offered far more possibilities to the promising young painter than Leyden ever could. In Amsterdam he began to receive specific commissions; in 1632, for example, he was commissioned to paint the anatomy lesson given by the famous anatomist Dr Nicolas Tulp of the Surgeons' Guild of Amsterdam. In the same year Rembrandt is recorded as being domiciled in the city, as a boarder of Hendrick Uylenburch. During this period he produced a number of etchings, including the great work on the descent from the cross, and a number of paintings, including commissioned portraits of greater or lesser citizens of Amsterdam, such as the remonstrant minister Johannes Uyttenbogaerdt in 1633 and Nicolas Ruts in 1639.

It was during this period, too, that Rembrandt made the acquaintance of his wife to be. On a signed portrait of Saskia, dated 1633, Rembrandt wrote: "This is the portrait of my wife at the age of twenty-one, three days after our wedding on June 8, 1633." Rembrandt and Saskia were officially married a year later on June 22, 1634, as is recorded in the register of the reformed parish of St Annaparochie in Friesland, the former home of the bride. Saskia was the youngest daughter of Rombertus Uylenburch and Sjukje Osinga, who were already dead by the time the wedding took place. She no doubt came to Rembrandt with a certain amount of personal wealth therefore, which was certainly welcome to Rembrandt whose means must still have been relatively modest, although he was now beginning to make a steady living from his art and from his dealing.

The couple settled in Amsterdam at the house of Saskia's uncle, Hendrick van Uylenbruch. At this period affairs began to go very well for them: in addition to the new income from Saskia's own fortune, Rembrandt had also begun to command a substantial income. He was much sought after as a portrait painter and had a large number of pupils – including Ferdinand Bol and, around 1635, Leendert Cornelisz. – who also paid him for his instruction. Their work with him, consisting mainly of copies of the work of the master himself, would be retouched or repainted by Rembrandt if necessary, and then sold. Rembrandt also produced a large number of noncommissioned

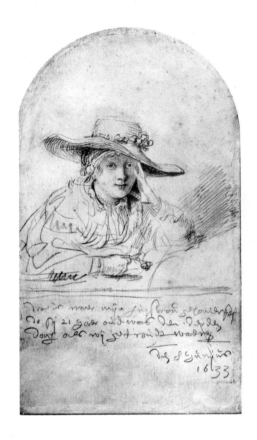

SASKIA WITH A HAT
Drawing in silver point
7¼ × 4 in (18.5 × 10.7 cm)
1633
Berlin, Staatliche Museen
Preussischer Kulturbesitz,
Kupferstichkabinett (Benesch 427)
(KdZ 1152)
At the foot of the picture the following words have been written by Rembrandt: "Portrait of my wife at the age of 21, the third day after our wedding, 8 June 1633." Rembrandt and Saskia van Oylenburch were officially married on 22 June 1634.

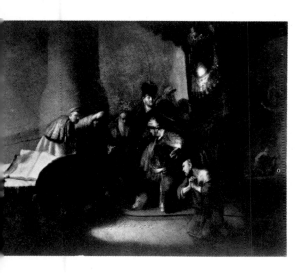

JUDAS RETURNING THE
THIRTY PIECES OF SILVER
Oil on panel; 31½ × 40¼ in
(76 × 101 cm)
1629
Mulgrave Castle (England)
Normanby Collection

Pages 20–21:
CHRIST AT EMMAUS
Detail
Paper on panel
15¼ × 16½ in (39 × 42 cm)
Signed: RHL. Circa 1628
Paris, Musée Jacquemart-André
(Br. 539)
Rembrandt was probably inspired by
Elsheimer's painting of *Philemon and
Baucis.*

work, paintings and etchings, for which he was able to command good prices
and which found their way to the eventual owners via the trade.

Rembrandt's fine art business – his profession is stated as that of dealer in
a legal document of 1634 – must also have been producing considerable
profits. He was frequently to be seen at auctions, buying works of art and
curios for his own collection, but also spending considerable sums on items
for his own business. At an important auction of rare works of art, prints and
drawings from the estate of the deceased Jan Basse, held from March 9 to 30,
1637, Rembrandt bought a large number of drawings and prints, principally
by Raphael, and an art book – a large bound folio in which drawings are kept
between the blank leaves – full of drawings by Lucas van Leyden. At
another auction a few months later, he bought a painting by Rubens, *Hero
and Leander*, for 425 florins. In February 1638 Rembrandt bought prints
and drawings by Lucas van Leyden, the Italian masters, Albrecht Dürer and
Goltzius. From the accounts of these purchases it is clear that Rembrandt
intended them for his business, since in some cases he bought as many as a
dozen copies of the same print.

On December 15, 1635 his first son, Rumbartus, was born, named after
Saskia's father; he was not to live long, however.

Rembrandt's fame was now very much on the ascent. From the
correspondence extending over the period 1636–1639 between Rembrandt
and Constantijn Huygens, who was then secretary to Prince Frederick
Henry, we learn that the prince commissioned Rembrandt to do three
paintings on themes from the Passion for his summer residence at
Honselaarsdijk: *The Entombment* (p. 84), *The Resurrection* (p. 84) and *The
Ascension* (p. 86), to go with *The Raising of the Cross* (p. 40) and *The Descent
from the Cross* (ps. 43–45), both by Rembrandt and both already in the
prince's possession. Having delivered the first two subjects, *The Entombment*
and *The Resurrection*, Rembrandt asked 1000 florins per painting, "or as
little as the prince is prepared to pay . . ." Frederick Henry, however, gave
600 florins a painting, with an extra forty-four to cover the cost of framing
(February 17, 1639). On November 29, 1646, Rembrandt was paid 2400
florins for two paintings on the birth of Christ and the circumcision.

We can gain some idea of Rembrandt and Saskia's life together from the
records of a civil action for libel brought by them against two members of
Saskia's family, Mayke and Dr Albertus van Loo. They had declared on July
5, 1637, that Saskia had squandered her parents' heritage "with pomp and
ostentation," although she had been richly and *"ex super abundanti"*
endowed. This charge, which fortunately did not correspond with the truth,
could hardly be allowed to pass by Rembrandt, and he demanded that
Mayke and Dr Albertus van Loo retract their accusation, pay a fine and the
costs of the lawsuit. Van Loo, however, succeeded in convincing the court of
Leeuwarden, where the trial was held, that his words of disapproval had not
been intended for Saskia or Rembrandt, but for Jeltie Uylenburch, Saskia's
sister, and that they had not been uttered with malicious intent. The court
therefore dismissed the case and ordered the plaintiff to pay the costs.

It would seem from this incident that Rembrandt was an especially
sensitive person, since he appears to have gone straight to court without
going through the preliminaries of discussion with the people involved. This
lawsuit also reveals something about the relations within the family. The
plaintiffs were condescendingly described as "being only a painter or
painter's wife;" we may conclude that Saskia's respectable family
disapproved of her *mésalliance.*

On July 21, 1638, the baptism took place of a daughter of Rembrandt and
Saskia, to whom the name Cornelia was given. It is unlikely that this child
lived very long, since it is recorded that one of their children was buried in
the Zuiderkerk on August 13, of the same year. Another daughter was
baptised Cornelia on July 29, 1640; she was also very short-lived.

Sixteen thirty-nine is remarkable for one very important event:
Rembrandt bought a large house for 13,000 florins next door to Nicolas

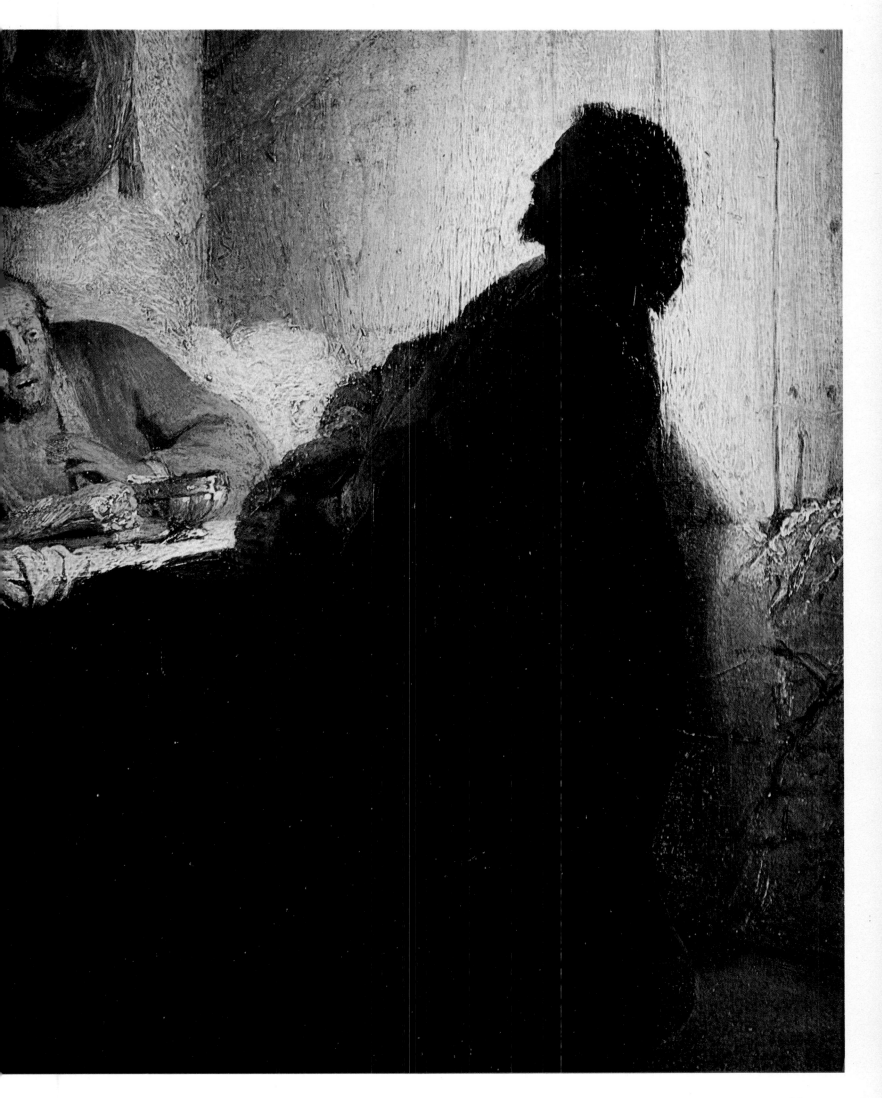

Elias, the well-known portrait painter; the house was in the Anthonie Breestraat, in the Jewish quarter. It is this house which has now been designated a museum and which bears the name "Rembrandthuis." The purchase of the house caused Rembrandt to contract substantial debts from which he was never quite able to extricate himself. His difficulties, however, lie in the future, and for the moment he was concerned with living in a style commensurate with his great success, and not least of all to satisfy Saskia. In 1641, Orlers, his biographer, whom we have already quoted, described him as "one of the most famous contemporary painters." Orlers also states that "his art and work pleased and delighted the citizens and inhabitants of Amsterdam considerably, and he was given numerous commissions for portraits and other work." Work by Rembrandt could be found in many collections, even in that of Charles I of England, as an inventory of 1639 shows.

The death of Rembrandt's mother, the subject of so many loving portraits, occurred in 1640, leaving a modest fortune, which was shared between Rembrandt and his three surviving brothers and sister. A year later, in 1641, his son Titus was born. His enjoyment of a much longer life than Rembrandt and Saskia's other children meant that he was to play a considerable role in the life and work of his father.

Most modern biographers agree that the year 1642 can be seen as a turning point in Rembrandt's life, work and fame. This was the year in which his beloved wife Saskia died. It was also the year in which Rembrandt finished the famous painting *The Night Watch* (pp. 94–95), of which the correct title is *The Militia Company of Captain Frans Banning Cocq*. These events are considered by Rembrandt's biographers to mark the end of Rembrandt as a famous painter in the public eye, painting according to what was acceptable to public taste. After 1642 he abandoned the Baroque style and its insistence on the external qualities of a subject for an art which was more concerned with spiritual values and deep human emotions. Rembrandt also seems to have ceased to enjoy public success at about this time. Continuing this theme of a turning away from worldly values a number of earlier authors have conjured up a picture of Rembrandt finally dying as a poor, unrecognized genius who was only to gain recognition centuries later. This interpretation of Rembrandt's life has been convincingly related in more recent publications, especially Emmens' book, *Rembrandt en de regels van de kunst* (Rembrandt and the Rules of Art). Indeed, it hardly accords with historical fact and the real position of Rembrandt in the seventeenth century, and says far more about the way in which the position of the artist was seen by the Romantic sensibility in the latter half of the nineteenth century and the first half of the twentieth. It was certainly true that a strong classical trend began to appear in taste from 1650 onwards and that Rembrandt remained very much apart from it; but it would still be hardly true to say that he died in poverty or that he was unknown at his death.

It is a fact, however, that on June 14, 1642 Saskia died. She must have felt that the end was near shortly before, for we find her making her will on June 5, "lying ill in bed." Titus, her only surviving son, was her sole heir, while her husband, Rembrandt van Rijn, was to have full use of the property. In the event of Titus dying without offspring, then everything would go to Rembrandt. There was no need even to make an inventory of her possessions, unless Rembrandt were to remarry or die. In that case the whole property would have to be divided, one half passing to Rembrandt's heirs, and the other half returning to Saskia's family. Saskia was buried on June 19, in the Oudekerk, leaving behind a large fortune of 40,000 florins.

The second woman in Rembrandt's life was Geertje Dircx. The usual interpretation of the part this woman played in Rembrandt's life originated during the second half of the nineteenth century. It has generally been believed that, after the death of his beloved Saskia, finding himself alone with a newly-born child, Rembrandt engaged a housekeeper to look after the young Titus. This older woman, the widow Geertje Dircx, arrived penniless

SELF-PORTRAIT
Oil on panel; 6 × 5 in (15.6 × 12.7 cm)
Signed and dated: RHL 1629
Munich, Alte Pinakothek (Br. 2)
Collection of the Dukes of Saxe-Coburg-Gotha.

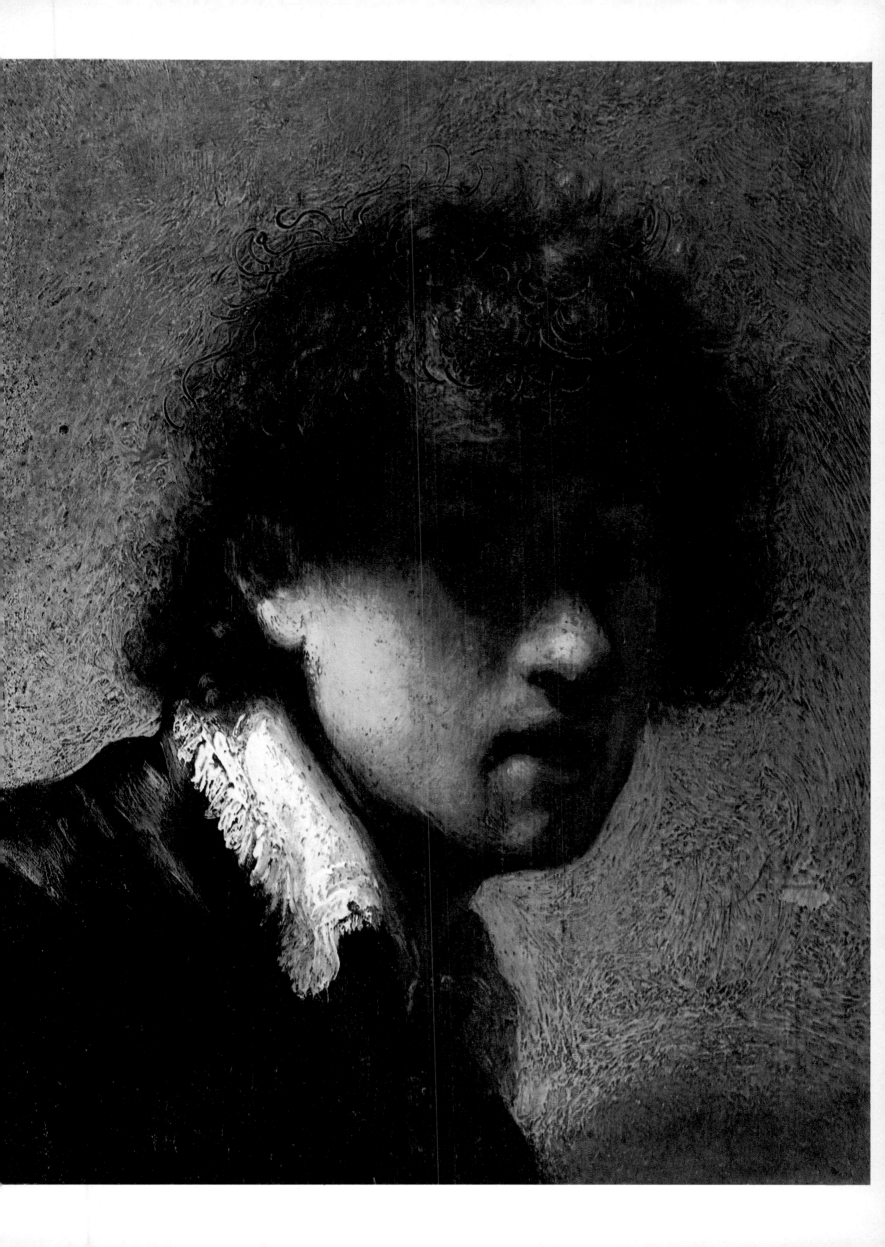

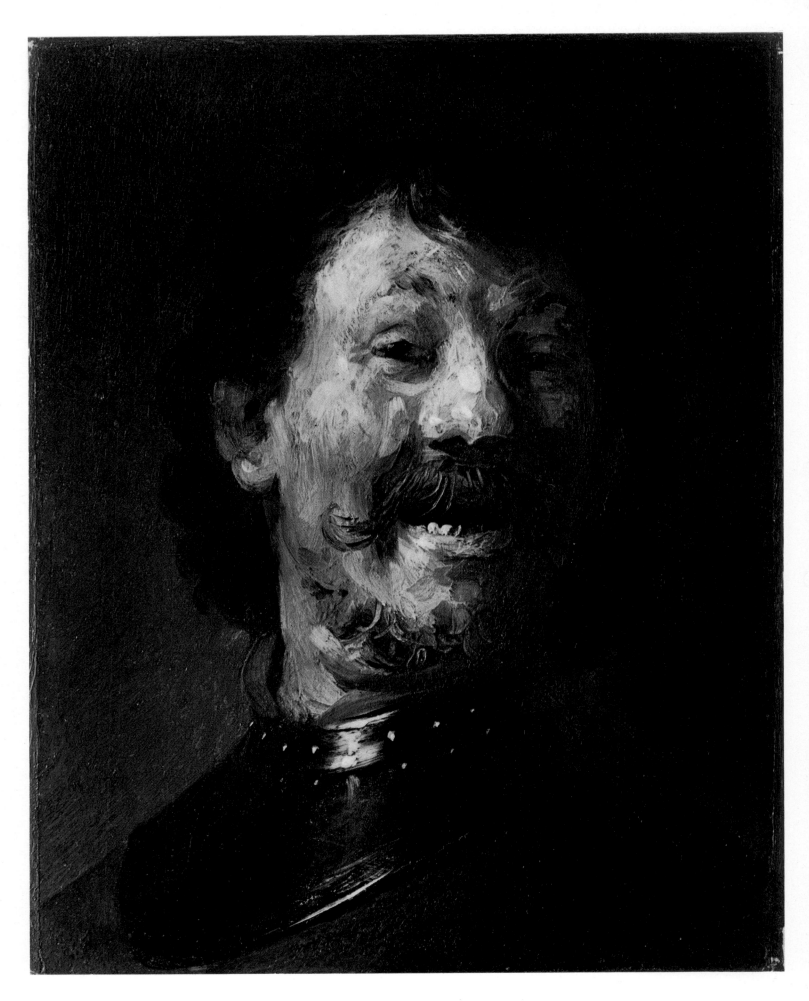

to take up her post in Rembrandt's service. Taking thorough advantage of the situation, she succeeded in extending her influence over Rembrandt. It appears though that she was genuinely fond of Titus, since she made him her sole heir. It was only with considerable difficulty that Rembrandt was able to rid himself of this difficult and hysterical woman and have her cared for in an institution at his own expense. The recent research of Mr Vis into the

relationship between Rembrandt and Geertje does, however, provide us with a more convincing picture of what actually happened.

Geertje Dircx, who had been widowed when still a young woman, came to look after Titus at the Rembrandt house during Saskia's lifetime. During the years immediately after Saskia's death, she lived with Rembrandt apparently as his common-law wife. Their life together seems to have been relatively quiet and peaceful, until the arrival of Hendrickje Stoffelsdochter Jegher to help run the large domestic establishment in 1646. Rembrandt's preference then seems to have been gradually transferred to the new arrival, not unnaturally incurring Geertje's jealousy. Her relationship with Rembrandt gradually began to deteriorate and they finally separated in June of the year 1649. Strangely enough, Geertje had made her will on January 24, of the previous year, in which she made Titus her sole heir. It now seems more than likely that she did this not only from love of her foster child, but also on Rembrandt's insistence, since he could foresee a separation and wished to salvage as much as possible from the situation. The known facts and surviving legal documents relating to the separation have now been placed and studied in correct chronological order. It now appears that Geertje initially issued a writ against Rembrandt, summoning him to appear before the commissioners of the special court which dealt with marital problems and claims – also referred to as the "chamber of the marriage quarrel" – on September 25, 1649. Rembrandt, however, declined to appear. Instead, he persuaded Hendrickje, then aged twenty-three, to sign a declaration on October 1 to the effect that: Geertje Dircx, widow of the trumpeter Abraham Claesz., having resided for a period in Rembrandt's house, now wished to leave. Hendrickje then witnessed an agreement between Rembrandt and Geertje on a number of disputed points, which remained unspecified. From the testimony of another witness, Octaeff Octaeffsz., a shoemaker, dated October 14, we learn the following version of events: at Rembrandt's request, he presented himself at Rembrandt's house on October 3 to act as a witness to an agreement between Rembrandt and Geertje settling all matters and claims, including financial claims, relevant to their situation. Octaeff went on to claim that he was also present on October 10 when an agreement was signed. Below is given a brief summary of the unsigned and undated draft agreement which Rembrandt must have had drawn up between October 3 and 10.

Geertje's declaration notes that she was first engaged as "nurse" for Rembrandt's small son Titus, and that afterwards she lived for a long period in Rembrandt's house. The small amount of her wealth had been earned in this employment and that was why she had left everything to Titus. Now that she had left Titus and Rembrandt to live in a single room, she was no longer able to support herself. The declaration then continues with a request to Rembrandt, her "former master," for 200 florins to enable her to redeem the gold and silver she had pawned and for an annual maintenance allowance of 160 florins. In return for this, Geertje would be prepared to give up all further claims against Rembrandt; these claims are again not specified in this document. Rembrandt seems to have agreed to this, on the following conditions: that Geertje's will made in 1648, naming Titus as sole heir, should remain unchanged (Rembrandt was thus aware of its existence), and that Geertje should promise that the rose ring with diamonds, which is specified, and all other valuable goods which she still had in her possession should remain free and unencumbered.

These conditions were probably contained in the draft agreement referred to by the witness Octaeff Octaeffsz. in his declaration of October 14. He further declares that the agreement was given to Geertje to sign on October 10 in Rembrandt's kitchen, and that on that occasion Geertje "behaved very violently and unreasonably, refusing to listen to the reading of the agreement, let alone signing it." This was hardly surprising, considering that the draft had been drawn up at Rembrandt's request, although this passage quoted above is often adduced by the traditional commentaries on

A MAN LAUGHING
Oil on copper; 6 × 4¾ in
(15.5 × 12.5 cm)
Circa 1630
The Hague, Mauritshuis (Br. 134)
This painting was for a long time erroneously considered to be a self-portrait. There are also some doubts surrounding its attribution.

Rembrandt's life as proof that Geertje was not very stable. It is much more likely, however, that she was simply overcome by extreme anger on being presented with this one-sided view of their affairs.

The first battle, then, was undoubtedly won by Rembrandt, although Geertje did not admit defeat. Rembrandt was summoned to the court for a second time, and again failed to appear. The third time, however, he did accept, and the trial was swift and to the point. The plaintiff, Geertje, declared that the defendant had verbally promised her marriage and that he

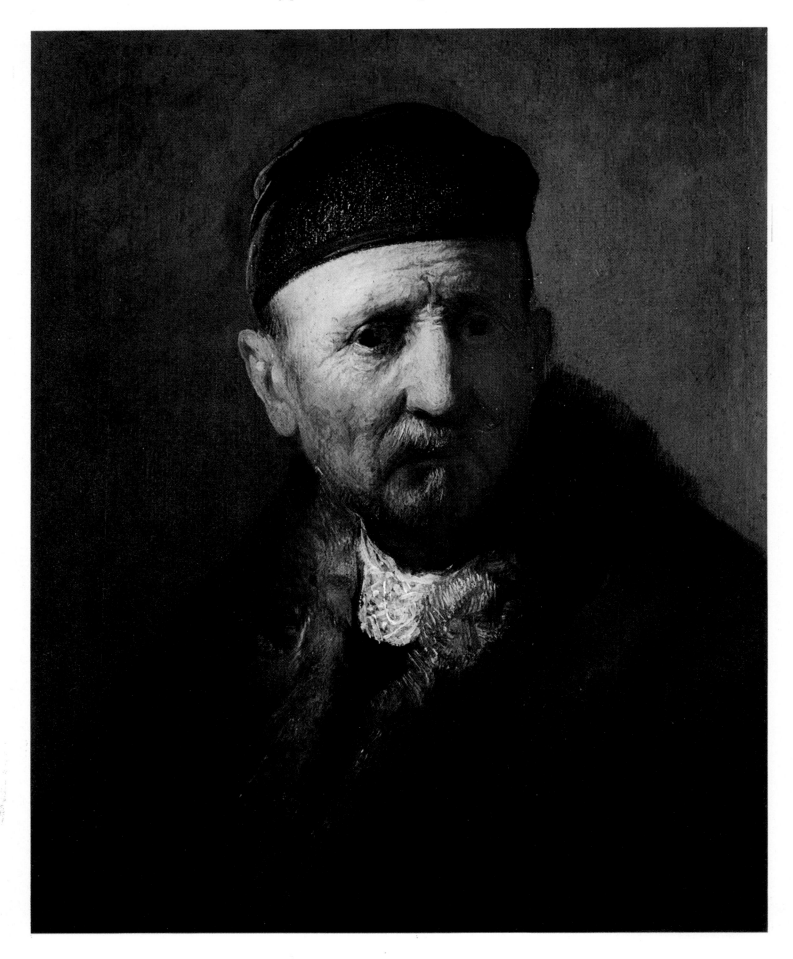

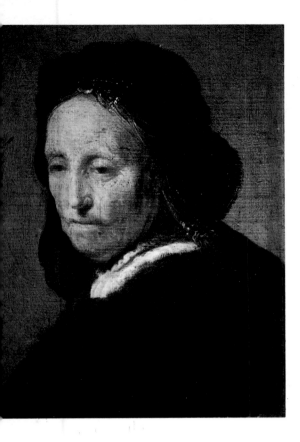

"REMBRANDT'S MOTHER"
Oil on panel; 6¾ × 5 in (17 × 13 cm)
The Hague, Mauritshuis (Br. 67)
Considered by some critics to be a good
copy of a lost original.

"REMBRANDT'S FATHER"
Oil on panel; 18½ × 15¼ in
(47 × 39 cm)
Circa 1630
The Hague, Mauritshuis (Br. 77)

had given her a ring as a token of this; sexual intercourse had been frequent between them. Geertje therefore demanded that Rembrandt should marry her or at least provide for her maintenance. In turn, Rembrandt denied that he had ever promised marriage and declared that he was not obliged to admit that he had slept with Geertje; the plaintiff would have to prove that point.

The verdict of the court, however, was that the defendant should pay the plaintiff 200 florins annually, instead of 160, for the rest of her life. With regard to all other matters, the situation remained as stated in the contract of October 14, 1649. It now seemed that Rembrandt had succeeded in establishing a legal advantage over Geertje. Nothing could have been further from the truth: Geertje now decided on a counter-move, involving the rose ring and the other valuable objects which she had been given by Rembrandt and which the latter so much wanted to come into Titus' possession. Rembrandt's concern for these objects perhaps indicates they had once belonged to Saskia. It is likely that Geertje then pawned these objects, in spite of the prohibitive clauses of the contract, and that this was known by Rembrandt. In any case, she was arrested at his instigation and taken to the women's prison and not – as has been often incorrectly supposed – to the lunatic asylum at Gouda. Rembrandt's action was responsible for Geertje's spending almost five years in the women's prison, where she was obliged to earn her living spinning wool with the other prisoners. This punishment does seem to have been excessive. It is also probable that Rembrandt failed to pay her maintenance during the period which he knew her to be safely shut away in the prison at Gouda. This factor was later to weigh very much in Geertje's favor, and she was to be one of Rembrandt's most considerable creditors at his bankruptcy proceedings in 1656.

The episode with Geertje Dircx, while essentially little more than a rather squalid affair with a past housekeeper, has been discussed extensively because of what it tells us firstly about Rembrandt himself: that he was a hard, inflexible man towards those of whom he no longer had any need. Secondly, it tells us something about how the nineteenth-century image of Rembrandt came into being – an image which still finds popular support today. The indignities inflicted on Rembrandt by the art theorists of Classicism led in turn to the Rembrandt myth of Romanticism, in which the painter plays the role of misunderstood genius who, rejecting fame and honor, develops in the opposite direction to prevailing taste, to follow his own bent as "the first heretic in the art of painting." Now that the criticism of Rembrandt has turned to the study of the painter in the context of his own life and times, the Romantic interpretation seems totally at odds with the real circumstances of the seventeenth century. This new departure in Rembrandt scholarship, pioneered by the Utrecht art historian, the late Jan Emmens, has for instance shown that the description "first heretic in the art of painting" – the phrase used by Andries Pels in his classical criticism of Rembrandt of 1681, twelve years after Rembrandt's death – must be understood in the sense of "most important representative of the older generation," a generation which could not be heretical in the sense of rebelling against a set of rules, since those rules were not yet in existence.

The myth constructed around Rembrandt by the Romantics and their uncritical admiration for the great talent of Rembrandt the artist for expressing the most deeply felt human emotion were also directed towards Rembrandt the person, who thus came to be seen as being almost above criticism. And within the framework of the myth very little attention was given to events which could be interpreted as revealing less pleasant sides of the painter's character.

The confusion of Rembrandt's art and personal life can already be seen in the work of his first biographer, Joachim von Sandrart; this confusion arose substantially from the classical view that the surroundings of a painter were reflected in his work, almost as if the work was a series of illustrations of the painter's life. A very curious example of this view occurs in the work of the classical art scholar, William Goeree of Middelburg, who advanced the

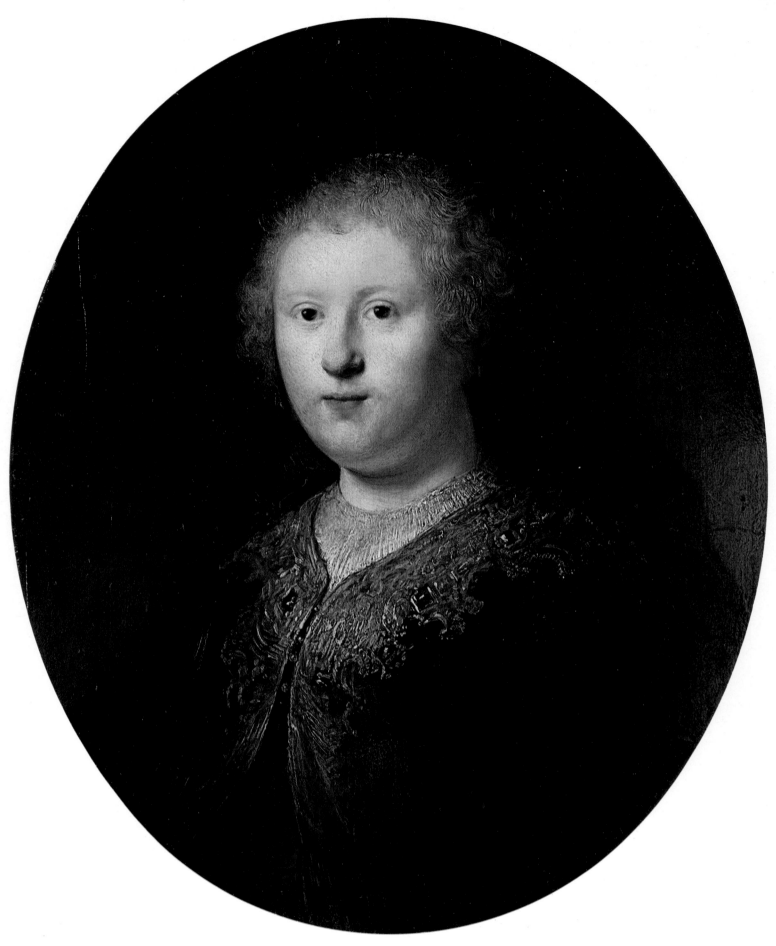

theory in 1668 that flaws in the physical beauty of the painter would result in corresponding faults in the representation of a nude model in a work by that painter: "... the soul, which is the mistress of the body, is synonymous with the faculty of judgement, and therefore tends to communicate the likeness of the body which it inhabits to the work which it inspires."

Contemporary art theory is of course very different: the painting of beggars does not necessarily involve frequenting them, nor does a painter of obviously happy groups of people have to be a joyful person himself. Emmens elaborates this point by pointing out that the twentieth-century

PORTRAIT OF A YOUNG WOMAN
Oil on panel; $21\frac{3}{4} \times 19$ in (55×48 cm)
Signed and dated: RHL van Rijn 1632.
Milan, Pinacoteca di Brera (Br. 87)
Transferred from the Louvre to the Pinacoteca di Brera in 1813.

It is generally accepted that the model was Liesbeth van Rijn, Rembrandt's sister.

notion of self-expression was quite foreign to the seventeenth century, when the objective "expression of passion" was the ideal to be pursued: attentiveness, anger, anxiety, tenderness, sadness, etc. These qualities would be conveyed principally through the portrayal of the physiognomy and, in the case of Rembrandt, the study of movement and non-symbolic facial expressions and gestures.

Rembrandt's pursuit of this ideal in his work is known from a famous and much-quoted letter of January 12, 1639, which he wrote to Constantijn Huygens about the paintings of the entombment and the resurrection mentioned above, the latter executed "to the great terror of the guards." "... These two canvases are now ready for delivery after having applied myself carefully to finishing them; they should please his royal highness, since in the two paintings the finest and most natural movement has been observed and this is the main reason why they have taken so long ...," by which Rembrandt probably literally meant movement as well as the deeper emotions expressed.

Care and application remained characteristics of Rembrandt's work, as well as a great capacity for self-criticism. His work changes and varies; as Houbraken tells us, he used to make at least ten different sketches before being satisfied with a draft for a painting, and he could spend days "trying to arrange a turban to his taste."

Rembrandt often used to take note of the people and incidental happenings which he saw in the street. He also frequently drew from live models in his studio and, for a certain period, sketched a considerable number of local landscapes. In 1915 the great collector, Frits Lugt, published a study identifying and classifying the numerous drawings, prints and paintings with landscape or topographical subjects drawn from Amsterdam and the surrounding countryside. The drawings, which were from direct observation, were often later used in etchings or paintings, as were objets d'art and curios from Rembrandt's personal collection.

Especially noteworthy is the "journalistic" drawing of the Town Hall of Amsterdam after it had been burned down; the event is recorded in Rembrandt's own handwriting: "Amsterdam Town Hall after being burned down, 9 July 1652."

A panegyric on one of Rembrandt's paintings in the collection of the Amsterdam art dealer Maerten Kretzer of 1650 gives some idea of the popularity the artist still obviously enjoyed, even after 1642:

> "I will not try to depict
> your fame, O Rembrandt, with my pen.
> Everyone knows the honor which is yours
> when I merely mention your name. ..."

Hendrickje Stoffelsz. was the third woman in Rembrandt's life. She first joined the Rembrandt household as a maid in 1646, when she was aged twenty. After the departure of Geertje Dircx, she remained with Rembrandt and looked after him for the rest of his life. As with Geertje, Rembrandt does not appear to have wished to marry her, though this may have been to avoid jeopardizing the income from Saskia's legacy, which would have been halved in the event of a second marriage by Rembrandt. This, however, could not occur as long as Titus lived. But whatever the reasons, Rembrandt and Hendrickje did not marry.

The only objector to this state of affairs was the Church Council of Amsterdam, and both Rembrandt and Hendrickje were summoned to appear before it in the summer of 1654 to answer for their immorality. After the fourth summons, which was directed to Hendrickje, she finally appeared before the Council, obviously pregnant. She admitted her transgression and suffered the severe punishment of being condemned to penitence and excluded from communion for her irregular association with Rembrandt. Their daughter Cornelia was baptized in the Old Church in the October of the same year, Hendrickje being referred to as Rembrandt's 'house-woman,"

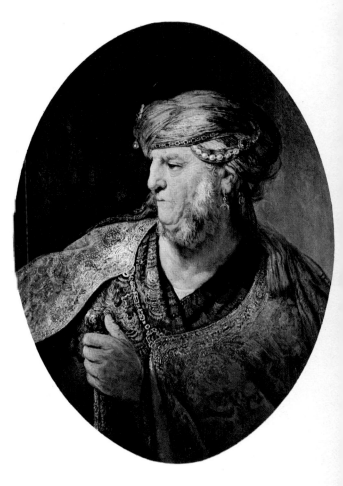

A MAN IN ORIENTAL COSTUME
Oil on panel; 33¾ × 25 in
(85.5 × 63.7 cm
Signed and dated: Rembrandt f. 1633
Munich, Alte Pinakothek (Br. 178)

which is more or less the same as his common-law wife.

Rembrandt was obviously no longer a member of the Low German Reformed Congregation by 1654, since only Hendrickje was finally summoned before the Church Council and punished. It is also probable that Rembrandt, who had become so adept at representing so many varieties of religious experience in his paintings, felt attracted to more than one of the very varied bodies of religious belief which were current in the tolerant atmosphere of seventeenth-century Amsterdam. One of his early biographers, the Italian Filippo Baldinucci, noted in 1686 that Rembrandt *"professava in quel tempo (c. 1640) la Religione dei Menisti. . . ."* By which he

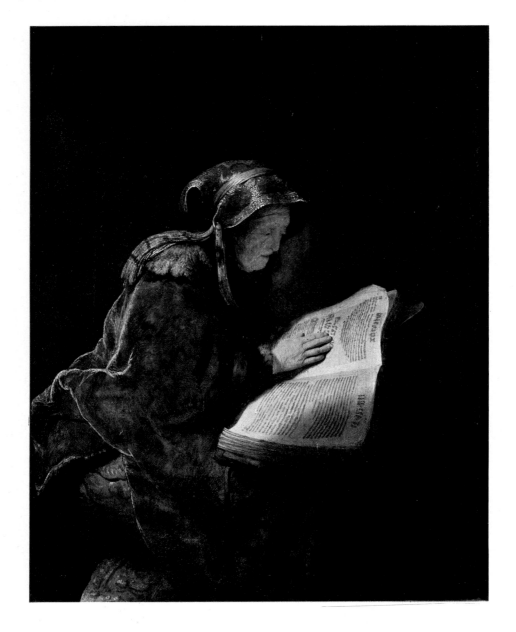

"REMBRANDT'S MOTHER" AS
A BIBLICAL PROPHETESS
(HANNAH)
Oil on oak panel; $23\frac{1}{2} \times 19$ in
$(60 \times 48$ cm)
Signed and dated: RHL 1631
Amsterdam, Rijksmuseum (Br. 69)
This painting was in the Schönborn Collection in Pommersfelden in 1719; at the sale of this collection (Paris, 1867), it was acquired for the Augusteum of Oldenburg. On loan in 1922 and finally left to the Rembrandt Society in 1928, being included in the Rijksmuseum collection in the same year.

Neeltje Willems-dochter van Zuytbroek, Rembrandt's mother, is represented in this painting as the prophetess Hannah reading the Bible.

must have meant the Mennonite Congregation or Baptists. The careful research of the art historian H. van de Waal has thrown new light on Rembrandt's religious convictions. It is not, for instance, completely certain that Rembrandt would have been a member of the Mennonite community, since Mennonite was a term used to describe all sorts of unorthodox movements, from the Remonstrants to the notorious Socinians. This was an anti-trinitarian sect, which denied the divinity of Jesus Christ as the son of God, the existence of the Holy Ghost and the Fall of Man, all concepts of the greatest importance in Christianity. The Socinians considered Christ to be simply a man, albeit a man in the purest possible form. These beliefs were too much even for the tolerant city of Amsterdam; the sect was banned and persecuted, especially during the 1650s. The beliefs of the Mennonites had considerable similarity to those of the Socinians, though perhaps more on the

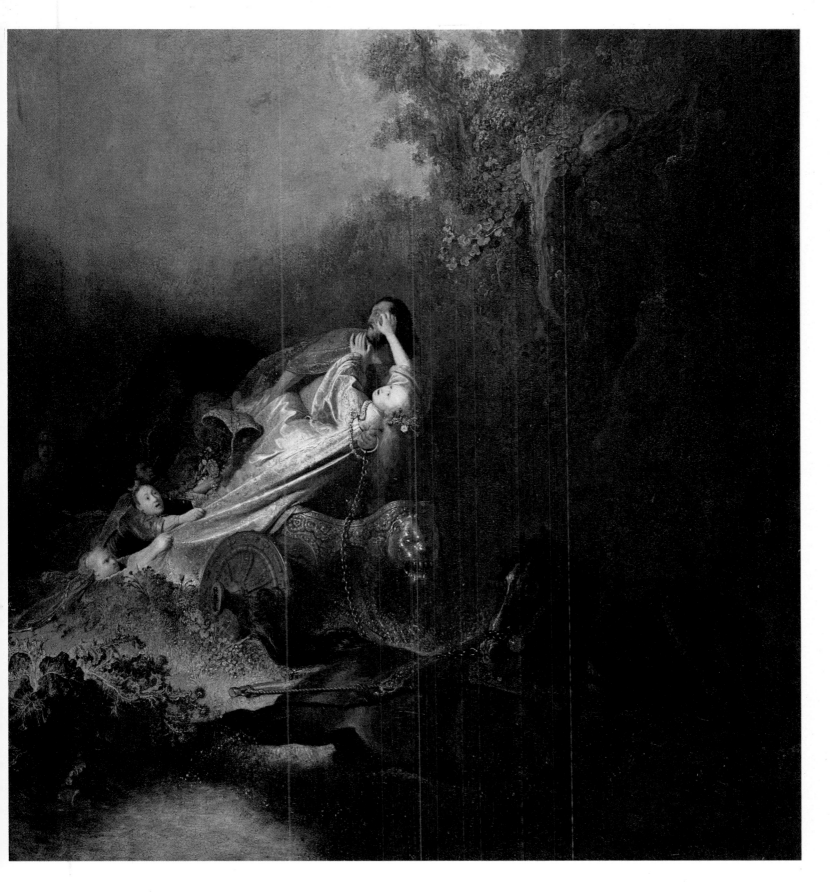

THE ABDUCTION OF
PROSERPINE
Oil on panel; $32\frac{3}{4} \times 30\frac{3}{4}$ in
(83 × 78 cm)
Probably 1628–1629
Berlin, Staatliche Museen Preussischer
Kulturbesitz, Gemäldegalerie (Br. 463)

practical plane than the theoretical. Thus they attached great importance to the individual confession of faith, the reading of the Bible and socially responsible behavior, based as closely as possible on the example of Christ.

Van de Waal's researches have shown that Rembrandt did indeed have contacts with this sect which, in addition to being banned, was generally regarded as being extremely dangerous; nor was the contact limited to the affinity between Rembrandt's representation of Christ's suffering as a human being and the Socinian concept of Christ as "human." The key to the discovery of this contact was found during van de Waal's new critical study of Rembrandt's etching *Dr Faustus* (p. 32), a work which had never been satisfactorily explained. This print shows a scholar in his study, surrounded by the usual accoutrements of a globe and books. Rising from a sitting position, the scholar looks with intense interest towards a mysterious source

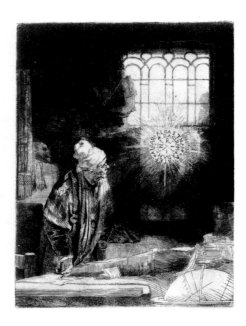

DOCTOR FAUSTUS
Etching; 8 × 6¼ in (20.9 × 16.1 cm)
Circa 1652–1653
(Bartsch 270)

DIANA, WITH SCENES FROM
THE STORIES OF ACTAEON
AND CALLISTO
Oil on canvas; 29 × 36¾ in
(73.5 × 93.5 cm)
Signed and dated: Rembrandt fc 1635
(the last figure has been written over
another; the date was probably
1632–33).
Anholt, Collection of the Prince of
Salm-Salm (Br. 472)

of light in front of the study window; in the light can be distinguished a number of cryptic words and the vague outline of a hand pointing to a mirror. Behind the man to the left, and behind a curtain, can be distinguished a skull-like object, symbol of human vanity signifying the transitory nature of our existence on earth.. The rest of the space in the work is left vague. Van de Waal has proved conclusively that the scholar portrayed is an idealized Dr Faustus Socinus, the founder of Socianism, and presented as a second Martin Luther. The mysterious light represents his inspiration, and not the Holy Ghost which was supposed to have determined Luther's thoughts and actions. Since the Socinians were subject to so much persecution, the print was entitled *Dr Faustus*, which was only completely meaningful to the initiated.

Rembrandt need not have been a member of the Socininian sect to have done this etching, but it seems reasonable to assume that he was at least a sympathizer. This work also makes clear which side Rembrandt took in the politico–religious struggle which dominated the affairs of the Republic. The religious aspect of this struggle was characterized by the continual dispute between orthodox Calvinism, which felt its doctrines threatened, and the liberal tendencies which were seen as the chief agents of this threat. A very plausible interpretation of the situation suggests that the differences in belief were as much a reflection of the social situation as of the religious, the vital differences being between the tiny governing class and the vast mass of the people, or the haves and the have-nots.

The situation is summed up very well in *De lage landen bij de zee* (The low countries near the sea) by Jan and Annie Romein. The authors conclude that the upper classes, whatever the personal convictions of individuals, tended to take up a position opposed to traditional beliefs – beliefs which sprang from a deep sense of the magical and religious in life. For the first time in history, the authors continue, the collective consciousness of a class took on an entirely secular aspect; it was not surprising, then, that the upper classes of the country became a hot bed for every kind of free thinking. It was this growth of the spirit of free enquiry and its effect on attitudes towards traditional religious belief which substantially strengthened the cause of Arminianism. It was inevitable that traditional Calvinism, which maintained the older religious traditions, should attract those opposed to the interests of the ruling class. We may conclude, therefore, that Rembrandt enjoyed a reasonably high position, or at least that he did not identify himself with the interests of the "people."

From the fact that Rembrandt's religious convictions were in no way conventional, we may conclude that he sympathized with all those who did not conform to contemporary political and religious dogma.

We have already noted that Rembrandt showed considerable interest in the Jewish community and maintained contact with prominent Jewish ecclesiastics and scholars; it is not surprising therefore that his work contains a large number of representations of Jews. Many of these are not formal portraits, but studies of types which he saw in his immediate surroundings in what was then the Jewish quarter of Amsterdam. These studies were used as models for his paintings of biblical scenes: Jesus Christ and the world in which he lived were indeed Jewish and therefore to be depicted as such, according to Rembrandt's vision.

These studies were not Rembrandt's only representations of Amsterdam Jewry. He also painted a large number of portraits of the Jews of Amsterdam, both prominent and unknown. Among those to have their portraits painted who are known by name was the physician and poet Dr Ephraim Bueno (Bonus) (p. 121), a prominent member of the Sephardic community. Rembrandt also painted the portrait of the scholar Rabbi Manasse Ben Israel, who was also a painter and publisher, and whose reputation stretched beyond Amsterdam to the rest of Europe. It was thanks to this scholar that the Jewish traditions became much more widely known among non-Jews. He was a favorite guest of such non-Jewish

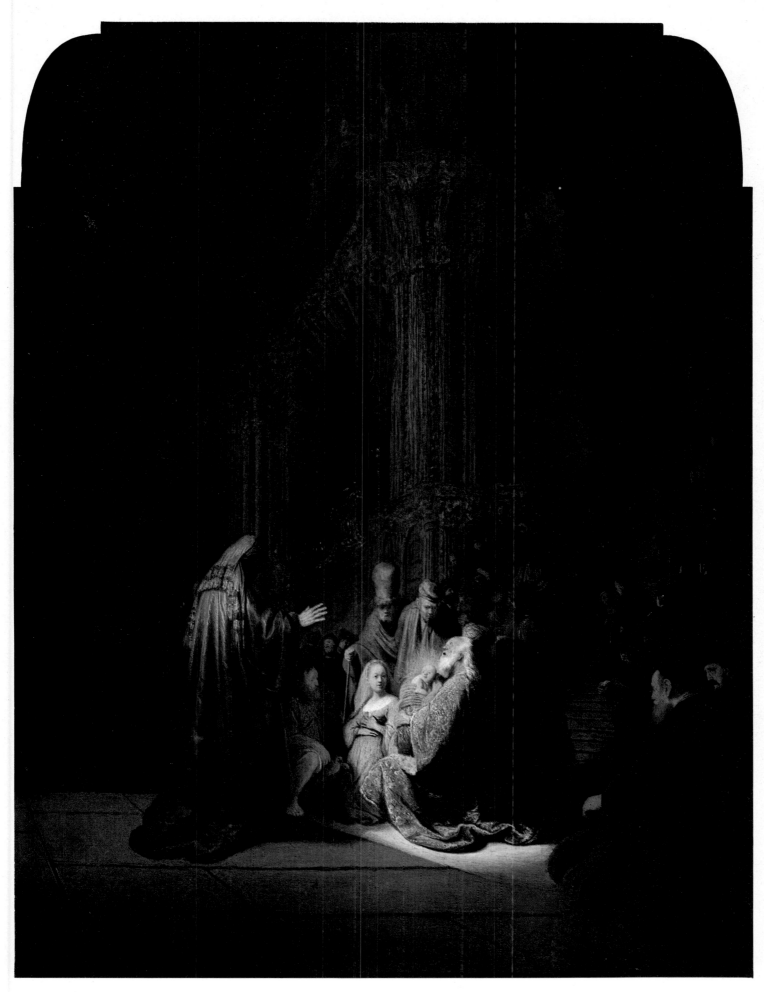

THE PRESENTATION OF
JESUS IN THE TEMPLE
Oil on panel; 24 × 19 in (61 × 48 cm)
Signed and dated: RHL 1631
The Hague, Mauritshuis (Br. 543)
Pages 34–35: Detail

scholars as Vassius and Berlæus, and maintained a lively correspondence
with other eminent men, including Hugo de Groot (Grotius). There was one
very good practical reason why Rembrandt and Manasse Ben Israel should
become acquainted: they lived opposite each other in the Anthoniebrees-
traat, which was also sometimes referred to as the avenue of the Jews. This
acquaintance grew into a lasting friendship which they maintained for
twenty years. Through the offices of Manasse Ben Israel, Rembrandt

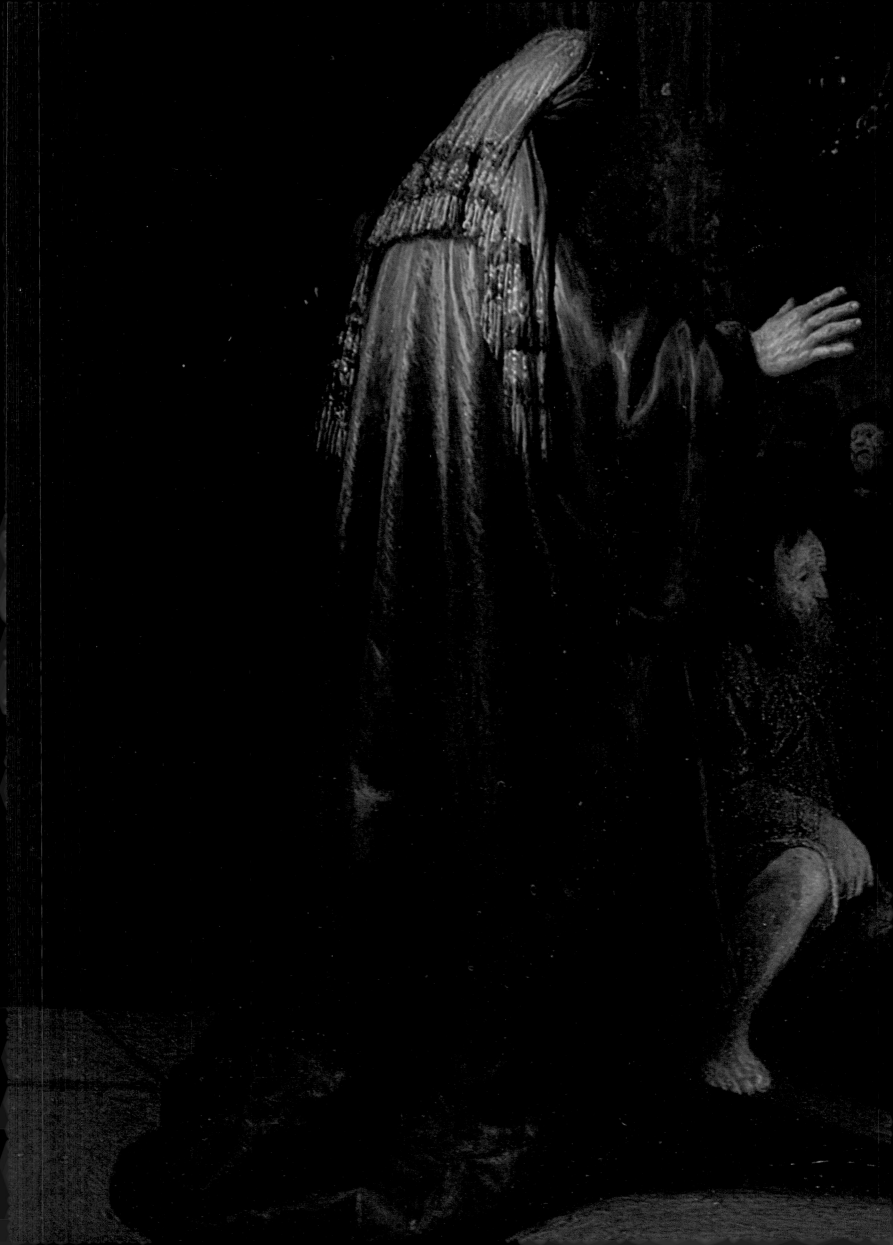

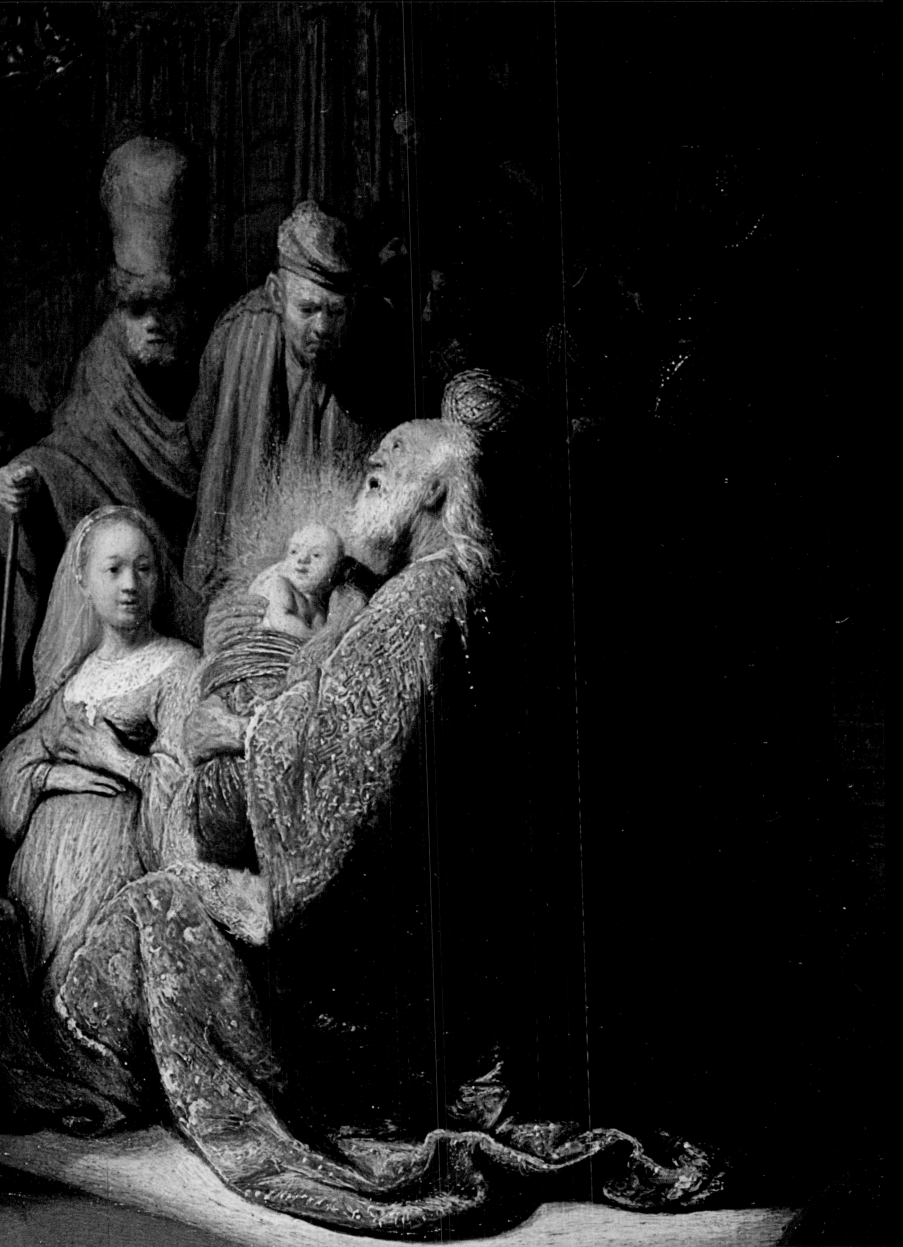

acquired a deep insight into Jewish traditions and developed a considerable respect for them, which he conveyed so excitingly in his paintings.

On one occasion Rembrandt was brought into direct contact with Jewish interpretation of the Bible; in 1655 he was asked by Manasse to provide the illustrations for a book written by him in Spanish, *Piedra Gloriosa, o de la estatua de Nebuchadnesar* (The Glorious Stone, or the Statue of Nebuchadnezzar), which discusses certain Messianic passages from Daniel 2:32–35.

Only three books are known to have been illustrated by Rembrandt, and we may therefore assume that the work he did on Manasse's book was done as a special favor.

The financial difficulties which were to mark the next years of Rembrandt's life, were mitigated to some extent by the presence of Hendrickje and Titus. Rembrandt had by now incurred considerable debts, including money still outstanding on the purchase of his house. His trade suffered losses and Geertje was still on hand to make the situation even more difficult. In addition, from about 1650 onwards a new attitude, which was eventually to develop into a whole new aesthetic, had begun to show itself in the appreciation of art.

We learn that, in the summer of 1656, Rembrandt asked for a deferment of payments to his creditors and to be declared insolvent, "having found himself in such difficulties because of losses suffered in business and damages and losses at sea." On July 25 and 26 an inventory was made of all his household effects, his collection of objets d'art and curios, and of his furniture and other household goods. Shortly before, in May 1656, Rembrandt had taken the precaution of making the house over to his son Titus as part of Saskia's legacy. This was a maneuver over which the creditors and the representative of Titus, who was still under age, were to argue for a very long time. The son was in fact one of his father's most considerable creditors: half of Rembrandt's fortune at the time of Saskia's death was due to Titus as his mother's legacy, amounting to the considerable sum of 20,375 florins. Relations between father and son, however, do seem to have remained fairly good, as can be seen from the first will which Titus made in October 1657. Titus, who was then sixteen years old, named his half-sister Cornelia as sole heir of all his goods and effects; Rembrandt van Rijn and Hendrickje Stoffelsz., Cornelia's parents, were appointed trustees of the legacy, to the exclusion of the orphan's court. This was done on the condition that his father would enjoy the benefit of the income derived from those goods and effects. This income was to be used simply for personal maintenance and could not be used for repaying debts already incurred or still to be contracted. Rembrandt was clearly not named as joint-heir to protect the legacy from creditors. How far Rembrandt influenced the drafting of the will can only be surmised, but it is certain that the existence of this document ensured continued income for his maintenance. He was only destitute *de jure*; *de facto* his fortune was only halved. A second will, drawn up a month later than the first, made one addition: Rembrandt, as the sole and absolute guardian of his daughter Cornelia, could manage and use those goods left by Titus as he thought fit, and could even draw on the capital in case of need. More extensive mention was also made of Hendrickje in this later document.

Rembrandt's possessions were not auctioned immediately after the declaration of his bankruptcy. In November 1657 the commissioners of the bankruptcy court ordered the sale of part of Rembrandt's estate, and sometime during 1658–1659 the house in the Anthoniebreestraat was also sold, though for a sum smaller than that which he had paid for it.

Rembrandt and his family then moved to a less pleasant house at the Rozengracht, "near the maze," which they rented for 226 florins a year. In February 1658 the furniture and household effects were sold followed in September by Rembrandt's collection of prints and drawings, including works by important Italian, French, German and Dutch masters, as well as many drawings and sketches by Rembrandt himself. The creditors were

DOCTOR NICOLAES TULP DEMONSTRATING THE ANATOMY OF THE ARM
Oil on canvas; $66\frac{3}{4} \times 85\frac{1}{4}$ in (169.5×216.5 cm)
Signed and dated: Rembrandt f: 1632
The Hague, Mauritshuis (Br. 403)
This work was Rembrandt's first important commission after his move to Amsterdam in 1632.
Pages 38·39: Detail

then paid from the proceeds of these sales, though not all of them received the outstanding sums in full.

To rid Rembrandt of the attentions of creditors and the worry of other, more trivial matters for the rest of his life, Titus and Hendrickje concluded an agreement on December 15, 1660 to set up a company to trade "in paintings, pictures and paper, engravings, and woodcuts, the printings of these, curiosities, and all pertaining thereto. . . ." This company had effectively come into existence two years earlier, but it was now officially agreed that the company should remain in existence for the duration of Rembrandt's life and for six years after his death. The conditions governing the formation of the company provided for the continued sharing of expenses between Titus and Hendrickje, including the purchase of household effects, furniture, paintings, works of art, curiosities, tools, and the payment of the rent and other taxes. Both the parties to the agreement put all their possessions into the partnership – Titus slightly more than Hendrickje – and committed themselves to maintain this situation by holding all future earnings in common. Both were to share profits and losses equally, and to do as much as possible to promote the company's interests.

There then follows an interesting passage relating to the role Rembrandt would play in relation to the company: if the two partners needed help in the business, then it was agreed that no one was more qualified than Rembrandt van Rijn to provide this help. It was therefore agreed that Rembrandt, in exchange for his help and advice, would live with them, receiving "free

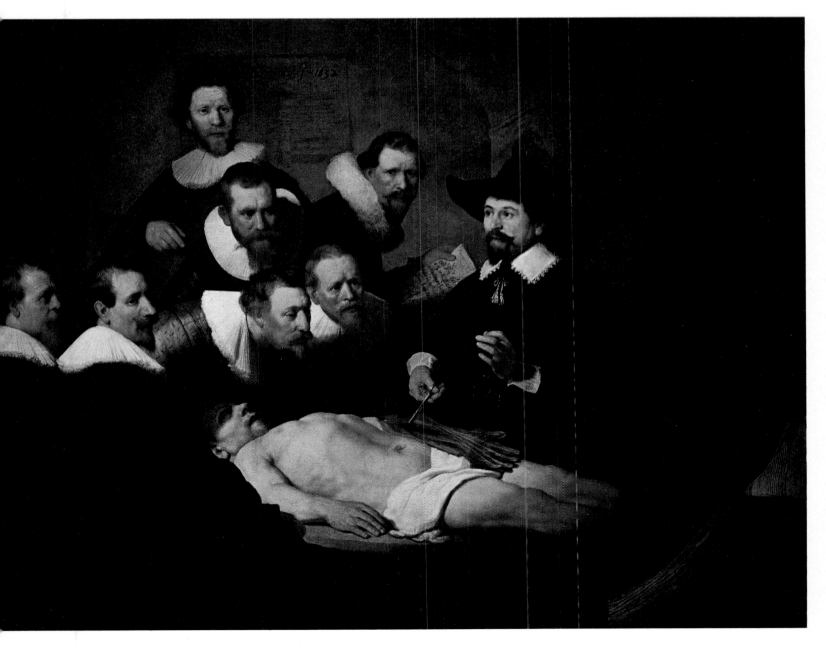

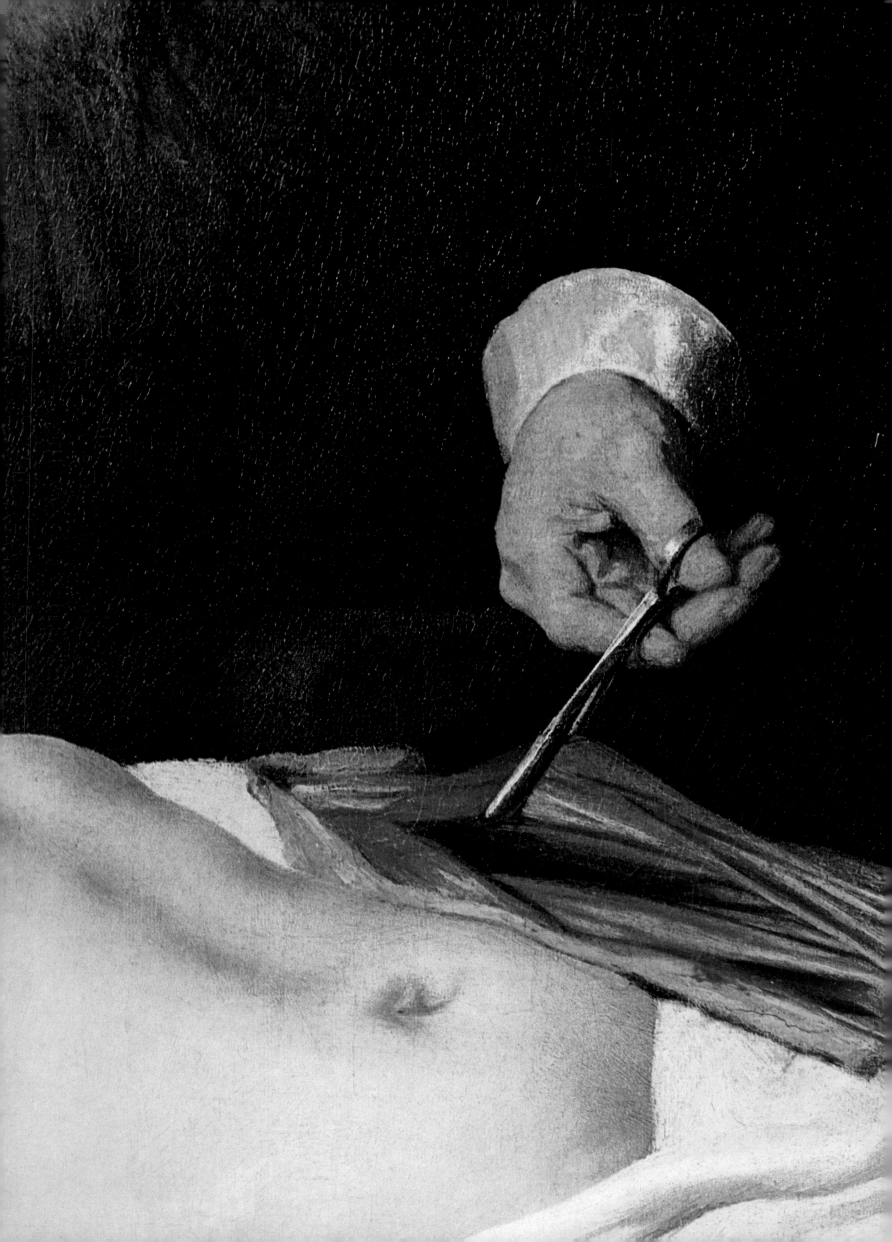

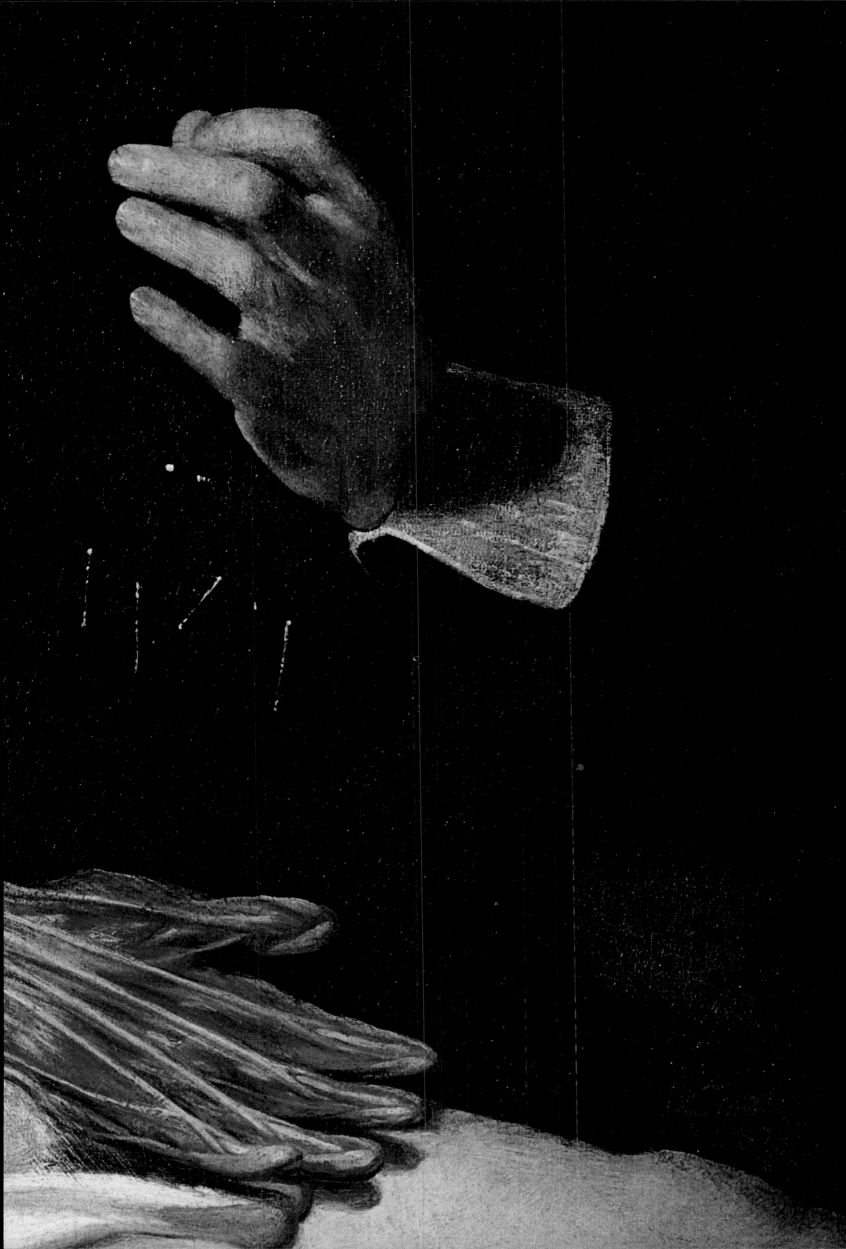

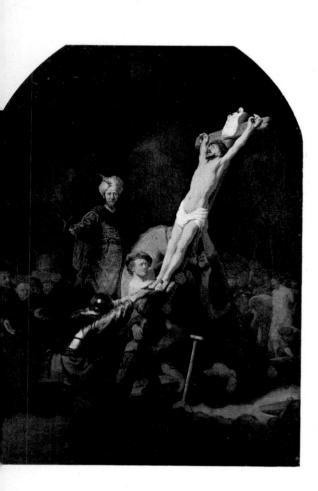

THE RAISING OF THE CROSS
Oil on canvas; $37\frac{3}{4} \times 28\frac{1}{4}$ in
(96 × 72 cm)
Munich, Alte Pinakothek (Br. **548**)
From the Gallery of Düsseldorf.
Together with four other works, *The Descent from the Cross* (pp. **43–45**), *The Entombment of Christ, The Resurrection* (p. **84**) and *The Ascension* (p. **66**), this painting was commissioned and bought by Prince Frederick Henry of Orange-Nassau (**1584–1647**) through his secretary, Constantijn Huygens.
Opposite page: Detail. The man at Christ's feet is Rembrandt himself.

board and lodging and be excused of all housekeeping expenses and rent, on condition that he will promote the interests of the company and help to make profits for it; all this he promises to do." It is also stated explicitly, as in Titus' wills mentioned above, that Rembrandt himself would have no share in the business nor in the domestic establishment. The document also acknowledges that Rembrandt had received 800 florins from Hendrickje and 950 from Titus; he promises to repay these debts as soon as he has earned something with his painting; everything earned from paintings painted in their house was to be handed over to them until they were completely reimbursed. It was further agreed that neither of the two shareholders could sell, misappropriate or embezzle anything belonging to the company without the consent of the other.

Rembrandt's fine art business was thus taken over by Hendrickje and Titus, making it safe from creditors and other claims by a third party.

Hendrickje, was unable to manage the business for very long. She made her will on August 7, 1661, while being "sick in body," though "still walking and standing, and having and using her reason, memory and means of expression." Her death probably occurred in 1662.

Titus, who had still not come of age, continued with the business, but began to experience considerable difficulties because of his minority. In 1665, therefore, when he was about twenty-four years old, he asked the States of Holland for a *veniam aetatis*, or a declaration of majority; the request was made with his father's approval. The legal age for attaining majority was in fact twenty-five, but on June 19, 1665, he was officially declared of age.

It seems reasonable to conclude from all these agreements that Rembrandt was hardly living in poverty. We are left instead with the impression of a relatively sheltered life, not particularly lonely or troubled.

On February 10, 1668, Titus, now aged twenty-seven, married Magdalena van Loo, a native of Amsterdam and of the same age as her husband. Their life together was of short duration, for we find Titus' name in the register of deaths of the Westerkerk for September of the same year as the marriage. His wife Magdalena was then three months pregnant with his posthumous daughter Titia, who was baptized on March 22, 1669.

A few months later Rembrandt also died, on October 4, 1669. Although the contract of December 15, 1660 had explicitly laid down that the entire contents of the house in which Rembrandt lived belonged to Titus and Hendrickje – and thus exclusively to Titus after the death of Hendrickje – an inventory was drawn up of the entire contents of the living room. Even the most mundane objects are found on the list, such as "4 green net curtains," or, further on, "8 small scarves, old and new." The collection of paintings, drawings, curiosities and antiquities was stored in three separate rooms and placed under seal on the application of Magdalena von Loo, who was also acting on behalf of Cornelia, the daughter of Rembrandt and Hendrickje, in anticipation of the final settlement.

On October 8, 1669, Rembrandt, "painter living on the Roosegraft, opposite the labyrinth," was buried in the Westerkerk. He left behind two descendants: Cornelia, his daughter, aged fifteen, and Titia, his grand-daughter, seven months old. Less than two weeks after Rembrandt's funeral, Magdalena van Loo was also buried in the Westerkerk.

Rembrandt's Leyden Years

Rembrandt started his career as a painter around 1621, when he was fifteen years old. However, to understand properly the place occupied by Rembrandt in his own time, a brief description of the state of painting in the Netherlands during Rembrandt's apprenticeship may be necessary.

The attacks on church images, which came to a head in 1566, signify an

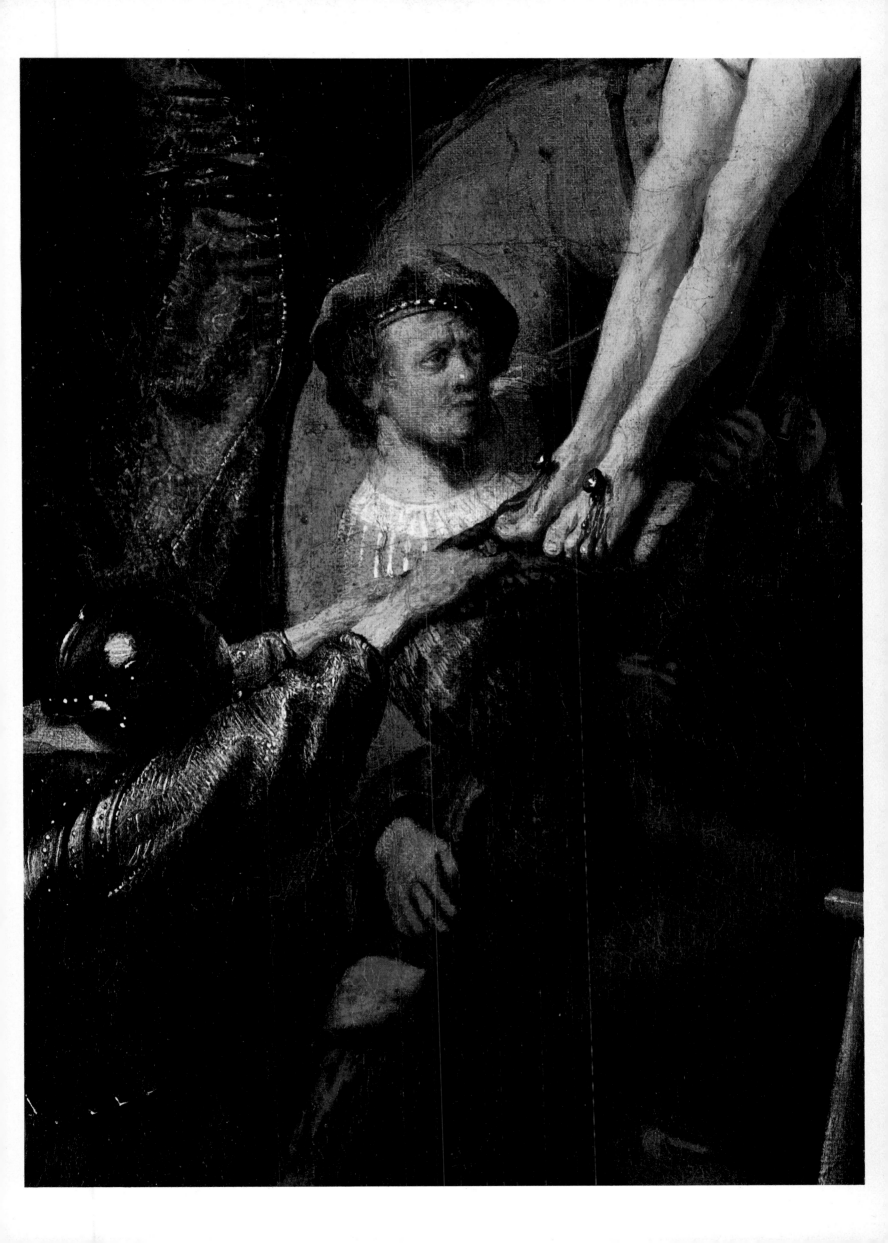

important break in the traditions of painting; very little church art escaped destruction, and this genre was never to regain its former pre-eminence in the Protestant churches – the only ones permitted. The Calvinists held a particularly sober view of the function of church buildings, and the commandment, "Thou shalt not make unto thee any graven image, or any likeness of any thing that is in heaven above, or that is in the earth beneath, or that is in the water under the earth" was applied literally to the interiors of the Calvinist churches. Decisive liturgical changes were also happening. The word of the Bible – passively received by way of the preacher or actively sought in the reading of the Bible – was paramount and was heard and read in the vernacular. This was in direct opposition to Roman Catholic practice, in which the mass was said in Latin, making paintings a necessity as "devotional aids" for the faithful. The Church thus ceased to be the most important patron of the arts.

The regent and his immediate entourage had for a long time been another source of commissions for works of art. But if there had ever existed a cultural climate in the Netherlands in which royal patronage could flourish, its existence was certainly impossible in the context of the new bourgeois society. Even the stadholder Frederick Henry who, together with his wife, still cherished certain royal pretensions, remained of little significance as a patron of the arts when compared to the sovereigns of other European nations. It was in fact the burgher class, only too conscious of its success, and its institutions, in the form of guilds and town councils, which provided the new patrons. The new patronage also required a different kind of art, which best flourished – it was hardly likely to do otherwise – in the towns.

Many of the towns had more or less distinct traditions of their own. Sixteenth-century Haarlem was an important center of Mannerism, drawing its inspiration from the aesthetic and intellectual ideals of the humanist Italian High Renaissance. Maerten van Heemskerck, later much admired and to a degree imitated by Rembrandt, began to use the ideas and forms he had observed in Italy in his Haarlem works of about the middle of the century. Of a later generation of Haarlem Mannerists, the best-known are the graphic artist and engraver Hendrick Goltzius (1558–1617), Cornelis van Haarlem (1562–1638) and Karel van Mander (1548–1606). They all borrowed forms from the Italian school, but perhaps the greatest influence on them was the work of Bartholomaus Spranger (1546–post 1627), whose style could be said to be international. Karel van Mander's main claim to fame rests on his writings on art theory, to which we owe much of our knowledge of views on art current at the time. These painters, however, were essentially orientated towards the practices of the sixteenth century; in contrast, a new, startlingly modern tendency in art began to make its appearance round about the turn of the century. This new spirit attached great importance to the representation of the non-idealized, daily surroundings of the ordinary man. The greatest and best-known exponent of this new current was the portrait painter Frans Hals (1580–1666). And in landscape painting, the Haarlem school first began to use the prosaic Dutch landscape as an important motif in painting.

Utrecht, which remained substantially Catholic, also developed as an art center with an individual style. During the sixteenth century Mannerism, derived from the ideals of Italian painting, was also the dominant style, coming to resemble that of Haarlem during the last quarter of the century. Abraham Bloemaert (1564–1651) and Joachim Wittewael (1566–1638) were the most important representatives of the Utrecht school. By the end of the sixteenth and the beginning of the seventeenth century other, more realistic, influences were beginning to make themselves felt. After the turn of the century, Bloemaert seemed to lose himself in an eclectic style, and an important new influence appeared in the art of Utrecht, in which the controversial Italian realist, Caravaggio (1569–1609), was the dominant force. Extremely important to Rembrandt's development was Gerrit van Honthorst, the most famous and influential of the Utrecht Caravaggisti,

THE DESCENT FROM THE CROSS
Oil on panel; $35\frac{1}{4} \times 25\frac{3}{4}$ in
(89.4×65.2 cm)
Signature not authentic: C Rhmbrant
Munich, Alte Pinakothek (Br. 550)
From the Gallery of Düsseldorf.
On the back of the painting there is a watercolor by Rembrandt, dated 1633.
Pages 44–45: Detail. The man supporting the arm of Christ is probably Rembrandt himself.

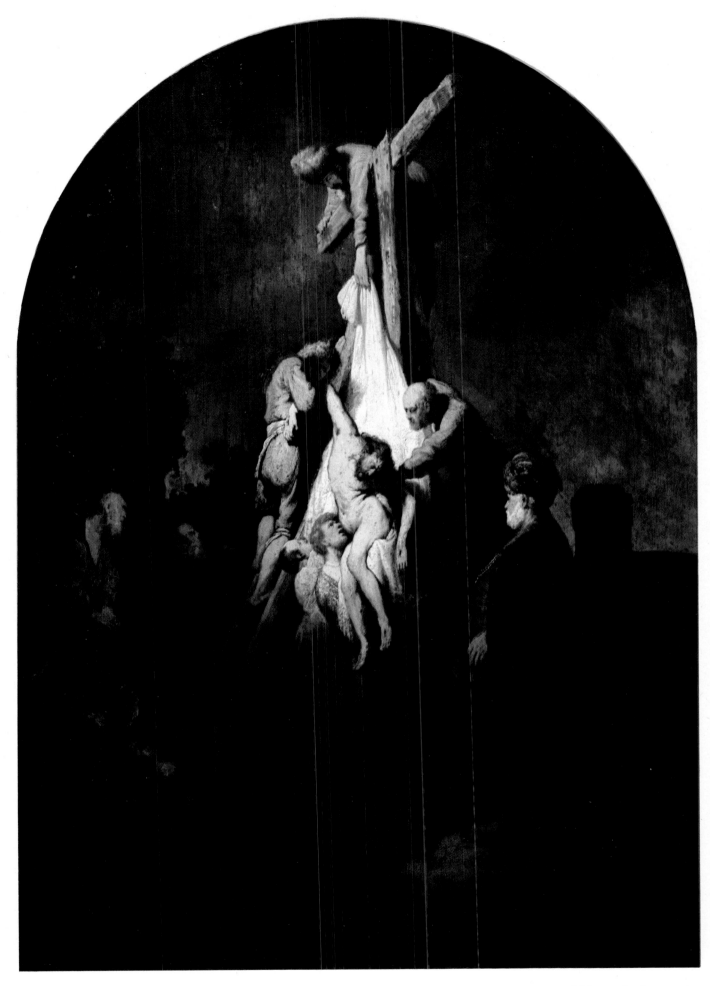

whose constant use of chiaroscuro in his painting caused him to be known in Italy under the name of "Gherardo della Notte."

Among other towns notable for the high quality of their art and artists was Rembrandt's own birthplace of Leyden; David Bailly (1584–c. 1657), Jan van Goyen (1596–1656), Jan Steen (1626–1679) and Gerrit Dou (1613–1675) were the leading painters of the Leyden school. In Delft there were a number of painters who specialized in paintings of interiors, including Pieter de Hooch (1629–post 1638), Jan Vermeer (1632–1675) and Hendrick

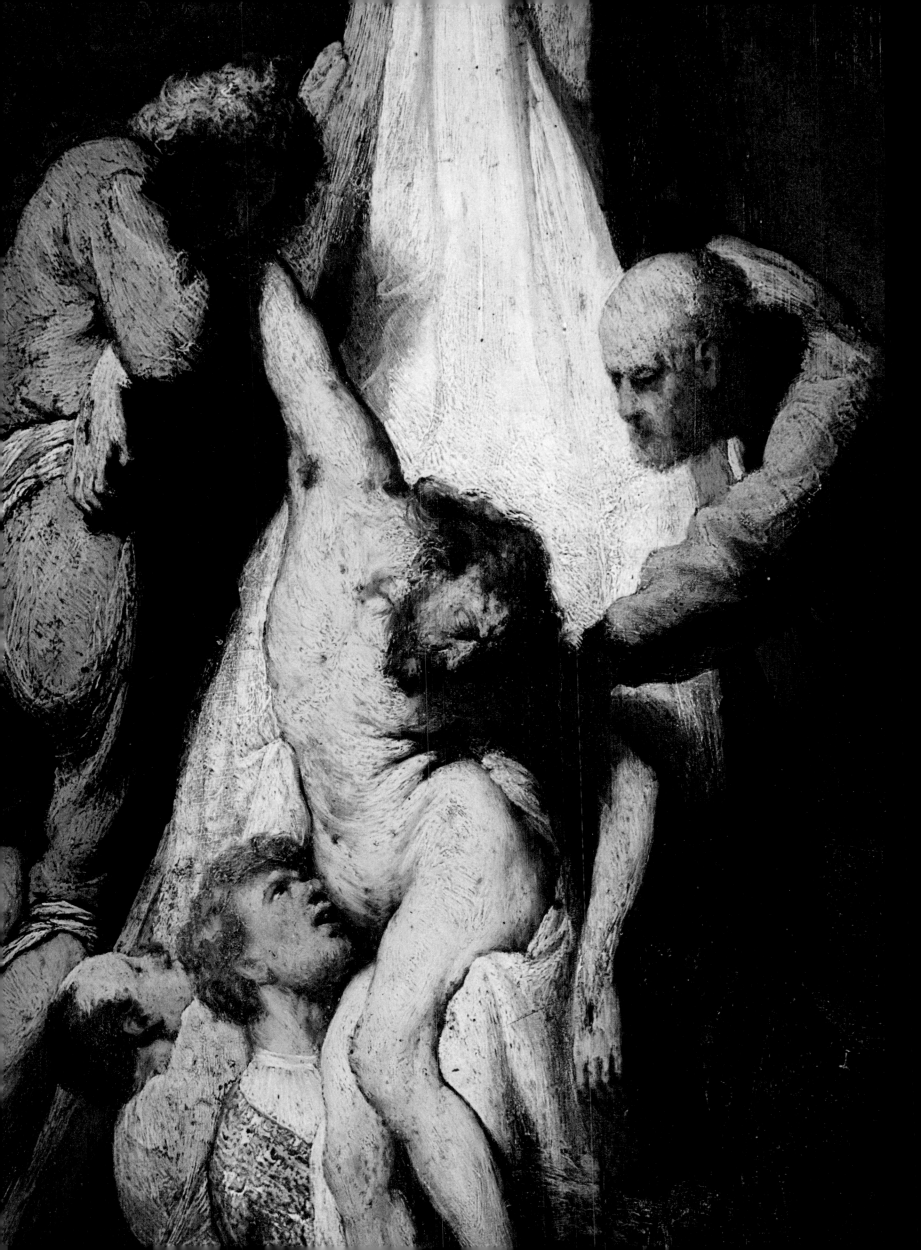

van Vliet (1611–1675). In contrast, the Hague, with its atmosphere of government, was notable for a fashion in court portraits.

But of all towns, Amsterdam remained the most important center of attraction for artists. Even those not born or settled permanently there would come and stay for longer or shorter periods to acquaint themselves with all the styles, influences and tastes from abroad as well the Netherlands. It was in Amsterdam that Pieter Lastman (1583–1633), Rembrandt's master, introduced both the Roman, historical narrative style of painting and the Romano–Germanic influence of Adam Elsheimer (1578–1610). Lastman's work succeeds in achieving a synthesis of

PORTRAIT OF AN 83-YEAR-OLD WOMAN
Oil on panel; 27 × 21 in
(68.7 × 53.8 cm)
On the left is written: AE. SUE. 83, and on the right it is signed and dated: Rembrandt f. 1634.
London, National Gallery (Br. 343)
Acquired in 1867.

Elsheimer's feeling for atmosphere and the typically Roman ideals of fine form and posture in the treatment of the human figure. The correct representation of historical detail also plays an important part in the narrative style. Italy remained the most important source of subject matter for the historical painter – and Lastman was the most famous of his time – and her artists were the principal inspiration in the style of the genre.

During the second half of the sixteenth century Antwerp had taken over from Brussels as the principal art center of the Southern Netherlands. From the time Pieter Breughel moved to the city on the Scheldt, Antwerp had become a center of the arts and the humanist studies, helped by the establishment of a great printing and publishing trade. Peter Paul Rubens (1577–1640) and Anthony van Dyck (1599–1641) were later to become the leading painters there. They developed a sweeping, monumental style, utterly alien to the spirit prevalent in the Northern Netherlands.

It could be said in conclusion that the situation in the Northern Netherlands around 1620 was beginning to be significantly influenced by the appearance of a specifically bourgeois art; the basis for this art was the

observation of the details of daily life and nature in its unidealized state. This was the context in which the young Rembrandt started his career as a painter, and it is not surprising, therefore, that the influence of this milieu recurs constantly throughout his work.

A dominant feature of Rembrandt's work, especially during the Leyden period, was his preoccupation with the representation of historical events; events which actually happened or which were thought to have happened. The subjects could be taken from secular history, in which case the history of one's native country or town, or the events of classical antiquity, were the most frequent subjects in the genre. And religious history was also an important source for themes; to rival the extensive subject matter provided by classical antiquity, there were the Old and New Testaments and all the stories and legends linked to the development of the Christian faith.

The earliest known painting by Rembrandt, only recently discovered in 1962, is that of the *Martyrdom of St. Stephen* of 1625 (Lyons, Musée des Beaux-Arts, Bredius/Gerson 531A, illustration p. 10). The story of St. Stephen is related in the Acts of the Apostles, 6 7–8:3, from which Rembrandt chose the moment of the stoning: "... and the witnesses laid down their clothes at a young man's feet, whose name was Saul. And they stoned Stephen, calling upon God and saying, Lord Jesus, receive my spirit. And he kneeled down and cried with a loud voice. Lay not this sin to their charge. And when he had said this, he fell asleep. And Saul was consenting unto his death."

Rembrandt gives Saul – later to be called Paul after his conversion and to become one of the greatest fighters for the Christian cause – an important place in the center of the painting, where he is shown sitting in an elevated position in the background. The composition of the painting can be divided into two parts, separated by a diagonal line. In the section on the left, which is left relatively dark, appear a number of very large figures. In the lighter, right-hand section appear three groups of figures, of which the most important is the largest and is placed in the foreground.

Rembrandt has adapted two discernible influences to his own ends in this painting. Both these influences can be traced back ultimately to Italian practice. The great impression made on Rembrandt by his last teacher, Pieter Lastman, is also clearly visible, appearing especially in the forceful gestures which so well express the states of mind of the protagonists, in the handling of various figures, such as the horse rider in Eastern dress on the left, in the grouping of the figures, in the suggestion of the landscape in the background, and even in the choice of subject itself. The influence of Elsheimer can also be sensed through that of Lastman. The discovery in 1965 of a painting on the same subject by Adam Elsheimer, dated between 1602 and 1605, has thrown new light on the history of Rembrandt's own painting. The main elements in the composition of both paintings match to such a degree that it must now be accepted that Rembrandt not only knew Elsheimer's style through Lastman, but was also personally acquainted with Elsheimer's own composition on the martyrdom of St. Stephen. Elsheimer's *St. Stephen* was in fact painted in Rome, and since Rembrandt had never been to Italy, it seems likely that he knew the painting through an engraved reproduction produced by someone in the circle of Rubens.

In spite of the fact that Rembrandt borrows elements from Elsheimer's painting, he does not copy it. In contrast with his model, Rembrandt limits the number of figures and shows himself very concerned with the arrangement of the various groups. Elsheimer uses a diagonal ray of light to represent St. Stephen's vision – God the Father with Christ seated at his right hand in the clouds – in the top left-hand corner of his painting. Rembrandt also uses the same arrangement, except that he drops the representation of God and Christ. The light is given the miraculous quality mentioned in the Bible version of the story, but it is also characteristically used as an integral part of the overall structure of the painting.

There is also another, more modern, influence to be detected in this,

THE PREACHER JOHANNES ELISON
Oil on canvas; 68⅛ × 48⅞ in
(171 × 122.5 cm)
Signed and dated: Rembrandt ft. 1634
Boston, Museum of Fine Arts
William K. Richardson Fund
(Br. 200)
The portraits of the Reverend Elison, a pastor in Norwich, and of his wife, Maria Bockenolle, were commissioned by their son during one of their stays in Amsterdam in 1634.

Rembrandt's earliest painting: Caravaggio's ideas of form, which Rembrandt derived from Gerrit van Honthorst, a member of the Utrecht Caravaggisti. In contrast to the traditional mode of narrative painting, which involved the use of a large number of small figures, and in which tradition Lastman was still working, Caravaggio preferred fewer, larger figures to present his themes. The figures themselves are painted realistically and situated in a space with clearly perceptible contours. His characters occupy almost all the surface of his paintings and thereby give the impression almost of stepping out of the frame. This reversal of the usual effect of perspective reveals Caravaggio's essential modernism: what is represented moves out of the painting towards the onlooker, a principle used today in advertising.

Caravaggio thus achieves greater directness and involves his audience more closely. And this aspect of his painting must have fascinated Rembrandt. The large scale of the figures in the foreground and the bringing forward of the center of action in this early work are unmistakable pointers to the influence of Caravaggio. Rembrandt chose exactly those elements from his mentors which best suited his immediate purpose. The principal action of the story takes place in the foreground, creating a sense of physical involvement right at the front of the painting, and not in the middle ground as is usually the case in Lastman's work, where the compositions tend to take on the appearance of reliefs and which therefore seem to remain very close to the surface of the actual painting. Such characteristics were only to appear later in Rembrandt's work, after further study of Lastman, Titian and antique relief work.

Although Rembrandt was subject to Italian influence in his handling of space, he did not follow the Italian models slavishly. The way in which space was suggested on the flat surface of a painting was an important preoccupation of Italian art theory. Spaces had to be clearly delineated and conveyed through the correct use of perspective. In contrast, Rembrandt purposely left space in his paintings vague and unclear, so that it is frequently difficult for the spectator to reconstruct it exactly. His main intention was to draw the attention to the center of events and to hold it there, and for this reason he considered the representation of correct perspective a subordinate consideration, even an undesirable one at times. This is not to say that the sense of physical space is not present in Rembrandt's work, but it is achieved in the *St. Stephen*, for instance, by situating the dark figures in the left foreground to set off the rest of the action – a technique frequently used in theater design. The contrast between light and dark is indeed particularly striking in this work, and one of the most notable aspects of Rembrandt's future development was to be his increasingly subtle use of chiaroscuro. It is the combination of this play of light and shade, coupled with the emphasis on the foreground, which makes Rembrandt's work both a very direct experience and an invitation to further thought on the subject represented.

Rembrandt himself appears in this painting, to the right above the head of the martyr, and it is probable that the figure on the right beneath Stephen's raised arm is his Leyden friend, Jan Lievens – thus appearing as witnesses or even guilty participants in the cruel punishment. This mechanism is not unusual in painting and serves to increase the involvement of the onlooker.

As well as demonstrating the precocious mastery of the nineteen-year-old Rembrandt, it can also be assumed that this painting indicates his ambitions for the future. Most important, he has chosen an historical subject; and he has shown that he is conversant with both contemporary and traditional modes of representing space in painting. He has also shown his skill in representing the human figure and the various human emotions, and his ability both as a portrait and landscape painter. However, this painting still lacks a certain homogeneity – the unity of conception so notable in his later work. It is essentially made up of various clearly distinguishable elements in the narrative, handled in a way conforming to the compositional principles

THE HOLY FAMILY
Detail
Oil on canvas; $72\frac{1}{4} \times 48\frac{1}{2}$ in
(183.5 × 123 cm)
Signed and dated: Rembrandt f.
163 · · ·
Circa 1634–1635
Munich, Alte Pinakothek (Br. 544)
Auctioned in Amsterdam on 17 August 1735. Transferred to the Alte Pinakothek from the Mannheim Gallery.

of early Baroque, with its heavy concentration on the use of the diagonal.

Another early painting (Leyden, Municipal Museum, Bredius/Gerson 460, illustration p. 10) shows a subject from classical history, which has received a number of interpretations. The first title suggested for the painting was *The Justice of Brutus*, though this has never been thought to be totally convincing and other titles have subsequently been suggested: *Judgement on the Son of Manlius Torquatus*, *Clemency of the Emperor Titus*, and finally, *Consul Cerealis Pardons the Legions Which Have Taken Sides with the Rebels*, suggested by Kurt Bauch in 1960, which is accepted, though with some reservations by Gerson. The Old Testament subject of *Saul sentencing Jonathan* has also been mentioned as a possibility. More recently, however, it has been almost conclusively proved by Kellerhuis that the subject of the painting is indeed *The Justice of Brutus*, a conclusion based on the following: the source of the story is the Latin text of Livy's *Histories* II, 4–5, which Rembrandt obviously knew and followed in detail. According to Livy, two of Brutus' sons and two of his brothers-in-law had taken part in the abortive conspiracy; they were later condemned by Brutus himself. In the foreground of the painting Brutus is meting out justice to his sons, who are kneeling, and to the brothers-in-law, who are shown standing. The proconsul is standing to Brutus' left, while the clerk is seated on his right; behind him are shown other high dignitaries. The arms of the conspirators lie surrendered at Brutus' feet. The rest of the conspirators can be seen in the background on the right around the column of justice, which is surmounted by a she-wolf. According to historical account, they were first whipped and then beheaded. One of them is holding an article of footwear up, which usually betokened that punishment was taking place in seventeenth-century iconography. The last item of proof of the painting's subject is the ship's sail which is just visible to the right of the upraised arm of the brother-in-law who stands farthest to the right; again, according to Livy, the setting for the incident was an island in the Tiber.

This painting is dated 1626 and has exactly the same dimensions as *The Martyrdom of St. Stephen*, so that we can assume that the two paintings go together. If Kellerhuis' interpretation is correct, then both paintings deal with the subject of handing out punishment – both in Christian and classical contexts – thus making it even more likely that the paintings were meant to be considered as a pair.

The composition of this painting is related to Lastman's *Coriolanus Receives the Emissaries* of 1622 (Dublin, Trinity College, illustration p. 8). In the Leyden painting Rembrandt draws the action towards the foreground, thus enlarging the scale of the composition. He includes a smaller number of figures, but again makes them much larger. In this painting, too, Rembrandt includes his self-portrait, just to the right of the main figure.

Very recently, in 1976, an early painting by Rembrandt, signed and dated 1626, was discovered. The panel, which already clearly demonstrates the characteristic talents of the young Rembrandt, represents *The baptism of the eunuch* (Utrecht, Archepiscopal Museum, *not* in Bredius/Gerson, illustration p. 11). The story of the Moorish eunuch occurs in the Acts of the Apostles, 8:26–40. Obeying the command of the Angel of the Lord, Philip, a disciple of Jesus, sets out on a journey. On his way, he meets an important Ethiopian who is in charge of all the treasures of the Queen of Ethiopia. He is returning from Jerusalem, where he has been on a pilgrimage, and is reading the book of the prophet Isaiah in his chariot. The eunuch asks Philip to accompany him in his chariot and to explain to him the passage of scripture he is reading. Philip tells him about Jesus, "And as they went on their way, they came unto a certain water: and the eunuch said, See, here is water; what doth hinder me to be baptized? And Philip said, If thou believest with all thine heart, thou mayest. And he answered and said, I believe that Jesus Christ is the Son of God. And he commanded the chariot to stand still: and they went down both into the water, both Philip and the eunuch; and he baptized him."

Rembrandt shows the moment immediately after the baptism, though

SASKIA WITH A HAT
Oil on panel; $39\frac{1}{4} \times 31$ in
(99.5 × 78.5 cm)
Circa 1633–1634
Kassel, Staatliche
Kunstsammlungen, Gemäldegalerie
(Br. 101)
This painting was sold by Rembrandt to Jan Six in 1652; it afterwards passed into the collection of Valerius Röver (1702 or 1734) and then to that of the Landgrave Wilhelm VIII von Hesse-Cassel (1750)
Pages 52–53: Detail.

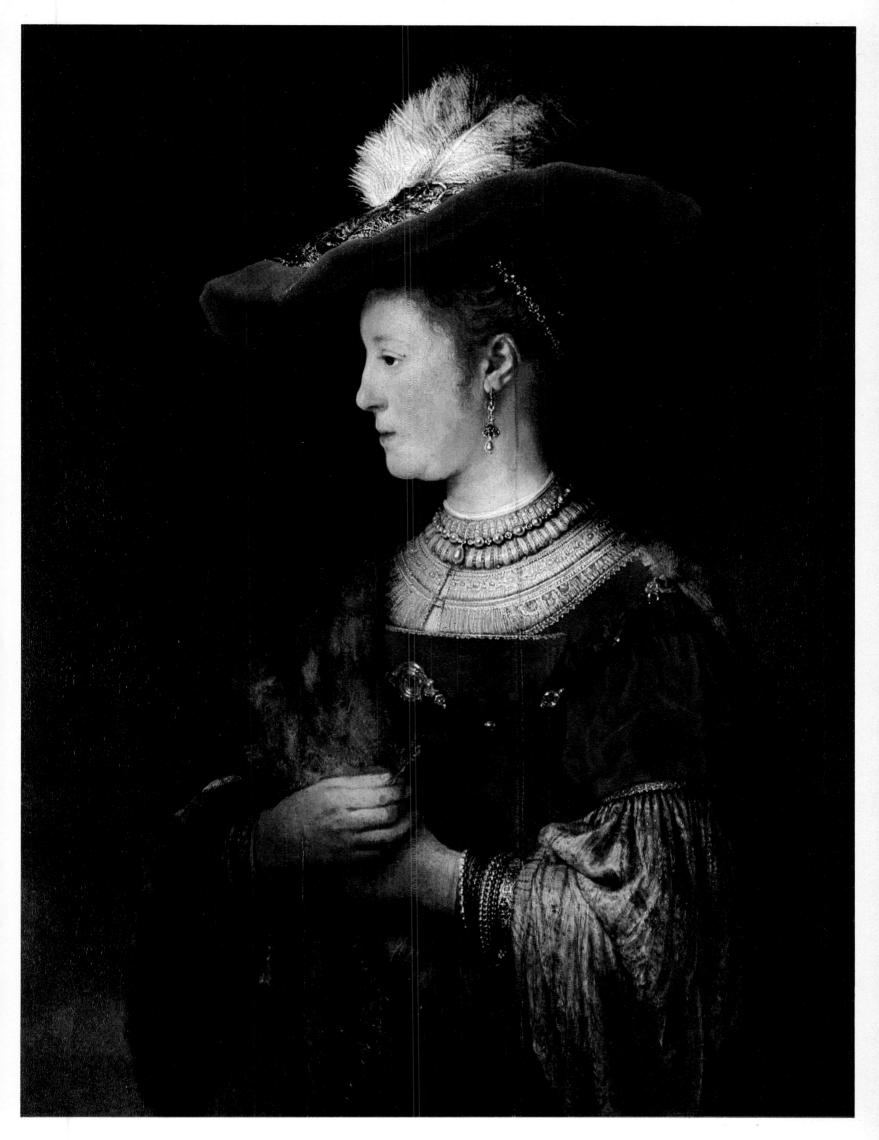

the figures are at the edge of the water and not in it, as is stated in the Bible passage. In his treatment of this theme, which was painted several times by Lastman, Rembrandt aims to manipulate the sense of space to maximum effect. The *dramatis personae* are situated towards the front of the chariot in which the Moorish courier travels. In spite of two glimpses of a faraway vista of hills, to the left and right of the chariot, the elevated position of the chariot and the pair of horses effectively closes off the scene at the back. The attention is thereby unavoidably directed towards the foreground and the baptism itself. The dog drinking, on the lower left of the painting, suggests the presence of water. The dog also serves to lead our gaze into the painting, while the palm tree on the upper left directs our eyes down to the action taking place in the center.

The eunuch is shown in the center foreground, kneeling facing towards the left, while Philip is shown standing to the left behind him, carrying out the action of baptism downwards towards the right. The grouping of the two figures is taken up again in a related group of two figures, who are placed diagonally to the right of the first group: the standing man with the open Bible, from which Philip and the eunuch read, is looking forward and thereby involves the spectator in what is happening; in front of him, the squatting figure of a Moorish servant watches the baptism.

The chariot, placed higher behind the main center of interest, lies along the opposite diagonal. The result of this arrangement of the various elcments in the painting is a spiral movement towards the foreground. This very imaginative use of the space around the compact group of figures in the landscape is unmistakably the work of Rembrandt, as is the suggestion of the soft light of late afternoon, which seems to go so well with the subject.

As far as the disposition of the compositional elements on the flat surface of the painting is concerned, the work is dominated by two crossing lines. The first is a slightly curved, diagonal line, which is formed by the squatting black servant, the man with the open Bible, the charioteer with his whip, sitting on the box of the chariot, and the figure leaning over the back of the box; this line dissolves into the opposing movement of the waving branches of the palm tree. The other line can be drawn from the kneeling eunuch over the man with the Bible to the rider, turning to the left, in the background.

In this early painting Rembrandt has brought together a sense of spatial movement and a feeling of serene equilibrium. The result is a contradiction in terms: dynamic harmony. It is this seemingly incongruous, but totally integrated combination of elements, which gives the picture the inner tension traceable in all Rembrandt's work.

A characteristically Leyden feature in *The Justice of Brutus* is the still-life of the armor, painted in careful detail in the left foreground. Still-life was a much practiced genre in Leyden, notably by Isaac Claesz. van Swanenburgh, the father of Rembrandt's first master. It was given new life in the second decade of the seventeenth century by David Bailly, who became particularly famous for this genre of painting, together with Jan Davidsz. de Heem, Harmen and Pieter van Steenwijk and Pieter Potter as his pupils. Especially central to the Leyden tradition was the *vanitas vanitatis* type of still-life, with its reminder of the transitory character of life on earth. Recurrent artifacts in these paintings are the human skull, the candle which burns up like life itself, musical instruments, the sound of which appears and then dies away, and also books, indicating that the accumulation of knowledge is also but vanity in the face of death.

In the early paintings of Rembrandt such still-lifes occur frequently, as in *The Money Changer* of 1627 (Berlin–Dahlem Art Gallery, Bredius/Gerson 420, illustration p. 12), *The Apostle Paul in Prison*, also dated 1627 (Stuttgart, Staatsgalerie, Bredius/Gerson 601, illustration p. 13), and in a favorite subject for Rembrandt, 'scholar in his study.' These still-lifes have a dual function in Rembrandt's work; they serve to convey the vanity of human wishes and give the opportunity to indulge in the realistic representation of a setting, thus indicating the occupation of the subject of the painting.

SASKIA AS FLORA
Oil on canvas; 49¼ × 39¾ in
(125 × 101 cm)
Signed and dated: Rembrandt f.
1634
Leningrad, Hermitage (Br. 102)
From the Arentz Collection

SOPHONISBA RECEIVING THE POISONED CUP

Oil on canvas; $56 \times 60\frac{1}{4}$ in
$(142 \times 153$ cm)
Signed and dated: Rembrandt f. 1634
Madrid, Prado (Br. 468)
The identity of the female figure has been subject to various interpretations. She has been thought to be Sophonisba, daughter of the Carthaginian general Hasdrubal and the wife of Syphax, who drank poisoned wine when taken prisoner by Scipio, and Artemisia, queen of Caria (d. 351 BC) and wife of Mausolos, who added the ashes of her husband to her wine.

Again, the subject of the scholar in his study had a long tradition behind it, especially in seventeenth-century Leyden. It is in fact the Dutch version of the traditional theme of showing one of the church fathers in an interior setting, which was later to be secularized in the Renaissance, as van de Waal points out in his article mentioned above on the etching of *Dr Faustus* (p. 32), which also belongs to the same tradition. The presence of the new university of Leyden could also be another explanation of why this theme should have been so popular with painters in that town.

The painting *Two Scholars Disputing* (1628, Melbourne, National Gallery of Victoria, Bredius/Gerson 423, illustration p. 12) also belongs to this group. It is generally accepted that this painting represents a genre scene with a subsidiary historical subject. Both the famous philosophers, Democritus and Heraclitus, as well as the prophets Elijah and Elisha, have

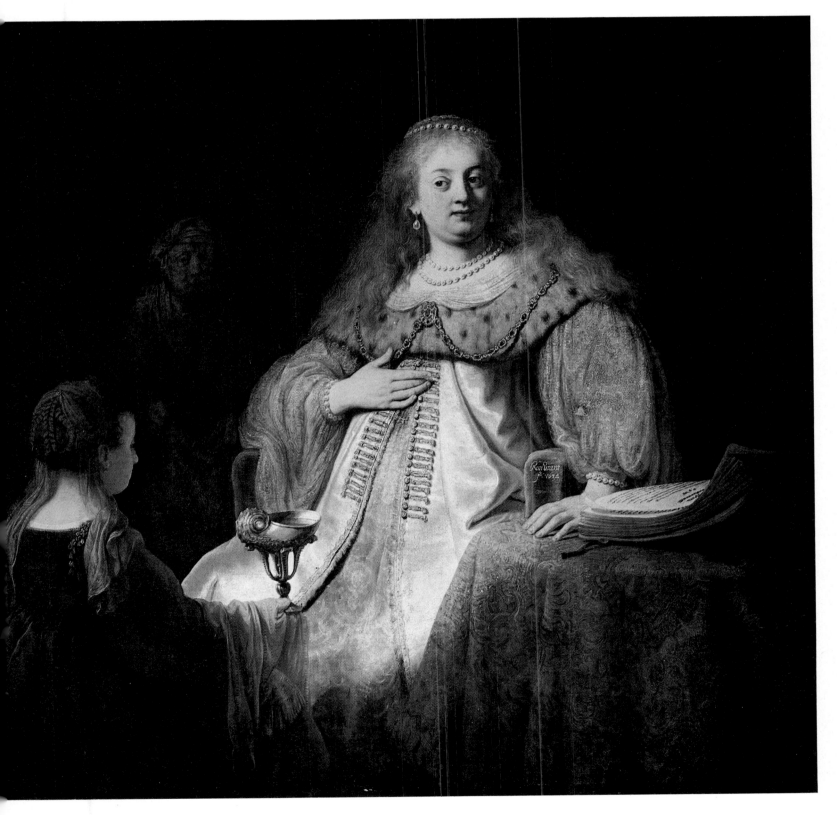

been put forward as the inspiration of this work; the story of Elijah foretelling his death to Elisha seems to have particular relevance here.

The relevant episode on the death of Elijah can be found in the Second Book of Kings, 2:1–18: "And it came to pass, when the Lord would take up Elijah into heaven by a whirlwind, that Elijah went with Elisha from Gilgal.

"And Elijah said unto Elisha, Tarry here, I pray thee; for the Lord hath sent me to Beth-el. And Elisha said unto him, As the Lord liveth, and as thy soul liveth, I will not leave thee. So they went down to Beth-el.

"And the sons of the prophets that were at Beth-el came forth to Elisha, and said unto him, Knowest thou that the Lord will take away thy master from thy head today? And he said, Yea, I know it; hold ye your peace.

"And Elijah said unto him, Elisha, tarry here, O pray thee; for the Lord hath sent me to Jericho. And he said, As the Lord liveth, and as thy soul liveth, I will not leave thee. So they came to Jericho.

"And the sons of the prophets that were at Jericho came to Elisha, and said unto him, Knowest thou that the Lord will take away thy master from thy head today? And he answered, Yea I know it; hold ye your peace.

"And Elijah said unto him, Tarry, I pray thee, here; for the Lord hath sent me to Jordan. And he said, As the Lord liveth, and as thy soul liveth, I will not leave thee. And they two went on.

"And fifty men of the sons of the prophets went, and stood to view afar off: and they two stood by Jordan.

"And Elijah took his mantle, and wrapped it together, and smote the waters, and they were divided hither and thither, so that they two went over on dry ground.

"And it came to pass, when they were gone over, that Elijah said unto Elisha, Ask what I shall do for thee, before I be taken away from thee. And Elisha said, I pray thee, let a double portion of thy spirit be upon me.

"And he said, Thou hast asked a hard thing: nevertheless, if thou see me when I am taken from thee, it shall be so unto thee; but if not, it shall not be so.

"And it came to pass, as they still went on, and talked, that, behold, there appeared a chariot of fire, and horses of fire, and parted them both asunder; and Elijah went up by a whirlwind into heaven.

"And Elisha saw it, and he cried, My father, my father, the chariot of Israel, and the horsemen thereof. And he saw him no more. . . ."

The story in the Bible seems to indicate that Elisha and Elijah are engaged in almost constant conversation, yet at the same time are travelling. Given the fact that Rembrandt usually keeps precisely to the details of any story, and rarely or never changes historical situations without good reason, it seems reasonable to conclude that this painting does not represent Elisha and Elijah, and that the scholars represented are more likely to be Heraclitus and Democritus. The fact that Elisha was bald (2 Kings 2:23–25) is hardly likely to have escaped Rembrandt's attention and he would undoubtedly have used this particular feature to identify the figures. Nor did he ever miss the opportunity of introducing some action to support his narrative if this were legitimately possible.

A dominant feature, if not the most dominant, of this early work is Rembrandt's very individual use of chiaroscuro. In the slightly earlier *The Apostle Paul in prison* (p. 13), Rembrandt uses a clearly realistic source of light in the shape of the sunlight streaming through the barred window on to the wall; the grayish contours of the apostle stand out against the light. Paul himself, his pen poised thoughtfully in his hand, is not subject to very great contrasts of light and dark, and is still painted in what is essentially the manner of Pieter Lastman. In the painting of the two disputing scholars, the source of light is invisible. There is bright light present in the picture, but the source is not indicated. The light enters the painting from the top left-hand corner and leads the eye on to the most important element: the two heads. One of the heads is seen from behind, the top of the head illuminated, while the other is seen from the front and is completely in the

THE GREAT JEWISH BRIDE
Etching; 8¾ × 6½ in (22 × 16.8 cm)
Signed and dated (state III): R 1635
(Bartsch 340)

REMBRANDT AND SASKIA
Oil on canvas; 63¼ × 51½ in
(161 × 131 cm)
Signed: Rembrandt f.
Dresden, Staatliche
Kunstsammlungen, Gemäldegalerie
(Br. 30)
Acquired in Paris in 1739, but only reached Dresden in 1751, a few years after the end of the War of Austrian Succession (1740–48).

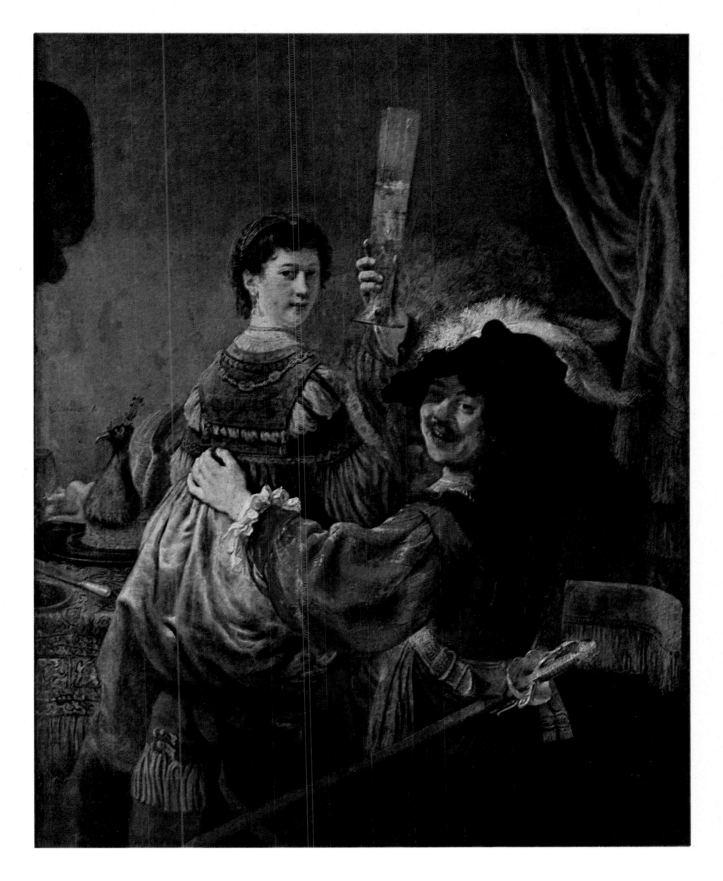

light. From the heads the light falls on the hands with the book, the central element of the composition, finally ending on the open books in the bottom right-hand corner, which counter-balance the open books of the still-life to the top, right. These books in fact form the end of the opposite diagonal which runs up from the left, via the book in the hand of the scholar with his back to us, to the upper right corner of the composition. Rembrandt is not here using chiaroscuro in a rationalized, realistic way in the mode of Caravaggio and his followers: indeed, the candle, part of the still-life composition and frequently a mechanism for locating the source of light in the works of the Caravaggisti, is not even lit, and thus stands solely as a symbol in the *vanitas* composition, without its usual light-giving function. The use of light and shade has a double function in this painting: it determines its diagonal structure, and also illuminates the central subject of the work – the two scholars in dispute, which is expressed through their

STUDY OF A BABY WITH A
BOTTLE
Ink drawing
Circa 1635
Munich, Staatliche Graphische
Sammlung
(Benesch 259)

BABY LEARNING TO WALK
Red crayon drawing; 4 × 5 in
(10.3 × 12.8 cm)
Circa 1640
London, British Museum
(Benesch 421)

heads, hands and books. It could almost be said that the chiaroscuro itself is a subject of the painting, since its application here brings about a fusion of form and content, a phenomenon which has been described by J. Bruyn with reference to the painting *The Prophet Jeremiah Mourning over the Destruction of Jerusalem* of 1630 (Amsterdam, Rijksmuseum, Bredius/Gerson 604, illustration pp. 14, 15, 16–17). Rembrandt employs gestures with traditional significance to express states of mind: the mourning Jeremiah rests his head on his hand, an image which illustrates the melancholy temperament of the doleful old man. According to Bruyn this image was known to Rembrandt from Italian models, and also from the famous and influential print *Melancholia*, executed by Albrecht Dürer in 1514.

Another early masterpiece depicts the theme from the New Testament, *Christ at Emmaus* (Paris, Musée Jacquemart André, Bredius/Gerson 539, illustration pp. 20–21), of which a detail is reproduced here. In the Gospel according to St. Luke, 24:13–35 occurs the description of a journey by two of the followers of Christ to Emmaus and the appearance of Christ to them: "And they drew nigh unto the village, whither they went: and he made as though he would have gone further. But they constrained him, saying, Abide with us: for it is toward evening, and the day is far spent. And he went in to tarry with them. And it came to pass, as he sat at meat with them, he took bread, and blessed it, and break, and gave to them. And their eyes were opened, and they knew him; and he vanished out of their sight." Rembrandt has chosen to represent the miraculous apparition of Christ to his followers. The man facing Christ across the table reacts with fear, as he realizes that the stranger they have met on their way is in fact Christ himself. The other, almost totally obscured in the foreground, is kneeling at the feet of Christ, already recognizing his master.

The striking use of chiaroscuro by Rembrandt in this painting to achieve a certain structural effect is similar to its use in the painting of the two disputing scholars and is characteristic of the early work in general. In this work, the light-diagonal goes from the bottom left-hand corner to the upper right, culminating near and around the head of Christ, who is represented completely in shadow. At the same time, the light enhances the God-like quality of the apparition, which is traditionally represented by a halo or aureole around the head. Here again, Rembrandt manages to revitalize traditional forms, making them such a realistic part of the situation represented that they almost cease to be traditional. The theme of Christ at Emmaus was later to be treated several times in different ways (see p. 114).

Emmens has a number of interesting comments to make on the painting of self-portraits in the seventeenth century. In the first place, the self-portrait stresses the dignity of the painter's role, which far from all seventeenth-century Dutchmen regarded as dignified – witness the derogatory remarks passed by Rembrandt and Saskia's brother-in-law during the libel suit described above. In Leyden, notably, there was no guild to act for painters' interests until the middle of the seventeenth century, and local painters were forced to stand up for themselves. Emmens further suggests that the self-portrait is also an indication of the artist's ability to imitate what he sees. The artist presents himself as *imitator*, and can reproduce himself in all kinds of roles, either in the form of studies or as a model for certain parts.

The *Self-portrait* of 1629 (Munich, Alte Pinakothek, Bredius/Gerson 2, illustration p. 23) is a representation of Rembrandt at the age of twenty-three. It almost seems as though he has used this early self-portrait as an opportunity for further study of the effects of chiaroscuro, rather than as a chance to represent himself accurately. Many of his self-portraits – and he painted about sixty – can be thus considered as studies of form or studies of facial expression.

A man laughing (The Hague, Mauritshuis, Bredius/Gerson 134, illustration p. 24) also looks as though it has been done with the same purpose in mind. It is possible that the model was Rembrandt's brother Adriaen. It is essentially a study of the expression of gaiety, a usual subject in

STUDIES OF HEADS AND
FIGURES
Ink and red crayon drawing,
heightened with watercolor; $8\frac{3}{4} \times 9\frac{1}{4}$ in
$(22 \times 23.3$ cm)
Circa 1636
Birmingham, The Barber Institute of
Fine Arts, University of Birmingham.

physiognomy studies. The portraits of other members of Rembrandt's family, such as that of his father (The Hague, Mauritshuis, Bredius/Gerson 77, illustration p. 26) and of his mother (The Hague, Mauritshuis, Bredius/Gerson 67, illustration p. 27) could also have had a double function: a study of facial expression and a figure study. This purpose could also be the explanation of a series of paintings with the provisional title of "Rembrandt's sister," but which can also be assumed to represent Saskia or even other women in Rembrandt's entourage. One of these is illustrated here (Milan, Pinacoteca di Brera, Bredius/Gerson 87, illustration p. 28). The same could be said for the portraits of the painter's father in a variety of costumes and headgear. Rembrandt probably used members of his family as models, and they occasionally seem to be recognizable in his historical paintings. In 1631 he painted his *Rembrandt's Mother as a Biblical Prophetess* (Amsterdam, Rijksmuseum, Bredius/Gerson, illustration p. 30).

One example of Rembrandt's interpretation of stories from classical mythology is *The Abduction of Proserpine* (Berlin–Dahlem, Gemäldegalerie, Bredius/Gerson 463, illustration p. 31). If this painting is compared with that by Rubens on the same subject, which hangs in the Petit Palais in Paris, then it soon becomes obvious that Rubens' high heroism was somehow nearer to the antique ideal of the world of the gods than Rembrandt's uneasy narrative style, although Rembrandt's painting, which was originally in the

possession of the stadholder, does follow the events of the story faithfully.

Another classical narrative painting represents two scenes from the myth of Diana, goddess of chastity and the hunt, who is painted with the traditional sickle moon head decoration (Arnholt, Salm-Salm Collection, Bredius/Gerson 472, illustration p. 32). The stories of Actaeon and Callisto are enacted against an overpowering, impenetrable forest, which only offers one slight background vista on the left of the painting.

Actaeon, the great hunter, encounters Diana bathing with her nymphs on one of his expeditions. Diana is shocked and offended because she has been seen naked by a man, even worse, a mortal. As punishment, she changes Actaeon into a deer, which is then pursued by his own dogs and torn to pieces. On the left-hand side of the painting Actaeon can be seen, alarmed by the sudden sight of the goddess. The metamorphosis has already started, because it is possible to see the antlers growing on his head. To enliven the painting somewhat, Rembrandt then added the story of Callisto in the right-hand side of the painting. Callisto, one of Diana's favorite nymphs, discovers that she is pregnant while bathing, apparently by Zeus. Diana, her regard for chastity outraged, flies into such a rage over this dishonor that she changes her companion nymph into a she-bear which will be killed during a hunt. It is the moment of discovery of Callisto's pregnancy which is depicted here, giving Rembrandt the opportunity to show all varieties of states of mind through gesture, position of the body and facial expression: chastity, shame, fear, anger, curiosity, exuberant joy (malicious pleasure?), etc. He probably used a number of prints by Antonio Tempesta as models for this scene, as well as prints after figures by Raphael, as Van Rijckevorsel has pointed out.

In spite of these excursions into the world of classical mythology, the Old and New Testaments remained the principal sources of subjects for Rembrandt's historical paintings. It has now been established that Rembrandt did not necessarily draw upon his own interpretation of the Bible to guide his choice of biblical subjects, as was sometimes thought in the past. As well as drawing on the work of the great Italian masters, Rembrandt knew the work of sixteenth-century northern artists, such as Dürer, Lucas van Leyden, Maerten van Heemskerck, Maerten de Vos, Pieter de Jode, Stradanus, etc., and borrowed from their work when necessary.

From the inventory of 1656 it seems that Rembrandt possessed the complete works of Maerten van Heemskerk in print form. Bruyn and, more recently, Campbell have shown how extensively Rembrandt made use in his work of a series of prints of stories from the Bible which were very popular during the sixteenth century. This growth in Bible illustration is also closely linked to a changed attitude towards the book. Since the Reformation the emphasis in Bible study had no longer been exclusively liturgical and devotional; there was now much more attention paid to the narrative and moral qualities of the Bible. This new approach went together with the Christian humanism which had become an important ingredient in religious thought in seventeenth-century Holland, thanks to the original work of such thinkers as Erasmus and Coornhert. Historical circumstances also tended to favor this tendency. The Council of Trent (1545–1563), which laid down guidelines for the Counter-reformation, and turned religious art into another weapon in the fight for Catholicism and its saints, forbade work which did not meet with the approval of the Church. The Protestant Republic of the United Netherlands remained outside the influence of such decrees, which thereby failed to have any effect on the visual arts of the country. And although Rembrandt borrowed themes from the Italian masters, his work remained within an essentially sixteenth-century iconographical tradition.

One of the greatest achievements of Rembrandt's Leyden period is *The Presentation of Jesus in the Temple* (1631, The Hague, Mauritshuis, Bredius/Gerson 543, illustration pp. 33, 34–35). The tiny baby Jesus is presented to the Lord in an interior of colossal proportions, which represents the synagogue. The passage in the Bible which relates this event can be

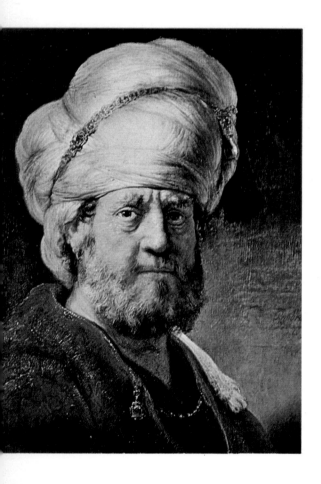

A MAN IN ORIENTAL COSTUME
Detail
Oil on panel; $28\frac{1}{4} \times 21\frac{1}{2}$ in
(72 × 54.5 cm)
Signed and dated: Rembrandt ft. 1635
Amsterdam, Rijksmuseum (Br. 206)
In the collections of H. Ketelaar, Amsterdam (1775), Lord Barnard, Durham; found its way on to the Amsterdam art market in 1922. Donated to the Rijksmuseum by Mr. and Mrs. Kessler-Hülsmann.

found in the Gospel according to St. Luke, 2, 22–39. The old man Simeon is holding the child in his arms, while the parents stand by, seemingly somewhat surprised. There is, however, some disagreement as to whether the figure with the hand upraised in blessing is the High Priest or the prophetess Anna. The strong light which falls upon the central group of figures creates a sense of intimacy. This work was originally in the collection of the stadholder Frederick Henry.

The First Period in Amsterdam

In 1631/32 Rembrandt moved to Amsterdam, both to broaden his artistic experience and for economic reasons. It was in that city that his art was to develop and mature over the next thirty-seven years. There was, however, no distinct break in Rembrandt's work to mark the move from Leyden to Amsterdam, and it is not known whether a number of the paintings discussed in the previous chapter date from the Leyden period or from Rembrandt's first years in Amsterdam. It is also probable that Rembrandt took a number of unfinished paintings with him when he moved, which he then went on to finish in Amsterdam.

It was in 1632, too, that Rembrandt painted the work which used to be known as *The Anatomy Lesson of Dr Nicolaes Tulp*, but which is now known under the title of *Doctor Nicolaes Tulp Demonstrating the Anatomy of the Arm* (The Hague, Mauritshuis, Bredius/Gerson 403, illustration pp. 37, 38–39). This commission could have been the real reason for Rembrandt's move to Amsterdam.

This painting was indeed his first big commission; it was also his first large group portrait. The corpse, which is about to be dissected, lies on a table, along one of the diagonals of the painting. The light enters the painting in the top left-hand corner, though no precise source of light is indicated; it falls on the faces of the men present and on the trunk of the pallid corpse, the head and feet of which remain in shadow. The dead body is that of Adriaen Adriaensz., nicknamed "the Child," a twenty-eight-year-old criminal from Leyden who had been hanged; his body had then been made available for the dissection, which took place on January 31, 1632. Dr Tulp sits behind the corpse; he is the only person wearing a hat, which distinguishes him very clearly from the other onlookers. These latter are prominent members of the Guild of Surgeons, and all of them react differently to their instructor. Dr Tulp, thus depicted in his capacity of professor of anatomy, is busily dissecting the hand and arm of the otherwise intact corpse with his right hand. His left hand is caught in a gesture which indicates that he is speaking. The portrait group to the left of Tulp is triangular and is of particular interest in relation to the painter's suggestion of space within the painting. The heads on the bottom row, though painted horizontally in the picture, do in fact suggest a diagonal in space; this suggestion is repeated with the two heads above, which reinforce this diagonal, which runs in the opposite direction to that of the corpse. The eyes of the spectator are thus led from the faces of the bystanders to Dr Tulp and his hands, and from there via the body to the lower right-hand corner where the gaze is sharply halted by the diagonally-placed open book. This book also has a dual function: it serves to remind us of Tulp's erudition, and also acts as a *vanitas* symbol. The theme of the transitory quality of life can be seen only too clearly in this painting.

Dr Nicolaes Tulp, successor to Dr Joan Fonteyn, was an anatomist and praelector of the Amsterdam Guild of Surgeons from 1628 to 1652. He was followed by Dr Deyman, who was also to be the subject of another anatomical piece by Rembrandt (pp. 140–141). Tulp gave his first anatomy lesson on January 31, 1631, and this painting was executed on the occasion of his second anatomy demonstration in January 1632.

The anatomy painting as a basis for a group portrait of the members of the

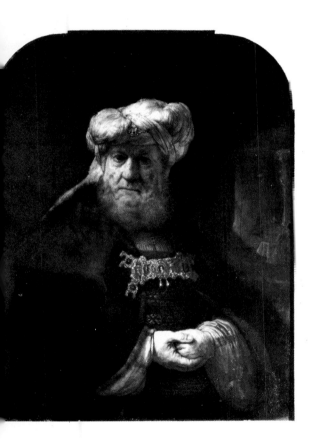

UZZIAH STRICKEN WITH LEPROSY
Oil on panel; 40 × 30½ in (101 × 79 cm)
Signed and dated: Rembrandt f. 1635
Chatsworth, The Trustees of the Chatsworth Settlement (Devonshire Collection) (Br. 179)

Guild of Surgeons somehow typifies the new burgher culture of the Northern Netherlands, which was reaching its peak in the seventeenth century. The earliest known seventeenth-century anatomical painting is that of Dr Sebastian Egbertsz., painted by Aert Pieters for the Surgeons' Guild of Amsterdam in 1603. It is an elongated work in which twenty-nine rather rigid portraits are ranged in three rows, one above the other. The corpse is largely invisible, and functions in this early painting principally as an indication of the profession of those portrayed. Unlike the painting of Dr Tulp, there is not the slightest difficulty here in seeing that this is a group portrait which has been made up from separate portraits. Such paintings were usually commissioned on the occasion of the first anatomy lesson given by a praelector. These public demonstrations were held once a year in the winter and were considered rather as public festivals which were also sources of learning and pleasure. The event started with the dissection of the abdominal cavity and the intestines, later progressing to the rest of the body. These demonstrations were held in the "Theatrum Anatomicum," and drew large crowds. In Rembrandt's time it was possible to gain entrance for about seven pence. One of the earliest anatomical theaters in Europe was that of Leyden (1594). As well as being used for the annual winter anatomical demonstration, that particularly vivid reminder of the transitoriness and mortality of man, the theater also served as a kind of museum in which it was possible to see a variety of fascinating and sinister objects, such as human skeletons and all kinds of animals. There were also moralizing prints which demonstrated the tenuous nature of life on earth. Rembrandt must have visited the theater many times as a young boy. Tulp, too, who had studied in Leyden, must have known this amazing place. The official Theatrum Anatomicum for Amsterdam was opened in 1639; before that, anatomical demonstrations were usually held in former Roman Catholic churches and convents, which had been taken over by the municipal authorities and which were suitable for this use because of their circular shape.

The holding of such demonstrations indicates how the medical profession handled its public relations at the time. That things had been very different in the past is apparent from a description of the development of anatomy up to the time of Rembrandt, giving added meaning to the painting of Dr Tulp.

Anatomy was practiced during the Middle Ages, from about the fourteenth century onwards, and the Renaissance in two ways. In the first place it was taught in the universities as an important part of medical science from the original Greek texts. These had first been translated into Arabic and then retranslated, paraphrased and commented on in Latin. The absolute authority in the field of anatomy was Galen, who had a celebrated career in Rome during the second century AD. His texts were read to the students by the *praelector anatomiae*, which means "reader in anatomy," if translated literally. This type of lesson was a solely theoretical one; there was not even a corpse to help explain the theory, and Galen himself had never dissected a human body, having acquired all his anatomical knowledge from the dissection of animals, especially monkeys. It has been suggested by Van den Berg that the study of anatomy in today's sense was still impossible, because of the taboos attendant on the opening of the human body, which were also operative in many other civilizations. Although the church had never expressly forbidden the practice of anatomy, the traditional reluctance to open the human body with the aim of studying the inside amounted in practice to a declaration of illicitness. There were those, however, "who cut up corpses and cook them in order to send the bones which become separated from the flesh during this process, for burial in their own land, without the sacraments," according to a Papal Bull of 1360. Such treatment was given to important people during the crusades, including Frederick Barbarossa. There is no reference at all in the Bull to the anatomical opening of the human body, and it is therefore to be supposed that the practice was not yet current. A possible explanation for this can perhaps be found in Galen's principles, where he tends to argue from the

THE ABDUCTION OF GANYMEDE
Oil on canvas; $67\frac{1}{4} \times 51\frac{1}{4}$ in (171.5 × 130 cm)
Signed and dated: Rembrandt ft. 1635
Dresden, Staatliche Kunstsammlungen, Gemäldegalerie (Br. 471)
There is a preliminary sketch of this painting, also in Dresden.

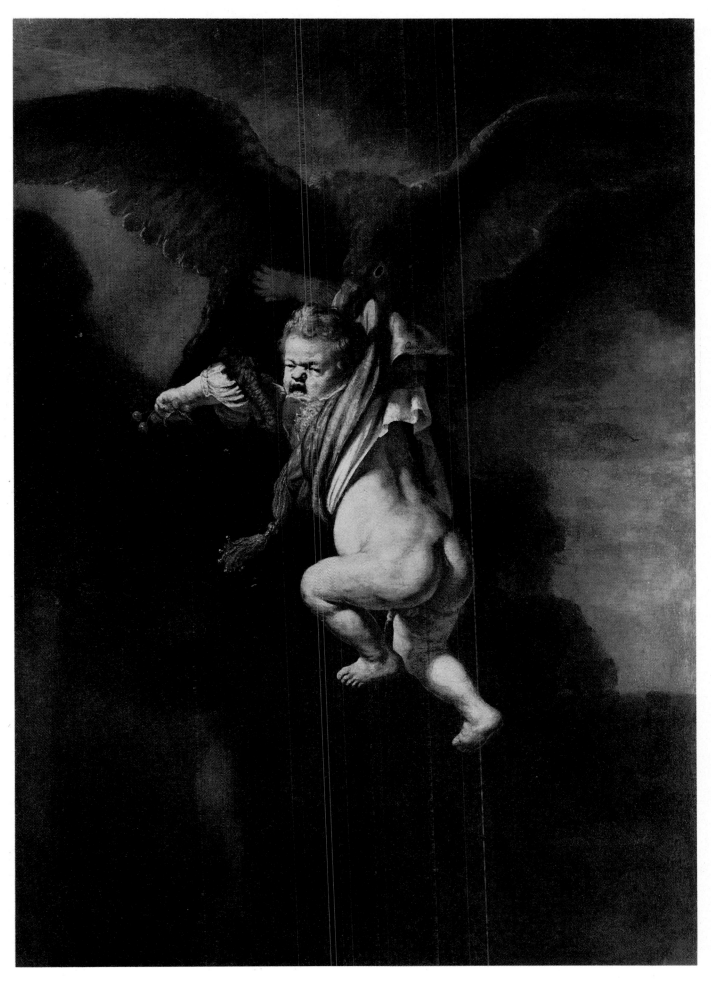

basis of the *living* human body, and it is the science of the living body which was studied during the Middle Ages and the early Renaissance. The first anatomists, such as Mundinus (1316) and Vigavano (1345) did dissect a person who, for practical reasons, must have been dead. But they were principally interested in the body as a *person* rather than as a corpse.

As another source of anatomical knowledge, Hekscher names the practice of dissecting deceased persons for the purpose of post-mortem or autopsy.

This was usually carried out with the aim of establishing the cause of death, if there was question of an unnatural death, or of preparing the body for embalmment, as in the case of Pope Alexander V (1410). This operation was generally carried out by two or three people in the cellars of a hospital. It was certainly not considered a spectacular or even honorable occupation, and anatomical studies were thus carried out by all kinds of amateurs, in addition to apothecaries and surgeons. A well-known example is that of Leonardo da Vinci, whose artistic interest caused him to be present at at least thirty dissections; he also made a large number of finely detailed anatomical drawings, but because these were never reproduced as prints, they had very little influence, and such as they had was on the artistic world rather than the medical.

It was at the beginning of the sixteenth century that the ceremonial anatomical demonstration as a public event began to make its appearance; its real function was to boost the standing of the local faculty of medicine or, where there was no university, that of the Guild of Surgeons, as was the case in Amsterdam. The demonstrations were given by academic scholars, while the corpses upon which the dissections were performed were invariably those of criminals. Again, the starting point for the demonstration were the writings of Galen, which were read aloud by the praelector in the chair. The actual dissection, however, was left to an assistant, while a third person pointed out the various parts referred to in the text. Galen's text was considered to be beyond question.

This rigorous division between theory and practice remained current until well into the Renaissance, but this situation was changed by the famous anatomist Andreas Vesalius (Andre van Wezel). After studying in Louvain and Paris, he began the practice of carrying out dissections himself and at the same time teaching his students.

He thus became the first modern anatomist of the human body, and his own personal involvement in the dissections enabled him to correct many of Galen's errors. The relationship between theory and practice is described in his seminal work *De humani corporis fabrica libri septem* (Seven books on the structure of the human body), which was first published in Basel in 1543. This was also the year in which Copernicus made the controversial statement that the earth revolved round the sun, thereby invalidating the geocentric astronomy of Ptolemy which had been accepted for centuries.

Vesalius' *De humani corporis fabrica* was the first work in which the human body was accurately described, both inside and out, in words and pictures; this was also the first work on anatomy which gave as much prominence to the illustrations as the text. This balance is taken for granted today, but the detailed and clear illustration of Vesalius' text created complete astonishment in contemporary medical circles.

In almost all the editions of *De humani corporis fabrica* there is a picture of Vesalius himself, aged twenty-eight and represented as the anatomist of the hand and arm. This picture has a dual significance: Vesalius had been the first to dissect the muscles of the hand and arm, and he had also been the first person to recognize the importance of the anatomist's own hands in carrying out his profession. His term for the hand was *primarium medicinae instrumentum* (the first instrument of medicine), and he went some way towards restoring the eminence of manual skills in surgery – a position which they had originally enjoyed ("surgery" is derived from the Greek word *cheir*, which means "hand"). The representation of Vesalius became the traditional image of the anatomist. And this image had a particular importance in Rembrandt's portrait of Dr Nicolaes Tulp. Tulp is seen to be busy dissecting the arm and hand, and the rest of the corpse has not yet been touched. Since anatomical lessons usually started with the dissection of the abdominal cavity and the intestines, we can conclude that the painting is not a representation of Tulp during one of the annual public anatomical demonstrations as had been thought. Dr Tulp seems to have had himself painted by Rembrandt, in his function as anatomist and praelector,

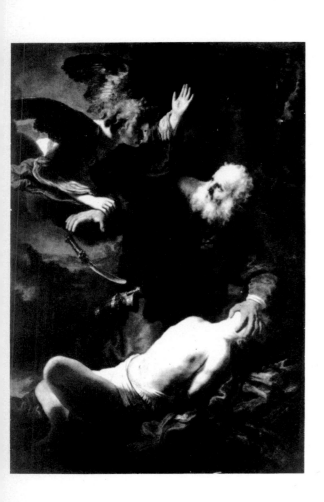

THE ANGEL STOPPING ABRAHAM FROM SACRIFICING ISAAC TO GOD
Oil on canvas; 76 × 52½ in (193 × 133 cm)
Signed and dated: Rembrandt f. 1635
Leningrad, Hermitage (Br. 498)
Bought in 1778 in London from the Walpole Collection by the Russian ambassador for Catherine II. A preliminary sketch is in the British Museum. Another version of the work is in the Alte Pinakothek in Munich (438); according to the inscription which follows the signature, however, it seems to have been the work of a pupil, corrected by Rembrandt.

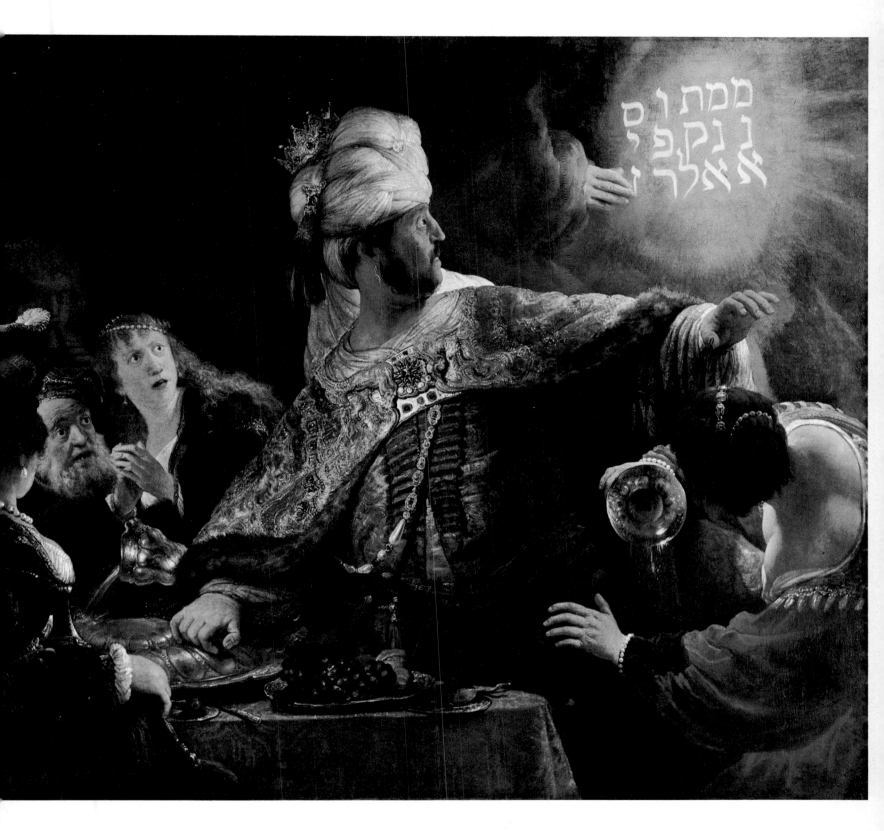

The Hebrew text on the wall reads:
מנא
מנא תקל
ופרסין


ממתו ס
נקפל
אאלר

THE FEAST OF BELSHEZZAR

Oil on canvas; $66 \times 82\frac{3}{8}$ in
$(167.6 \times 209.2$ cm)
Signed and dated:
Rembrandt fecit 163 . . .
(The last figure is not legibile, but the work was probably executed shortly after **1635**.)
London, National Gallery (Br. 497)
Acquired by the National Gallery in 1964 with a grant from the National Art Collections Fund.

performing a role very similar to that of Vesalius, who significantly also taught during the dissection. Tulp had been the pupil of the Leyden physician Pieter Paauw, who in turn had been taught by Vesalius in Padua and was a committed follower of his methods Tulp saw himself as the direct descendant of Vesalius and is therefore depicted as such. The fact that Rembrandt has chosen to represent a single moment of action here brings an excitement to the group portrait which is usually lacking in the more rigid grouping of the conventional work of this nature. It is perhaps this vitality which makes the erroneous interpretation of the painting's subject-matter possible, since it thus gives the impression of being an exact visual record of the anatomical lesson of January 31, 1632.

The contractual arrangements between Rembrandt and the stadholder Frederick Henry via Constantijn Huygens also date from the 1630s. Frederick Henry had already commissioned a number of paintings from the young Rembrandt. At the suggestion of Huygens, his secretary and an

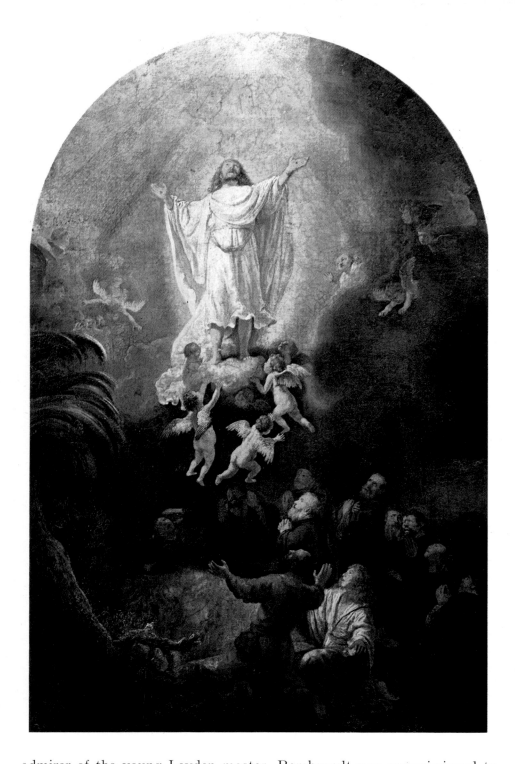

THE ASCENSION OF CHRIST
Oil on canvas; 36½ × 27 in
(92.5 × 68.5 cm)
Signed and dated: Rembrandt f.
1636
Munich, Alte Pinakothek (Br. 557)
This is one of the series of paintings
from the Passion, executed between
1633 and 1639 and bought by Prince
Frederick Henry of Orange-Nassau.

admirer of the young Leyden master, Rembrandt was commissioned to
execute a series of paintings representing scenes from the Passion. The seven
letters from Rembrandt to Huygens which have survived give more details
of this particular commission and these are more extensively discussed in
Rembrandt's biography (see p. 19). A number of the paintings which were in
the collection of Frederick Henry are reproduced here: *The Raising of the
Cross* (Munich, Alte Pinakothek, Bredius/Gerson 548, illustration pp. 40, 41)
and *The Descent from the Cross* (Munich, Alte Pinakothek, Bredius/Gerson
550, illustration p. 43). As far as is known, these two paintings had not been
specifically commissioned by the stadholder, although they were in his
collection. Rembrandt had probably painted them on his own initiative and
then sold them to the stadholder with Huygens acting as intermediary,
which Gerson suggests. It seems probable that Frederick Henry wanted to
complete the story of the Passion by ordering more scenes to be painted: *The
Entombment, The Resurrection* (both p. 84) and *The Ascension* (p. 66).
Frederick later bought two more paintings from Rembrandt, *The Birth* and
The Circumcision of Jesus.

The painting of *The Raising of the Cross* is dominated by the half-raised
beam of the cross, from which Christ hangs; it is placed diagonally from
bottom left to top right and is strongly illuminated. In the left foreground
there is a soldier wearing a helmet and a cuirass, he is seen obliquely from

behind, as he exerts all his strength to pull the beam towards him, an image which had become internationally known through Tintoretto's dramatic treatment of it in the Scuola di San Rocco in Venice. In the center background can be seen a horseman, seated higher than the rest of the people present, who was probably the chief officer of the soldiers of Pilate and who is responsible for seeing that the sentence is carried out. Rembrandt indicates that he is a Jew by giving him a turban; this is a frequent device in Rembrandt's paintings and one which he learned from Lastman. The horse is hardly visible being hidden behind the cross and the men who are raising it. To the man with the beret Rembrandt lends his own features. The dark figure on the right under the beam of the cross forms a compositional counter-balance to the heaving figures, as well as forming one side of the triangle which is the basic shape of the composition. A few more figures can just be made out in the left background of the painting. The man at the front of this group, who is completely against the edge of the painting, holds out both hands. It is possible that Rembrandt intended this figure to represent Pilate and was referring to an incident which precedes the crucifixion and is recounted in Matthew 27, 24–26: "When Pilate saw that he could prevail nothing, but that rather a tumult was made, he took water, and washed his hands before the multitude, saying, I am innocent of the blood of this just person: see ye to it. Then he answered all the people, and said, His blood be on us, and on our children. Then released he Barabbas unto them: and when he had scourged Jesus, he delivered him to be crucified."

Another group of figures can vaguely be made out in the background to the right of the painting, including soldiers with lances and a half-naked figure. This figure has an air of extreme suffering, and it almost seems as though this is a representation of Christ as he must have been immediately preceding his crucifixion. If this interpretation were correct, it would mean that Rembrandt has chosen to paint different scenes of the story within the same painting, thus going back to the medieval tradition of representing consecutive scenes of the same story within the same work of art. The scene, however, is treated so realistically – there is the violent tugging and pushing and even the spade which has been used to dig the hole in which the cross must be placed – that the possibility that a number of different events may be presented within the painting does not immediately strike the onlooker. The two scenes taking place in the background do in fact add greatly to the dramatic quality of the central event. It seems reasonable therefore to

THE BLINDING OF SAMSON
Oil on canvas; 93 × 119 in
(236 × 302 cm)
Signed and dated: Rembrandt f.
1636
Frankfurt, Städelsches Kunstinstitut
(Br. 501)
Acquired in 1905
In 1639 this work was given by Rembrandt to Constantijn Huygens, his patron and the secretary to Frederick Henry of Orange–Nassau.
Pages 68–69. Detail: Delilah fleeing with Samson's hair.

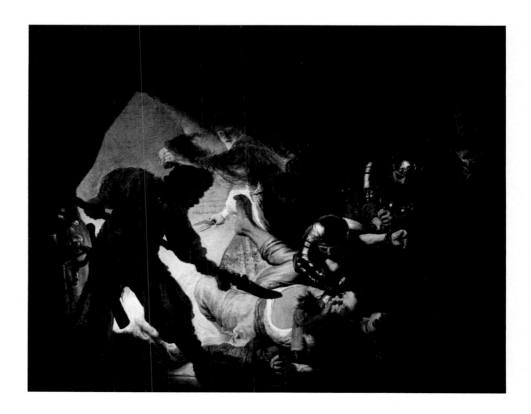

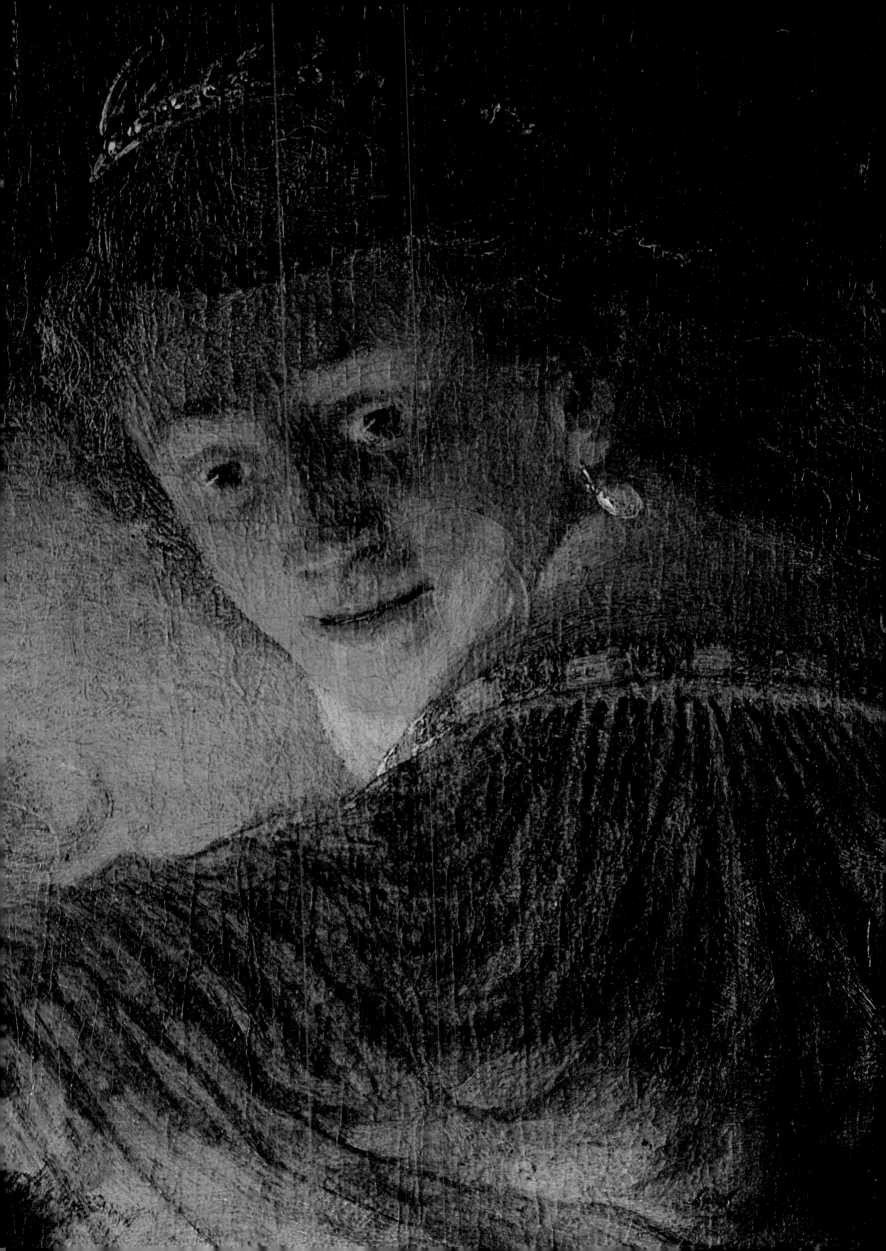

identify the figure on the right as one of the two criminals who were crucified on either side of Christ. This interpretation has been suggested by Gerson, following a comparison with Rubens' work on the same subject (Antwerp Cathedral), in which the two murderers with the soldiers are represented on the right-hand panel of the triptych, although they do not look as long-suffering as in the Rembrandt work. However, Rembrandt gives no attention whatsoever to the criminals in his painting of *The Descent from the Cross*, and it could therefore be legitimately supposed that the figure on the right of the painting is indeed another representation of the suffering Christ. This interpretation is given further support by the fact that there are consecutive scenes in Rembrandt's late painting of *The Apostle Peter Denying Christ* (p. 149). It may be assumed, then, that Rembrandt had no absolute objection to the old-fashioned technique of presenting consecutive scenes within the same painting, providing it added to the work's sense of conviction.

The other painting illustrated here from the suite on the Passion is that showing the descent from the cross (p. 43). All four gospels tell the story of how the wealthy Joseph of Arimathea, a follower of Jesus, went to Pilate and asked for the body of Christ. Pilate grants his request and Joseph removes the dead body from the cross, first wrapping it in cloth and then laying it in the tomb which has been hewn out of rock. Mary the mother of Jesus, Mary Magdalene and Mary the mother of Jacob and Joseph are also present at the removal of the body. The three women are represented in the left foreground of the painting; the mother of Jesus, who has fainted, is supported by the two other Marys. This group is linked to the center of the painting by the ladder on which one of the helpers stands, as Christ's slack,

LANDSCAPE WITH A STONE BRIDGE
Oil on panel; $11\frac{1}{2} \times 16\frac{3}{4}$ in (29.5 × 42.5 cm)
Circa 1636
Amsterdam, Rijksmuseum (Br. 440)
Bought in London by the museum at the sale of the James Reiss collection with the financial aid of the Rembrandt Society and Abraham Bredius. The painting probably represents a landscape in the vicinity of Ouderkerk, where there was a stone bridge which was demolished in 1649.

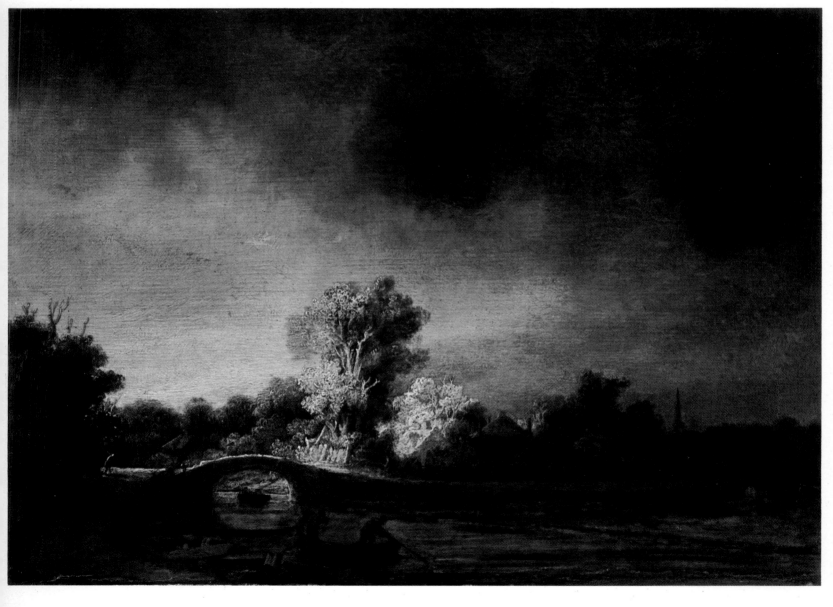

dead body is lowered by three other men and caught by a fourth, the beloved disciple John, to whom Rembrandt has given his own features. This central group is brightly illuminated. In the right foreground, seen from the side, is the richly clad Joseph of Arimathea, holding a stick and looking on. Two bearded figures, other disciples, are visible in the background to the left of the central group; one of them is shown in an attitude of great suffering, while the other watches the descent from the cross attentively.

The cross beam forms a diagonal in this painting, unlike the cross represented in the slightly later painting on the same theme, dated 1634 (Leningrad, Hermitage, Bredius/Gerson 551, not reproduced here). In this later painting the cross is shown frontally and Christ is being lowered in front of it. Another significant difference between the two paintings is that the Leningrad work shows the fainting Mary far to the right of the painting, while Joseph is seen only from the back. On the left foreground of the later painting is a group of women engaged in arranging the cloth in which the body is to be wrapped. In contrast, the Munich painting shows far fewer figures. Its atmosphere is serene and peaceful compared to the nervous restlessness which dominates the later Leningrad work and which is created by the large number of figures represented and the much greater degree of physical activity in which these groups seem to be engaged.

From the Munich *The Descent from the Cross* Rembrandt made an etching which is signed and dated 1633. There is some disagreement on the dating of both *The Raising of the Cross* and *The Descent from the Cross*, but it is certain that both works were painted during Rembrandt's early Amsterdam period.

It is always tempting to compare the two paintings with the works by

LANDSCAPE WITH A COACH
Oil on panel; 18 × 25¼ in (46 × 64 cm)
Circa 1640–1641
London, Wallace Collection (Br. 451)

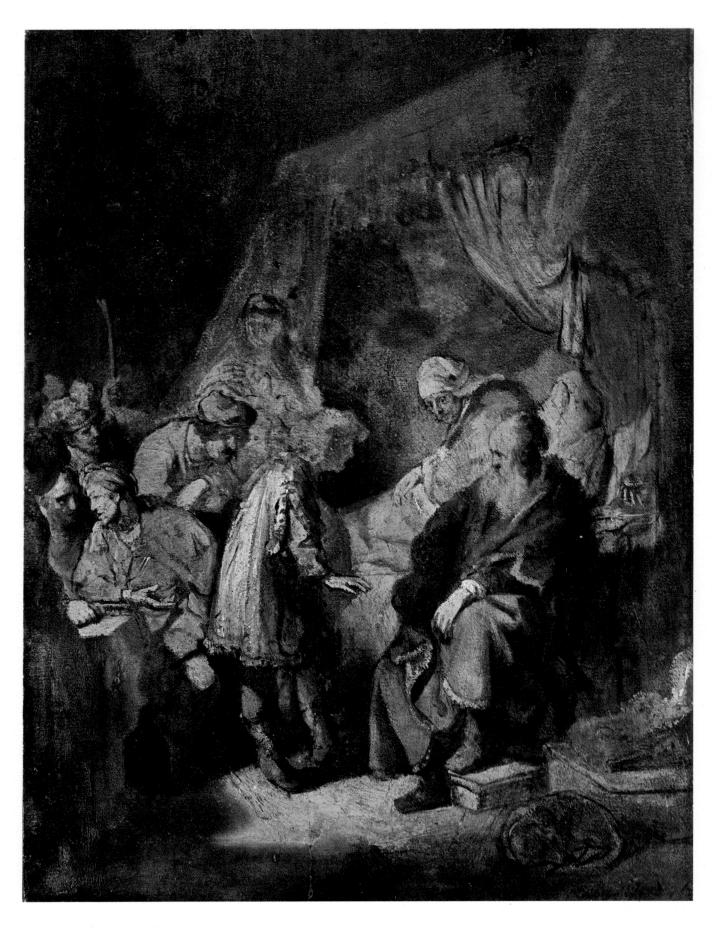

Rubens on the same subjects: the central panels of two triptychs, painted
for Antwerp cathedral, *The Raising of the Cross*, dated circa 1610–1611, and
The Descent from the Cross, circa 1611–1614. Although Rembrandt, unlike his
friend Lievens, did not himself go to Antwerp, he must have known the two
Rubens works through prints. If the two works on *The Descent from the Cross*
by these two very different painters are compared, a great many similarities
as well as great differences come to light. Rubens presents the whole scene
frontally, with the cross fully turned towards the onlooker, just as

STUDY OF AN OLD MAN SITTING
Drawing in red crayon; $8\frac{3}{4} \times 6\frac{1}{4}$ in
$(22.6 \times 15.7$ cm)
1630–1631
Berlin, Staatliche Museen
Preussischer Kulturbesitz,
Kupferstichkabinett
The old man shown in this drawing
served as a model for Rembrandt
several times during the years 1630–31.

JOSEPH RELATING HIS DREAMS
Paper on panel; $20 \times 15\frac{1}{4}$ in
$(51 \times 39$ cm)
Signed and dated: Rembrandt
163 . . .
Circa 1637
Amsterdam, Rijksmuseum (Br. 504)
Mentioned in the inventory of Ferdinand Bol, in 1669. After several changes of ownership, it was bought in 1928 by A. W. Volz of The Hague, who left it to the Rembrandt Society. The painting shows the young Joseph relating his dreams to his father, while his brothers listen.

Rembrandt does in his later painting. Rubens distributes the figures in the work more or less equally over the whole area of the painting. There are few diagonals in this painting, unlike the same painter's *Raising of the Cross*, where they are used in profusion. The figures are all on one plane, thus giving a sense of peace and classical order. Christ is lowered in a cloth from top right to bottom left, where the three women are represented in devout attention, thus terminating the movement down the painting. John, one foot on the ladder, receives the body, tended by four symmetrically placed helpers.

A comparison of this impressive composition with *The Descent from the Cross* by Rembrandt (p. 43) reveals the interesting fact that the latter is the mirror image of the Rubens work. This fact can possibly be explained by the theory that Rembrandt did not know Rubens' original painting, but a print of it, probably that by Lucas Vorsterman from 1620. The basis of Rembrandt's painting, however, is not a rectangle, which is the case in the Rubens, but a very obvious triangle. This compositional form was very fashionable during the High Renaissance and was frequently used by Raphael, always an object for careful study by Rembrandt. The figure of Joseph of Arimathea is not represented in the Rubens. In accordance with sixteenth-century narrative tradition, Rembrandt follows the story as it is told by the evangelists, thus creating an essentially historical work, in strict contrast to the devotional work by Rubens. The great and essential difference between the two masters can be seen in their differing representation of Christ. Rubens endows the body of the dead Savior with a sense of heroism, which is emphasized by the athletic musculature of the body, a quality totally lacking in the Rembrandt. There is no idealization in the body of Rembrandt's Christ: life has expired, leaving a human corpse.

From the beginning of his life in Amsterdam Rembrandt was much in demand as a painter of portraits. Though many of the portraits are known by the name of the sitter, many of them have not yet been identified, such as the brilliant painting, *Portrait of an 83-year-old Woman* (1634, London, National Gallery, Bredius/Gerson 343, illustration p. 46).

An early portrait, dating from 1634, is that of Johannes Elison (*c.* 1581–1639), a Protestant minister from Norwich, England (Boston, Museum of Fine Arts, Bredius/Gerson 200, illustration p. 47). The preacher and his wife spent some time in Amsterdam during 1634, and their son commissioned portraits of his parents. Jan Elison the Younger stipulated in his will of 1635 that both portraits (the painter's name is not mentioned) should be left to his brother-in-law in Norwich. They remained there in the possession of the Elison family until the middle of the nineteenth century.

The painting of *The Holy Family* (Munich, Alte Pinakothek, Bredius/Gerson 544, illustration p. 49) also dates from these early years in Amsterdam. The painting is not dated, but the distinctly Baroque style makes it seem likely that the painting was done around 1635. Indeed, the stylistic characteristics almost automatically lead to a search among Rubens' works for models which Rembrandt might have used. This painting seems comparatively simple at first sight; the figure of Mary is made to act as the focus of the action and of the sentiments expressed in the work. The protective, attentive love which she stands for is conveyed by such compositional elements as the semi-circle created by the continuous line from Mary's foot, by way of her arm, to her head, where the line ends. The eyes are then led to the child who lies along a diagonal in the opposite direction to that of Mary's arm and leg, but parallel to the upper part of the body. Spatial balance is achieved by the introduction of the forms of Joseph and the empty crib, and these also help to balance the arrangements of the various elements on the flat plane. The use of the human figure to define spatial relationships, as well as to emphasize the dramatic content of a painting, was still something of a revolution in Dutch art. Bruyn has suggested that Rembrandt became acquainted with this technique less through his acquaintanceship with the work of Rubens than through his

study of Italian models, which he interpreted for his own needs. In any case, the work of Rubens is more notable for its continuity of rhythm than for its spatially contrasting elements.

As far as is known, Rembrandt lived with the art dealer Hendrick van Uylenburch during his first years in Amsterdam; it was in his house that the painter subsequently met Uylenburch's niece Saskia, whom he later married. Saskia was frequently painted and in many different ways by Rembrandt. This is usually taken to indicate Rembrandt's great love for Saskia; it is also clear that the use of Saskia as a model meant that he did not have to hire a professional and that she was at hand when he needed her.

How Rembrandt saw Saskia and himself about 1633/1634 can be seen in the *Self-portrait* (Florence, Uffizi, Bredius/Gerson 20, not reproduced here) and *Saskia with a Hat* (Cassel, Gemäldegalerie, Bredius/Gerson 101, illustration pp. 51, 52–53). The portrait of Saskia is painted in great detail. She is shown wearing very expensive clothes, on which are visible a large number of jewels. She is wearing a wide, flat hat with a large plume. It is interesting to note that Rembrandt has chosen to show Saskia in profile in this painting, which he only does rarely. The resemblance in the position of the head and the hand to a drawing ascribed to Titian is remarkable (Teylersmuseum, Haarlem). From the early Renaissance the painting of portraits in profile had been practiced in imitation of the representation of emperors on Roman coins. It is possible, then, that Rembrandt borrowed this rather formal pose for the portrait of Saskia from Titian, as Van Rijckevorsel has suggested.

Titian, however, would have shown the whole figure of the woman in profile, creating a static, neatly defined image, typical of the High Renaissance. In the painting by Rembrandt only Saskia's head is shown in profile, while the rest of the body is turned three-quarters towards the onlooker, thus giving the whole figure a relatively complex position in space, derived very much from seventeenth-century Baroque. It is also clear from this painting that Rembrandt never makes an exact copy of the works he uses as examples, but rather adapts them to his own ends.

The history of this painting can be traced back without a break to 1652, when Rembrandt sold it to Jan Six. It then passed into the collection of Valerius Röver, after the Six auctions of 1702 and 1734, and finally reached the collection of the Landgrave Wilhelm VIII of Hesse-Cassel.

In two further portraits Rembrandt represented Saskia as Flora. The first of these dates from 1634 (Leningrad, Hermitage, Bredius/Gerson 102, illustration p. 54). The other is dated 1635, but is probably a contemporary copy after a lost original. In 238 BC a temple was dedicated in Rome to Flora, the goddess of flowers. In both paintings Saskia is represented in the fullest bloom of life, and is decorated with blossoming flowers.

The identity of *The Great Jewish Bride*, an etched portrait of a woman, dated 1635 (B. 340, illustration p. 56) is less clear. The traditional title is based on the hypothesis that the woman was the daughter of Dr Ephraim Bonus. There are a number of copies of the etching, of which a late one is reproduced here.

The subject of the painting *Sophonisba Receiving the Poisoned Cup* is taken from classical history; it is also thought that this painting could be a representation of Artemisia, who added the ashes of her dead husband, King Mausolos, to her beaker of wine (Madrid, Prado, Bredius/Gerson 468, illustration p. 55). The story of Sophonisba is an episode from Roman history of the period of the Punic wars against Carthage. Sophonisba was the daughter of Hasdrubal, leader of a Punic army in Spain in 214–206 BC. She married Syphax, chief of a Numidian tribe in North Africa, thereby winning the tribe over to the side of Carthage in her struggle against Rome. When Syphax was beaten by the Romans (203 BC), Sophonisba poisoned herself. Rembrandt chooses the moment just before the taking of the poison for his painting – a moment of great psychological complexity. There is some resemblance in the features of Sophonisba to those of Saskia as Flora in the

DIANA BATHING
Etching
Circa 1631
Signed: RML f.
(Bartsch 201)

SUSANNA SURPRISED BY THE ELDERS
Oil on panel; 18¾ × 15¼ in
(47.5 × 39 cm)
Signed and dated: Rembrandt f. 1637 (?)
The Hague, Mauritshuis (Br. 505)

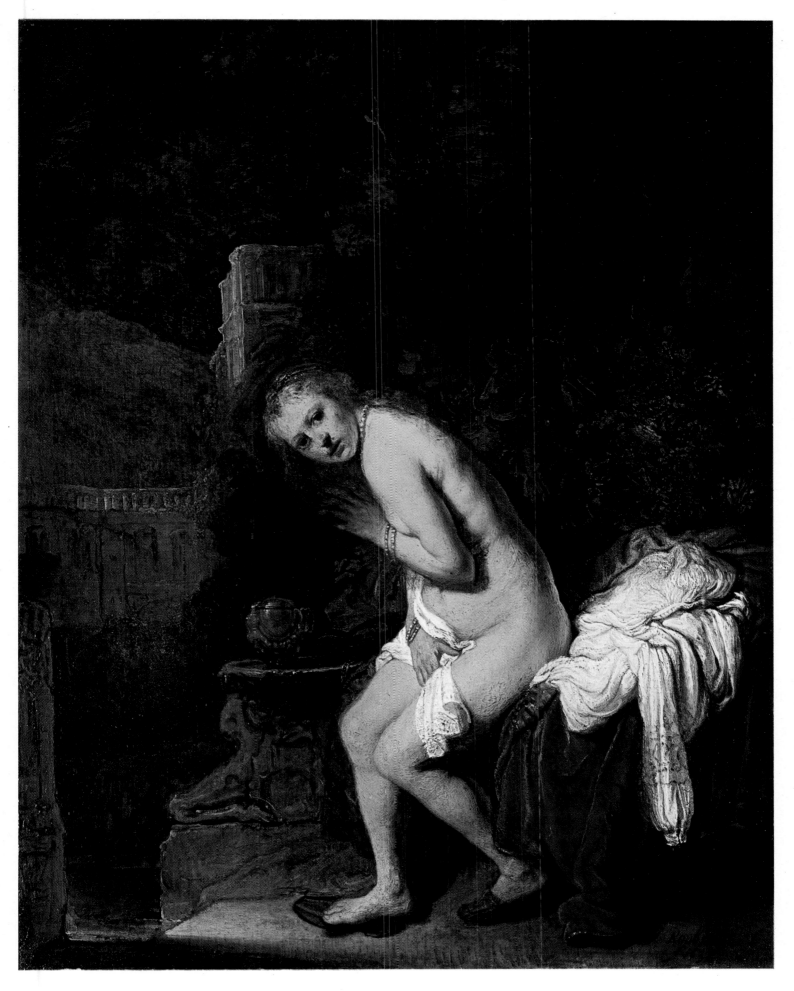

portrait of 1635 (p. 54). It is not in any case absolutely certain that the painting of *Sophonisba Receiving the Poisoned Cup* is by Rembrandt himself.

The painting of *Rembrandt and Saskia* (Dresden, Gemäldegalerie, Bredius/Gerson 30, illustration p. 57), sometimes called *The Prodigal Son in the Tavern*, is frequently discussed with direct reference to Rembrandt's private life. The work may thus be interpreted as a celebration of the worldly Rembrandt and his enjoyment of the good life with Saskia. This

interpretation would perhaps bear out the declaration by other members of Saskia's family that she had squandered "with ostentation and pomp" the legacy of her parents (see p. 19) and thus the law suit which followed. It is misleading, however, to interpret the painting within an autobiographical context. The subject is clearly intended to convey a moral lesson, whether it is drawn from the parable of the Prodigal Son or from some other biblical text (Paul's Epistle to Titus, 2:12); it cannot be considered as an actual representation of Rembrandt's and Saskia's life.

An interesting comparison can be made between the two paintings of figures clad in oriental costume, reproduced on pp. 60 and 61. The first dates from 1635 and bears the title *A Man in Oriental Costume* (Amsterdam, Rijksmuseum, Bredius/Gerson 206, illustration p. 60), and can best be understood as a head study of the type which Rembrandt frequently painted and used in his works on biblical subjects (Munich, Alte Pinakothek, Bredius/Gerson 178, illustration p. 47). The other portrait of a man in oriental costume reproduced here (Chatsworth, the Trustees of the Chatsworth Settlement, Devonshire Collection, Bredius/Gerson 179, illustration p. 61) was also considered to be simply a head study, until the correct identification of the subject was made: King Uzziah affected by leprosy beside the altar of incense. In II Chronicles 26:16–20, this punishment for Uzziah's pride is described: "But when he was strong, his heart was lifted up to his destruction: for he transgressed against the Lord his God, and went into the temple of the Lord to burn incense upon the altar of incense.

"And Azariah the priest went in after him, and with him fourscore priests of the Lord, that were valiant men:

"And they withstood Uzziah the king, and said unto him, It appertaineth not unto thee, Uzziah, to burn incense unto the Lord, but to the priests the sons of Aaron, that are consecrated to burn incense: go out of the sanctuary; for thou hast trespassed; neither shall it be for thine honour from the Lord God.

"Then Uzziah was wroth, and had a censer in his hand to burn incense: and while he was wroth with the priests, the leprosy even rose up in his forehead before the priests in the house of the Lord, from beside the incense altar.

"And Azariah the chief priest, and all the priests, looked upon him, and, behold, he was leprous in his forehead."

This historical portrait of King Uzziah also has a moralizing function; it shows how pride is punished and thus encourages man to lead a pious and devout life.

It is generally accepted that the painting entitled *The Abduction of Ganymede*, signed and dated 1635 (Dresden, Gemäldegalerie, Bredius/Gerson 471, illustration p. 63) does represent an incident from mythology. Zeus, the supreme god of the Greeks, picked out Ganymede because of his youthful beauty, and had him kidnapped by an eagle, or by himself in the shape of an eagle, with the intention of making him the cup-bearer of the gods. In the painting, we see an eagle carrying away a screaming child, who is also urinating from fear. The expression of the child is treated realistically and Rembrandt probably modeled it on a plaster cast of the head of a putto, as well as on his own observations of children crying, of which he made a number of studies.

As a rule, Rembrandt would follow to the letter the details of any story he was illustrating, and it is therefore surprising that he should choose here to represent a child who could hardly have had any attraction for Zeus, instead of the beautiful youth which Ganymede must have been at the time of his kidnapping. It is also impossible to explain the bunch of cherries in the child's hand in the context of the Ganymede story, and they are far too prominent to have been added as a simple embellishment. A more acceptable interpretation of this painting has been put forward by Th. Kellerhuis, who has pointed out its connection with a sixteenth-century

NAKED WOMAN WITH SNAKE
(CLEOPATRA?)
Drawing in red crayon
Circa 1637
London, private collection
(Benesch 137)

ADAM AND EVE
Engraving
Signed and dated: Rembrandt f.
1638
(Bartsch 28)

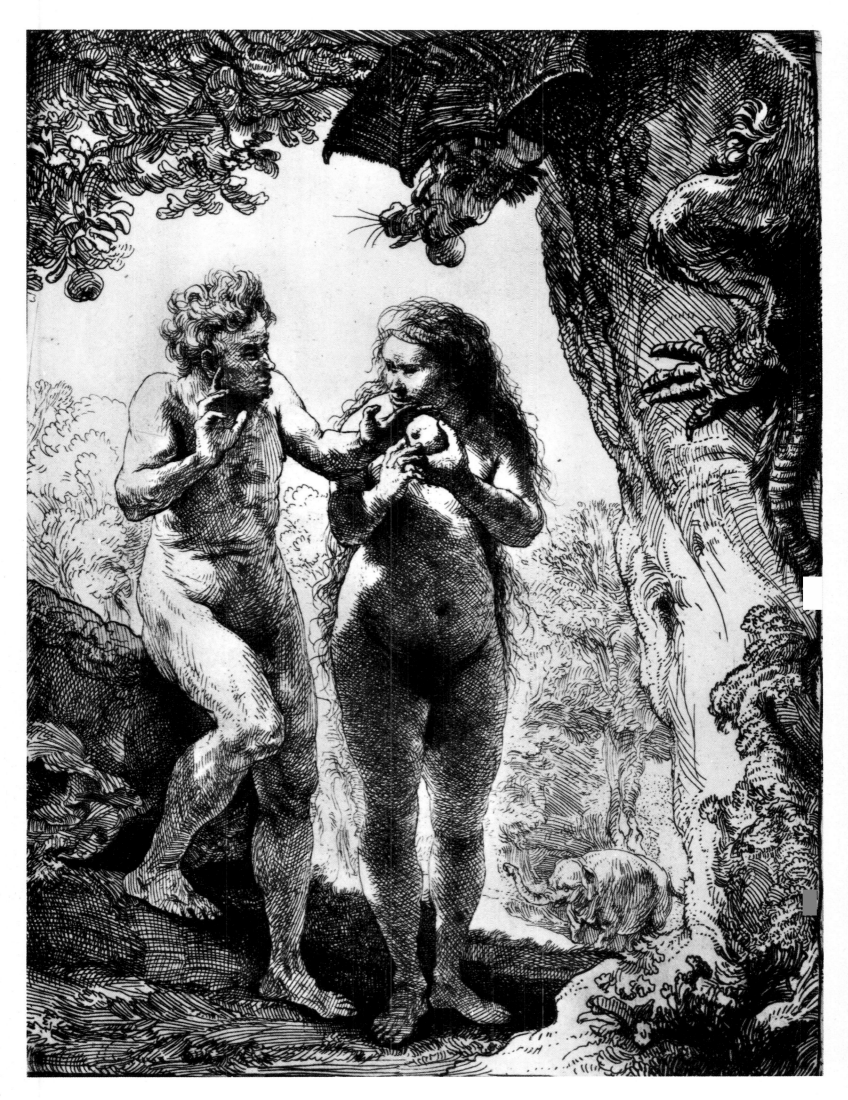

emblem – a small print with a, usually, moralizing text beneath – by Covarrubias Orozco. This emblem *Captivam duxit captivitatem* (literally translated: "He takes captivity into captivity") is a symbol of redemption by Christ. The emblem shows two figures gazing at a dead being taken to heaven by an eagle, symbolizing Christ. The narrative element represented by the two figures is dropped, characteristically, by Rembrandt in his painting. Instead, he concentrates on the central point, the kidnapping of the child and the effect of this on the child's expression. In a signed study for the painting (Benesch 92) the two figures are in fact included, though they were always thought to represent Ganymede's parents in the traditional interpretation of the painting.

A key to the interpretation is provided by Rembrandt in the cherries in the child's hand; cherries were the Christian symbol of heavenly fruit, or the rewards which man could expect in eternal life because of his redemption by Christ. If this interpretation is correct, then the painting demonstrates how a basically classical image has been shaped to express Christian contents: Christ delivering the sinner.

The subject of the painting *The Angel Stopping Abraham from Sacrificing Isaac to God* (Leningrad, Hermitage, Bredius/Gerson 498, illustration p. 64) is taken from the Old Testament, where the story can be found in Genesis 22, 10–13. God, wishing to test Abraham's faith, orders him to offer his only son Isaac as a sacrifice. Abraham prepares to obey but, as he is on the point of killing his son, this fatal course of events is changed by the intervention of the Angel of the Lord. The moment of intervention is represented in Rembrandt's painting: the Angel holds Abraham's arm back, causing the knife to fall, and the defenseless body of Isaac remains unharmed.

There are in fact two versions of this painting. The one in the Alte Pinakothek in Munich is signed "changed and painted over by Rembrandt," which indicates that it is by one of Rembrandt's pupils, but has been corrected by Rembrandt. The pupil in question is thought to have been either Govaert Flinck or Ferdinand Bol. The painting reproduced here, painted by Rembrandt himself, is in the Hermitage, Leningrad. Both versions are very like that by Pieter Lastman on the same subject, which in turn betrays strong influence by Elsheimer (Amsterdam, Rijksmuseum).

As in the case of *The Angel Stopping Abraham from Sacrificing Isaac to God*, Rembrandt conveys a frozen moment in *The Feast of Belshazzar* (London, National Gallery, Bredius, Gerson 497, illustration p. 65). This episode is taken from the Book of Daniel 5, 1–6: "Belshazzar the King made a great feast to a thousand of his lords, and drank wine before the thousand.

"Belshazzar, whiles he tasted the wine, commanded to bring the golden and silver vessels which his father Nebuchadnezzar had taken out of the temple which was in Jerusalem; that the king, and his princes, his wives, and his concubines, drank in them.

"They drank wine, and praised the gods of gold, and of silver, of brass, of iron, of wood, and of stone.

"In the same hour came forth fingers of a man's hand, and wrote over against the candlestick upon the plaister of the wall of the king's palace: and the king saw the part of the hand that wrote.

"Then the king's countenance was changed, and his thoughts troubled him, so that the joints of his loins were loosed, and his knees smote one against the other."

King Belshazzar then sends for all the wise men of Babylon and asks them to explain the meaning of the words. No one however is able to give an explanation of the words, and then Daniel is called to provide an interpretation: "And this is the writing that was written, MENE, MENE, TEKEL, UPHARSIN.

"This is the interpretation of the thing: MENE; God hath numbered thy kingdom, and finished it.

"TEKEL; Thou art weighed in the balances, and art found wanting. . . .

"In that night was Belshazzar the king of the Chaldeans slain."

SAMSON POSING THE RIDDLE TO THE WEDDING GUESTS
Oil on canvas; 49½ × 69 in
(126.5 × 175.5 cm)
Signed and dated: Rembrandt f.
1638
Dresden, Staatliche
Kunstsammlungen, Gemäldegalerie
(Br. 507)
The two figures standing near
Samson's shoulders are probably port-
raits of contemporaries; perhaps one of
the two is even a self-portrait of
Rembrandt himself.

Here again, Rembrandt chooses the most dramatic moment of the story
and limits himself essentially to its main point: the appearance of the
writing on the wall and the terrified reaction of king Belshazzar and the
women around him. This reaction is signified in the painting itself by the
falling drinking goblets. In his representation of Belshazzar, Rembrandt
makes full use of his studies of heads wearing oriental turbans. The painting
is not dated, but it is accepted that it was painted in 1639. This dating is
arrived at by the fact that the Hebrew inscription occurred in the book *De
termino vitae* by Manasse Ben Israel, which appeared in that year. The
painting is sometimes dated earlier, about 1635, though this dating is based
upon an analysis of the style.

The Ascension of Christ (Munich, Alte Pinakothek, Bredius/Gerson 557,
illustration p. 66), belongs to the suite of paintings depicting scenes from the
Passion, which were commissioned from Rembrandt by the stadholder
Frederick Henry. This painting is also specifically mentioned in one of the
seven letters written by Rembrandt to Huygens concerning this commis-
sion. It is now accepted that the letter and hence painting date from 1636.
Christ stands, arms outspread, on a cloud which is borne by a number of

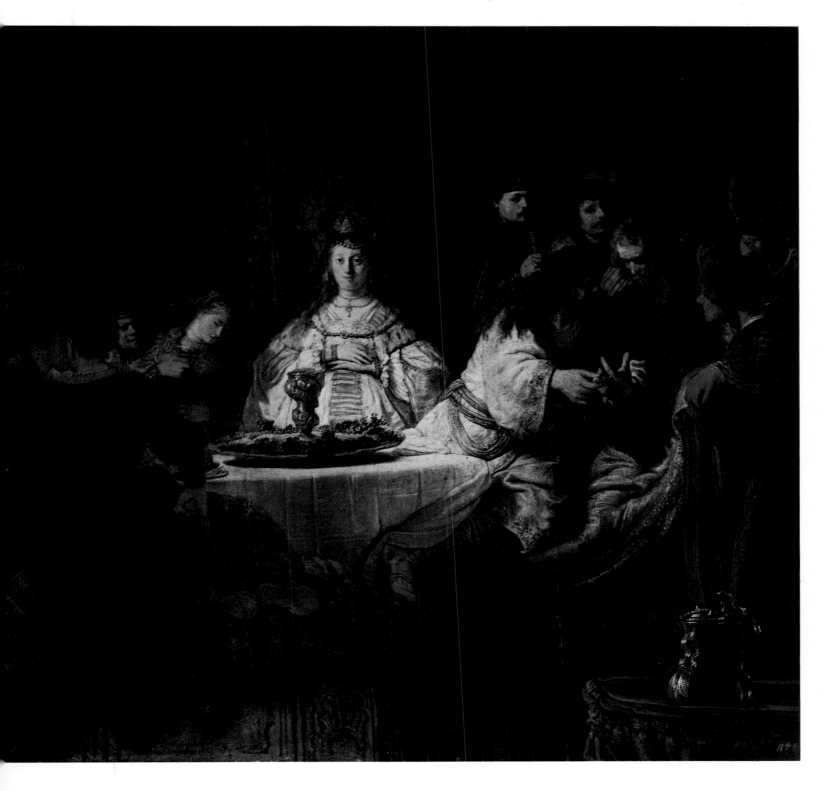

angels, and is carried thus to heaven. His gaze is directed upwards, towards the Holy Ghost, who is represented in the traditional form of the dove, which appears in the top center of the painting, right against its edge. On earth, a number of figures, the disciples, are shown. Two among them are brightly illuminated: Peter, with folded hands and beard, who is to be Christ's representative on earth, and the youthful John, his favorite follower.

The attitude of Christ, the presence of the winged putti carrying the cloud on which Christ is standing, and the presence of the disciples below, give this painting a structure similar to *The Assumption of the Virgin* by Titian,

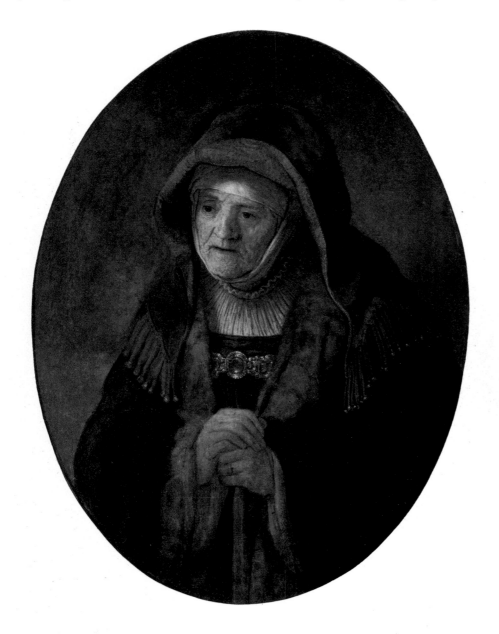

"REMBRANDT'S MOTHER"
Painting on limewood panel
$31\frac{1}{4} \times 24\frac{1}{4}$ in (79.5 × 61.7 cm)
Signed and dated: Rembrandt f.
1639
Vienna, Kunsthistorisches Museum, Gemäldegalerie (Br. 71)

dating from 1516–1518, which the Venetian master painted for the Church of the Frari in Venice, and which Rembrandt must have known at second hand.

The Blinding of Samson (Frankfurt, Städelsches Kunstinstitut, Bredius/Gerson 501, illustration p. 67) depicts the enactment of a gruesome drama. The story of Samson and Delilah occurs in the Old Testament book of Judges 16, 4–22. Samson, the possessor of enormous strength, loves Delilah, a Philistine. On the command of the lords of the Philistines, she attempts to make Samson tell her the secret of his strength. After constant pleading on her part, Samson finally reveals his secret: "If I be shaven, then my strength will go from me, and I shall become weak." Delilah betrays him to the Philistines and causes him to have his head shaven while he is asleep, "... and she began to afflict him, and his strength went from him.

"And she said, The Philistines be upon thee, Samson. And he awoke out of

his sleep, and said, I will go out as at other times before, and shake myself. And he wist not that the Lord was departed from him.

"But the Philistines took him, and put out his eyes, and brought him down to Gaza, and bound him with fetters of brass...."

Rembrandt shows the moment of the blinding. The event is shown with great realism, apparently at the entrance to a cave; the source of light appears on the left of the painting, whence it falls on the now hairless, and therefore helpless Samson. His body, tortured and without strength, forms a diagonal through the imaginary space of the painting, from the rear left to the front right; the light, which determines the structure of the composition, also falls in the same direction. In the immediate foreground is a group of soldiers, dressed in cuirass and helmet, carrying out their gruesome task. These soldiers form an opposite diagonal to the body of Samson; the other man in the left foreground, more or less in the dark and bearing the pointed weapon, sets off the space at the back. There, Delilah can be seen fleeing from the scene, her body bent in a direction parallel to that of Samson's body; brightly illuminated, she holds the keys to what is taking place: her traitor's trophies, the hair and the scissors with which it has been cut. She turns to look back on the bloody maiming of her lover.

In his positioning of the figures within the painting, both those of Samson and the soldiers assaulting him, Campbell argues that Rembrandt made direct use of antique reliefs of battle scenes and groups of antique statuary, such as the Laocoön group. He did, however, paint from live models placed in the required positions, perhaps explaining the realistic effect.

The direct narrative style and the prosaic manner of representing his subjects continued to characterize Rembrandt's work; this method of working was considered reprehensible in classical art theory, though Rembrandt frequently used classical models as an inspiration for his works. Van Mander's advice was that the artist should always look for "charm" in the figures he represented. The aim of the artist's training was thus to teach him to recognize true beauty, and it came to be considered a mark of bad taste and judgement to choose a gruesome scene as the subject of a painting and to depict in a direct way. The argument between what is "beautiful" and what is "ugly" in art thus becomes of direct relevance to the work of Rembrandt. According to Emmens, theorists of the pre-classical period, in which Rembrandt lived and worked, tended to the belief that what was ugly in "life" could be represented beautifully in art. The champions of the classical ideal of beauty tended to take a very different stance; the introduction to Jan de Bisschop's book of drawing examples, published in 1669, states that "it is clearly an error of judgement to think that what is ugly to the eye in life can be beautiful and pleasant when represented in art," and beauty and pleasure are obviously considered to be the true aims of art.

Rembrandt, however, essentially follows the advice offered in the fourth part of Van Mander's didactic poem on the subject (his *Schilderboek*), verse 40, regarding what is fitting subject-matter for a work of art: to show those qualities which correspond to the character and circumstances of what is represented: "In brief, all figures should have an effect commensurate to the strength and state of mind of each character, and it should also reflect whatever activity they appear to be engaged in: a fighting man, indeed, will exert himself in a very different way – wilder in his attitudes and gestures and generally less restrained – from a philosopher who, from his gestures, will appear to be engaged in serious argument. All this must be distinguishable as far as possible."

It was clearly considered commendable in Rembrandt's time to represent a story as truthfully as possible. An otherwise unimportant artist, Philips Angel, made a speech in 1642 on *Praise of the Art of Painting*, which was later recorded in writing; in it, Angel advises careful browsing through old books to gain an accurate knowledge of the past. He goes on to say that, if this knowledge is to be expressed in drawings, prints or paintings, then the artist's own "long and faraway memories" must be added so that the "poetic

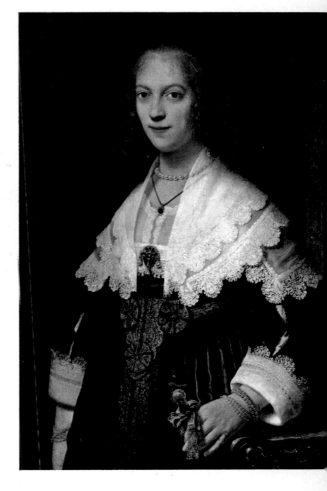

MARIA TRIP, DAUGHTER OF ALOTTA ADRIAENSDR.
Oil on teak panel; 42 × 32¼ in (107 × 82 cm)
Signed and dated: Rembrandt f. 1639
Amsterdam, Rijksmuseum (Br. 356)
On extended loan to the Museum since 1897 from the van Weede Foundation.
The portrait is that of the daughter of an Amsterdam merchant, Elia Trip, an ancestor of the van Weede family. There is an accurate preliminary sketch in the British Museum (Ben. 442).

license" of the artist can be expressed in the work, without detracting from "the Sense of History or the further embellishment of the work."

The *Samson* painting, with its gruesome subject, was not then considered repulsive by Rembrandt himself or his contemporaries. This is made sufficiently apparent by the fact that the painter offered this work to Constantijn Huygens as a gift in recognition of the commission for the series of scenes from the Passion which Rembrandt obtained from stadholder Frederick Henry through the intervention of Huygens.

The chiaroscuro which Rembrandt applied so dramatically to his portraits and group paintings, both to emphasize the content and to help point up the structure, is similarly applied to his landscapes. The *Landscape with a Stone Bridge* (Amsterdam, Rijksmuseum, Bredius/Gerson 440, illustration p. 70), dated *c.* 1636, is reproduced here. The German painter Adam Elsheimer, working in Rome at the beginning of the seventeenth century, had brought the atmospheric landscape very much into fashion; the "imaginative" content of landscape painting was derived from Flemish tradition, which had been introduced to the Northern Netherlands by Gillis van Coninxloo of the Frankenthaler painters' colony. The tradition was developed and modified by Hercules Seghers, and the courtly and "chivalrous-romantic" aspect tended to disappear, to be replaced by a strain of realism. It was at this point that the development of the landscape was taken up by Rembrandt, who introduced a note of high drama to the genre. The crux of Rembrandt's approach to landscape was the resolution of the problem of how to suggest the immense space of a landscape on canvas, simply using paint and brushes. Although the landscape with the stone ridge (p. 70) has been located as being near Ouderkerk, a small village on the river Amstel near Amsterdam, it is not the strictly topographical aspect which is the most important characteristic of the painting. Rembrandt's landscapes rarely give an exact picture of a given topographical formation. He is concerned, rather, with the effect of light on the landscape, which makes certain elements very visible and others dark and difficult to distinguish.

Landscape painting occupies a particularly important place in the Dutch painting of the seventeenth century. A considerable number of well-known painters confined their work to this area. Among them were Aelbert Cuyp, Jan van Goyen, Meindert Hobbema and Jacob van Ruisdael. Rembrandt and his followers – especially Philips Koninck – differed from these landscape painters, not only because their work was not confined to the genre, but also because they used light in a particular way in relation to the form and content of the painting.

The *Landscape with a Coach* (London, The Wallace Collection, Bredius/Gerson 451, illustration p. 71) is dated about 1640/1641. The painting is divided horizontally into two equal parts: the land in the lower half and the sky in the upper. The scene represented gives the spectator a variety of things to look at, and it is not difficult to see that the painter wants to represent a summer landscape. In this, Rembrandt is returning to an older tradition, in showing a landscape held in the cyclical pattern of the seasons. In addition to the grazing cattle on the left, there is a cart loaded high with hay. Behind it can be seen the corn drying in sheaves, more of which can be seen at the edge of the ornamental water at the right of the painting. The castle, lit by the rays of the sun from the left, gives an impression of some delapidation; it does, however, form an important vertical element in the painting and dominates the middle ground. The spatial structure of the painting is determined by alternating light and dark, almost diagonal, sections, with a heavy concentration of light in the narrative and structural center of the painting. The carriage which is being driven along the track in the foreground leads our eyes into the central space of the work from the figure in the extreme right foreground; the movement is first diagonally to the left, then in the opposite direction towards the back of the painting, from the very light spot in the middle plan. The sky, with its marked differences of light and shade, is a repetition of the structure of the

LAMENTATION OVER THE DEAD CHRIST
Grisaille; oil on paper and canvas on panel; $12\frac{1}{2} \times 10\frac{1}{2}$ in (31.9 × 26.7 cm)
Probably painted between 1637–38 and 1640
London, National Gallery (Br. 565)
Donated to the Gallery by Sir George Beaumont in 1823–28.

82

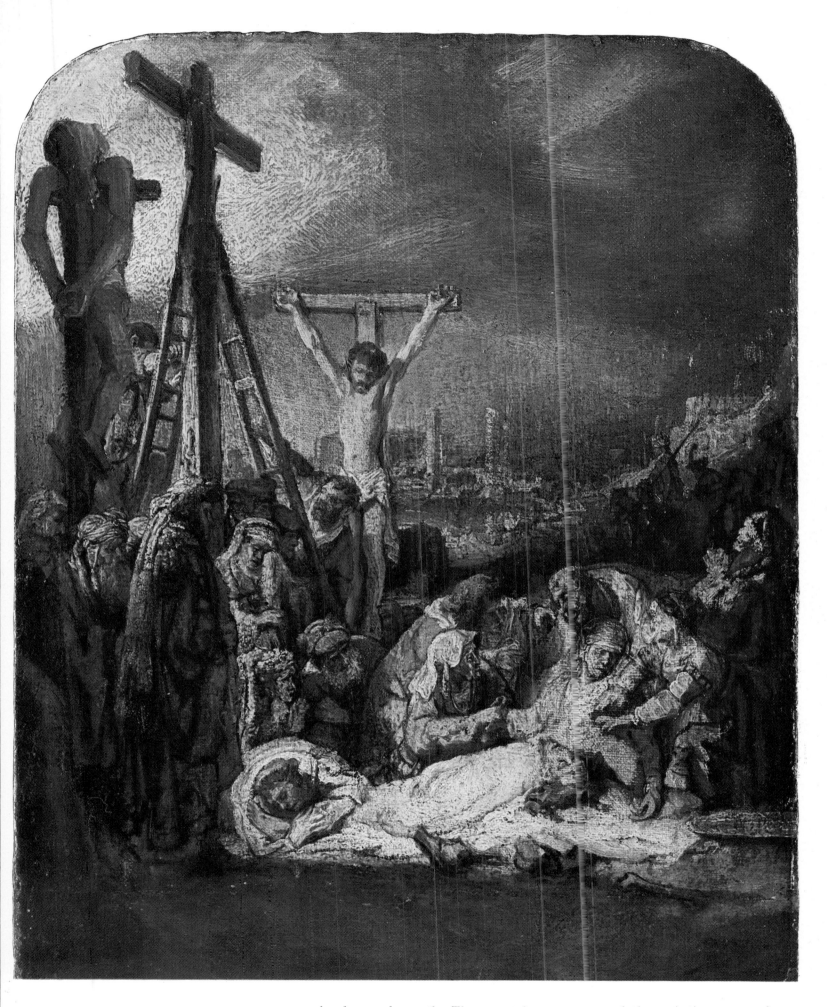

landscape beneath. The great homogeneity of the painting comes from Rembrandt's determination to treat every element as part of a grand design.

Rembrandt drew on material from the first book of the Bible, Genesis 37, 9–11, for his lightly, almost sketchily, painted *Joseph Relating his Dreams* (Amsterdam, Rijksmuseum, Bredius/Gerson 504, illustration p. 72). It is important here to note the great contrasts between the attitudes of Joseph relating his story, and the very different reactions of the brothers and their

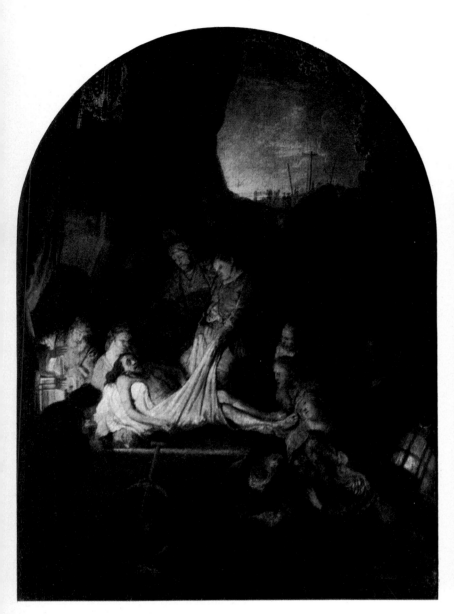

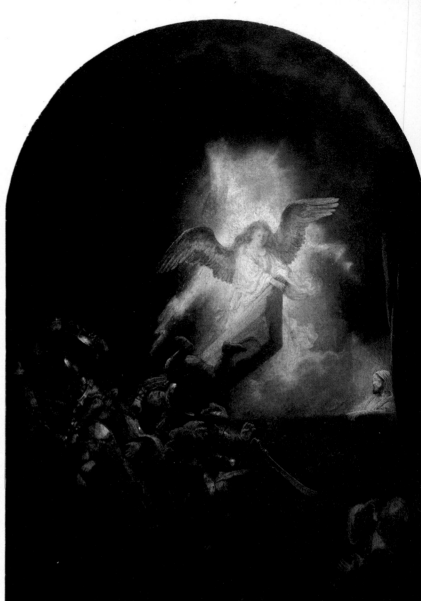

THE ENTOMBMENT OF CHRIST
Oil on canvas; $36\frac{1}{2} \times 27\frac{1}{4}$ in
(92.5×68.8 cm)
Executed between 1636 and 1639
Munich, Alte Pinakothek (Br. 560)
This painting, *The Resurrection* (reproduced next to it) and *The Ascension* (p. 66) are the last works in the Passion cycle which was painted for the Prince of Orange. In spite of the subjects, neither Rembrandt nor his patron thought that the works should be put to a religious use.

old father Jacob to the report of his dreams. This painting is considered to be a preparative study for the etching of 1638 (Bartsch 37), which gives a mirror-image of the scene. The figure of the old Jacob is based on a study drawing of 1631 (Benesch 20).

There is considerable similarity of form, although they are very different as far as content and meaning are concerned, between the etching of *c.* 1631, *Diana Bathing* (Bartsch 201, illustration p. 74) and the painting of *c.* 1637, *Susanna Surprised by the Elders* (The Hague, Mauritshuis, Bredius/Gerson 505, illustration p. 75). Both works depict a naked woman bathing, and both women are looking up from what they are doing. The surroundings of the women, however, are different. Diana, classical goddess of the hunt and of chastity, is represented in a distinctly unclassical manner. Although Rembrandt probably borrowed this particular attitude of Diana's from an example in antiquity, the harmonious and dignified equilibrium prescribed by the classical theorists is totally absent.

The figure in the other painting is the biblical Susanna, renowned for her chastity. Her story is told in the apocryphal thirteenth chapter added to the Book of Daniel. The figure of Susanna evinces even stronger unease here than Diana in the etching. Campbell points to a possible example for Rembrandt's Diana and Susanna in Rubens' 1614 version of the Susanna story, in which he used the squatting Venus of Doidalses, an antique sculpture in the Vatican, as his model. A print of this work by Vorsterman was in circulation in 1620 and Rembrandt would have known it.

Rembrandt's approach to the examples of antiquity is characteristically individualistic, as we have already seen in the case of *The Blinding of Samson*. He does not copy from plaster figures in the prescribed way, but has a live

THE RESURRECTION OF CHRIST

Oil on canvas on panel; 36¼ × 26½ in (92 × 67 cm)
Signed and dated: Rembr . . . t f. 163 . . .
(Circa 1636–1639)
Munich, Alte Pinakothek (Br. 561)
There is an inscription on the back by the restorer, the court painter Ph. H. Brinckmann: *Rimbrand Creavit me P.H. Brinkman resuscitavit Te, 1775.*

model take up the position of the antique and then paints from that. We can see this method at work again in the painting of Susanna: she is not squatting like her prototype, but is caught in an attitude which shows that she has just risen from the squatting position. Rembrandt chooses this particular moment to capture Susanna's "surprise" as vividly as possible through expression and gesture.

The etching *Adam and Eve* (Bartsch 28, illustration p. 77) is signed and dated 1638. Rembrandt chooses an evocative narrative style for this etching; in the foreground Adam is trying to prevent Eve from eating the fruit of the Tree of Good and Evil. In the top right-hand corner the devil is represented in the shape of a dragon, while the Garden of Eden is indicated in the background by trees and an elephant.

The way in which Rembrandt creates an image on paper by way of the etching plate is again highly individual: it is not only the dark etched lines and areas which make up the final image; the areas of paper which are left white are equally important. Van Rijckevorsel has noted the curious idea of representing the devil as a dragon and not as a snake, as in Genesis 3, 1–6. Rembrandt is thought to have borrowed this detail from Dürer's engraving of 1512 of *Christ in Limbo* (Bartsch K15), thus making very free use of a medieval iconographical tradition. Such deviation from the letter of the text was much disapproved of by later classical theorists, ". . . one must always try to express truths, otherwise one may be guilty of originating and perpetuating false images," according to Houbraken, who goes on to reprimand Rembrandt by name for representing the snake as a dragon, which he regarded as an unwarranted liberty with the text of the Bible.

The story of Samson must have held a particular attraction for Rembrandt, and in 1638 he painted another scene from the story of the Old Testament Judge. The theme is *Samson Posing the Riddle to the Wedding Guests* (Dresden, Gemäldegalerie, Bredius/Gerson 507, illustration p. 79). Rembrandt enjoyed considerable success with this painting; three years after it was finished, it was picked out for especially lavish praise by Philips Angel in the speech quoted above, which was given on St Luke's day, October 18, 1641, the day of the painters' guild: "Among other things, I have seen Samson at the wedding, painted by Rembrandt, about which we can read in the Book of Judges, chapter 14, verse 10. This demonstrates how observant the painter has been of the seating arrangements (or rather the lying arrangements) of the guests at the table. Indeed, it used to be the practice for people to lie on couches, and not sit at table in the way in which we do; this is still the habit with the Turks. Here, Rembrandt has shown this aspect particularly well. To make this wedding quite distinctive, Rembrandt has placed Samson in the foreground; his hair is still long, a proof that it has never been cut. We can further see from the position of Samson's hands that he is busy posing the riddle to a number of guests who are listening attentively; we can see that he is trying to convey something verbally because he has taken the left middle finger of one of the guests between the thumb and forefinger of his right hand, a very natural act for someone who is trying to explain something. At the same time, the other guests are shown in a variety of activities. Rembrandt has shown some making merry and, instead of listening to the riddle, raising a glass of wine and laughing; others are embracing. All in all, it seems to have been a very merry wedding. But although the atmosphere is rather like that to be found in our wedding feasts today, Rembrandt has still succeeded in making this particular wedding feast different from ours. This fruit of his own native imagination was created after a thorough reading of the story and the modification of what he read by his own distant memories."

In his *Het Gulden Cabinet van de Schilderkonst* (The Golden Cabinet of Painting), published in Antwerp in 1661, Cornelis de Bie further praises Rembrandt's painting of Samson at the wedding in almost exactly the same terms as Angel. The subject of the painting consists essentially of "figures round a table," and in it Rembrandt tackles one of the great problems in the

THE SLAUGHTERED OX
Oil on panel; $28\frac{7}{8} \times 20\frac{3}{8}$ in (73.5×51.5 cm)
Signed and dated: Rembrandt f. 16 ...
Executed between 1635 and 1640
Glasgow, Art Gallery and Museum
(Br. 458)

THE SLAUGHTERED OX
Oil on panel; 37 × 26½ in (94 × 67 cm)
Signed and dated: Rembrandt f.
1655
Paris, Louvre (Br. 457)
Acquired in 1857.

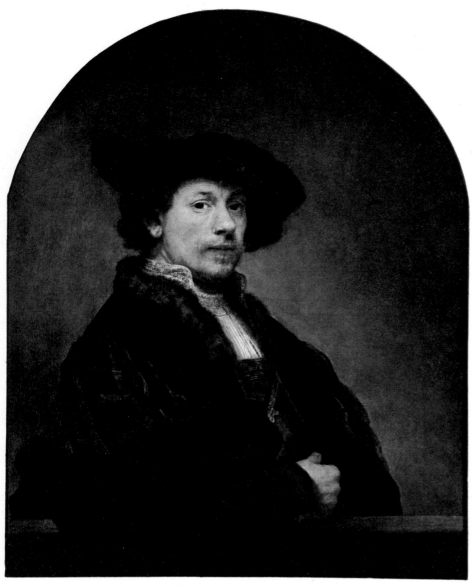

SELF-PORTRAIT
Oil on canvas; $40\frac{1}{8} \times 31\frac{1}{2}$ in
$(102 \times 80$ cm)
Signed and dated: Rembrandt f.
1640
Under the signature can be read the
word *Conterfeycel*, not in
Rembrandt's hand.
London, National Gallery (Br. 34)
Acquired in 1861.
This portrait was inspired by two
Italian works: the *Portrait of
Baldassarre Castiglione* by Raphael
(Louvre), and the *Portrait of a Man* by
Titian in the National Gallery (1944).
Rembrandt had probably seen them in
1639 on the premises of the
Amsterdam art dealer, Alfonso
Lopez.

painting of groups of people – a problem tackled before by Leonardo da Vinci in *The Last Supper* and by Tintoretto in his revolutionary treatment of the same theme. Leonardo's influence is especially notable in the grouping of the figures in the work by Rembrandt. The position of the bride shows certain similarities to the bride in Bruegel's *The Peasant Wedding*, in which the sixteenth-century Antwerp painter found a northern solution to the problem of grouping figures round a table.

The liveliness which Rembrandt brings to his representation of Samson's wedding is created by the wide range of contrasts within the painting; this is as true of his use of chiaroscuro as of the varying attitudes of the various figures. The bride, slightly to the right of center and seated frontally behind the table, forms a static element in the composition; this figure is built up with vertical and horizontal bands, in contrast to the figure of Samson in which diagonals dominate. The varied facial expressions also reinforce this impression of great liveliness.

In 1639 Rembrandt painted the oval portrait of an old woman, who is sometimes said to be his mother (Vienna, Kunsthistorisches Museum, Bredius/Gerson 71, illustration p. 80); his mother was in fact to die a year after this was painted. This is the only portrait of Rembrandt's mother of his Amsterdam period. According to Bauch, however, this painting is more likely to have been intended as a representation of the prophetess Anna than a portrait of his mother.

Commissions for portraits by Rembrandt came principally from the trade-aristocracy who were in both economic and administrative control of the Dutch Republic in the seventeenth century. A typical representative of this newly risen class was Maria Trip, daughter of Alotta Adriaensdr., whose portrait Rembrandt painted in 1639 (Amsterdam, Rijksmuseum, on loan

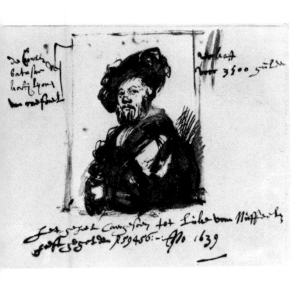

PORTRAIT OF BALDASSARRE
CASTIGLIONE (by Raphael)
Drawing in ink and watercolor
6½ × 8 in (16.3 × 20.7 cm)
Dated 1639
Vienna, Graphische Sammlung
Albertina
(Benesch 451)

from the Van Weede Family Foundations, Bredius/Gerson 356, illustration p. 81); this painting was once thought to be a portrait of Saskia. This self-conscious, yet purposeful-looking young lady is dressed in a distinctly modern style for the times; she is not wearing the traditional high black dress with white ruff, instead the neck is open and decorated with fine lace, as are the cuffs. The front of her satin dress is covered with beautiful brocade. Around her neck and wrists are necklaces and bracelets of pearls, which have also been worked into her earrings and brooch. All the aspects of her dress are painted in the finest detail. The richness of the lady's finery is further accentuated, doubtless to the great satisfaction of the person represented, by the contrast with the simple, dark background. The Trip family owed its wealth to its holdings of iron mines, arms factories and other businesses. This portrait shows that its members made no attempt to hide their wealth.

In addition to his commissions, Rembrandt also executed a lot of paintings for sale in the "free" trade. *The Lamentation over the Dead Christ* (London, National Gallery, Bredius/Gerson 565, illustration p. 83) is a sketch in brown and gray and was probably meant as a study for an etching. The center of action is at the foot of the cross from which Christ has already been removed. In contrast to *The Descent from the Cross* of 1633, which has already been extensively discussed, the two criminals who were crucified one on either side of Christ, are shown in this later work. In the foreground Mary cradles the dead body of Christ in her lap, surrounded by the disciples. Mary Magdalene is kneeling at his feet, while Joseph of Arimathea stands watching on the left. The episode of the lamentation is not specifically mentioned in the Gospels, but it was a recurrent devotional theme in the late Middle Ages and the Renaissance. This work is remarkable for the way in which light and shadow effects alternate. The forms of one of the criminals and the abandoned cross stand out against the light in the upper left-hand corner, while the main grouping – the lamentation of Christ – forms a center of light against the surrounding dark sections of the work.

Rembrandt worked a particularly long time on this painting between 1637/38 and 1640; he changed the composition several times, as he tended to do quite frequently. This was especially the case with his etchings, where there is very often more than one state of the same etching, i.e. different editions from the same etching plate, which has been changed slightly between each edition.

The Entombment of Christ (Munich, Alte Pinakothek, Bredius/Gerson 560, illustration p. 84) and *The Resurrection of Christ* (Munich, Alte Pinakothek, Bredius/Gerson 561, illustration p. 84) both belong to the suite of paintings by Rembrandt from the Passion, which had been commissioned by Prince Frederick Henry, and for which he had to wait for some considerable time. Both works were only half finished in 1636 when Rembrandt delivered *The Ascension of Christ* (p. 66). It is likely that Rembrandt finished the two works around 1639. In the letter of January 12, 1639 to Huygens, mentioned above, he gives as the reason for the long delay in the delivery of the paintings that in them is represented "the finest and most natural movement." This statement was probably intended to be taken both literally and figuratively, and refers both to the way, for instance, that the soldiers fall about in *The Resurrection of Christ*, as well as to the various emotions aroused by the events which are depicted.

The atmospheres of the two paintings are totally different. All the figures of *The Entombment of Christ* react separately and individually to the dead Lord. Their emotions are conveyed in their attitudes and facial expressions, as they dwell in quiet depression over Christ's dead body. The dominating emotion in *The Resurrection of Christ* is the fear of the guards of the tomb, an emotion which is very clearly expressed in their movements. Yet the disruptive turbulence of this group of figures is tempered by the grace and power of the angel who holds open the tomb.

In mentioning his concern for "this most natural movement," Rembrandt goes back, probably via several intermediary sources, to the concepts of the

first great theorist in the art of western Europe, Leon Battista Alberti (1404–1472). In his treatise on painting Alberti makes a distinction between the movements of the mind, such as anger, joy, suffering and anxiety, and the movements of the body, as when, for instance, the body moves for some reason in space. In a historical painting, however, the movements of the body must reflect the countless movements of the mind and convey the content of the story at the same time.

Rembrandt's very obvious use of movement in both paintings suggests that the painter was thinking along similar lines to the ideas of Alberti, whose influence was indeed widespread and highly considered.

The painting *The Slaughtered ox* (Glasgow, Art Gallery and Museum, Bredius/Gerson 458, illustration p. 86) dates from the late 1630s. The skinned ox hangs diagonally in space on a beam suspended from the ceiling, while a woman is busy cleaning the floor in the left background of the painting. The head of the ox lies in the right foreground.

There has never been any doubt about the scene actually shown in this painting: there is the carcass, and the woman is cleaning the blood from the floor after the slaughter. It is not certain, however, whether a secondary meaning to the painting was intended. Campbell connects this painting with a drawing by Rembrandt of 1635, *Two Butchers at Work on a Carcass* (Benesch 400). The motif of this sketch is to be found in sixteenth-century engravings of the parable of the Prodigal Son, in which butchers are shown preparing the fatted calf. From the end of the sixteenth century and during the seventeenth, these prints, which were originally wholly religious and moral in significance, were adapted to secular works; and Rembrandt's *The slaughtered ox* could be explained in the light of this fact.

It is also true that paintings with similar subjects, including a woman in the background, were being done as early as the middle of the sixteenth century: for example, Joachim de Beuckelaer's *A Slaughtered Pig* of 1563 (Cologne, Wallraf Richartz Museum) and *A Slaughtered Ox* of 1566 (Vienna, Kunsthistorisches Museum). There is no indication in either of these paintings, or in that by Rembrandt, of an allusion to the episode from the parable of the Prodigal Son. It is possible that these representations of slaughtered cattle simply belong to the tradition of kitchen and genre works which gained strength during the sixteenth century and which is typified in the works of Pieter Aertsen (1508–1575). This genre included carefully painted still-lifes of vegetables, fruit, slaughtered cattle and game and other meat, together with a biblical scene, such as *Jesus at Martha's and Mary's*, Luke 10, 38–42. This text describes how the two sisters Martha and Mary receive Jesus. Martha is busy sewing, while Mary sits at Christ's feet, listening. When Martha asks her sister to come and help, Jesus says, "Martha, Martha, thou art careful and troubled about many things: But one thing is needful: and Mary hath chosen that good part, which shall not be taken away from her." The biblical scene, which was originally the principal subject of such paintings, gradually declined in importance and finally disappeared completely, leaving an essentially secular tradition of still-lifes.

Rembrandt returned to the theme of *The Slaughtered Ox* in 1655 (Paris, Louvre, Bredius/Gerson 457, illustration p. 87). A comparison of the two paintings shows how much Rembrandt's technique had developed. The Glasgow painting is distinctly pictorial, but the painting in the Louvre has been executed with such contrasting brush strokes that the differing patches of light and shade almost give it the appearance of a modern abstract. Perhaps it was for this reason that a number of nineteenth and twentieth-century painters, including Delacroix, Bonvin and Soutine, copied it.

Rembrandt again painted his *Self-portrait* in 1640 (London, National Gallery, Bredius/Gerson 34, illustration p. 88). On this canvas, semi-circular at the top, Rembrandt shows himself three-quarters turned towards the right; his right arm rests on a stone ledge. He is wearing a wide-sleeved, velvet coat, embellished with fur around the neck, and a flat beret.

There is an etched self-portrait which shows Rembrandt in an almost

identical position, but looking in the opposite direction; this etching is signed and dated 1639 (Bartsch 21). It has been suggested that a possible source for the form of these self-portraits is the so-called portrait of Ludovico Ariosto (London, National Gallery), which used to be attributed to Giorgione, but which is now thought to be by Titian. It is sometimes suggested that this portrait is in fact a self-portrait of Titian himself. This suggestion is particularly interesting in the context of the Rembrandt painting, since the work by Titian was in the collection of the rich Spanish merchant, Alfonso Lopez, in 1640; Lopez lived in Amsterdam and was in the service of Richelieu. Rembrandt certainly knew this portrait well, and uses the stance of the subject in his own self-portrait, the arm swathed in a wide sleeve and resting on a ledge.

Another painting which inspired Rembrandt was the portrait of Count Baldassare Castiglione by Raphael, now in the Louvre in Paris. This famous painting, which Rembrandt copied in a rapid sketch during an auction in Amsterdam in 1639, and which also went into the Lopez collection, gave Rembrandt further ideas for the form of his self-portrait. Like the two Italian examples, his self-portrait of 1640 is based on a triangle, one of the fundamental forms of Renaissance painting. Rembrandt, however, in accordance with the Baroque ideal, introduces a strong diagonal, which is missing completely in the Raphael; this diagonal is indicated by the light areas of the head, shirt and hand, thus making the image less static.

One of Rembrandt's most famous and most discussed portraits is that of Cornelis Claesz. Anslo, a preacher of the Baptist community in Waterland (Berlin–Dahlem, Gemäldegalerie, Bredius/Gerson 409, illustration pp. 91, 92–93). Anslo, who lived from 1592 to 1646, also published a number of writings on theological subjects. There is also an etched portrait of the preacher by Rembrandt, also dated 1641 (Bartsch 271), for which two drawings exist in Rembrandt's hand, both dated 1640 (Benesch 758 and 759). The painting, particularly lively in its effect, falls into two parts compositionally. On the left of the work is the table, placed diagonally in space, on which can be seen the oft-recurring still-life of books with a snuffed-out candle. To the right can be seen Cornelis Anslo himself, still wearing his hat as he talks; his wife sits to his right, listening attentively. As in the case of Dr Tulp (p. 37), Anslo is represented here in a dual capacity: the still-life of books alludes to his learned writings, and to the *vanitas* symbolism, while Anslo himself is represented as a servant of the Word, an aspect emphasized by the representation of his wife as she listens quietly. The configuration of the painting, then, is very much an expression of Rembrandt's particular artistic concern: to achieve the maximum range of expressiveness through the attitudes and movements of his models.

According to a poem by a famous Amsterdam poet, Joost van den Vondel, Cornelius Anslo seems to have been a talented speaker:

On Kornelis Anslo
Rembrandt is the painter, Kornelis the voice.
What we can see are the least of his attributes.
Those that are unseen can only be appreciated through listening.
Whoever wants to see Anslo must hear him.

Emmens suggests that this verse refers to Rembrandt's etched portrait of Anslo. It seems probable that Rembrandt took up van den Vondel's challenge in his painting, and decided therefore to paint Anslo while speaking or, perhaps even more accurately, by painting Anslo's *speech*.

The painting which Rembrandt executed after the portrait of Anslo in 1642 was the world-famous *The Night Watch*. This work is the greatest attraction in the Rijksmuseum in Amsterdam. Indeed, the creation of this national museum of painting was in many ways bound up with this painting, since it was conceived partly as a means of resolving the violent controversy at the end of the nineteenth century among artists, critics and art historians as to how the canvas, measuring some fifteen square yards, should be hung.

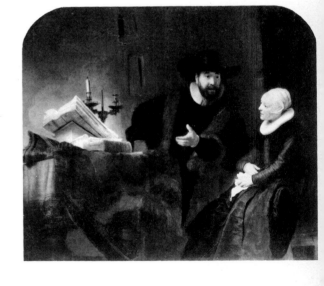

THE MENNONITE MINISTER CORNELIS CLAESZ. ANSLO WITH HIS WIFE
Oil on canvas; $67\frac{1}{4} \times 82\frac{3}{4}$ in (172×209 cm)
Signed and dated: Rembrandt f. 1641
Berlin, Staatliche Museen Preussischer Kulturbesitz, Gemäldegalerie (Br. 409)
The Mennonite minister, Cornelis Claesz. Anslo (1592–1646) was a well-known and popular preacher.
Pages 92–93: Detail.

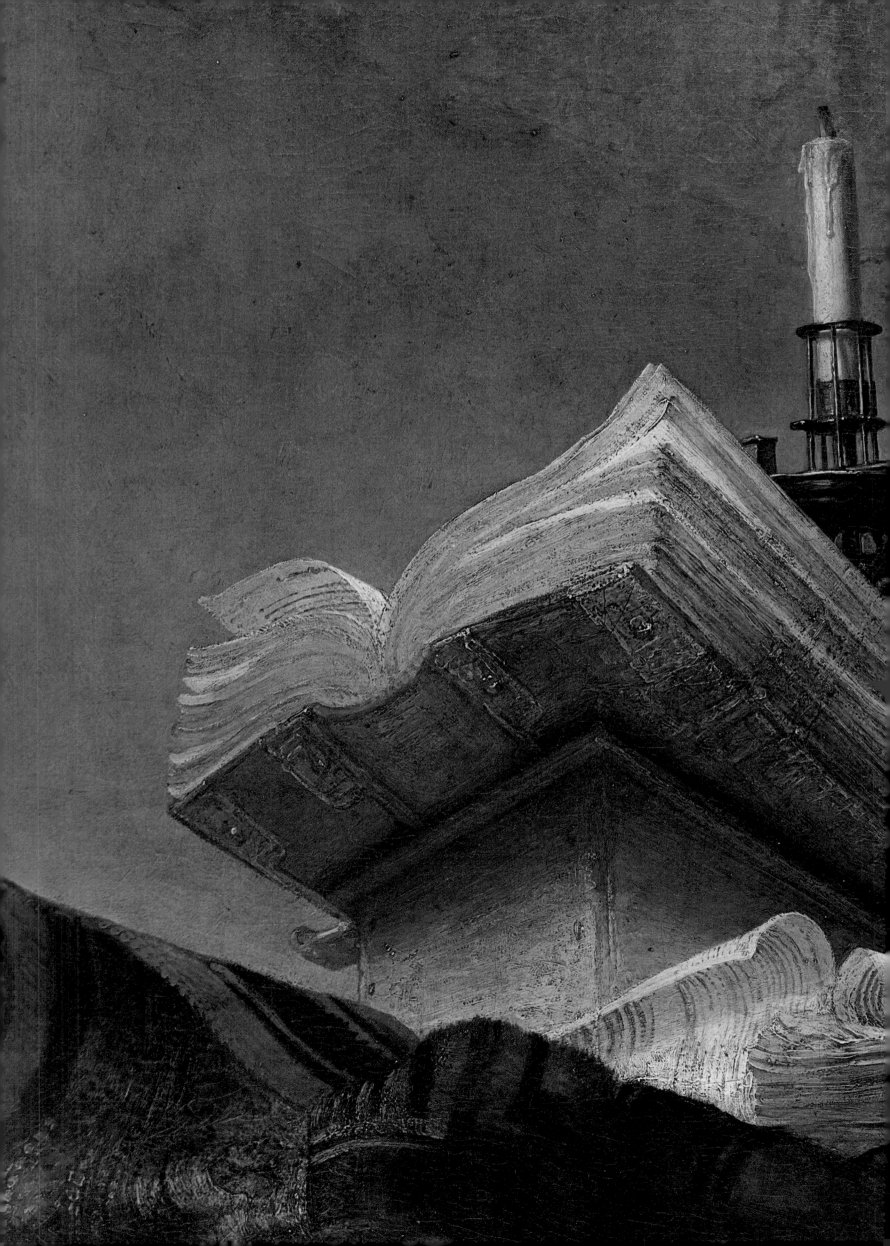

THE MILITIA COMPANY OF
CAPTAIN FRANS BANNING
COCQ ("THE NIGHT WATCH")
Oil on canvas; 143 × 172 in
(359 × 438 cm)
Signed and dated: Rembrandt f.
1642
Amsterdam, Rijksmuseum (Br. 410)
This painting was commissioned from
Rembrandt by the very same Captain
Banning Cocq who appears in the
center of the work, dressed in black
with a red sash. Next to him is his
lieutenant, Willem van Ruytenburgh.
The canvas was probably trimmed on
all four sides to pass it through a door
when it was transferred from the Civic
Guard Building to the Town Hall of
Amsterdam in 1715. Some idea of the
parts which were cut away can be
gained from a copy of the painting,
executed by Gerrit Lundens, and dis-
played in the Rijksmuseum, and from a
watercolor drawing by Rembrandt in
the family album of Captain Banning
Cocq. Both copies show that a large
strip on the left of the painting,
showing two male figures, and nar-
rower strips on the other three sides,
have been removed.

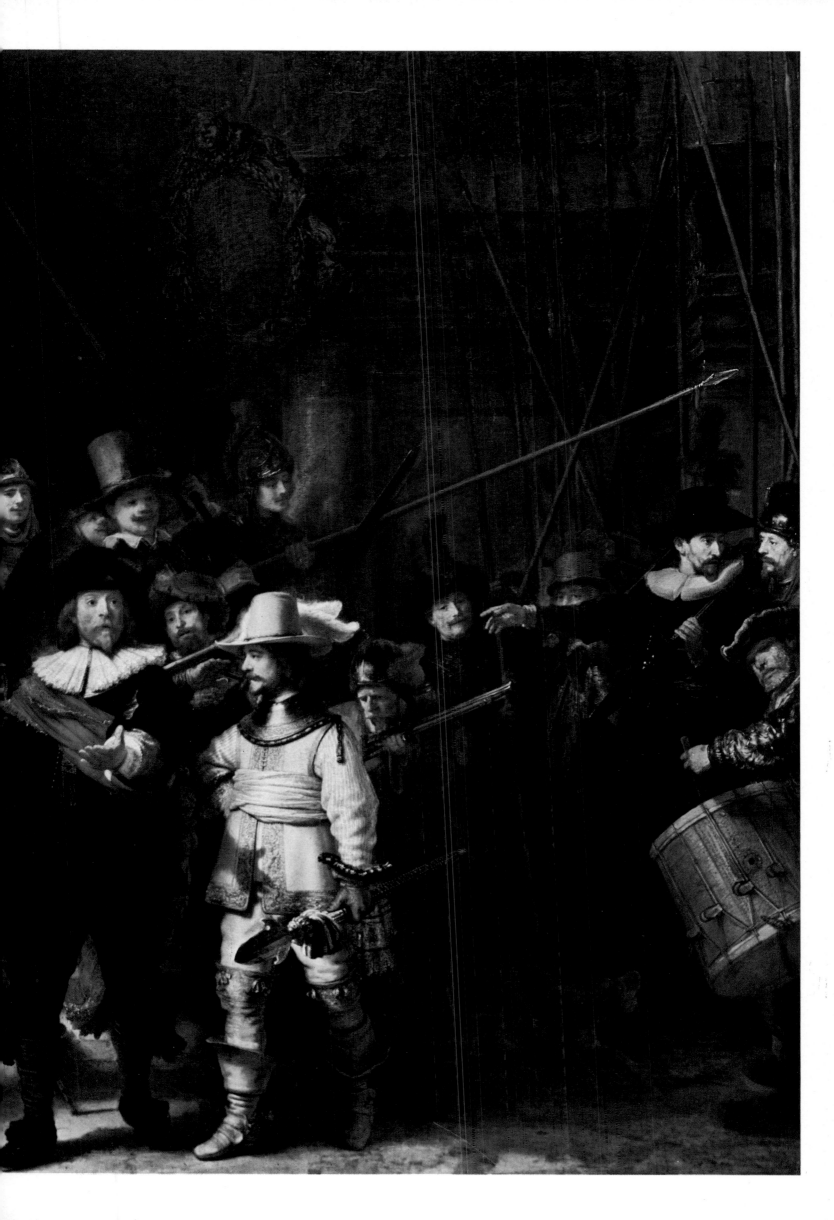

The Night Watch (Bredius/Gerson 410, illustration pp. 94–95) is a misleading title for this painting; it was first applied to the work in the nineteenth century when the colors had become considerably darker than they were really intended to be. It could also be concluded from this title that it was Rembrandt's intention to paint an anecdotal genre scene, in the style of the *cortegaardjes*, a popular subject in seventeenth-century Dutch painting. The term *cortegaardje* is a corruption of the French *corps de garde* and was used to refer to the genre scenes of soldiers in their guard-house or in the courtyards of their barracks. A genre painting usually implies that the human subjects are shown in a non-historical context, or, in the case of the present work, where man is represented in a generalized situation: soldiers in their usual occupations of weapon-maintenance and training, chatting, playing dice and drinking in the inner courtyard of their billets. Historical painting, as we have noted before, implies the placing of man in a non-recurring, historical or supposedly historical situation as, for instance, the militia company of Captain Frans Cocq readying themselves on January 15, 1641 to march to fight the besiegers of Amsterdam. There is also another category of painting to which this work could conceivably be thought to belong, that of the *schutterstuk*. This term refers to the group portraits of the civic guards formed in Dutch towns during the Wars of Independence. The group or, in some cases, the individual, may be shown with various attributes which characterize its members either as individuals or as a group, but is never shown in a generalized or historical situation.

Rembrandt's contribution to the tradition of the group-portrait was revolutionary: he dissolved the group. The military group-portrait still remained distinctly a group portrait in the work of the famous Haarlem

THE THREE TREES
Engraving; $8\frac{1}{4} \times 11$ in (21.1×23 cm)
Signed and dated: Rembrandt f.
1643
(Benesch 212)

painter, Frans Hals, whose paintings of this type still showed homogeneous groups of military men. The group, however, in Rembrandt's hands, becomes compositionally broken and loses the overriding sense of order. The soldiers no longer look as if they are carefully posed. It is true that Hals managed to achieve considerable effects of liveliness and variety in the poses of his subjects, but they still remain subject to their placing within the group – each portrait clearly visible, as was thought fitting – which inevitably creates a static effect. Rembrandt certainly catches Banning Cocq's company in a representative enough scene, but at the same time he manages to introduce the effects of liveliness, movement and even surprise.

It seems fairly certain that Rembrandt was influenced by the theater in this work. Rembrandt attended a number of performances of the play *Gysbrecht van Aemstel*, by the seventeenth-century poet Joost van den Vondel, at the theater in Amsterdam, which had been built a few years before Rembrandt painted *The Night Watch*. A series of drawings of characters from this play in Rembrandt's hand show what a keen interest he took in these performances. And it is thought that the opening scene of the play, in which Gybrecht introduces the events which are to follow, is the model for *The Night Watch*.

The painting shows the militia company of Captain Frans Banning Cocq, which was one of the volunteer companies of Amsterdam burghers which, with the mercenary armies, occupied a very special place in the military system of the seventeenth century. Rembrandt shows this particular group of the civil guard engaged in one of their habitual activities and one which therefore helps to define their status. The eloquent gesture of the leader's hand, in the center foreground, indicates that he is ordering his lieutenant, Willem van Ruytenburgh, to march on. In the background can be seen other members of the militia and a number of onlookers. In spite of the overwhelming number of movements depicted in the painting, each figure seems to occupy a very definite position within the composition. The depicting of the disorderly scene is perhaps made more convincing by the fact that the lance and the flag point in opposite directions. In contrast to the figures of Banning Cocq and Ruytenburgh in the foreground, there are figures in the middle ground who appear to be trotting forwards, while the small boy on the left has actually broken into a run, thus creating direct contact with the onlooker. A similar effect is achieved by Banning Cocq's outstretched hand. In spite of the disorder among the figures in the background and the forward movement of the two officers at the front of the group, our actual experience of the movement within the picture is the reverse: Banning Cocq and his lieutenant form an island of rest and order in the middle of the turbulence. The implication is that these two men will soon impose order on the disorganized confusion behind them.

The company is standing in front of one of the gates of the town, which is barely visible in the gloom of the background; it is not, in any case, an exact reproduction of any of the town gates of Amsterdam. Advocates of the "theater theory" consider this vague shape at the back of the composition as a suggestion of the monumental throne which was situated in the center of the backdrop of the Amsterdam stage. Whatever is intended, the background is effectively closed off, again emphasizing the forward movement of the group. Although the sources of light are not visible, certain areas of the painting are strongly illuminated, defining its spatial structure.

The painting was once even larger than it is in its present state. Strips of the canvas on the left, and on the upper and lower margins, were removed when the painting was moved in 1715 from the Kloveniersdoelen – the meeting house of the civic militia, for whom it was originally painted – to the war council chamber of the town hall on the Dam. Only a narrow strip was removed from the bottom and top, but the painting originally included two more onlookers on the left and a section of bridge in which they are standing. This mutilation detracts considerably from the compositional arrangement of the painting. In an old copy of *The Night Watch* in its original state, which

BROKEN WILLOW ON A BANK
Drawing in pen, ink and wash
6½ × 5½ in (16.7 × 14.1 cm)
Recto of a sheet the *verso* of which is also drawn
Turin, Biblioteca Reale

has been attributed to Gerrit Lundens, and which is now on permanent loan from the National Gallery in London to the Amsterdam Rijksmuseum, it is possible to see that the spatial treatment of the group is much more satisfactory than in the present state of the work.

This group work was probably commissioned by Captain Frans Banning Cocq himself, who is here shown so prominently; he also probably bore the lion's share of the costs. Another interesting detail is that sixteen of the other guards portrayed paid sums of more or less one hundred florins, according to their position in the painting.

In addition to *The Night Watch*, five other *schutterstukken* decorated the large hall of the Klovenierdoelen, which is another reason for interpreting the work as a military group-portrait. The other works were executed during the period of 1638–1645. In one case, the portrait of Joachim van Sandrart, there is an iconographical reference to Marie de Medicis, dowager queen of France, who visited Amsterdam with great pomp in 1638. The Amsterdam civic militia played an important part in this event as a guard of honor. It is sometimes argued that all six *schutterstukken* in the Doelenzaal were commissioned to commemorate this celebrated event. If this was the case, it left few traces in Rembrandt's contribution to the series.

The painter and art theorist Samuel van Hoogstraten (1626–1678), himself a pupil of Rembrandt's, though not always disposed to be uncritical of his master, passed favorable judgement on *The Night Watch* in his *Inleyding tot de Hooge Schoole der Schilder Konst*, published in 1678. He refers to the painting as being "picturesque in thought," from which it must be understood that he thought Rembrandt had chosen an interpretation of the subject which could be best resolved in painterly terms. He also notes that

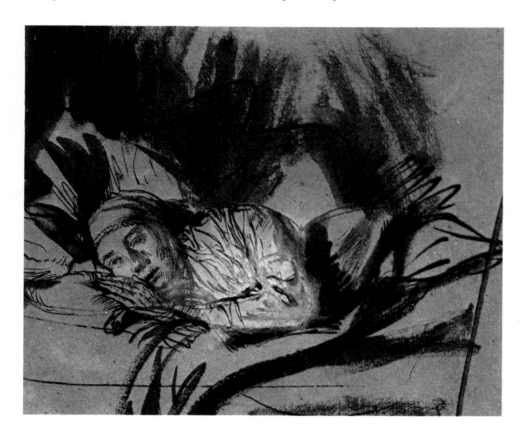

SASKIA ILL
Watercolor drawing
Paris, Petit Palais
(Benesch 283)

SASKIA (POSTHUMOUS PORTRAIT)
Oil on panel; $28\frac{1}{4} \times 23\frac{1}{4}$ in
(72 × 59 cm)
Signed: Rembrandt f. 1643
Berlin, Staatliche Museen (Br. 109)
Preussischer Kulturbesitz, Gemäldegalerie
This portrait was painted by Rembrandt one year after the death of his wife.

Rembrandt was "elegant in his movement," which probably refers not only to movement, but also the ingenious and apparently careless way in which the various figures are disposed in space. Hoogstraten finally summed the painting up as being "so powerful, that some found that the other group-portraits in the Doelenzaal which hung next to it looked like playing cards." This was great praise indeed, although Hoogstraat would have liked the painting even more if there had been more light in it.

In the various seventeenth-century documents which refer to *The Night*

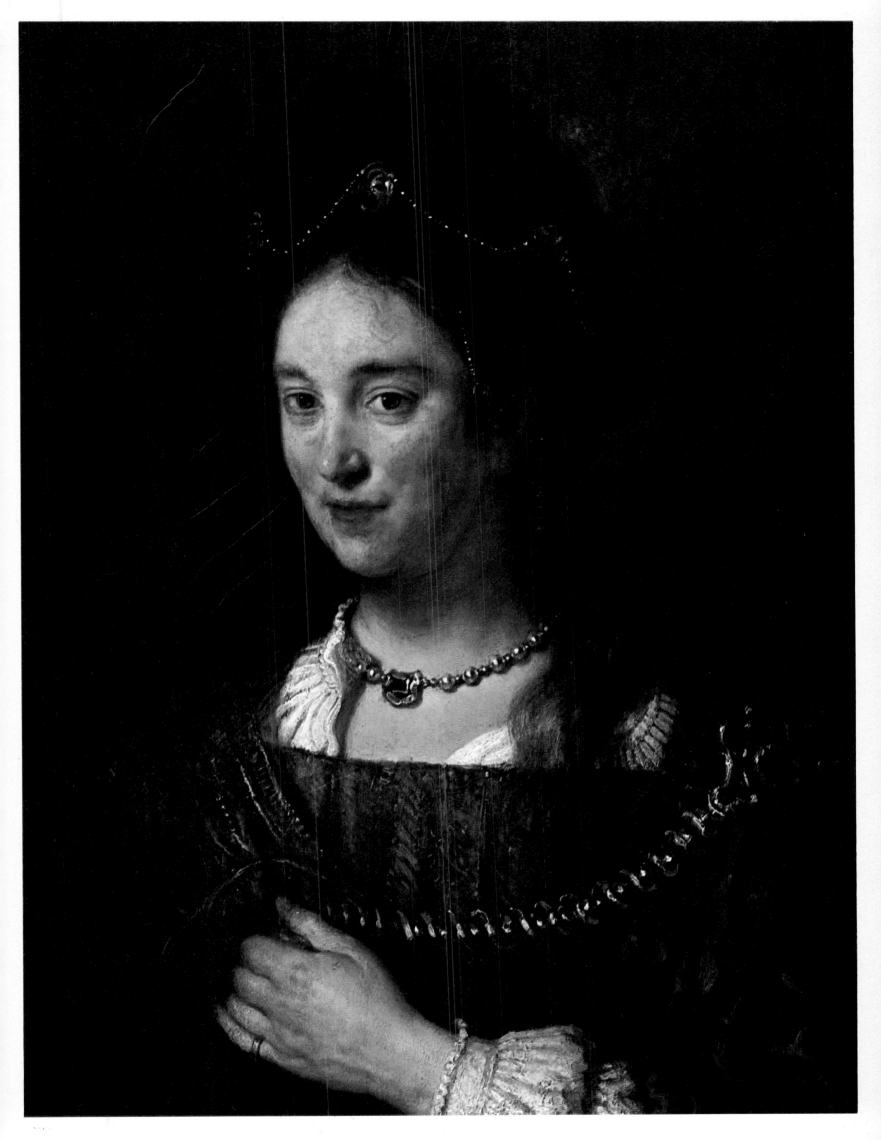

Watch, there is no indication that it was ever thought of as a genre scene. Discussion is confined, on the contrary, to the people represented and the actions which go with their status. The *schutterstuk* was originally usually painted in the form of rows of heads and busts arranged next to each other. In the second half of the sixteenth century the first full-length military group-portraits were painted, and from then on there was a constant process of development towards treating the group in a more lively fashion and towards using space more freely.

If it is necessary to sum up *The Night Watch* in a few words, it should be remembered that it is first and foremost a *schutterstuk*. The thought uppermost in Rembrandt's mind must have been how to represent the militia company of Captain Frans Banning Cocq as though in the performance of a great feat of arms in the history of Amsterdam, that of Gysbrecht van Aemstel, which had again been made topical by Vondel. The painting can thus be described as a military group-portrait masquerading as a historical work.

The Second Period in Amsterdam

The great sense of liveliness which Rembrandt succeeded in bringing to his treatment of the separate figures and to the composition as a whole in *The Night Watch* can be taken to represent the culmination of the development of his style during the first Amsterdam period. However, there were already certain elements present in his style at this time which were to develop further during the following years. If there is a new departure in Rembrandt's work at about this time, it probably resulted from his thorough study of classical relief work, Italian art and renewed interest in the work of Pieter Lastman. There is already an element of *haut relief* in the spatial conception of *The Night Watch*: the background is closed off behind the civic guard from which the pair of Banning Cocq and Ruytenburgh detach themselves. The diagonals which tend to delimit space in the work done during the 1630s, and which are still present in the immediate foreground and the middle ground of *The Night Watch*, become less prominent during the 1640s and 1650s. The representation of detail also begins to take second place to a more subtle use of chiaroscuro, increasing the evocative qualities of the paintings.

In addition to the paintings, Rembrandt also executed a large number of drawings during this period, both as studies and also as independent works of art, destined for sale. The first group, the studies, were usually observed from life and then later drawn in the studio: street scenes, figures from the artist's immediate environment, both inside and outside the house. Rembrandt drew outside, as opposed to in the studio, many landscapes around Amsterdam during the early 1640s. He also began to do more etchings during this period. After painting, etching is one of the most direct ways for the artist to record an observed situation; it is in fact fairly easy to sketch sensitively with the etching needle on the copper etching plate without applying too much pressure. When the copper plate is immersed in acid, the acid eats away the plate where the needle has scratched through the layer of acid-resistant varnish or wax with which the plate is covered. A print from the plate will thus present a mirror image of the original. It is also possible to work directly on to the plate without first covering it with the layer of wax; this process is called dry-point and was often used by Rembrandt. The burr of the groove made by the needle on the plate retains the ink and produces great subtlety of line and texture. If a plate is reworked several times, and each time more prints are pulled from it, then these different editions are referred to as states of an etching.

The etching, *The Three Trees* (Benesch 212; illustration p. 96), signed and dated 1643, was made both with a dry-point needle and a normal etching

CHRIST AND THE WOMAN TAKEN IN ADULTERY
Oil on panel; $33 \times 25\frac{3}{4}$ in
(83.8×64.5 cm)
Signed and dated: Rembrandt f. 1644
London, National Gallery (Br. 566)
Acquired in 1864.

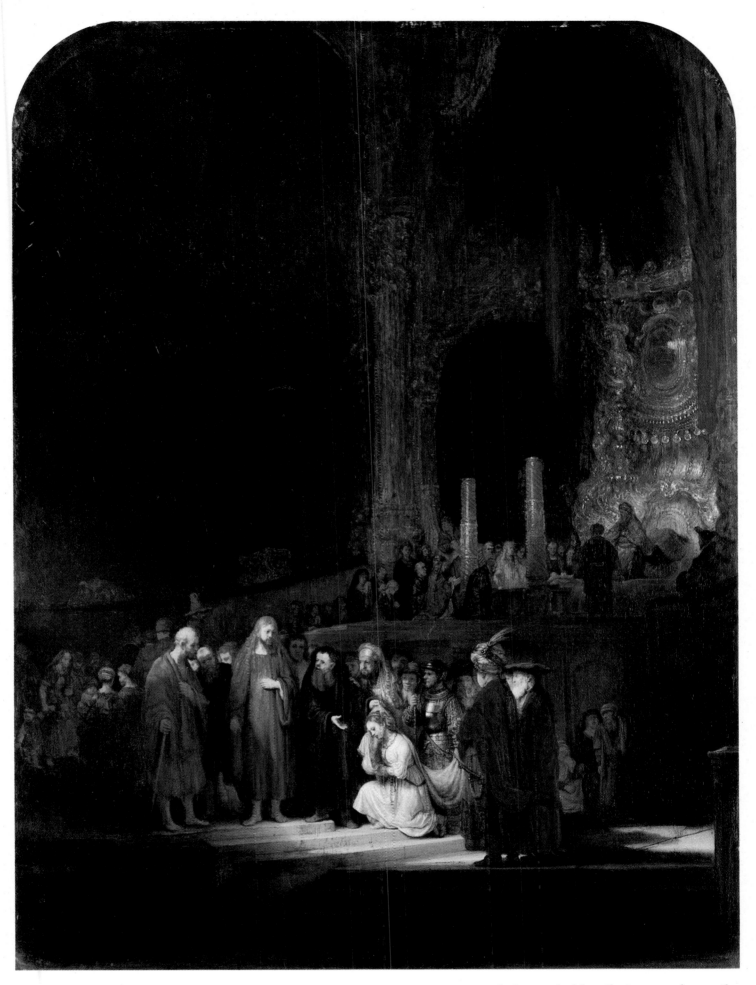

needle. The landscape represented is probably that seen from the Diemerdijk, or somewhere close by, in the neighborhood of Amsterdam. The topographical aspect however, remains of secondary importance to the dramatic expressiveness of the scene. This dramatic effect is created by the contrast between the flat land to the left of the work, and the isolated group of trees on higher ground, which appear darkly outlined against the light horizon of the expanse of sky, on the right. The disorder of the clouds in the

left center of the sky is very lightly etched and therefore evokes an impression of great space. The harder, darker diagonals, executed with the etching needle, in the top left-hand corner and the dark area towards the upper edge of the etching, are often taken to represent an approaching thunderstorm, strengthening the atmospheric effects of the background space. Rembrandt is here experimenting with the representation of movements of air, just as Leonardo da Vinci had done a century earlier for the whirling movements of water in his drawings of the *Deluge*.

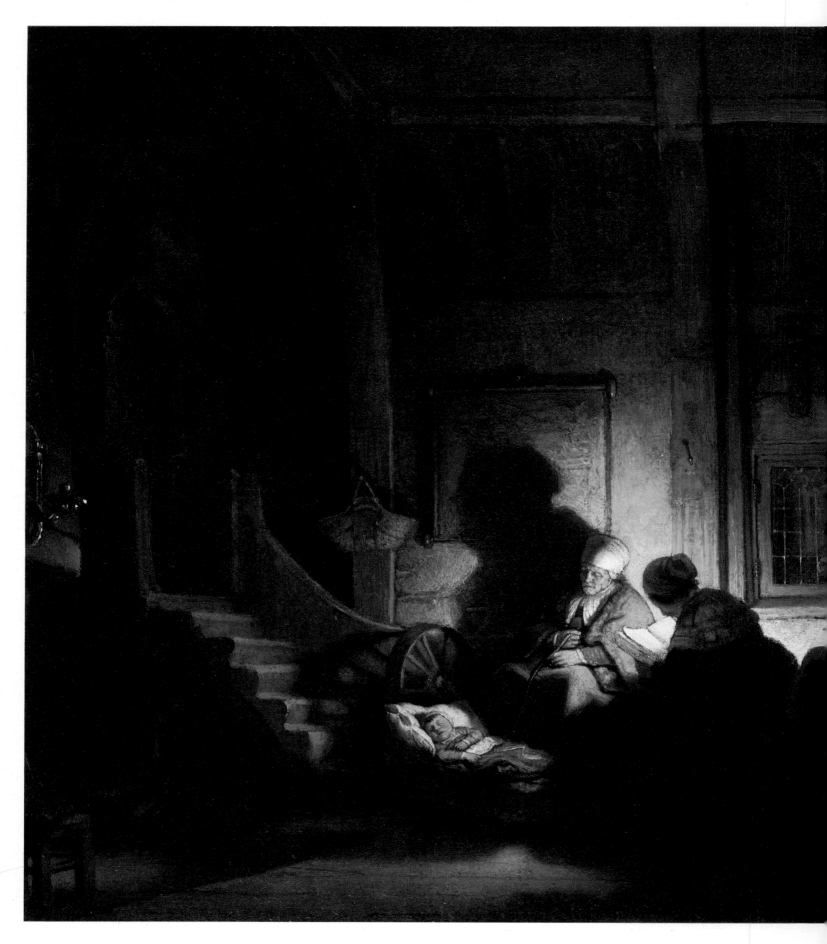

THE HOLY FAMILY
Oil on panel; 23½ × 30¼ in
(60 × 77 cm)
1638–1646
Amsterdam, Rijksmuseum (Br. 568)
Dating and authenticity are uncertain.

In the landscape of *The Three Trees*, a small group of figures is shown in the left foreground; they appear somehow carefree and almost form an organic part of the landscape. Rembrandt seems here to be showing the grandeur of nature and also to be making the point that man and his pursuits are an essential part of it, no matter how small. This kind of appreciation of the great world of nature was to become central to nineteenth-century Romantic landscape painting, which is perhaps why this etching was often copied poetically by Byron, the greatest Romantic of them all.

Apart from landscape, Rembrandt also found that most of what went on around him provided subject-matter for his drawings. Almost any scene from daily life could be used in the paintings of biblical scenes, since the actions and people were similar, although in a different context.

How ill, for instance, Saskia looks in bed, as we see her represented in a quick, direct sketch (Benesch 283, illustration p. 98). This drawing also has a biographical importance for us, apart from its aesthetic aspect. For Rembrandt the sketch must have also had another, practical function: a sick (or old) person lying in bed occurs frequently in the biblical subjects.

The portrait of a woman of 1643 is often considered to be a *Posthumous Portrait of Saskia* (Berlin–Dahlem, Gemäldegalerie, Bredius/Gerson 109, illustration p. 99). By 1643, however, Geertje Dircx had already been in the Rembrandt household for some time as a nurse for Titus, who was born in 1641, and she had also probably been known to Rembrandt as a friend. It is surprising that we do not know what she looked like, apart from a description of her by Houbraken as "somewhat small in person, with a fine countenance, and plump." In the traditional view of Rembrandt's life, Geertje's role was almost entirely an unpleasant one, while the painter is seen to have remained faithful to Saskia, which would certainly explain why Rembrandt never painted a portrait of Geertje. There are, however, a large number of portraits of women which have not been identified, and it is thought that a large number of these do in fact represent Saskia; closer investigation, however, frequently reveals that they are of someone else. An example of this kind of reappraisal happened in the case of the portrait of Maria Trip, discussed above (p. 81), which was also thought at one time to represent Saskia. The identification of the subjects of portraits is a difficult, sometimes impossible, task, since there is frequently no real starting point to such an investigation. In the case of the posthumous portrait of Saskia, Vis suggests that the painting originally represented Geertje, but that Rembrandt, because of the unpleasant circumstances of his separation from Geertje, later painted over it as to render it unrecognizable. This would also explain the fact that the structure of this portrait is relatively incoherent.

A year later, in 1644, Rembrandt painted *Christ and the Woman Taken in Adultery* (London, National Gallery, Bredius/Gerson 566, illustration p. 101). The theme is taken from John 8, 3–12: "And the scribes and the Pharisees brought unto him a woman taken in adultery; and when they had set her in the midst,

"They say unto him, Master, this woman was taken in adultery, in the very act.

"Now Moses in the law commanded us, that such should be stoned: but what sayest thou?

"This they said, tempting him, that they might have to accuse him. But Jesus stooped down, and with his finger wrote on the ground, as though he heard them not.

"So when they continued asking him, he lifted up himself, and said unto them, He that is without sin among you, let him first cast a stone at her.

"And again he stooped down, and wrote on the ground.

"And they which heard it, being convicted by their own conscience, went out one by one, beginning at the eldest, even unto the last: and Jesus was left alone, and the woman standing in the midst.

"When Jesus had lifted up himself, and saw none but the woman, he said unto her, Woman, where are those thine accusers? hath no man condemned thee?

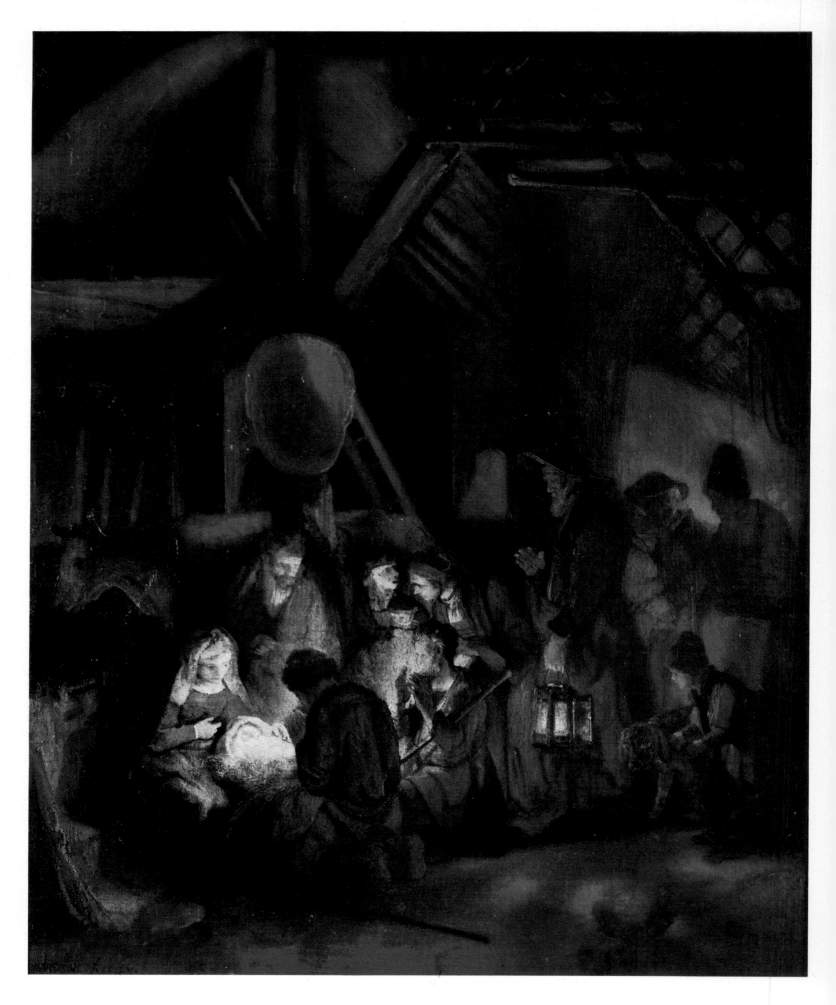

"She said, No man, Lord. And Jesus said unto her, Neither do I condemn thee: go, and sin no more." This episode does not occur in the other Gospels.

This painting displays many stylistic similarities to the earlier *The Presentation of Jesus in the Temple* (p. 33), which Rembrandt painted while he was still in Leyden: in both cases, the area of main action is brightly illuminated, without any indication being given of the source of light, and

the architectural setting is also very similar. The painter's handling of space displays further similarities: in both paintings the main scene takes place in the middle ground, while the subsidiary scenes are relegated to the background on a raised level. In the later *Christ and the Woman Taken in Adultery* the diagonal movements, which are essential to the structure of *The Presentation in the Temple*, have largely disappeared and been replaced by a distinctly horizontal movement.

Both scenes in the later painting are represented separately on the canvas, a typical stylistic arrangement for this period of Rembrandt's work. The foreground is left completely empty and the events in the middle ground are given a relief-like quality by the use of many small figures. Two smaller groups can be distinguished within the main group: left is a group of bystanders and disciples, with Christ as the most important figure; on the right are the scribes and Pharisees. This latter sub-group also includes the woman taken in adultery, who is brightly illuminated and the greatest center of attention. The figure clad in a dark gown, and especially his outstretched right hand, acts as a link between these two very different groups. The grouping is closed off on the right by the figures who are seen half from the back. The direction of the action gathers momentum from the right, moving leftwards from the kneeling woman towards Christ.

On the raised level in the background can be seen a number of people kneeling before the high priest who, unlike Christ, is placed apart and looks down from richly decorated, almost altar-like, surroundings. The eye is led from left to right, from the group towards the high priest, thus forming a further contrast with the positioning of the Christ group. Apart from these differences, however, the scenes are similar to each other in many respects. Firstly they are represented parallel on the plane of the canvas; secondly, both groups show a spiritual leader with the faithful and other onlookers.

The two groups, then, are formally related, but the contrast between the values which each implies could not be greater in a single painting. It is

THE ADORATION OF THE
SHEPHERDS
Oil on canvas; $25\frac{3}{4} \times 21\frac{5}{8}$ in (65.5×55 cm)
Signed and dated: Rembrandt. f. 1646
London, National Gallery (Br. 575)
Acquired in 1824.

WINTER LANDSCAPE WITH
SKATERS
Oil on panel; $6\frac{3}{4} \times 9$ in (17×23 cm)
Signed and dated: Rembrandt f. 1646
Kassel, Staatliche
Kunstsammlungen, Gemäldegalerie
(Br. 452)
Pages 106–107: Detail

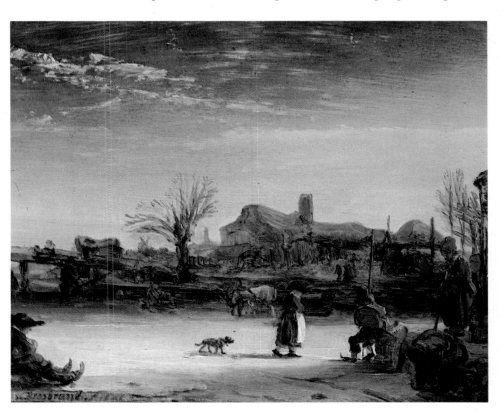

almost as if Rembrandt were trying to express the contradiction between the Christian faith as it appears in the New Testament and that of the Old. He thus raises the painting from the level of pure narrative and makes it the means of bringing home a more generalized point.

Rembrandt represents Christ realistically, as a man – though a good man – standing in the midst of the people, preparing to be helpful; the figure is

devoid of any Italianate, idealized quality, although he is immediately recognizable, standing out above the others, though barefoot. His clothing is hardly to be distinguished from that of his simply clad followers. Both through his choice of subject and his manner of presenting it, Rembrandt is here stressing the importance of Christian ethics and the good act as against the dogma of the divine origin and revelation of Christ. This unheroic, human Christ-type is characteristic of Rembrandt's work from the 1640s and is very much in keeping with the ideas of the Socinians and the Mennonites, whom Rembrandt almost certainly strongly favored.

The Holy Family (Amsterdam, Rijksmuseum, Bredius/Gerson 568, illustration pp. 102–103) is represented in the secure intimacy of a seventeenth-century interior in this undated painting. The various datings of this panel vary from 1638 to 1646, and there is some argument as to whether the work is in fact by Rembrandt. It has been noted, however, that the painting is in the style of Rembrandt's work of the 1640s, although it appears somewhat drier; the method of composition, however, with its use of chiaroscuro, makes it more similar to the work of the 1630s. These two aspects of the painting have caused some experts to attribute it to Nicolaes Maes, a pupil of Rembrandt. Many of the details of the interior do, however, occur in other paintings by Rembrandt, such as the cartwheel, which also appears in *Tobias Healing his Father's Blindness* of 1636 (Stuttgart, Staatsgalerie, Bredius/Gerson 502, not reproduced here) and in *The Homecoming of Tobias* (Rotterdam, Museum Boymans van Beuningen), which Gerson attributes to Gerrit Dou, another pupil of Rembrandt. The motif of the bag hanging on the wall in the background is also found in *Christ at Emmaus* of about 1628. The precision with which the details of the interior are painted is not found to this extent in Rembrandt's work from the 1640s onwards and would certainly tend to indicate some studio work.

A number of observations can also be made on the use of chiaroscuro. As is usual in Rembrandt's work, the source of light is not visible, but the light in this painting has a largely narrative function: it is needed for reading, but at the same time it inevitably creates shadow. Now Rembrandt does not normally use chiaroscuro in a narrative way: it need not indicate day or night. His application of it is, rather, fundamental to the sense of form in his paintings: what is represented is built up from a confrontation between light and dark, held in carefully determined balance.

The brush-work of *The Adoration of the Shepherds* (London, National Gallery, Bredius/Gerson 575, illustration p. 104) is very free indeed, almost sketchy. The painting can be divided roughly into two parts. In the foreground of the left-hand section can be seen Mary and Joseph with the Child, being worshipped by the shepherds; the Child radiates an intense light, which illuminates the immediate bystanders brightly; judging from his gestures, one of the shepherds is even blinded by it. On the right various figures are seen coming into the stable. The man in front, bearded and wearing a flat hat, carries a lantern and looks in the direction of the Child, as does the little boy on the right. The group of figures in the background, which includes a woman carrying a child in her arms, is illuminated by a light coming from outside the stable, and does not appear to be yet involved in the events taking place in the foreground.

The episode represented is the announcement of Christ's birth to the shepherds, their arrival and adoration of the Child, as it is described in Luke 2, 16–19: "And they came with haste, and found Mary, and Joseph, and the babe lying in a manger.

"And when they had seen it, they made known abroad the saying which was told them concerning this child.

"And all they that heard it wondered at those things which were told them by the shepherds."

A striking detail of this painting is that the one realistic source of light, the lantern in the hand of the standing man, casts only a feeble glimmer on the ground, compared to radiant light coming from the Child. This is possibly

DANAE
Oil on canvas; $72\frac{3}{4} \times 80$ in
(185×203 cm)
Signed and dated: Rembrandt f.
16(3)6

Leningrad, Hermitage (Br. 474)
Acquired from the Crozat de Thiers
collection for Catherine II of Russia.
Identified as Danaë by E. Banofsky.
Pages 110–111: Detail

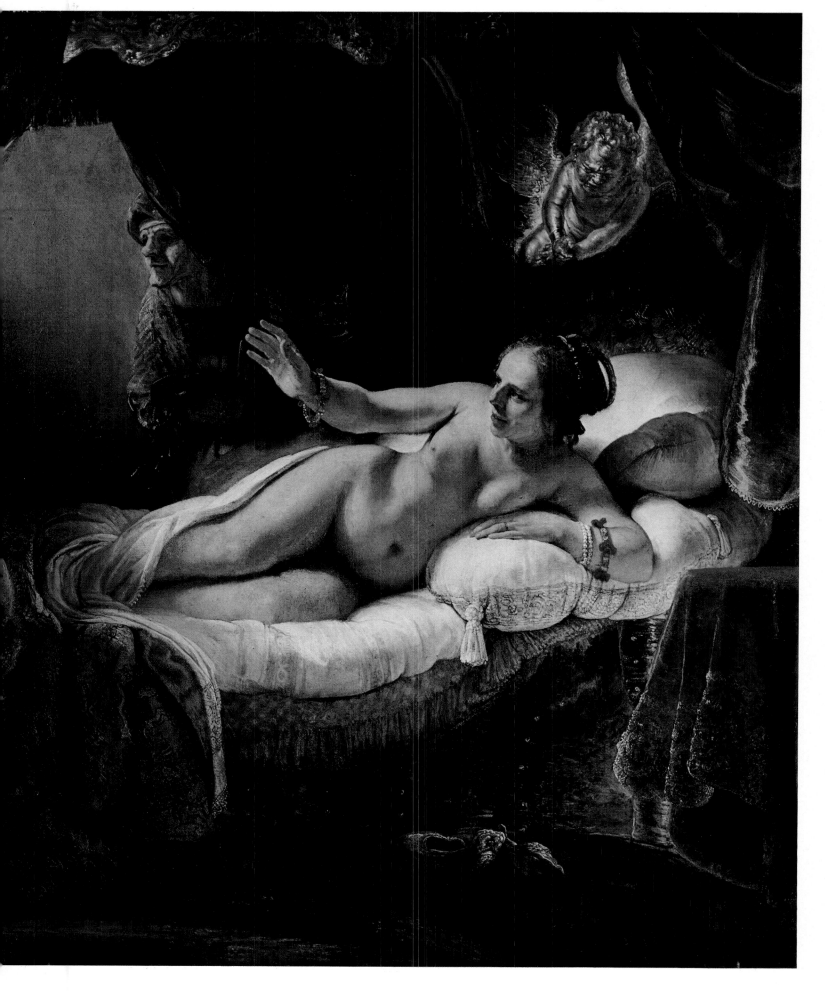

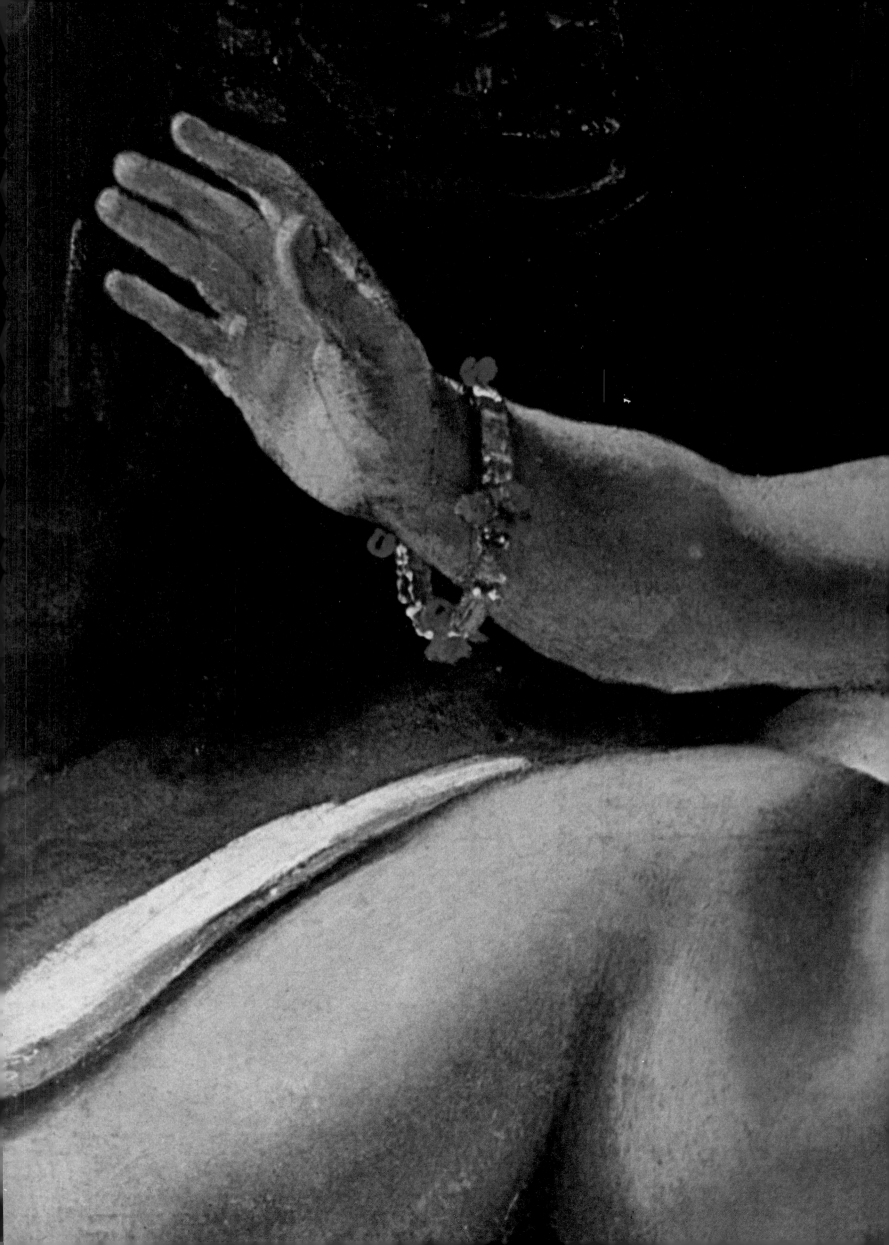

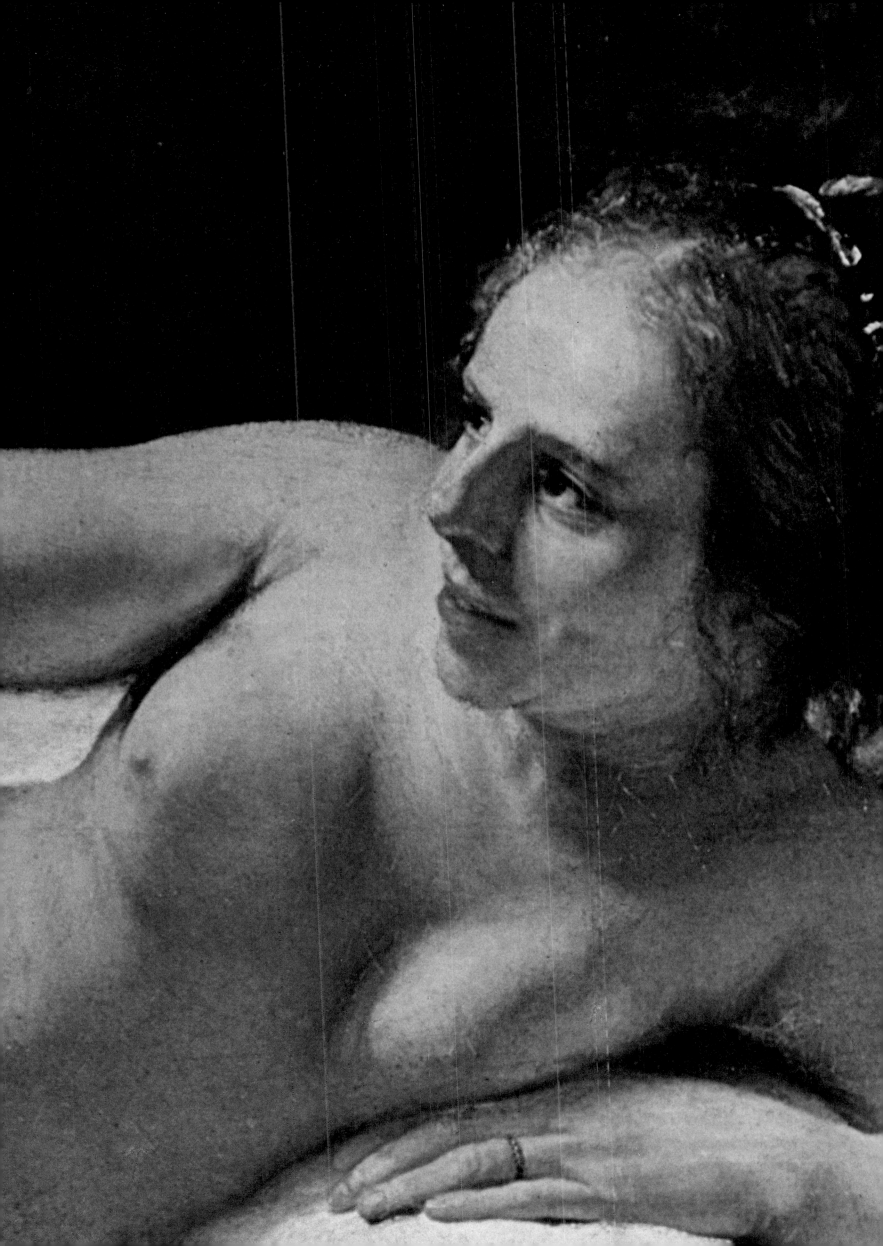

another reference to a New Testament text, in which the evengelist John reminisces about the coming of Christ: "That was the true light, which lighteth every man that cometh into the world." (John 1,9).

Another rather sketchily painted work, though stronger than *The Adoration of the Shepherds*, is the *Winter Landscape* (Kassel, Gemäldegalerie, Bredius/Gerson 452, illustration pp. 105, 106–107) which was also painted in 1646. The brushstrokes seem to have been applied quickly and fluently, as can be seen in the enlarged detail reproduced here. Yet it is in the very fluency of this sketch that Rembrandt's ability to create a tightly constructed painting is revealed. There is a great realism about the scene, and the rapid brush-strokes give an impression of immediacy, as though Rembrandt had painted from direct observation, although such a practice would have been unthinkable in the seventeenth century. Although drawings were executed outside before, it was not until the Impressionists of the latter half of the nineteenth century that painting from direct observation outside became current. The naturalistic effect in this painting is achieved by the fluent alternation of light and dark horizontal areas,

HENDRICKJE STOFFELS IN BED
Oil on canvas; 31 × 26½ in (80 × 66.5 cm)
Signed and dated:
Rembra . . . f. 164
. . .
Painted between 1645 and 1650
Edinburgh, National Gallery of Scotland (Br. 110)
Known also as "Sarah waiting for Tobias."

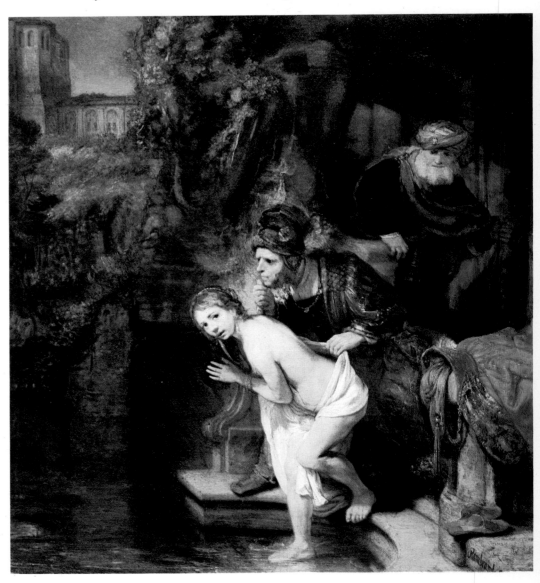

SUSANNA SURPRISED BY THE ELDERS
Detail
Oil on panel; 30 × 35¾ in (76 × 91 cm)
Signed and dated: Rembrandt f. 1647
Berlin, Staatliche Museen Preussischer Kulturbesitz, Gemäldegalerie (Br. 516)

between which, the small, vertical figures form linking elements. These figures have little to do with the situation observed, but are subtly made to serve strictly pictorial ends – so subtly, indeed, that they do impress us as being remarkably lifelike.

In form and color, the painting of *Danaë* (Leningrad, Hermitage, Bredius/Gerson 474, illustration pp. 109, 110–111) could be defined as Rembrandt's version of the classical Venetian nude. A naked woman, leaning relaxedly on her left arm, is represented parallel to the plane of the

canvas; the bed she is lying on, however, forms a diagonal in space. The tints are restricted to the browns, but there are so many gradations of tone, from gold-yellow to red-brown, that the effect is anything but monochromatic. The comparison with Venetian art ceases here; Rembrandt's rendering of the body indicates much more realistic ideals of beauty than was common among the Italian painters, who judged that proportions and appearance must ultimately be derived from the models of antiquity.

The woman is looking towards an opening in the draperies, which appears to the left of the painting; her hand and arm are raised in a gesture which anticipates the arrival of someone, anticipation which is also reflected in her facial expression. Behind her is an old woman, with a bunch of keys; she holds the curtain open in a gesture of invitation. Above the head of the main figure appears a golden, winged Cupid, indicating clearly that the woman is waiting for her lover. As is often the case with Rembrandt's paintings, this particular work has been interpreted in a variety of ways, classical and biblical. The reason for the constant doubt as to subject-matter is that Rembrandt rarely paints a story as a series of events, but rather chooses a moment of tension in a particular story, in which the relationship between God or the classical deities and man, or between man and man, is the real subject. It has been suggested, for instance, that this painting represents "Venus waiting for Mars." It has also been sugested that it shows a biblical scene in which a woman is waiting for a man, such as "Rachel waiting for Jacob," or "Sarah waiting for Abraham," etc. The presence of the winged Cupid, however, does tend to indicate that the subject is taken from classical mythology, and the most acceptable interpretation has been offered by E. Panovsky: that the woman represented is Danaë.

Legend tells how Acrisius, king of Argos in Greece, is warned by an oracle that the son of his daughter Danaë will kill him. In order to escape his destiny, he decides to imprison Danaë in a room made of bronze, so that no lover will be able to reach her. The ways of the gods, however, are not to be predicted, and Zeus, who had desired Danaë for some considerable time, descended on her as a shower of golden rain. Thus she came to bear a son, Perseus, who fulfilled the prophecy by striking his grandfather Acrisius with a discus thrown at some festive games; there is no escape from destiny.

The story of Danaë has been a frequent subject for painters. An essential part of the representation is, however, the golden rain, which makes the subject immediately recognizable. The figure of the woman in Rembrandt's painting is certainly in keeping with this pictorial tradition, but he has dropped the golden rain and replaced it by a golden light and the anticipatory expression of Danaë. The Cupid imprisoned would symbolize her forced and unnatural chastity.

The painting was commenced around 1636, but underwent some modifications probably around 1645, especially to the actual figure of Danaë, which have been revealed by X-ray photography. The first version showed her gazing rather more upwards, a typical pose for Danaë. Indeed, the changes make it much more difficult to identify the subject of the work. Danaë's face bears some resemblance to those portraits which are generally accepted as being of Hendrikje Stoffels, Rembrandt's third wife, although there is no documentary evidence to support this theory. Hendrickje came into Rembrandt's life in 1646 and remained with him until her death. She was probably also the model for the genre painting *Hendrickje Stoffels in Bed* (Edinburgh, National Gallery of Scotland, Bredius/Gerson 110, illustration p. 112), which shows a woman holding the curtain of a bed open with one arm, which Rembrandt painted at the end of the 1640s. The subject of the painting is simple enough and probably does not represent any special historical event or situation. Rembrandt painted a number of genre paintings in this fashion as, for instance, figures at doorways or at windows. It is especially in such paintings, where the attention is not distracted by the contents, that Rembrandt's unique use of chiaroscuro can be best appreciated. This is particularly important in the later work, where the

STUDY FOR SUSANNA BATHING
Drawing in pen and ink
Dresden, Staatliche Kunstsammlungen, Kupferstichkabinett.

painter no longer uses it simply as a formal mechanism, but also uses it to define atmosphere or character. The image of Henrickje Stoffels, emerging from the darkened bed, actually seems to come alive where the dark meets the light. The source of light is at the front, outside the confines of the painting; gradually it flows into the darkness, somehow giving the body of the subject volume, making it almost tangible through the gradations of light. This gradation of color, with the positioning of the figure in space, makes this a particularly intimate and sensitive painting.

Susanna Surprised by the Elders is the subject of a painting which Rembrandt executed in 1647 (Berlin–Dahlem, Gemäldegalerie, Bredius/Gerson 516, illustration p. 112). The human drama takes place against a background of grandiose architecture, which resembles the backgrounds of some of Elsheimer's paintings, and luxuriant brushwood. Susanna, the wife of Joachim of Babylonia and the daughter of Chelkias, was a beautiful and devout woman. One day she went, as was her habit, to bathe in her garden, first sending her two maids back to fetch soap. Two elders, or judges, who were both in love with her, had hidden in the garden, and now made scandalous propositions to her, threatening that, if she refused to do their bidding, they would accuse her of adultery. Susanna refuses, saying she would rather die. The elders then accuse her publicly, and falsely, of adultery with a young man. Susanna is subsequently condemned to death. However, she cries out her innocence to the Lord, who hears her voice and intervenes through the prophet Daniel. The latter questions the judges closely and reveals the false accusation. The elders are condemned to death, and the father and the husband of Susanna praise the Lord.

The half-naked Susanna stands slightly to the right of the center in the foreground of the painting, one foot already in the water. One of the men is standing just behind her, clutching eagerly at her clothing, while the other comes running in the background. Susanna looks up towards the onlooker, thereby involving us in her plight.

This painting was done in two phases. The first version was probably done around 1637, and Rembrandt added another layer on top of it in 1647, as appears from the dating. X-ray photographs have revealed that the second layer was painted over the original one. The earlier painting of Susanna being surprised, discussed earlier, in which the elders are not represented, can be considered as a study for the later version. Susanna's position is slightly altered, but is almost identical. The painting on the same theme by Pieter Lastman, now in Berlin, was also probably a strong inspiration for Rembrandt's later work.

The two works have much in common and Rembrandt even made a signed copy of the painting by his former master (Benesch 448). There is also another version of the story in a drawing by Rembrandt (Benesch 592). In spite of similarities in the treatment of the figure of Susanna, the version of 1647 is very different from that painted ten years earlier. One of the greatest differences is that the elders are represented in the later work, and Susanna, looking up, seems almost more surprised by our spying on her, than by the attentions of the elders. The more mature use of chiaroscuro, especially in the figure of Susanna, makes this later painting a far more evocative work.

The range of biblical subjects in Rembrandt's work is very great, but a number of themes, including that of Susanna surprised, seem to have interested him so much that he returned to them repeatedly, though with long intervals between each version. Another such subject is *Christ at Emmaus*. Around 1628, Rembrandt created a masterly, impressive image for this revelation. In 1648, twenty years later, he took up the theme again and painted two slightly differing versions, one of which is reproduced here (Paris, Louvre, Bredius/Gerson 578, illustration p. 115). If one compares the *Christ at Emmaus* reproduced here with the treatment of 1628, it becomes obvious how far Rembrandt's style and ideas had evolved during the intervening twenty years. The dynamic expressiveness which characterizes the work of 1628, and which is largely due to the strong diagonals in the

CHRIST AT EMMAUS
Oil on panel; $26\frac{3}{4} \times 25\frac{1}{2}$ in (68 × 65 cm)
Signed and dated: Rembrandt f. 1648
Paris, Louvre (Br. 578)

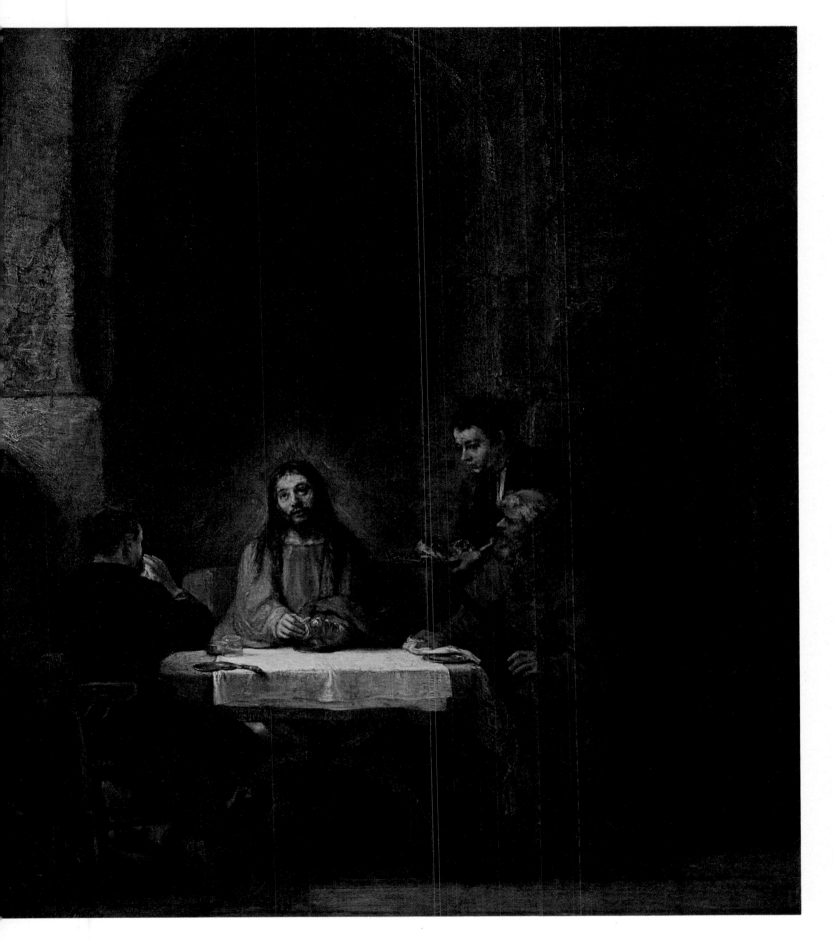

structure of the composition and the use of chiaroscuro particularly rich in contrasts to suggest space, is not to be found in the version of 1648. The amazing inventiveness of this latter painting can only be revealed through a close analysis of it.

The spatial structure is typical of Rembrandt's family portraits of his middle period. The immediate foreground is empty and left open. The main action of the painting takes place in the middle ground, parallel to the plane of the picture. We are shown four people around a rectangular table, one of

whom is standing, leaving three seated. The two disciples are seated on either side of the table, each reacting differently to Christ, who is seen frontally behind the table. The landlord, who is bringing in the food, does not seem to notice anything special in the scene. The disciple in the left foreground is clad in dark clothes; his back is half-turned towards us and his profile is only just visible. The onlooker's eye movement starts with him and moves towards Christ, who is breaking the bread. Jesus is seen frontally, seated slightly to the left of the axis of the table; he holds his head slightly to the left of the axis of his body. A vague trace of an aureole can be discerned around his head. The eyes then move, via the standing figure, to the other seated disciple, who is more lightly clothed; he is bearded and seen three-quarters on. His position brings our attention down to his hands, and back again to Christ. Apart from this self-contained group, Rembrandt fills in very few other details in the painting, thus providing no distraction. On the contrary, all the elements of the work go to support the formal group around the table, where all attention is drawn to the figure of Christ. The perspective at the back of the painting is closed off by a wall, which hints at monumental architecture in the vertical columns and the dark niche behind Christ. This simple, semi-circular niche, slightly to the left of the center of the group, but immediately behind Christ, emphasizes again the importance of the great simplicity of his figure, and also picks up the semi-circular form of the table legs. This asymmetrical form, found throughout the painting, determines the structure of the total image: it makes the situation immediately recognizable for what it is, yet also makes it somehow of great importance and mystery. This effect is further supported by the subtle use of chiaroscuro, which produces here an elegiac mood, in contrast to the violently contrasting effects of twenty years before.

Figures sitting or standing near a window was a favorite and oft-recurring image in Rembrandt's work; he used it especially in the etched portraits of the period. One etching dating from 1647 is *Jan Six (1618–1700) Standing Reading near a Window* (Bartsch 285, illustration pp. 116, 118–119). A panegyric on this etching by J. Lescaille was published in 1660.

In contrast to the customarily rather solemn image of the full-length portrait, Rembrandt gives his subject a lively, genre aspect. Jan is standing in an easy, perhaps characteristic attitude in his library, reading by the light from a window. The books and the swords lying casually on chairs are not there by accident: they refer to the rank, position and activities of the man depicted. Six was in fact a prosperous, cultivated Amsterdam merchant, greatly respected, and with whom Rembrandt probably maintained a close connection after 1641. The grandfather of Six had built up a large textile business, from which the Jan Six portrayed reaped the benefits. He was married to Margareta Tulp, the daughter of the anatomist Dr Nicolaes Tulp, whom Rembrandt portrayed in 1632. In 1652 Six retired from his business to devote himself to his hobbies, collecting works of art and writing poetry, as well as carrying out administrative duties. In 1659, for example, he became commissioner of maritime affairs for Amsterdam, and 1691 he became mayor of the city for one year. In short, he was a typical representative of the ruling class of seventeenth-century Amsterdam.

In 1648 Rembrandt produced one of his rare illustrations for a tragedy, *Medea*, written by Six (Benesch 112). In the inventory of 1656 of the content of Rembrandt's house, a copy of this work, *D'Medea by Jan Six, Tragedy*, was found among the art books. Further proofs of the friendship between Rembrandt and Six have also been preserved. In the family album "Pandora," Rembrandt did a drawing of *Homer, Reading his Verse* (Benesch 913), with the following dedication, "Rembrandt to Joannes Six, 1652." This was one of the first representations of the poet Homer in Rembrandt's work, and the Greek poet was to become a subject of fascination for the painter. In the same album, Rembrandt drew Six's mother, *Anna Wijnen, Sitting before a Window*, represented as Pallas Athene in her study (Benesch 914), also signed by Rembrandt f. 1652.

JAN SIX STANDING NEAR THE WINDOW
Etching; $9\frac{1}{2} \times 7\frac{1}{2}$ in (24.4 × 19.1 cm)
Signed and dated: Rembrandt f. 1647
Jan Six, a prominent figure of the Dutch upper classes and Mayor of Amsterdam for a short period, was probably a friend of Rembrandt's from 1641.
(Bartsch 285)
Pages 118–119: Detail

There is also a brilliant portrait of Jan Six, dating from 1654, in fact a painted knee-piece, for which Six himself composed a chronogram: "On my painting: *Aonidas qVI sUm tsar tenerIs Veneratus ab annIs | TaLIs ego IanUs SIXIUs ora tULI,*" which means, "I, Jan Six, who have honored the muses since childhood, had such a face." If the capital letters are read as Roman numerals and placed together, they give the year 1654.

Contact between the two men seems to have diminished after this date. It is possible that Six had begun to appreciate Rembrandt's work rather less, and that he now preferred the neo-classical style which was gathering momentum in the Netherlands. Another suggestion is that financial difficulty played its part in the break-up of the friendship. In a legal document of August 1, 1657 there is mention of a debt to Jan Six acknowledged by Rembrandt and then taken over by a third party. The actual acknowledgement of debt has never been found, but it is known that Rembrandt used to pay off debts sometimes with paintings.

The features of *The Man with the Golden Helmet* (Berlin–Dahlem, Gemäldegalerie, Bredius/Gerson 128, illustration p. 120) bear a certain resemblance to those of Rembrandt's brother, Adriaen; it is therefore generally accepted that Adriaen sat as a model for it, although he still lived in Leyden as a shoemaker. This work can be classed among the single-figure genre paintings, in which the figure is shown in a doorway or leaning out of a window. Like this type of painting discussed before, *The Man with the Golden Helmet* does not seem to allude to any event or subject outside itself. Chiaroscuro again plays a very important part: the figure comes to life in the surrounding darkness by the light cast from outside the painting itself. Thus, the space in front of the painting, in which we stand as onlookers, becomes part of the pictorial space. This effect is strengthened because the subject is looking at us. The direct relationship between the work of art and the spectator was, as we have seen above, first exploited by Caravaggio (d. 1610) and interpreted by Rembrandt in accordance with his own needs. In this painting the hard, material presence of the thickly painted, glistening helmet forms a visually interesting contrast to the fine texture of the plumes above it and the old, lined face beneath.

The painting *The River Landscape with Ruins* (Kassel, Gemäldegalerie, Bredius/Gerson 454, illustration pp. 121, 122–123) dates from about 1650. The landscapes of Rembrandt's middle period also show certain stylistic changes when compared with the landscapes of the 1630s, which were mainly intended to produce a dramatic effect. In contrast to many earlier works, this later landscape produces an effect of almost Arcadian peace: the river in the right foreground, and the ruin silhouetted in the background. Here too, the predominantly diagonal structure of the earlier work has been replaced by a structure of horizontal elements with vertical links to help the transition from one to the other. The areas of sky and land are approximately equal. The fact that the land element does seem larger can be explained by the profusion of different elements which catch the eye, in strict contrast to the light, almost cloudless, sky. The spectator's eyes are introduced to the landscape by the rider in the left foreground, are then drawn over the bridge to the middle ground, where there are further signs of human activity: the houses against the bridge, the boat, of which the image is reflected in the water. The lowered mast of the boat directs us towards the picturesque mills on the right. Our eyes then wander from the sails to the background, where the silhouette of the cypresses and a temple-like ruin appear against the light sky.

The light in the painting gives this landscape the quiet, meditative atmosphere appropriate to the peaceful transition from foreground to background. Like earlier works, however, there is little topographical exactitude here. Although the bridge recalls that near Ouderkerk and the boat and the mill seem to define the countryside as Dutch, the cypresses and the silhouette of the temple on the hilly background are Italianate elements, which came to play a decorative and spatially defining role in landscape

PORTRAIT OF JAN SIX
Oil on canvas
1654
Amsterdam, Collection Jhr. Six van Hillegom (Br. 276)

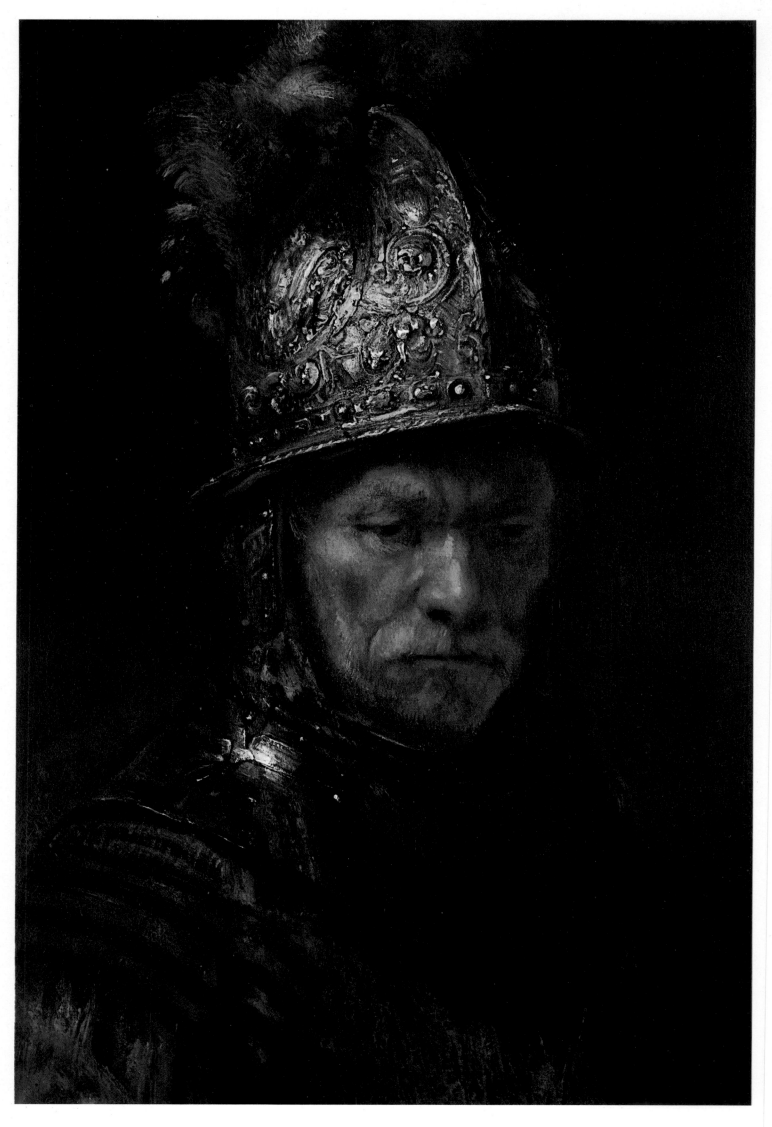

PORTRAIT OF THE JEWISH
PHYSICIAN EPHRAIM BUENO
Oil on panel; 7½ × 6 in (19 × 15 cm)
Circa 1647
Amsterdam, Rijksmuseum (Br. 252)
In the museum since 1948.
This small picture is a preliminary
study for an etching, dated 1647. E.
Bueno (1599–1665) was well known
both as a physician and as the author of
several works on Judaism.

"THE MAN WITH THE
GOLDEN HELMET"
Oil on canvas; 26½ × 19¾ in
(67 × 50 cm)
Circa 1648–1650
Berlin, Staatliche Museen
Preussischer Kulturbesitz,
Gemäldegalerie (Br. 128)

RIVER LANDSCAPE WITH
RUINS
Oil on panel; 26½ × 34½ in
(67 × 87.5 cm)
Signed: Rembrandt f.
Circa 1650
Kassel, Staatliche
Kunstsammlungen, Gemäldegalerie
(Br. 454)
Pages 122–123: Detail

painting after Elsheimer. Much more than defining a given place, Rembrandt is concerned with establishing the peaceful atmosphere which is so convincingly conveyed by this landscape.

Rembrandt maintained many, often intense, contacts with his Jewish fellow-citizens, and many of his portraits of them have been preserved. Dr Ephraim Bueno, whose Latin name was Bonus, was a physician and poet, and a prominent member of the Portuguese Jewish community, the Sephardic Jews, in Amsterdam. Rembrandt probably came to know him through his long friendship with the scholar, rabbi and publisher Manasse Ben Israel, who lived across the street from Rembrandt. Bueno also helped Manasse Ben Israel in his efforts to publish Jewish books. The oil sketch of Bueno (Amsterdam, Rijksmuseum, Bredius/Gerson 252 illustration p. 121) is directly related to the etching of 1647 (Benesch 278), where the scholar is represented in mirror image, his right hand supported by a handrail. In the painting, his left arm is rather out of proportion.

From 1630 Rembrandt had lived in the cheerful house on the Antoniebreestraat, or Jewish avenue, right in the heart of the Jewish quarter. He frequently used his Jewish neighbors as models, which he chose both from among the respectable Sephardic Jews and the less prosperous and socially evolved Askenazim, the Polish and German Jews. The results of these studies can be seen in the paintings, drawings and etchings.

The genre etching of 1648, reproduced here, is known as *The Synagogue* (Bartsch 126, illustration p. 124). This cannot, however, be the representation of an actual event, since Rembrandt places Polish and Portuguese Jews together in the same interior, while these two groups hardly ever went to the same synagogue for services.

It is remarkable that Rembrandt never depicted any specifically Jewish rituals, since these were already the subject of prints and illustrations.

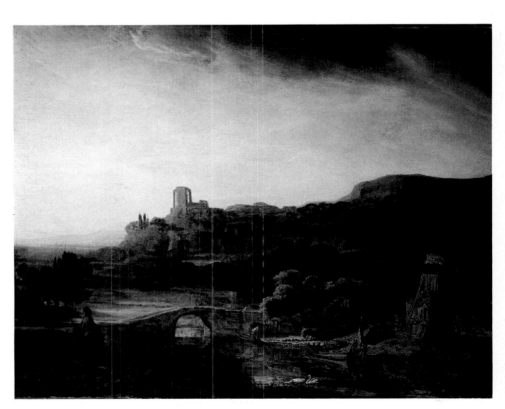

Rembrandt was not interested in the actual circumstances or the way of life of the Amsterdam Jews, but rather in their thoughts and their appearance. As a painter, he concentrated in the first place on finding suitable forms for his biblical works; these he found at hand in the daily life of the Jewish community, and in Jewish thought, which he began to know through Manasse Ben Israel. He was fascinated by the various Jewish types he came to know in his immediate environment, and noted their different manners.

He subsequently used these studies for the extensive range of characters from the Old and New Testaments, which appear in his works, to give them as much verisimilitude as possible.

A huge variety of these types are represented in the so-called *Hundred Guilder Print* (Bartsch 74, illustration p. 125). This elaborate but undated etching is one of the greatest achievements in Rembrandt's graphic work of his middle period, and even of the whole of his work. The etching was probably done, going on the evidence of its stylistic characteristics, between 1648 and 1650. This print had probably acquired its title in the seventeenth century, since it had already been sold for that high price. It was certainly known under its common name by 1711, since this can be verified from travel notes by Zacharias Conrad von Uffenbach. This German traveller visited the collector David Bremer in 1711, and the latter expressed great regret at not possessing the legendary print. A few days later, Uffenbach's

brother, with whom Uffenbach was clearly travelling, was able to buy the *Hundred Guilder Print* for one guilder from a collector of *curiosa* and *artifacta*, who, as Uffenbach notes, did not know or appreciate Rembrandt's prints. . . . *Sic transit gloria mundi!*

The print shows Christ standing in the midst of a large group of people, to whom he is speaking and seemingly blessing. This work is a compositional masterpiece; in spite of the large number of figures represented, there is a unity of conception which has been rarely matched and which is achieved by the subtle use of chiaroscuro, which is the common denominator of the work. The handling of suggested space is typical of Rembrandt's middle period. The structure of the group in the middle ground in which the principal interest lies is almost relief-like. The figures have been "knitted" together, apparently haphazardly, leaving little space between them. The space behind the group is definitively closed off by a wall, most of which remains very dark. The dark and lighter areas in it are a formal reflection of the group of figures towards the foreground of the painting. The darker arc above the figure of Christ is not a realistic detail, indicating a gate in the wall, but a formal accent to enhance even further the monumental quality of the principal character of the scene, and is similar to the mechanism used by Rembrandt in the painting *Christ at Emmaus*. The foreground, where only the alternation of the light and dark areas gives an impression of space, remains empty. In the middle ground the various groups of figures are arranged along lines which are slightly diagonal and point the attention to the clearly distinguishable figure of Christ, which forms a fixed, vertical element of supreme importance to the content as well as the composition of the picture. Perhaps the best description of the print, and certainly the oldest, is in a panegyric written about 1665, which appears on one of the impressions now in the Bibliothèque National in Paris. Under this copy, H. F. Waterloos, a precentor of the Reformed Church, visitor of the sick and

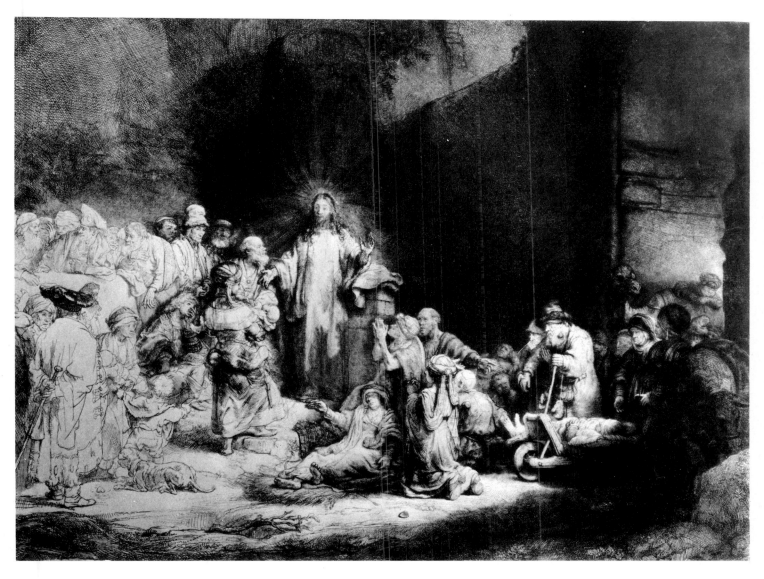

CHRIST AMONG THE SICK
(*"The Hundred Guilder Print"*)
Etching; $10\frac{3}{4} \times 15\frac{1}{4}$ in $(27.8 \times 38.9$ cm)
Circa 1648–1650
(Bartsch 74)

occasional poet, wrote a sensitive poem of four stanzas: the second describes the texts used by Rembrandt for this print:

"Here Jesus helps the sick. And the children (They are close to God) he blesses: And he punished those who prevented them from approaching. But the youth is sad. The scholars abused the faith of the Saints, but Christ's godliness shone out."

In the Gospel according to St Matthew (19, 1–26) can be found all the episodes mentioned here, where they are combined into one scene. These events took place after Jesus had left Galilee, crossed the Jordan and reached Judea.

Rembrandt had once, it is known, painted a *Noli me tangere* for Waterloos (the meeting between the resurrected Christ and Mary Magdalene), and maintained friendly contacts with him.

Christ stands slightly left of center against the dark background, while he speaks. He is dressed simply, but is clearly recognizable by his aureole and also because he stands out so obviously from the rest of the group. On the right-hand side of the canvas, moving forward towards the middle ground and the feet of Christ, can be seen the "great multitudes who had followed him and whom he healed there" represented in all kinds of attitudes and expressions. On the left, in front of Christ, is a woman bearing a child in her arms; she is seen from the back as she moves towards Christ, while the bearded disciple on the left of his master tries to hold her back with his right hand; he is seen in profile as he looks upwards to Christ's face. The latter, however, makes a gesture of welcome towards the woman: "Suffer little children and forbid them not, to come unto me: for of such is the kingdom of heaven!" In 1859 Charles Blanc thought that he recognized the features of the Greek philosopher Socrates in the disciple to the left of the child. This is

perhaps not the place to discuss the correctness of this assertion, but it is possible that Rembrandt chose to represent Socrates in that particular role, since, of all Greeks, he was considered a fine example of a just man, both in his teaching and in the way in which he died. The philosophy of Socrates is characterized by his great love for mankind and his faith in its capacity for doing good for its own sake, which brings it very close to Christian ethics. Like Christ, Socrates was condemned to death and executed for his ideas and acts. It is also remarkable that, in all the early Christian texts, attention is always drawn to the similarity between Socrates' death as a martyr and that of Christ and the early Christian martyrs.

On the left of the scene involving Christ and the woman, we are led by Christ's extended right arm to the seated figure of the rich young man, who is positioned between the woman and the disciples. Christ is giving the following advice to him: "Go and sell that thou hast, and give to the poor, and thou shalt have treasure in heaven: and come and follow me. But when the young man heard that saying, he went away sorrowful: for he had great possessions (verses 21–23)." This figure, with his head in his hand, resembles Titus. This position is often used to present "grief," as we have seen in the painting *The Prophet Jeremiah Mourning over the Destruction of Jerusalem* (pp. 14, 15).

To the rich young man, Christ further added, "And again I say unto you, it is easier for a camel to go through the eye of a needle, than for a rich man to enter into the kingdom of God." J. Bruyn argues that the presence of the camel in the background to the right of the procession of sick people waiting to be healed is an allusion to these words.

Behind the sorrowful young man and to his left is a group of figures in a slightly raised position, some of which are leaning over a wall. They have turned away from Christ and all that is happening around him and are listening to another character who appears on the far left of the etching. This speaker, with his classical Greek head band and beard, looks very much like the poet Homer as we know him from classical busts or copies of them. He is in fact looking towards Christ, although he does not appear to see him or take any notice of him. These figures represent the scornful scholars mentioned in Matthew 19, 8–12, and there is a possible explanation for Rembrandt's giving Homer's features to the scholar who is speaking. Homer's immortal epic poems, *The Iliad* and *The Odyssey*, are, together with the work of Hesiod on the origin of the gods, the most important poetical sources of our knowledge of early Greek religious beliefs regarding the creation of the world. In the seventeenth-century Netherlands Homer was considered as the only truly original poet, who had not borrowed from other sources to find the material of his epics. The parallel between Christ and Homer is then obvious. But though beautiful, the myth of creation as interpreted by Homer cannot be held to be true in the light of Christ's truth. And it was of course the scribes and the Pharisees who were in error and did not accept the truth of Christ as Messiah. The relation between Homer and Christ in Rembrandt's work is further clarified by H. von Einem in his article *Rembrandt und Homer*. He states in another context: "The poet becomes a savior, and Homer and Christ are both interpretors of everything divine. The borders between classical antiquity and Christianity are fading, as the theme of antiquity becomes imbued with the Christian spirit."

Finally there are the three striking figures to the left of Christ who form a link between the group on the extreme left and the disciple standing immediately to the left of Christ. The foremost of the three, the most visible, with the strange high hat, has unmistakably been given the features of Erasmus of Rotterdam, whose Christian humanism forms a transitional stage between the anthropocentric philosophy of antiquity and Christian faith. The head behind Erasmus, with the short, dark hair and skull, also seems to have features which are intended to portray someone specific, but they are less easily identifiable, although it is possible that they belong to Descartes. Judging from the 1656 inventory of the contents of Rembrandt's

THE DESCENT FROM THE CROSS
Oil on canvas; 56 × 41¾ in (142 × 106 cm)
Signed and dated: Rembrandt f. 165(1)
Washington, National Gallery of Art, Widener Collection (Br. 584)

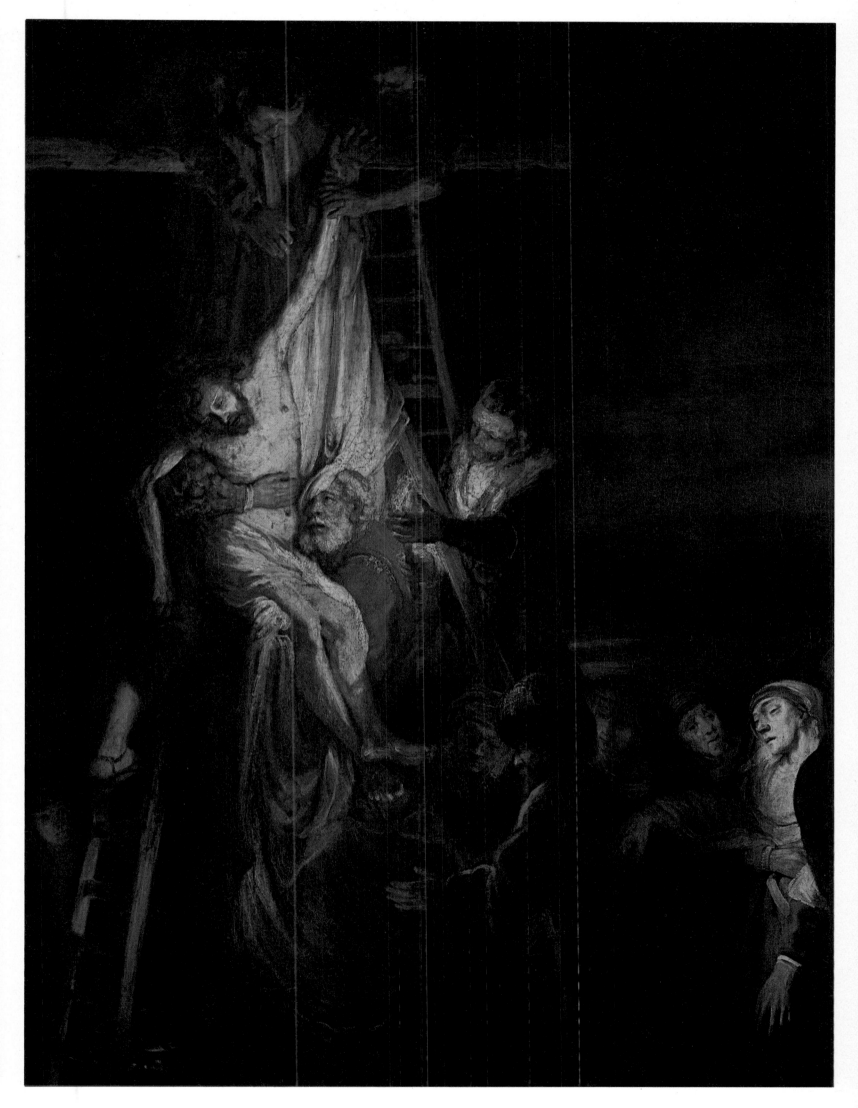

127

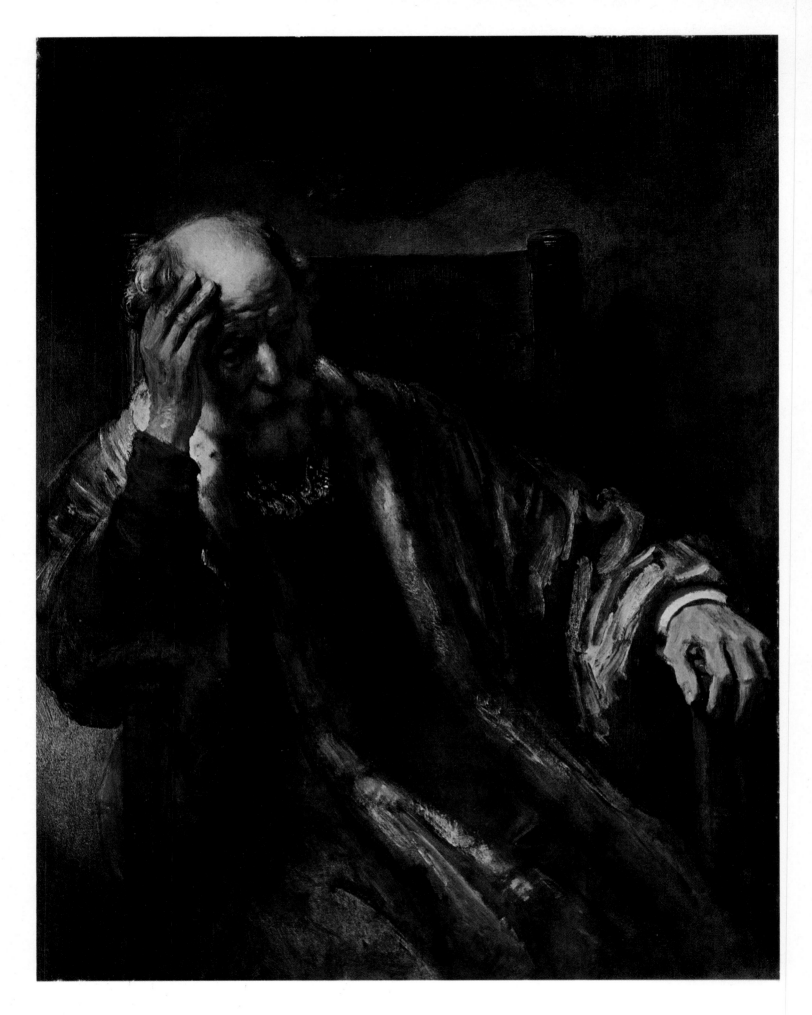

house at the time of his bankruptcy, it would appear that he possessed a number of classical busts, including those of Socrates and Homer, so that he would have had examples of their features immediately available for copying. And there was certainly no shortage of representations of Erasmus in protestant Holland. Perhaps Rembrandt was inspired by the famous woodcut of 1535 by Hans Holbein, which shows the scholar standing and

AN OLD MAN IN AN ARMCHAIR
Oil on canvas; $43\frac{5}{8} \times 34\frac{5}{8}$ in (111×88 cm)
Signed and dated: Rembrandt f. 1652
London, National Gallery (Br. 267)
Acquired in 1957.

looking in the same direction as in the work by Rembrandt. J. S. Held sees a connection between this print and Rembrandt's *Aristotle Contemplating the Bust of Homer* (p. 131).

Rembrandt, then, has combined the representation of certain New Testament episodes with a number of philosopher's portraits in *The Hundred Guilder Print*. There is a precedent for the representation of Christ together with philosophers and scholars in the print by Jan Saenredam (1565–1607) after Cornelis van Haarlem, *Antrum Platonicum* (Plato's Cave) (Bartsch 39), dated 1604, which Rembrandt probably knew and used for his own ends. The introduction of the portraits of the philosophers lifts Rembrandt's biblical etching from a purely narrative to an intellectual level, more in keeping with the expression of the painter's ideas. In all his works, however simple the subject, Rembrandt always brings his own intellectual concerns to bear, which is one reason why, whether admired or reviled, he has never ceased to command men's attention.

The choice of the philosophers and scholars – Homer, Socrates, Erasmus (and Descartes?) – does throw some light on Rembrandt's own religious convictions. He seems to have had a deep faith and trust in man as a responsible, moral creature, of whom the most perfect expression was Jesus Christ. This interpretation is further supported by his sympathy for the Mennonites and Socinians, which has been pointed out by H. van de Waal.

The Descent from the Cross of 1651 (Washington, D.C., National Gallery of Art (Widener Collection), Bredius/Gerson 584, illustration p. 127) has many points of similarity to the earlier version of 1634, now in Leningrad (Bredius/Gerson 551), which we discussed in relation to *The descent from the Cross* in Munich (pp. 43, 44–45). In the painting of 1651 the scene is presented in an almost identical fashion to the earlier painting, but it has been brought forward. All the most important figures appear enlarged: the dead body of Christ, bathed in bright light, slightly off center, and the fainting Mary in the lower, right-hand corner. The women who appear preparing the cloth in the left foreground of the Leningrad painting are not included; the figure of Joseph of Arimathea, who is represented from the back in the earlier version, is shown in profile in the 1651 painting and is placed among the other characters, though not very convincingly. This painting used to be considered to be an authentic masterpiece by Rembrandt, but H. Gerson's attribution of it to Barend Fabritius or Samuel van Hoogstraten, Rembrandt's pupils, now seems more acceptable. The use of highly contrasting chiaroscuro is broadly in keeping with the style of the 1630s, while the loose painting technique is that of the 1650s. The parts which are especially strongly lit are almost identical in both versions; this is unusual for Rembrandt who, when taking up old themes and reworking them, tended to bring new insight to them, as in the case of the later version of *Christ at Emmaus*. There are, however, differences of detail which have an important bearing on the overall effect of the painting. The relatively harsh treatment of Christ's body has been softened and the corpse almost seems to have been beautified. The gestures and attitudes, which demonstrate how difficult is the task of lifting the body down from the cross, seem clumsy and lacking in homogeneity in this later version. The features of Mary, as well as those of the old man with the beard – probably Peter – to whom the corpse of Christ is handed down, are treated with a certain amount of sentimentality, which is quite unlike the effect of the original treatment. The composition as a whole lacks unity of structure, both in its spatial implications and on the plane of the canvas itself, which is most unlike the majority of Rembrandt's works. All these elements point to the fact that this painting is a copy of part of the Leningrad *The Descent from the Cross* of 1634. It was in fact customary for a master to allow pupils to copy his original work and to sell these copies, whether corrected by the master or not.

For similar reasons, H. Gerson doubts whether the signed genre painting *An Old Man in an Armchair* (London, National Gallery, Bredius/Gerson

NICOLAES BRUYNINGH
Oil on canvas; $42\frac{1}{4} \times 36$ in (107.5 × 91.5 cm)
Signed and dated: Rembrandt f. 1652
Kassel, Staatliche Kunstsammlungen, Gemäldegalerie (Br. 268)
In 1728 this painting passed from the Bruyningh family to the Delft art dealer, Valerius Röver, who then sold it to the Landgrave Wilhelm VIII of Hesse.

267, illustration p. 128), dated 1652, is in fact by Rembrandt's own hand. Compared with Rembrandt's other portraits of old men of the same period, this painting shows noticeably less sensitive observation of individual features, and appears more closely related to the sketches of generalized old-men types found in the drawing book of Abraham Bloemaert, which appeared about the middle of the seventeenth century. These generalized types were made up by choosing the most typical elements of the old people observed and incorporating them in one portrait. This method led to the creation of generally acceptable portraits of non-specific old men, and was also the method advocated by Alberti in his attempt to define the way in which ideal beauty should be represented.

The process of creation was quite different in Rembrandt's case. Even when he painted the portrait of an old man, even if it is not a specific old man, the figure represented still seems to have been the subject of individual observation. Indeed, Rembrandt's old men have a general significance, not because they are shown as types, but because the painter's careful observation picks out what is special and unique in their features. He thus tends to drop details which he regards as inessential and concentrated on the main element in his painting, the old age of his model. Through his subtle use of chiaroscuro, Rembrandt gives his individual model that universal quality of resigned, knowing wisdom, which is native to the aged and which the painter selects from all the characteristics of the person posing for him. The process of observation is, however, quite individual and unlike the generalized, teachable method advocated by the classical theorists, which ascribed less importance to individual observation. In the painting illustrated, the clarity of detail of the back of the chair and its shadow and the use of light tend to break up the unity of the painting, which makes it probable that we are here dealing with a pupil – though a good one – who works in his master's idiom, but without conveying his depth of meaning.

The portrait of *Nicolaes Bruyningh* (Kassel, Gemäldegalerie, Bredius/Gerson 268, illustration p. 129) also dates from 1652, and further demonstrates the validity of the above remarks on the use of chairoscuro in Rembrandt's work. Light is used to illuminate essential points, although equally important aspects remain invisible in the shadow, forcing the onlooker to make the effort to complete the picture himself.

Nicolaes Bruyningh was a distant relation of Secretary Frans Jansz. Bruyningh, who was given the task of putting Rembrandt's affairs in order in 1657–1658, after the painter's bankruptcy. This portrait is one of the high points of Rembrandt's portraiture, where form and content merge with each other. The impression of dynamism and decisiveness which Nicolaes Bruyningh, here shown in the prime of life, makes is substantially created by the perfect balance between the diagonal and vertical elements of the painting. The attitude of the man is especially striking, as he leans obliquely over the chair, forming a diagonal to the plane of the canvas. This movement is fixed by the lighter accents of the painting: on the face (this is in fact a miniature portrait, with the nose forming a vertical element), on the white collar with the hanging tassels; these elements are related to the cuff and the hand, although these are seen less clearly. Finally, the back of the chair on the right is a subdued echo of the vertical line of the straight nose. The chiaroscuro is everywhere subsidiary to the overall intention of the portrait, functioning only to reveal the true appearance of Nicolaes Bruyningh.

Rembrandt's fame did not remain confined to his own country. In 1652 he received his first – and only – commission from abroad. The wealthy Sicilian nobleman and collector, Don Antonio Ruffo of Messina, commissioned Rembrandt to paint a "philosopher half-length," required for the decoration of his library – a developing custom since the Renaissance. It is not clear from the documents available whether Ruffo gave any further instructions: for instance, which philosopher should be painted. In any case, Rembrandt chose to paint *Aristotle Contemplating the Bust of Homer*. A further striking detail of the painting is the medallion bearing the head of

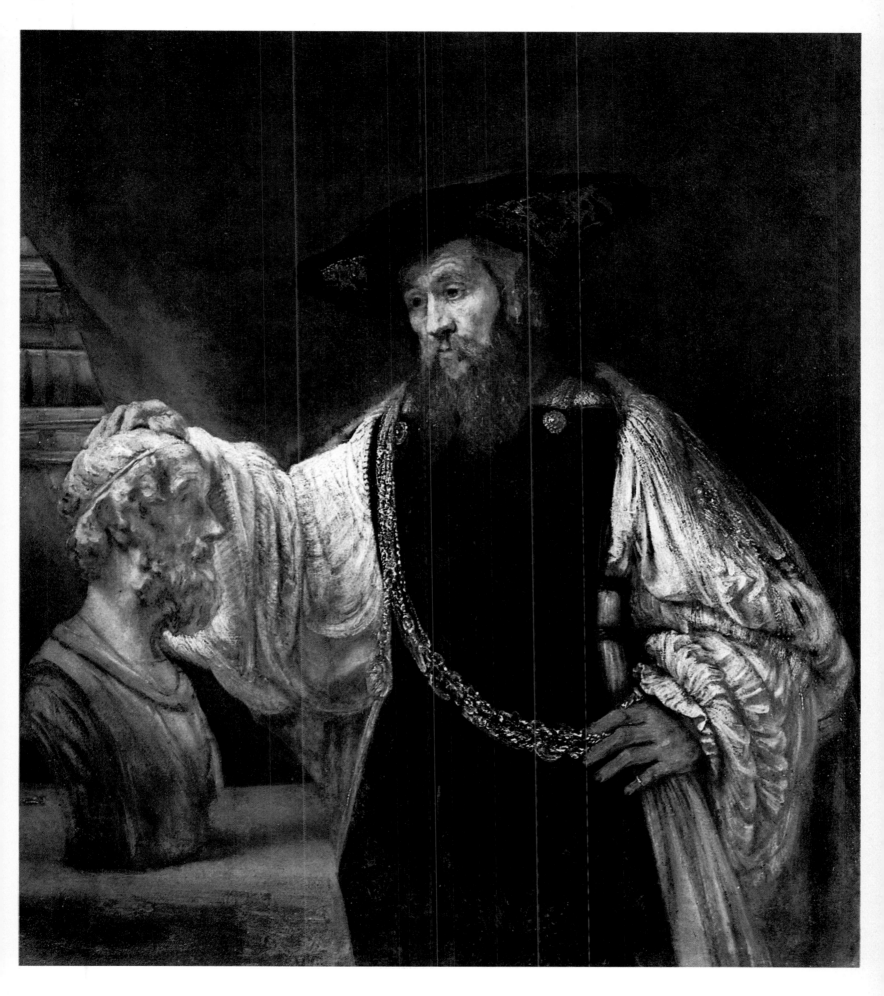

ARISTOTLE CONTEMPLATING
A BUST OF HOMER
Oil on canvas; 56½ × 53¾ in
(143.5 × 136.5 cm)
Signed and dated: Rembrandt f.

1653
New York, Metropolitan Museum of
Art (Br. 478)
This work was commissioned from
Rembrandt by Count Antonio Ruffo of

Messina, who received it after 1654.
Rembrandt painted two further works
for the Count: a portrait of *Alexander
the Great* (probably that reproduced on
p. 155) and a portrait of *Homer* (p. 164).

Alexander the Great, which is attached to the chain hanging obliquely over the philosopher's shoulders. The painting is signed and dated 1653, and is now in New York (Metropolitan Museum of Art, Bredius/Gerson 478, illustration p. 131). It reached Messina intact in the summer of 1654, after a journey of three months by boat. The nobleman, who had paid the high price of 500 florins for it, was particularly delighted with it, although the price was about eight times what an Italian master would have asked.

Six years later, in 1660, Don Antonio Ruffo commissioned a further painting as a companion piece to the work by Rembrandt from the famous Bolognese painter, Guercino (1591–1661), to be painted in his earlier style to harmonize more closely with the Rembrandt. In his reply to Don Antonio, Guercino expressed great admiration for Rembrandt's work, which he knew well through the etchings. He also asked for the measurements of the *Aristotle* painting and a small sketch of it, so that he would know the position of the half-length figure and the way the light fell, in order to match his own painting to it. From this letter, it is clear that Guercino did not know Rembrandt's painting in the original, nor does he even seem to have known that it represented Aristotle. In any case, Ruffo did not have to wait long for his Guercino: the painting was ready a few months later. On the assumption that Rembrandt's work represented a "physionomist," he chose a cosmographer as a fitting companion piece – a student of the macrocosm to

CHRIST PRESENTED TO THE PEOPLE
Etching; 15 × 18 in (38.3 × 45.5 cm)
Signed and dated (state I):
Rembrandt f. 1655
(Bartsch 76)

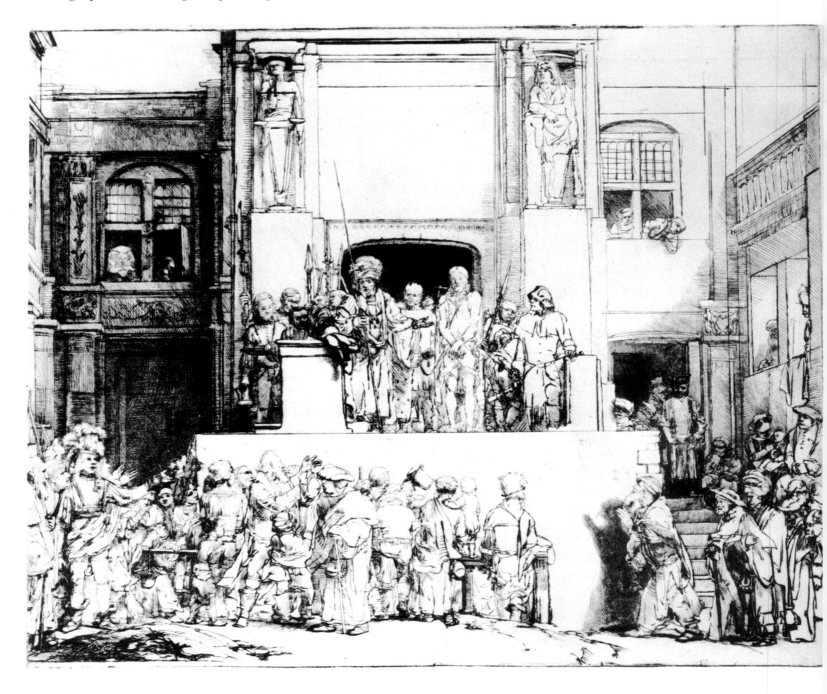

accompany the student of the microcosm.

It is generally accepted that the painting done by Mattia Preti for Don Antonio in 1662 of Dionysius of Syracuse was also intended as a companion piece to Rembrandt's *Aristotle*, although its dimensions were not the same and it was oval. The painting by Guercino has unfortunately been lost, but a drawing attributed to him by Rosenberg (Princeton University, Museum of Art) gives us some idea of the appearance of the painting.

Shortly after Guercino had finished his portrait of a cosmographer, Rembrandt sent two more paintings to Ruffo by boat in the summer of 1661. On their arrival, these works were found to be portraits of Alexander the Great (p. 155) and Homer (p. 164). As an explanation of this, J. S. Held suggests that Ruffo, after receiving the *Aristotle* with which he was so pleased, immediately commissioned further companion pieces from Rembrandt. Since, however, the paintings took so long to arrive, Ruffo commissioned the other painting from Guercino in the meantime.

There are other cases of Rembrandt making people wait for a long time; for instance Rembrandt made no concession at all to the stadholder Frederick Henry in the delivery of his commissioned works. It is likely, in any case, that his *Aristotle*, although represented as a companion to the *Alexander* and the *Homer*, was originally conceived as an entirely independent work. For a long time there was considerable doubt about the

THE THREE CROSSES
Etching; $15\frac{1}{4} \times 17\frac{3}{4}$ in (38.5 × 45 cm)
Signed and dated: Rembrandt f.
1653
(Bartsch 78)

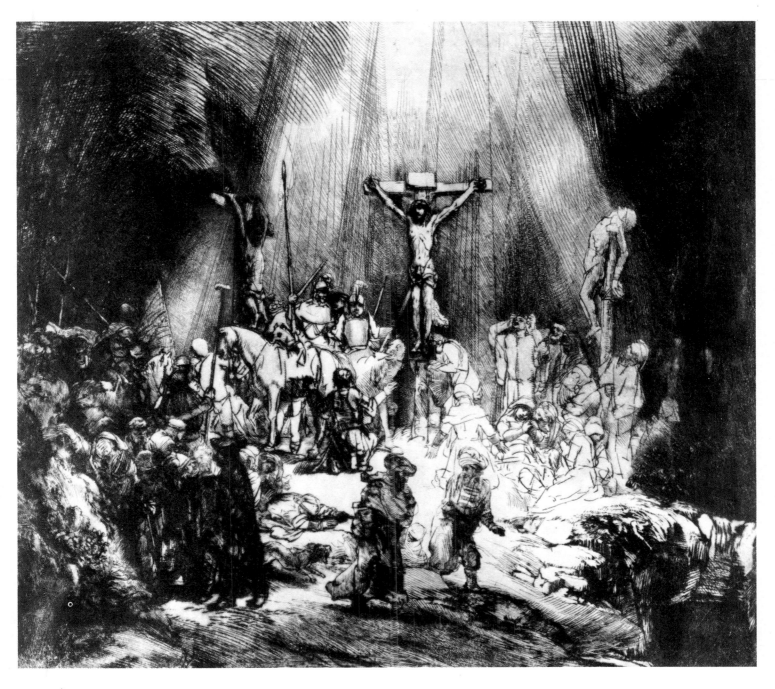

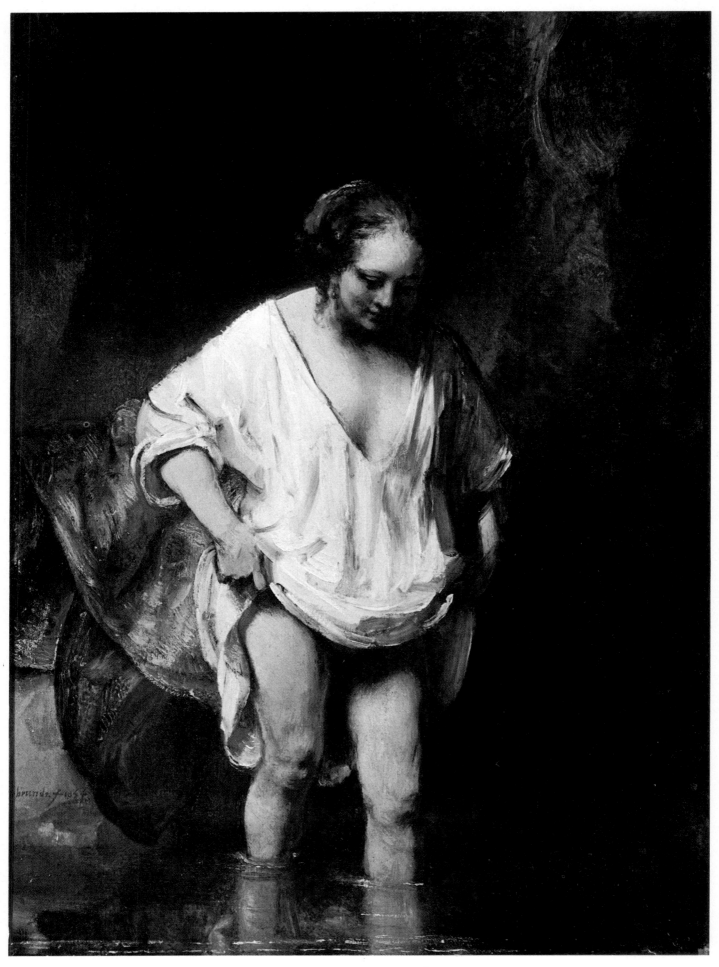

subject of the painting, and various figures were suggested, including the Roman poet Virgil, the Italian poet Torquato Tasso (1544–1595), and even Pieter Cornelisz. Hooft, a seventeenth-century Dutch poet who was hailed as the Dutch Homer during his lifetime. Only after the publication of the family archives by the Marquis Vincenzo Ruffo in 1916 was it possible to establish the correct title.

Aristotle's philosophy was first critically examined by Albertus Magnus in

the thirteenth century and became of fundamental importance to the thought of the later Middle Ages. Aristotle (384–322 BC) came to be considered the most important philosopher of all time, and his ideas were carefully related to the doctrines of the Church. Thomas Aquinas, the greatest of the scholastic thinkers, was a convinced follower of Aristotle, like his master Albertus Magnus; he wrote twelve expository works on the writings of Aristotle: among others the *Analytica*, the *Ethica*, the *Metaphysica* and the *Physica*. Aristotle's influence began to decline during the sixteenth century, but the discovery of his *Poetica*, which was first printed in Venice in 1508, and subsequently translated and reprinted many times, brought a new surge of popularity, especially among artistic circles. In this work on the nature of poetry, Aristotle distinguishes three components in the creative process: natural talent (*natura* or *ingenium*), learnable art (*ars* or *disciplina*) and practice (*exercitatio* or *usus*). These three distinctions were of fundamental importance to the theory of art in the sixteenth and seventeenth centuries.

Although it is not known whether Rembrandt himself chose the subject of Aristotle, the choice of such a subject in seventeenth-century Holland is not surprising. Although the influence of the Greek philosopher was on the wane in the Roman Catholic Church during the sixteenth and seventeenth centuries, he still remained the official philosopher of Dutch Calvinism. His works were obligatory subjects of study in the Northern Dutch universities, which indicates the importance attached to his thought in the country.

In addition to the busts of Homer and Socrates, Rembrandt also possessed a bust of Aristotle, which is mentioned in the inventory of 1656. This bust could have been a cast from the same original which was illustrated by Joachim von Sandrart in his *Academia Todesca* of 1675, as J. Emmens suggests. It is possible that Rembrandt used this as a model for his painting, as he made frequent use of antique sculpture and reliefs. He did not, however, copy directly from the bust, but instead used a live model whom he endowed with the same characteristics. There is another study portrait in existence of the man who posed for the *Aristotle* (Bredius/Gerson 238). Rembrandt thus created a "human" Aristotle, and even shows the philosopher in the garb of a sixteenth-century scholar.

Rembrandt shows Aristotle as the interpreter of Homer, on whose bust his right hand is resting, and as the teacher of Alexander the Great, from whom he is undoubtedly supposed to have received the chain of honor from which hangs the medallion of the great conqueror. Both Aristotle and Alexander shared an unlimited admiration for Homer as the unsurpassed great master of poetry. Homer was not, however, always highly appreciated among the exponents of classical theories of art, since his imagery was realistic, and was even sometimes considered vulgar; perhaps it was precisely these qualities which made him so deeply fascinating for Rembrandt. He was certainly respected among the Flemish and Northern Dutch writers of the seventeenth century. A new edition of *The Iliad* and *The Odyssey* was published by Cornelis Sc_hrevelius, rector of the high school attended by Rembrandt in Leyden, in 1658.

Aristotle is shown, then, with his right hand resting on the bust of Homer. This image had its origin in Venetian portraiture and especially in the Venetian tradition of paintings of collectors of antiquities, which was especially strong in the school of Tintoretto. It has been suggested that Rembrandt chose the Italianate pose to please his Italian client. But according to Emmens, his painting would have been considered old-fashioned in the more advanced Roman and Florentine circles, since half-length figures were already considered out of date.

Rembrandt's combining of three famous names within the painting should, according to Emmens, be interpreted in the light of the Aristotelian tripartite division of the creative process discussed above. The effects of this differentiation were felt long afterwards and it could be argued that the division also applies to human affairs in general. Homer thus stands for the

A WOMAN BATHING
Oil on panel; 24¼ × 18½ in (61.8 × 47 cm)
Signed and dated: Rembrandt f. 1654 (or 1655)
London, National Gallery (Br. 437)
Bequeathed by the Reverend W. Holwell Carr, 1831.
The model was probably Hendrickje Stoffels.

BATHSHEBA WITH KING DAVID'S LETTER
Oil on canvas; 56 × 56 in (142 × 142 cm)
Signed and dated: Rembrandt ft. 1654
Paris, Louvre (Br. 521)
The model is Hendrickje Stoffels.

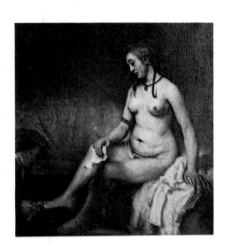

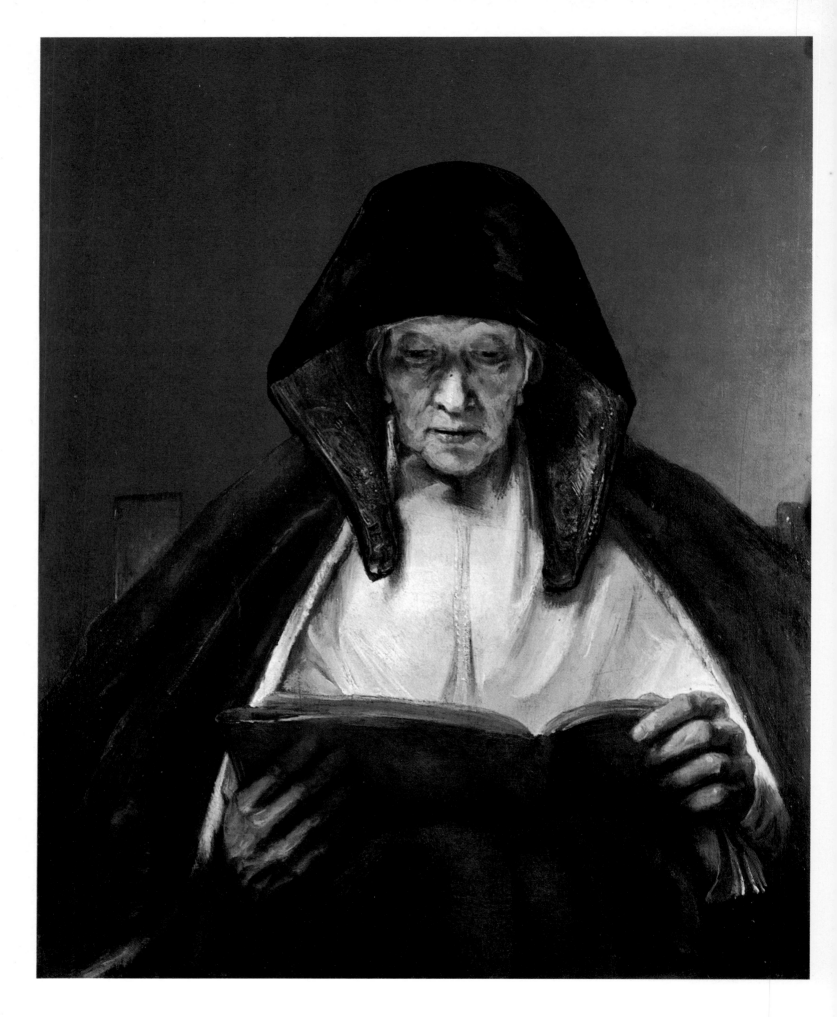

ingenium, the creative spirit; the person of Aristotle symbolizes the contemplative or philosophical *disciplina*, or learnable art; and finally Alexander is the supreme example of *exercitatio*, the active faculty.

The impressive etching *Christ Led before the People* (Bartsch 76, illustration p. 132), sometimes also called *Ecce Homo* (Behold the Man), shows an episode from the stations of the cross. If this latter title is correct, then

AN OLD WOMAN READING
Oil on canvas; $31\frac{1}{2} \times 26$ in
(79×65 cm)
Signed and dated: Rembrandt f.
1655
Drumlanrig Castle (Scotland), collection of the Duke of Buccleuch.

Rembrandt only loosely followed the Gospel according to St John, who is the only one to describe this episode, in chapter 19, 4–6: "Pilate therefore went forth again and saith unto them, Behold, I bring him forth to you, that ye may know that I find no fault in him. Then came Jesus forth, wearing the crown of thorns, and the purple robe. And Pilate said unto them, Behold the man!" In the etching, Christ is not shown wearing a crown of thorns, an element which would normally be essential to the representation of the *Ecce Homo* scene. It is probably therefore that the scene represents an earlier episode from the stations of the cross, which is described in all four Gospels. After Judas' betrayal and the subsequent capture of Jesus, there follows the trial and condemnation. It was the custom for the governor at every feast – in this case, Passover – to allow one prisoner chosen by the people to go free. In addition to Jesus, there was also a notorious criminal called Barabbas in prison, accused of rebellious acts and murder. The high priests and the elders succeed in persuading the people to plead for the freedom of Barabbas and therefore for the crucifixion of Jesus. And when Pilate, the governor, asks the people, "Whether of the twain will ye that I release unto you? They said Barabbas. Pilate saith unto them, what shall I do then with Jesus which is called Christ? They all say unto him, Let him be crucified" (Matthew 27, 21–23). In connection with the interpretation of this etching as *Christ Led before the People*, C. Campbell has discovered a possible prototype in a sixteenth-century print from a narrative biblical series, *Evangelicae Historiae Imagines* (Pictures of Stories from the Gospels). In this print the same scene is shown and there are many points of similarity with Rembrandt's etching. In the immediate foreground are the people, their backs to the spectator; they are looking up towards a balcony in the middle ground, where the principal figures are standing: Pilate, wearing a turban, together with Christ and Barabbas and a number of guards. A flight of steps in the background leads us to an open door, through which can be seen another incident in the story, Pilate's interrogation of Jesus. A remarkable detail is that the stairs on the left of the picture which lead to Pilate's palace are presented in mirror-image in the Rembrandt etching. Rembrandt also shows the people from behind, in the foreground, while the main action takes place in the middle ground on the flight of steps above. Barabbas is shown far less clearly, but far greater precision is brought to the main subject – Christ condemned by the people. Again, through his discrimination between what is important and what is not, Rembrandt raises his work from the merely narrative to a level of greater general significance. The clarity and simplicity of the picture's structure, whereby all the elements contribute to the expression of one dramatic moment, allow Rembrandt to transform the story into a general human drama.

There are eight different states of this etching, which means that there were eight separate reworkings of the etching plate. The later changes were so great that an almost totally different picture was created, ever farther removed from its popular prototype.

The etching *The Three Crosses* (Bartsch 78, illustration p. 133) dates from 1653. It shows Christ crucified between the two criminals. The figure of Christ on the cross is slightly off-center; on his right is shown the good criminal, while the mocking one is shown in a cramped position on the left (Luke 23, 39–43). To the right of the cross from which Christ hangs are the three Marys with some of the disciples, whose presence is mentioned in John 19, 25. On the other side is the officer on horseback with the soldiers who taunt Christ and offer him a lance with a sponge dipped in vinegar, as is related in Luke 23, 35–37. The scoffing scribes and high priests (Mark 15, 31–32) are shown in the foreground. This group remains in the shadow, and its function is to set off and suggest the space behind, as do the two fleeing figures in the center foreground. The dramatic events connected with the death of Christ take place in this suggested space in the middle ground. Characteristically, Rembrandt closes off the space behind the cross, further concentrating attention on the principal events. The dark areas of the sky on

TITUS
Oil on canvas; 30¼ × 24¾ in (77 × 63 cm)
Signed and dated: Rembrandt f. 1655
Rotterdam, Boymans-van Beuningen Museum (Br. 120)
This is the first portrait which has been identified as being definitely of Titus, who is seen here at the age of 13. Titus was the only son of Rembrandt and Saskia, and their only child to survive infancy; he died in 1668, at the age of 27.

the left and right contrast strongly with the lighter sections and create a suitably dramatic impression. There are also a number of states of this etching which differ greatly, especially in the intensity of the dark areas. The fourth state, for instance, is very dark indeed, and it is probable that this version was intended to show the exact moment of Christ's death, which is described in Matthew 27, 45–56: "And it was about the sixth hour, and there was a darkness over all the earth until the ninth hour." Then the death of Jesus occurs. The etching of *The Three Crosses* does indeed present a very impressive image of the death of Christ, combining in one work the sequence of dramatic events leading to it.

C. Campbell has also found a sixteenth-century prototype for this etching in the same series of popular narrative illustrations *Evangelicae Historiae Imagines*, to which the print used as the model for the etching of *Christ Led before the People* belonged. This and similar series of popular prints were common during the sixteenth century and still appeared until well into the seventeenth. Although there are thematic similarities between the etchings of Rembrandt and their sixteenth-century prototypes, the differences are even greater. Rembrandt transforms the scene from a mere narrative picture to the level of a visual drama of far greater significance. This effect is achieved partly by the brilliant use of chiaroscuro and partly by the positioning of the various groups of figures in space. The artist compels the spectator to disregard the trivial details and to concentrate on the principal event represented.

Rembrandt probably used Hendrickje as the model for the delightful painting of *A woman bathing* (London, National Gallery, Bredius/Gerson 437, illustration p. 134), which dates from 1654 or 1655. This painting was almost certainly conceived as a genre work and does not refer to any classical

JACOB BLESSING THE
CHILDREN OF JOSEPH
Oil on canvas; 69 × 82¾ in
(175.5 × 210.5 cm)
Signed and dated: Rimbran . . . f.
1656
Kassel, Staatliche
Kunstsammlungen, Gemäldegalerie
(Br. 525)

"THE POLISH RIDER"
Oil on canvas; 46 × 53⅛ in
(116.8 × 134.9 cm)
Signed: Re . . . (the painting has
been cut on the right, removing part
of the signature)
Circa 1655
New York, Frick Collection (Br. 279)
In the collection since 1910, after
various changes of ownership.

or biblical story, in contrast to another painting which shows a woman bathing, *Bathsheba with King David's Letter* (Paris, Louvre, Bredius/Gerson 521, illustration p. 135), which was also painted in 1654. This episode is taken from the Old Testament and appears in II Samuel 11, 1–27. One evening David is strolling along the roof of his palace, when he comes upon the pleasing sight of Bathsheba, the very beautiful wife of his neighbor, bathing naked. He sends for her and she comes to him. Rembrandt shows Bathsheba bathing, holding the letter of King David in her hand, while a servant dries her feet. H. Gerson points out that the position of Bathsheba is based on a classical relief which Rembrandt knew through an engraving from a series of prints of classical sculpture, *Icones et segmenta* by François Perrier, published in 1645, as was *Susanna Surprised by the Elders*. Here again, Rembrandt followed his usual practice of making a model, probably Hendrickje, take up the position shown in the classical sculpture, and then painting her, so that an effect of considerable verisimilitude is obtained.

An Old Woman Reading (Drumlanrig Castle, Scotland, Duke of Buccleuch, Bredius/Gerson 385, illustration p. 136) was painted in 1655. The woman's simple clothing, suggestive of the convent, consists of a light undergarment and a dark hooded cloak, which seems to strengthen the impression of devoutness in the attention which she is paying to the book. It is possible that this is a representation of the prophetess Anna. The frontal attitude of

STUDY FOR THE ANATOMY
LESSON OF DOCTOR JOAN
DEYMAN
Drawing
Circa 1656
Amsterdam, Rijksmuseum (Benesch
1175)

THE ANATOMY LESSON OF
DOCTOR JOAN DEYMAN
Fragment of the painting
Oil on canvas; $39\frac{1}{2} \times 52\frac{3}{4}$ in
(100×134 cm)
Signed and dated: Rembrandt f.
1656
Amsterdam, Rijksmuseum (Br. 414)
Acquired in 1882 by the City of
Amsterdam from the previous owner,
the Reverend E. Pryce Owen of Chel-
tenham. In the Rijksmuseum since
1885.
 This work was largely destroyed by
fire on November 8, 1723. There is a
drawing of the complete painting at
the Rijksmuseum (see above) from
which it emerges that the group in-
cluded seven other people. In the part
that remains can be seen the bust and
hands of Dr. Deyman, his assistant (on
the left), Gysbrecht Matthysz. Calc-
koen, and the corpse of Joris Fonteyn,
condemned to death for stealing.

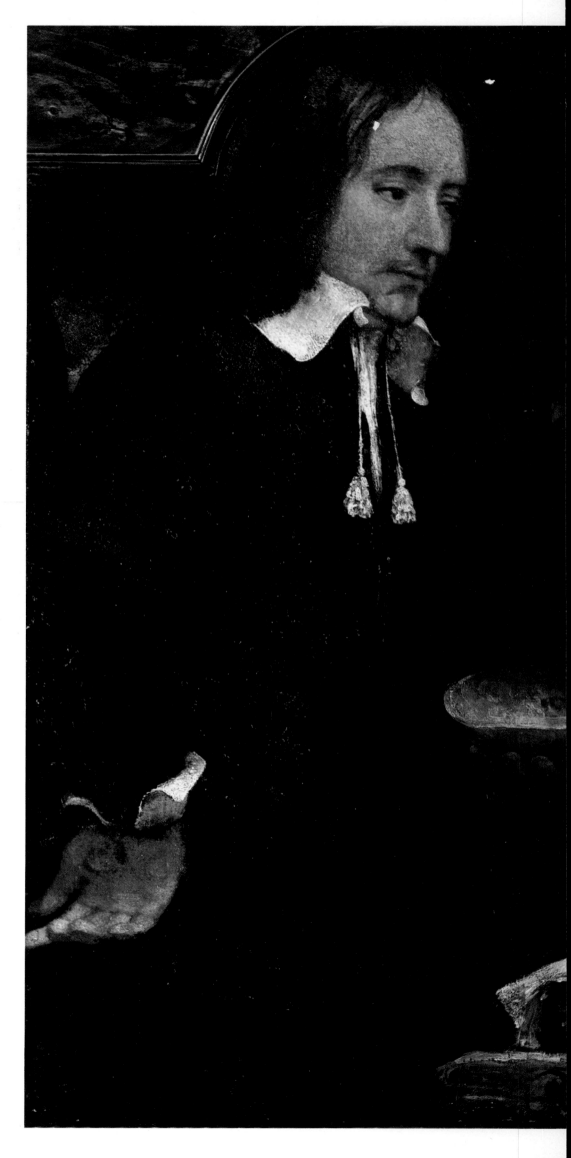

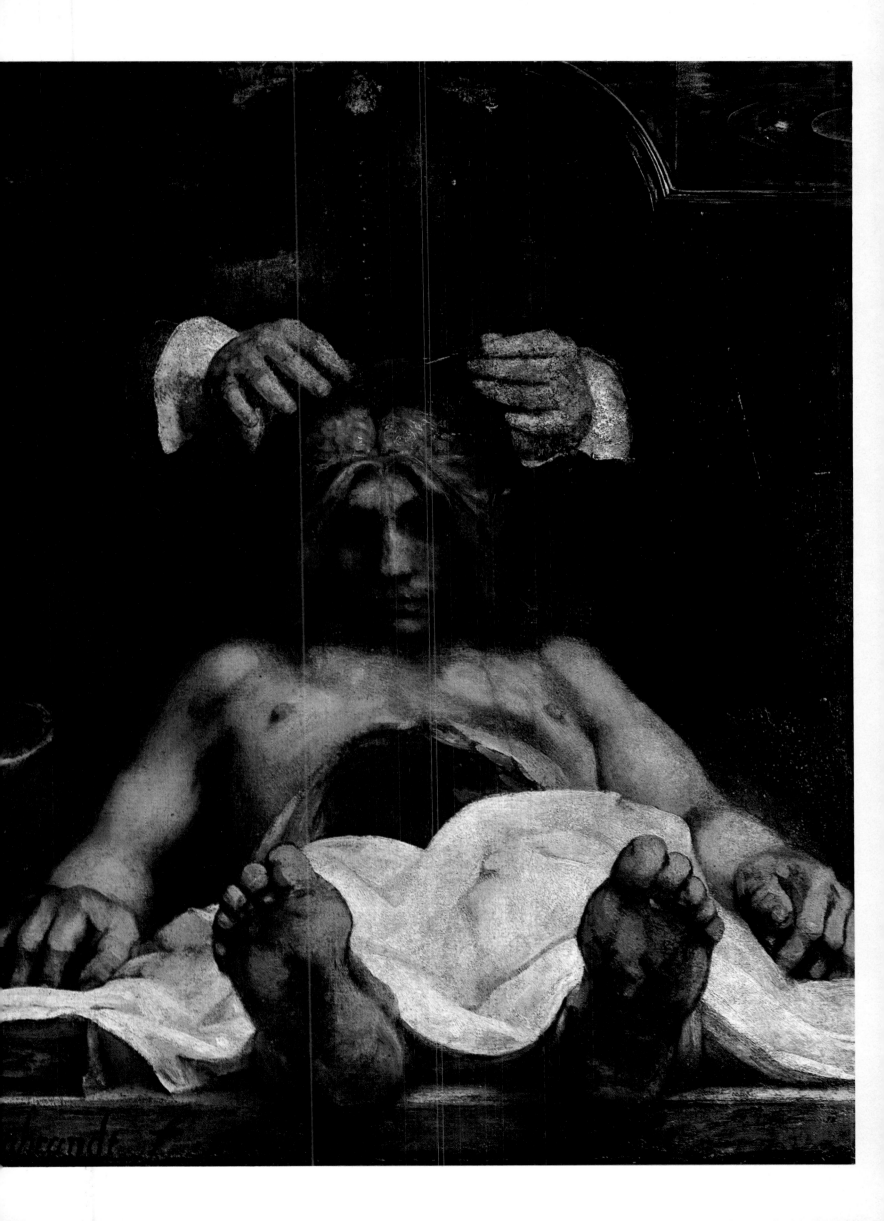

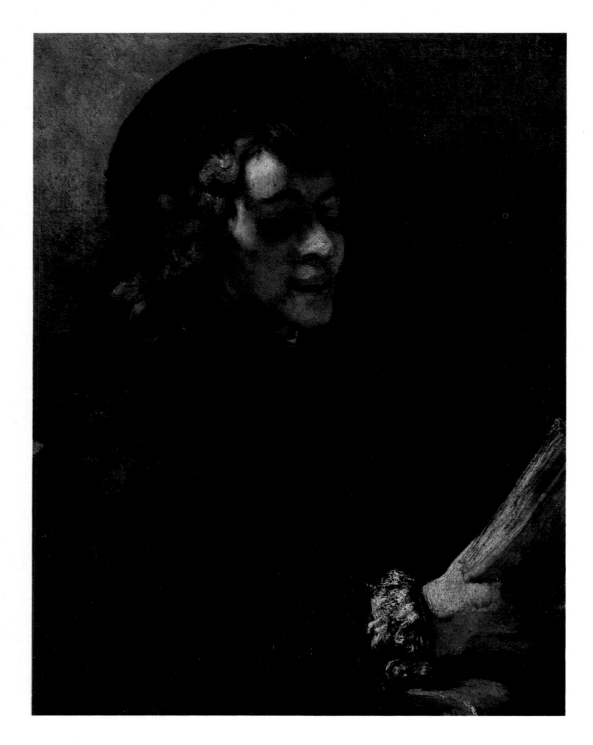

the figure, in the immediate foreground of the work, invites the direct involvement of the spectator in the image, while the book, parallel to the plane of the image, and the downcast eyes counter this feeling by giving an impression of remoteness. The contemplative atmosphere of this painting is largely created by Rembrandt's use of chiaroscuro. Light enters the painting from the front – although there is no visible source of light – which is the position of the spectator, who thus has the image right before his eyes.

A similar method of presentation can be seen in another painting by Rembrandt dating from 1655. This is the touching portrait of *Titus* behind a desk (Rotterdam, Boymans-van Beuningen Museum, Bredius/Gerson 120, illustration p. 137). The young Titus is seen resting his chin on the thumb of his right hand, in which he is also holding a pen; he gazes pensively in front of him. In his other hand he holds an inkwell and a pen case. Together with the pile of papers, these represent the attributes of the young student.

In this painting, too, Rembrandt succeeds in achieving a combination of distance and involvement which gives the painting its intriguing, yet peaceful atmosphere. This impression is further reinforced by the use of various pictorial effects: the restrained use of color, the compositional structure and, by no means least important, chiaroscuro. The soft light

TITUS READING
Detail
Oil on canvas; $27\frac{3}{4} \times 25\frac{1}{4}$ in
$(70.5 \times 64$ cm)
Circa 1656
Vienna, Kunsthistorisches Museum, Gemäldegalerie (Br. 122)
At the time of this portrait, Titus must have been about 15 years old.

HENDRICKJE STOFFELS
LEANING AGAINST A DOOR
Oil on canvas; $34 \times 25\frac{1}{2}$ in
(86×65 cm)
Circa 1656–1657
Berlin, Staatliche Museen
Preussischer Kulturbesitz,
Gemäldegalerie (Br. 116)

SLEEPING WOMAN
Drawing; $9\frac{3}{4} \times 8$ in (24.5×20.3 cm)
Circa 1655
London, British Museum
The woman is perhaps Hendrickje.
(Benesch 1103)

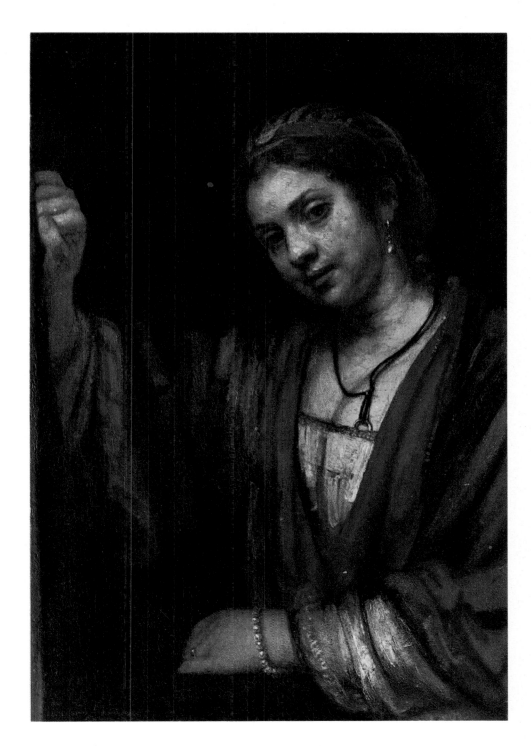

comes from the left foreground, lighting up the image of the thoughtful boy against the dark background. This work is in the mature pictorial style of the 1650s. One-third of the picture area is taken up by the plain, flat front of the desk, behind which sits Titus, leaning forward. This distancing of the boy is partly reduced by the white, protruding pile of papers, which leads our eyes on to Titus, as he bends forward. The boy is seen frontally, behind his pile of papers, but his gaze is directed past us, so that no direct contact with him is made. The positioning of the figure within the suggested space of the painting which, together with the closed-off background, projects him towards the front, does, however, still create a strong impression of involvement in the subject.

The figure of Titus is based on a triangular structure, which contrasts subtly with the two rectangular shapes created by the horizontal line of the desk. The hand which holds the inkwell and pen case, hanging in front of the desk, is the linking element which helps to bind the two structures together. This is also the way by which our eyes are finally led from the painting.

Rembrandt turned yet again to the Old Testament, Genesis 48, 13–20, for the theme of his masterpiece *Jacob Blessing the children of Joseph* (Kassel, Gemäldegalerie, Bredius/Gerson 525, illustration p. 138), painted in 1656.

The old, blind Jacob is blessing Manasseh and Ephraim, the two sons of Joseph, "And when Joseph saw that his father laid his right hand upon the head of Ephraim, it displeased him: and he held up his father's hand to remove it from Ephraim's head unto Manasseh's head." Manasseh was in fact the first born. The impression of simplicity which the painting makes upon us is created by a tight, though inventive, structure, which is as important in the suggested space of the composition as it is on the flat plane of the painting. The main action takes place in the center of the picture, parallel to its plane. The foreground is completely taken up by the front and side of a diagonally placed bed, while the background is closed off. The light, which illuminates the scene, comes from behind a curtain on the left. The old man is sitting in a semi-raised position, his right arm outstretched, again parallel to the picture's plane, in the gesture of blessing towards the head of the beautiful, blonde child, Ephraim, who receives the blessing with a devout expression on his face. The other child, Manasseh, is shown to the left of his brother and slightly behind him, looking up. Above his head and under Jacob's right wrist can be seen the hand of Joseph, who wishes to change the direction of his father's blessing. It should be noted that, while the heads of Jacob and Joseph are parallel on the plane of the image with the two heads of the children, the directions of the two groups of heads form transverse diagonals. The wife, Asnath, who looks on, helps to tighten and define the structure of the painting.

Again Rembrandt has chosen to represent a moment of especial psychological potency from the story. As we have already noted, Rembrandt was not so much concerned with telling a story in the narrative sense, as with representing the human emotions and reactions which occur in the stories. This painting is particularly rich in its display of human emotion: the son feels that his old father is making a mistake; there is the complex relationship between this group and the two children, who together form three generations (the three ages of man – youth, maturity and old age – have always been a popular theme in the visual arts); there is the relationship between the two brothers, the youngest of which has been given Jacob's blessing against all expectations, which makes this a particularly decisive moment for their futures. And finally there is the passive, contemplative figure of the woman on the right of the canvas who looks on at the more active groups of men and children on the left.

Rembrandt's remarkable gift for portraying human relations and reactions is often thought to be the direct result of his own personal feelings towards his environment. This line of enquiry is applied with particular frequency to the painting of *Joseph's Blessing* but, as we have argued before, this seems a peculiarly barren way of interpreting a work of art. If the artist paints a scene of apparent happiness this does not argue that the artist himself is happy. In the same way, he does not have to have constant contact with vast numbers of people to be fascinated by the representation of a wide variety of human emotions.

One of the most intriguing paintings by Rembrandt is the canvas which is known as *The Polish Rider* (New York, Frick Collection, Bredius/Gerson 279, illustration p. 139), painted about 1655. Anyone who has studied this work cannot help feeling that there must be some hidden meaning to this apparently simple picture. The painting depicts a young horseman, dressed in what has been identified as the seventeenth-century uniform of the Polish or Hungarian light cavalry. He is armed with a sword, a bow and arrows, and is riding on a fine white horse against a background of a landscape which is presented mainly in browns. A strip of the canvas on the right of the painting has been removed, so that only part of the signature is visible. The painting was owned for a long time by various Polish collectors under the title *Cossack on horseback*, after it had gone from Holland to Poland in the late eighteenth century; in 1910 it was sold to H. C. Frick.

Opinions are extremely varied on how this mysterious painting of a horseman is to be interpreted. J. S. Held has suggested that Rembrandt

WOMAN WITH ARROW
Engraving; $8 \times 4\frac{3}{4}$ in (20.3 × 12.3)
1611
(Bartsch 202)

intended the young man to represent *Miles Christianus*, the Christian soldier, a concept which originated with Erasmus of Rotterdam and was developed in his book, *Enchiridion militis Christiani* (Handbook of the Christian Soldier), published in 1504. The concept of the *Miles Christianus* had already served as inspiration for Dürer's engraving *Knight, Death and the Devil* (1513), which in turn may have inspired Rembrandt in *The Polish rider*. According to W. R. Valentiner the rider is a historical portrait of Gysbrecht van Aemstel, who is the legendary founder of Amsterdam. The Polish art historian J. Bialostocki believes there is a connection between Rembrandt's horseman and the Polish Socinian Jonas Szlichtyng. When the States General issued an edict against the Socinians in 1653 (the "Warsaw errors") Szlichtyng wrote a defense of the movement which appeared in 1654; this *Apologia* was signed with the pseudonym *Eques Polonus*, Polish knight or rider. This suggestion is particularly interesting, since Rembrandt was obviously sympathetic to this sect, as is apparent from his earlier etching of *Dr Faustus*, an idealized portrait of Dr Faustus Socinus.

The more recent interpretation of C. Campbell is even more ingenious. He argues that the emphasis should not be placed on the Polish clothing, but on the appearance of the young man, armed, on horseback. He comes to the conclusion that Rembrandt's *The Polish rider* should be considered as a scene from the parable of the Prodigal Son, from which Rembrandt had borrowed more than once. This picture, then, is supposed to show the departure of the young, wealthy son. If this is the case, then Rembrandt would again be following the narrative tradition of the series of the prints published in the sixteenth century, though in his very individual way.

The fact that many critics have searched so carefully for an "explanation" of this painting, which in itself is a very clear presentation of the subject in pictorial terms, can be partly explained by Rembrandt's fondness for hidden meanings in his other work. It is difficult, therefore, to resist the temptation to look for a hidden reason for the painting of this particular masterpiece. It hardly seems possible that Rembrandt could have painted a simple, uncomplicated picture of a rider in a landscape, in the manner of the numerous, popular *ruiterstukken* (rider-portraits) of, for instance, Philips Wouvermans or the less well-known Pieter Verbeecq, since the deeply felt tensions of his work make it so different from their bland images.

In 1656 Rembrandt painted another anatomical picture in the manner of his group portrait of Dr Nicolaes Tulp of 1632. The later commission was to paint *The anatomy lesson of Doctor Joan Deyman* (Amsterdam, Rijksmuseum, Bredius/Gerson 414, illustration pp. 140–141); Deyman was Tulp's successor at the Surgeons' Guild in Amsterdam. On January 29, 1656, Dr Joan Deyman conducted his first anatomical demonstration on the body of Joris Fonteyn of Diest, who had been hanged. Like that of Dr Tulp, Deyman's portrait was to hang in the dissecting room of the Amsterdam Theatrum Anatomicum. The German traveller Uffenbach, already mentioned in another context, visited the theater on February 20, 1711 and made the following entry in his diary: "In the morning we went to the dissecting room of the Theatrum Anatomicum. ... The young man who showed us round praised especially a painting hanging near the door, in spite of the fact that the corpse seemed rather short, and that the soles of the feet can be seen. ..."

This painting was unfortunately almost destroyed by fire in 1723. Only a fragment now remains, but a sketch (Benesch 1175) can still give us an impression of what the complete painting was like. Fuchs suggests that this painting, like the Tulp portrait, owes much to the Vesalius tradition. The example of the open skull comes straight from Vesalius' famous work *De humani corporis fabrica*. Deyman is thus presented as following in the tradition of the first modern anatomist, Andreas Vesalius

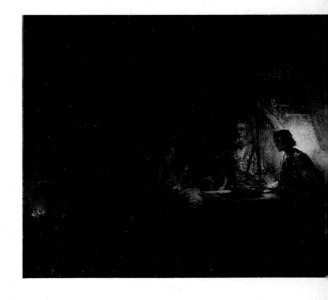

JUPITER AND MERCURY
VISITING PHILEMON AND
BAUCIS
Oil on panel; 21½ × 27 in
(54.5 × 68.5 cm)
Signed and dated: Rembrandt f.
1658
Washington, National Gallery of Art,
Widener Collection (Br. 481)
In the museum since 1942.
Pages 146–147: Detail

His later years

Rembrandt's style displays a distinct evolution as the painter grows older. From a style of relatively accurate and detailed representation, his painting moves in a direction where emphasis on the central concern of each work becomes the most important factor, and where the illustrative context is either only just indicated or even completely dropped.

A particularly fine example of his mature style can be seen in the drawing of a sleeping woman (Benesch 1103, illustration p. 143), for which Rembrandt used Hendrickje as a model. Drawing was traditionally considered the parent of painting. The ability to draw made it possible for the artist to achieve the correct and clear form required for the figures in his painting. Without this correct and clear form, it would be impossible to express clearly the narrative content of the painting. In other words, drawing was concerned with outline, the precise inner and outer outlines of the figures to be represented. Drawing was thus the first and foremost expression of the general characterization and incidental actions of the figure.

The study of the sleeping woman suggests that Rembrandt was here experimenting with the effects of line. It was customary to use a thin, precise line to describe the various curves of the body as closely to real life as possible, and the whole work should be anatomically correct. There had of course been drawings which deviated from this norm in their use of heavier, less precise line, including work by Elsheimer. In this drawing Rembrandt goes to the extremes of simplification and abstraction. In a few broad strokes, he indicates the overall shape and position of his model, and then uses a small number of heavy lines to indicate the leaden sensations of the sleeping person. As in the later paintings, Rembrandt's drawings achieve an increasing degree of expressiveness and conviction with fewer means.

Of the four children born to Saskia and Rembrandt, Titus was the only one to remain alive for any appreciable length of time. Following the example of his father, he was also active in the arts, principally through the art dealing business. He is shown reading a book, sitting in an armchair, in the brilliant portrait which Rembrandt painted of him around 1656 (Vienna, Kunsthistorisches Museum, Bredius/Gerson 122, illustration p. 142). The sense of personal involvement, of animated absorption of the boy in his book, surrounded by light, almost places the onlooker in the position of outsider. There are other, more formal, reasons for this impression: the arm, the back of the hand and the outside of the book form a barrier which prevents any intrusion on the scene. The attentiveness which the model is bringing to his reading, together with these visual elements conveys the idea of imperturbability, which is the real subject of the painting.

There are in all about eight known portraits of Titus painted by Rembrandt at different periods of his life. Titus died while still young in 1668, a year before the death of his father, at the age of twenty-seven.

In another painting, the devoted Hendrickje is represented in an informal pose (Berlin–Dahlem, Gemäldegalerie, Bredius/Gerson 116, illustration p. 143). She is gazing directly at the onlooker and therefore involving him in the scene. There is very little distance between ourselves and the subject of the painting: we are immediately in front of a doorway, while Hendrickje stands just behind it, leaning against the doorpost. That it is she who is looking at us rather than us at her is suggested by the outlining of the doorpost and the half-door on which her left arm is resting. She is safely behind the door, while our own position still remains vulnerable, a situation which does not invite relaxed observation.

Titus and Hendrickje actually saved Rembrandt from his financial difficulties and protected him from troublesome creditors by entering into a partnership to run his fine art business. Rembrandt was allowed no financial part in the company, but was engaged as advisor. Thus he was able to pursue his work as a painter, undisturbed by financial matters, for which he had considerably less talent.

A YOUNG CAPUCHIN MONK (TITUS)
Oil on canvas; $31\frac{1}{4} \times 26\frac{3}{4}$ in
(79.5 × 67.7 cm)
Signed and dated: Rembrandt f. 166(0)
Amsterdam, Rijksmuseum (Br. 306)
Acquired by the museum in 1933 with the help of the Rembrandt Society.

SELF-PORTRAIT WITH PALETTE AND TWO CIRCLES
Oil on canvas; $45 \times 37\frac{1}{2}$ in
(114 × 94 cm)
London, Kenwood House, The Iveagh Bequest. (Br. 52)

THE APOSTLE PETER
DENYING CHRIST
Oil on canvas; $60\frac{1}{2} \times 66\frac{1}{2}$ in
(154 × 169 cm)
Signed and dated: Rembrandt 1660
Amsterdam, Rijksmuseum (Br. 594)
After various changes of ownership,
this work was acquired by Catherine II
of Russia for the Hermitage In 1933 it
was bought by the Rijksmuseum with
a donation from the Rembrandt Soci-
ety. Two preliminary drawings are in
the Biblioteca Nacional de Madrid and
the Ecole des Beaux-Arts in Paris
respectively.

The portrait of Titus with the beret (London, the Wallace Collection,
Bredius/Gerson 123, not reproduced here) probably dates from the 1650s.

In one of the stories in Ovid's *Metamorphoses*, the Roman poet describes
how the aged Philemon lived with his wife Baucis in Phrygia. One day,
Jupiter and Mercury descended to earth to test the devoutness of men.
Everywhere they were refused hospitality, except at the house of Philemon
and Baucis who, in the true spirit of hospitality, were prepared to slaughter
their last goose for their visitors. The gods then disclosed their identity and
advised the aged couple to climb a mountain. When they had almost reached
the top, they saw that the land had been flooded. They then became priests
and were finally changed into trees so as to remain immortal.

Jupiter and Mercury Visiting Philemon and Baucis (Washington, D.C.,
National Gallery of Art, Widener Collection, Bredius/Gerson 481,
illustration pp. 145, 146–147) shows the hospitable reception which is
accorded to the godly strangers and, more precisely, the very moment when

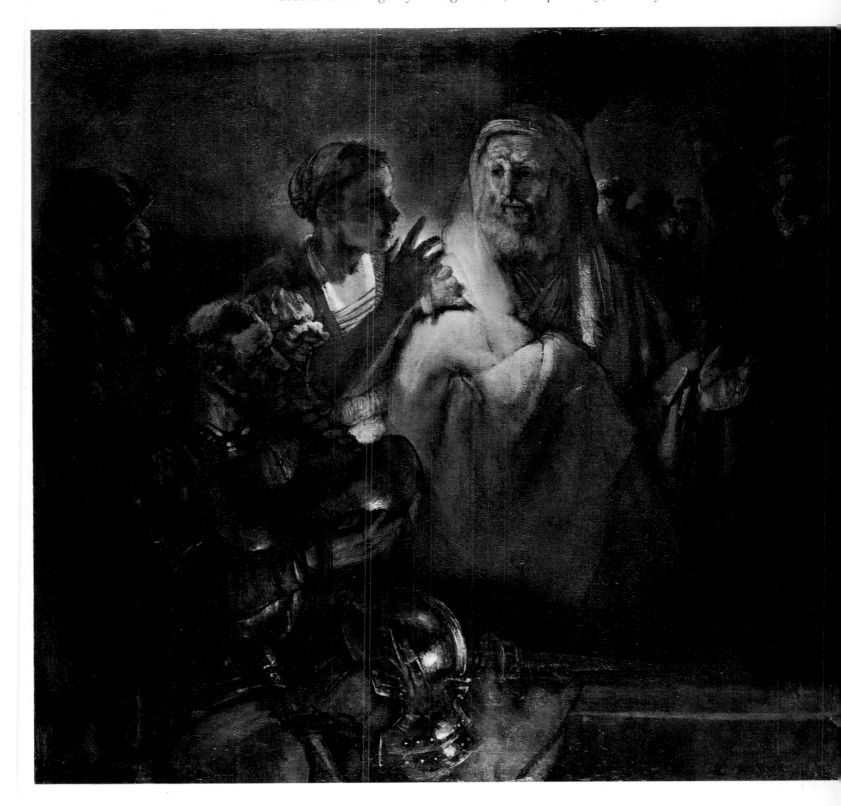

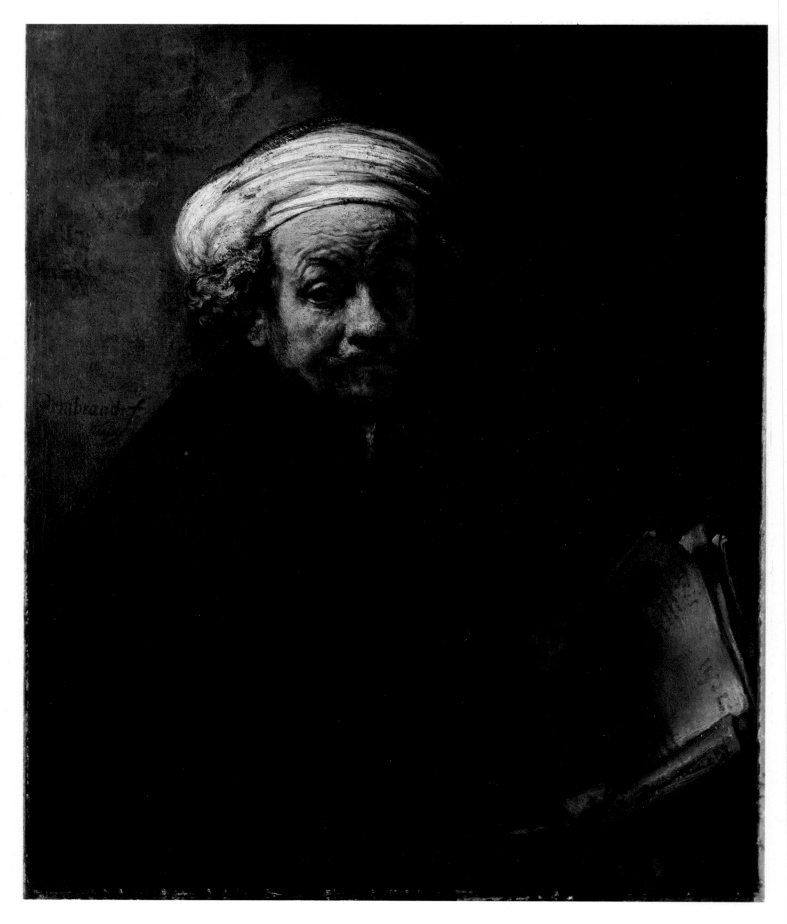

they disclose that they are in fact Jupiter and Mercury. The painting is dated 1658. Rembrandt returns in this painting to a compositional structure he had used in the *Christ at Emmaus* of 1628 and which can be traced back to the engraving *Philemon and Baucis* by H. Goudt after Adam Elsheimer.

Around 1660 Rembrandt painted a number of portraits of Franciscan or Capuchin monks. Titus probably served as the model for one of them (Amsterdam, Rijksmuseum, Bredius/Gerson 306, illustration p. 148). In the simple, almost monochrome, brown painting, the face is the only well

SELF-PORTRAIT AS THE APOSTLE PAUL

Oil on canvas; 35¾ × 30¼ in (91 × 77 cm)

Signed and dated: Rembrandt f. 1661

Amsterdam, Rijksmuseum (Br. 59)

Formerly in the Tournier collection, Paris, the Corsini collection, Rome, and that of Lord Kinnaird, Dundee. On loan to the Rijksmuseum from Mrs. J. G. de Bruyn–van der Leeuw.

THE EVANGELIST MATTHEW INSPIRED BY THE ANGEL

Oil on canvas; 37¾ × 32 in (96 × 81 cm)

Signed and dated: Rembrandt f. 1661

Paris, Louvre (Br. 614)

Pages 152–153: Detail

illuminated area. The finely painted flowers and vines behind Titus, who wears a Franciscan cowl, together with the soft light which plays on the boy's features, give a friendly, gentle atmosphere to the painting, which is especially suitable to the subject. Even in the painting of such a simple theme, Rembrandt succeeds in creating a sense of movement through the picture, from the left to the upper right, in which the downcast eyes play an important part.

It is generally accepted that this is not a portrait of Titus in the usual sense of the term. It could be a historical painting of St Francis, to which Rembrandt had added new meaning by choosing a contemporary person as model. It is also possible that it is simply a genre portrait of Titus as a Franciscan monk.

Rembrandt's self-portraits form an important part of his total *oeuvre*. It is rare for an artist to paint a portrait of himself almost annually, but it would almost be possible to follow the development of Rembrandt's style through his self-portraits alone. The *Self-portrait* with palette and two circles (London, Kenwood House, The Iveagh Bequest, Bredius/Gerson 52, illustration p. 148) is one of the most impressive interpretations of Rembrandt's own likeness. The painter stands silhouetted almost frontally against a light background – which is rare – with palette and maulstick. The grayish light falls from the upper left onto his face and gray hair. The white hat and shirt give the painting a high degree of brightness, further strengthened by the two circles on the grayish wall. Several explanations have been offered for the two partly visible circles. They have been related to the mystical signs of the Jewish Cabbala, and more precisely, to the circle which reflects God's perfection. According to Emmens, they should be seen as a reference to Rembrandt's theories of art. He argues that the circles represent the emblematic signs for Theory and Practice, similar to those published in Cesare Ripa's *Iconologia,* which appeared in the Netherlands in 1644. The circle on the left is supposed to represent Theory, since it could be drawn using only a compass, while the circle on the right, with what seems to be a ruled line in it right at the edge of the canvas, would represent Practice which uses a ruler and compass. Rembrandt would then appear as *ingenium*, the creative spirit, between Theory and Practice. These three elements are also found in the painting of *Aristotle Contemplating the Bust of Homer*.

A much simpler explanation is given by H. van de Waal: the two partly visible circles are a reference to the two hemispheres of a world map, which served Rembrandt as wall decoration, since he had already painted it in the double portrait of 1633 (Bredius/Gerson 405). One wonders however what world map could have been so large. In any case, the circles are so large that Rembrandt must have had something else in mind than just a decorative map for him to drop his customary dark background.

"Then took they him, and led him, and brought him into the high priest's house. And Peter followed afar off.

"And when they had kindled a fire in the midst of the hall, and were set down together, Peter sat down among them.

"But a certain maid beheld him as he sat by the fire, and earnestly looked upon him, and said, This man was also with him.

"And he denied him, saying, Woman, I know him not.

"And after a little while another saw him, and said, Thou art also of them. And Peter said, Man, I am not.

"And about the space of one hour after another confidently affirmed, saying, Of a truth this fellow also was with him: for he is a Galilaean.

"And Peter said, Man, I know not what thou sayest. And immediately, while he yet spake, the cock crew.

"And the Lord turned, and looked upon Peter. And Peter remembered the word of the Lord, how he had said unto him, Before the cock crow, thou shalt deny me thrice.

"And Peter went out, and wept bitterly."

Taking this text above from Luke 22, 54–62, Rembrandt painted the

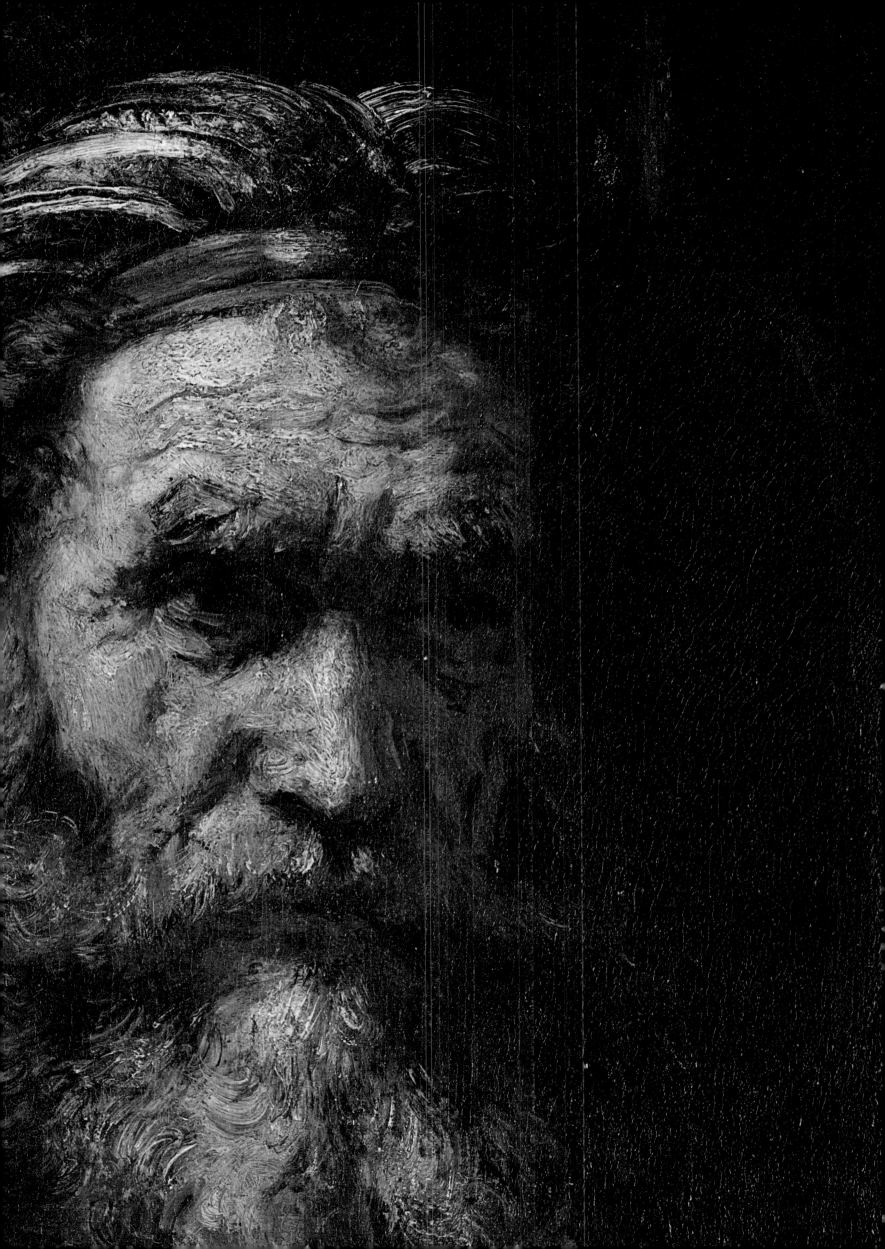

masterpiece *The apostle Peter denying Christ* (Amsterdam, Rijksmuseum, Bredius/Gerson 594, illustration 149) in 1660. The painting is constructed essentially in three sections. In the immediate left foreground is a group of soldiers in armor. Their attention is directed towards the scene taking place in the middle ground, where a woman is holding up a candle in order to be able to see the face of the bearded apostle more clearly. He is, of course, Peter, wrapped in a cloak. In the background on the right are more figures who are enacting the scene of Jesus before Caiaphas. The man in front of the group is Jesus; he is seen from behind, but turns his face round to look at Peter. Although a fire is mentioned in the biblical text, Rembrandt uses a candle as a source of light, shaded by the woman's hand. This detail accentuates the disturbing fact of recognition, and, at the same time, the arm serves to set off the figure of the disciple.

Here too Rembrandt treats two events within the same painting: in the middle ground we are shown the moment when the woman recognizes Peter, who then denies Christ for the first time, while the figure of Christ with turned head in the background is a reference to the third denial one hour later, when the cock crows. C. Campbell has found another prototype for this painting in a series of North Dutch biblical prints, published in the sixteenth century, which Rembrandt must have known and used as a source.

It was already considered rather old-fashioned in Rembrandt's time to represent several scenes in one painting, although this disapproval was only directly expressed by classical theorists. As in the classical theater, the unities of place, time and action were considered obligatory. Rembrandt, however, painted very much according to his own rules, which were rooted in a period during which there were no highly developed systems to govern artistic creation. There is a great spontaneity, then, in Rembrandt's work, emphasized by the dynamic compositional structure. In the *Peter* painting the diagonal movement from the lower left to the top right is accentuated by the fact that the three groups of people in the painting seem to be constantly receding towards the background.

At the beginning of the 1660s Rembrandt painted a group of paintings of the apostles. It is not known whether these were the result of a commission or for what reason the series was undertaken. The *Self-portrait* of 1661, in which Rembrandt portrays himself as *The Apostle Paul* (Amsterdam, Rijksmuseum, Bredius/Gerson 59, illustration p. 150) also belongs to this group. Indeed, the apostle Paul recurs several times in Rembrandt's work. Still as Saul, he is shown in *The Martyrdom of St Stephen* of 1625, in *Paul in Prison* of 1627, in which the attributes of sword, book and writing materials clarify the identity of the figure represented. And in 1630 Rembrandt painted the now gray apostle once more – Paul was one of the most outspoken of the disciples of Christ. After his early career as a ruthless persecutor of Christians, he underwent a dramatic conversion to become a devoted and fervent follower of Christ and one of the principal disseminators among the apostles of the Christian faith through deed and the written word. He was put to death by the sword in Rome in 64 AD. In the *Self-portrait as the Apostle Paul*, the handle of a sword protrudes from the clothes of the man, while in his hands he holds an open book, the special attribute of this apostle.

The Evangelist Matthew Inspired by the Angel (Paris, Louvre, Bredius/Gerson 614, illustration p. 151), signed and dated 1661, belongs to the same series. Just as the sword, books and writing materials are Paul's attributes in traditional Christian iconography, so is the angel for the evangelist Matthew. The symbols for the other three evangelists are: the eagle for John, the lion for Mark and the she-ox for Luke. These four creatures also occur in the Revelation of St John 4, 6–8: "And round about the throne, were four beasts. . . . And the first beast was like a lion and the second beast like a calf, and the third beast had a face as a man, and the fourth beast was like a flying eagle." In the painting, the angel stands on the left, behind Matthew; only his face and hand are visible, the hand resting on Matthew's shoulder, as he appears to dictate the words of the Gospel into

ALEXANDER THE GREAT
Oil on canvas; $54\frac{1}{8} \times 41\frac{1}{8}$ in
(137.5×104.5 cm)
(Two strips were added to the canvas by Rembrandt; it first measured 115.5×87.5 cm).
Circa 1655
Glasgow, Art Gallery and Museum
(Br. 480)
This painting is probably one of the three commissioned from Rembrandt by Count Ruffo of Messina. The addition of the two strips was presumably requested by the Count.

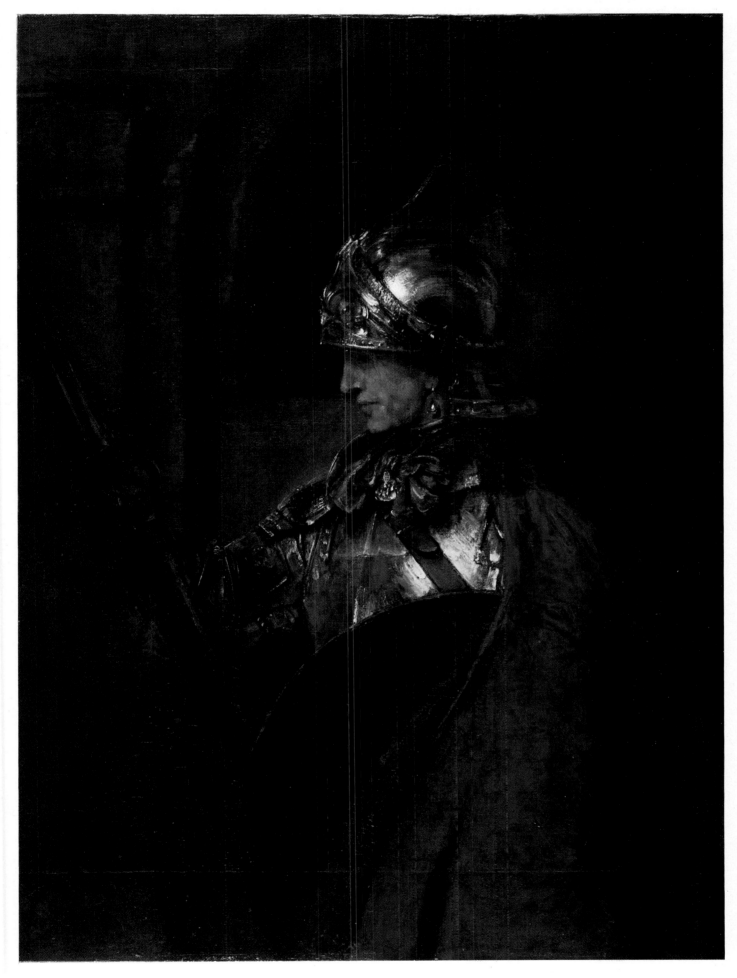

Matthew's ear. The angel has a dual function in the painting: he is both the symbol for Matthew and the direct source of inspiration from God. It is particularly striking in this painting how Rembrandt adapts the purely iconographical tradition to a penetrating and entirely personal representation of Matthew's inspiration. The youthfulness of the face of the angel is in sharp contrast to the rough, lined face and hands of the old Matthew who, unconscious of the ethereal presence of the angel, waits for divine knowledge.

It has already been mentioned in the context of our discussion of Rembrandt's "portrait" of the philosopher Aristotle (p. 131) that he had dispatched by boat a painting, probably of Alexander the Great, to the Sicilian nobleman, Don Antonio Ruffo, in the summer of 1661. We learn from the archives of the Ruffo family that Rembrandt in fact painted Alexander twice, because Ruffo was not totally satisfied with the first painting. This is perhaps hardly surprising, since Rembrandt had enlarged what was originally only a portrait head of Alexander by sewing on additional strips to all four sides of the canvas and then enlarging the portrait to the half-length which he had been commissioned to paint.

Two paintings are known in which a figure in full armor is represented and which can be identified as either Athene or Alexander the Great

STUDY FOR THE CONSPIRACY
OF THE BATAVIANS
Ink and watercolor; $7\frac{3}{4} \times 7$ in
(19.6 × 18 cm)
Munich, Staatliche Graphische
Sammlung
(Benesch 1061)

THE CONSPIRACY OF (CLAUDIUS) CIVILIS: THE OATH
Oil on canvas; $77\frac{1}{4} \times 121\frac{3}{4}$ in (196 × 309 cm) (originally 550 × 550 cm)
1661
Stockholm, Nationalmuseum (Br. 482). Sold at auction on August 10, 1734 and acquired by Nicolaes Cohl. Given to the Swedish Academy by the heirs of Cohl.

The Batavians swore an oath before Claudius Civilis to fight against the Roman invaders. The painting was commissioned, together with seven others, by the City Council of Amsterdam, to decorate a long gallery in the new Town Hall. Records show, however, that the painting was returned almost immediately to Rembrandt for modifications, perhaps because his treatment of the subject was not considered "heroic" enough.
Pages 158–159: Detail

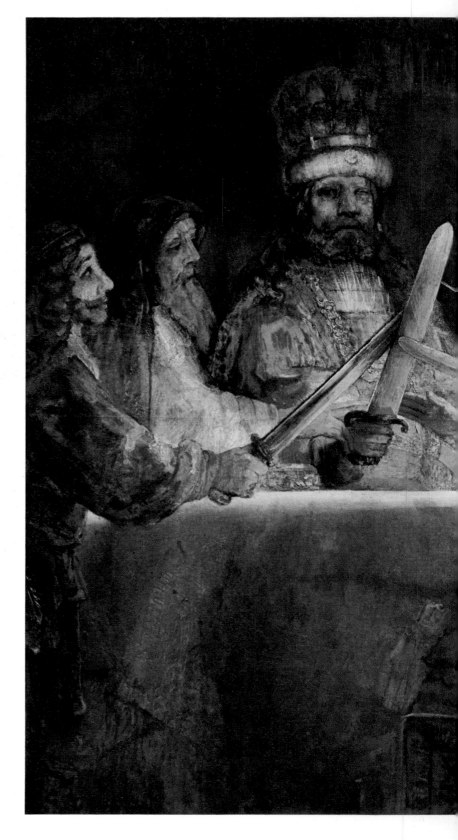

(Bredius/Gerson 479, 480). This confusion of subject may appear strange, since there should normally be considerable differences between them: goddess or historical figure, woman and man. There is nevertheless an explanation for this: both figures appeared on the face and reverse side of Greek coins, and in this way their likenesses may have become confused. All the attributes of Athene are to be found in the Alexander portraits: the shield of Medusa, the long curls of hair and the owl. It is not known for certain, however, if these two paintings are those mentioned in the Ruffo family records. The version illustrated here (Glasgow, Art Gallery, Bredius/Gerson 480, illustration p. 155) is the earlier one of 1655, and shows the signs of having been enlarged on all four sides to accommodate the half-figure; it is therefore generally accepted that this is the first Ruffo version.

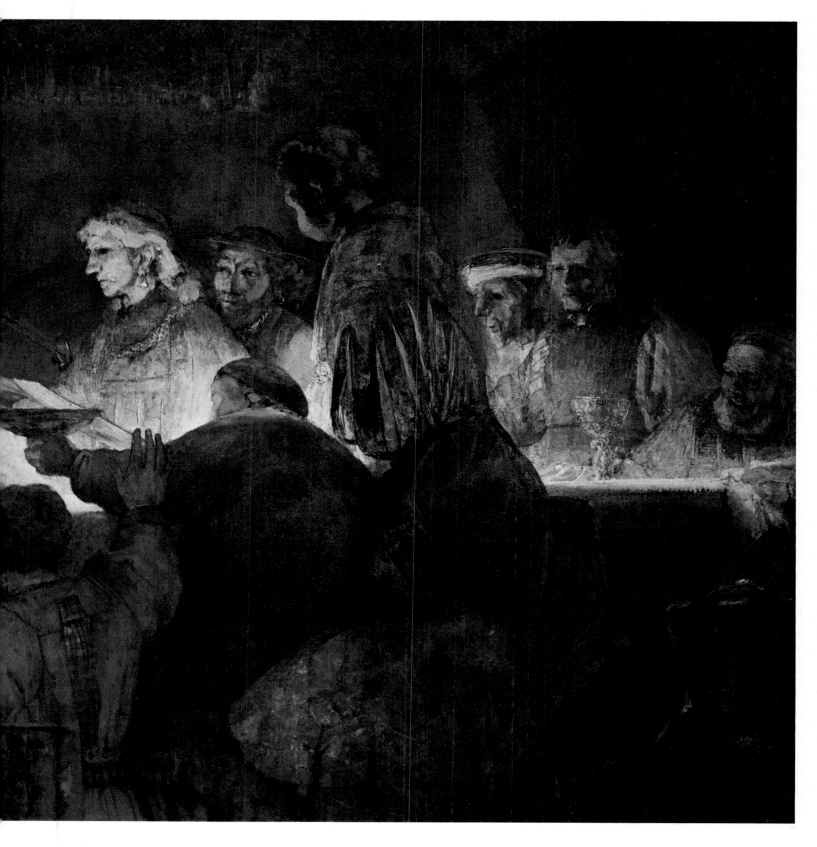

The other painting (Bredius/Gerson 479) is not reproduced here, but is a very similar composition, although the shield takes up almost the whole of the lower section of the canvas. The face – perhaps more feminine and certainly more youthful – is more brightly illuminated and directed more towards the spectator. The figure is seen from the side, with the head turned towards the left; in relation to the size of the canvas, it is painted on a larger scale than the earlier version reproduced here.

About 1660 Rembrandt was commissioned by the Amsterdam authorities – for the first and only time – to do a painting to hang in the new town hall. There had existed plans since 1639 for the building of a new town hall on the Dam. The expanding town had seen its fame and wealth increase and it seemed fitting that it should have a town hall which would adequately reflect its prosperity; it was also a fact that the old town hall was gradually becoming too small and delapidated. In 1648, the year in which the Treaty of Münster was signed with Spain and the Republic of the Netherlands was officially recognized, the first foundations of the new town hall were laid down. The building was designed by Jacob van Campen and was generally considered to be an example of modern classical architecture. It was the pride of Amsterdam, being portrayed frequently and praised in the work of a large number of poets.

Rembrandt does not seem to have shared this admiration, and he was certainly not especially interested in the new building. Although he drew many of the buildings of Amsterdam, we do not even know of the existence of a casual sketch by him of the new, much-admired town hall. He did, however, draw the picturesque ruins of the old town hall, which went up in flames while it was being demolished (p. 160).

On the occasion of the opening of the new building in 1655, the great Amsterdam poet Joost van der Vondel wrote a long poem entitled *Inwiidinge van Stadhuis t'Amsterdam* (Inauguration of the Amsterdam Town Hall), at the request of the owners of the building, in defense of the high costs. The poem is also a very considerable source of information about the building history of the town hall, which was still far from finished when the poem was written. The mayor of Amsterdam also had very ambitious plans for the interior decoration of the new building. A program of paintings with suitable, morally improving subjects from classical and biblical literature was drawn up for the embellishment of the council chambers and other offices. For the office of the treasurer, for instance, the appropriate theme of "Joseph's provident management" was chosen, while "Solomon's judgement," as an example of justice, was destined for the law court. To suit the dignity, simplicity and courage of the mayors, suitable themes were sought in the lives of the Roman consuls; such as Manlius Curtius Dentatus, who preferred to eat turnips rather than accept the gold of the enemy. And the Batavian Revolt under Julius Civilis against the Romans, an example for the young Republic in the struggle to free itself from Spanish domination under the leadership of the House of Orange, was also among the themes chosen. This revolt was to be the subject of a decorative painting in the gallery, which was in effect a wide corridor on the first floor of the town hall. Rembrandt was commissioned to paint the famous nocturnal conspiracy of Julius Civilis in the wood. Govaert Flinck, Rembrandt's pupil, had originally been commissioned to paint the series of paintings on the Batavian revolt, but after his death in 1660, Rembrandt was asked to paint the picture of the oath. Only a fragment of this picture has survived and is now in the National Museum in Stockholm (Bredius/Gerson 482, illustration pp. 156–157). An unsigned drawing still gives us an idea of the original grandiose conception of the painting (Benesch 1061). The date of the painting is unknown, but it must have been started before July 1662. Melchior Fokkens, an Amsterdam historian, mentions the painting in a description of the new town hall in that year in his *Beschrijen der wijdt vermaarde koop-stadt Amstelredam* (Descriptions of the famous trading town of Amsterdam). Fokkens had seen Rembrandt's painting hanging on the south side of the gallery and goes on to

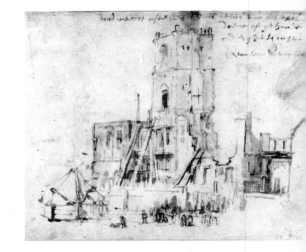

THE OLD TOWN HALL OF
AMSTERDAM AFTER THE
FIRE
Ink drawing
1652
Amsterdam, Rembrandtshuis
(Benesch 1278)

160

give a detailed description of it. Julius Civilis had summoned all the most prominent and admired men of the region to the wood where a banquet had been prepared, in order to organize a rebellion against the Roman occupation. The guests are first plied with wine, then drawn into a discussion of the courage of the local men and the oppressive nature of the occupation. The bravest of the guests finally accept Civilis' propositions and bind themselves to him with an oath, while Civilis curses those who are too frightened to join. A large golden mug of wine is drunk in celebration and the those who have joined the rebellion promise to follow Civilis wherever he goes. This is the subject of the first painting, by Rembrandt.

The painting did not hang in the town hall for very long. Unfortunately we do not possess the details of the painting's history, but there must have been some difficulty, because Rembrandt took the canvas back for repainting. After this, it was never hung again in the place for which it had been destined. The probable rejection by the Amsterdam authorities of Rembrandt's *Julius Civilis* has been the subject of a number of theories, of which that put forward by H. van de Waal seems the most plausible.

In 1612 a popular book appeared on the Batavian Revolt, in which parts of the original text on the episode by the famous Roman historian Tacitus were included. This book was lavishly illustrated with thirty-six stylish prints by the Italian Antonio Tempesta, after works by the Leyden painter and humanist Otto Vaenius (Otto van Veen), the master of Rubens. The prints in the book which was reprinted several times, came to be accepted as the traditional representations of the subject. In short, they established the norm for the presentation of scenes from national history.

Thus, Tempesta's etching after Vaenius of the taking of the oath in the wood was probably considered by the authorities in Amsterdam to be an acceptable model for the painting they commissioned from Rembrandt. Rembrandt, however, did not imitate the traditional prototype, but instead went back to the original story in Tacitus. The Roman historian describes

THE SAMPLING-OFFICIALS OF THE CLOTH-MAKERS' GUILD AT AMSTERDAM ("DE STAALMEESTERS")
Oil on canvas
Bears a double signature and double date: "Rembrandt f. 1662" on the table cloth, and on the upper right the apocryphal: "Rembrandt f. 1661."
Amsterdam, Rijksmuseum. (Br. 415)
On loan from the City of Amsterdam (August 15, 1808). Preliminary drawings are kept at the Kupferstichkabinett in Berlin (the three figures on the left: Benesch 1178), in Amsterdam (the figure seated on the extreme left: Benesch 1179) and at the Boysmans–van Beuningen (Benesch 1180).
Pages 162–163: Detail

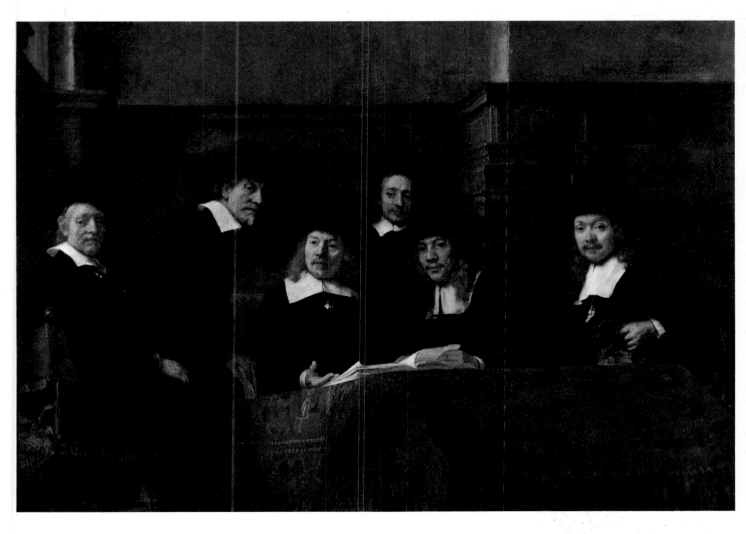

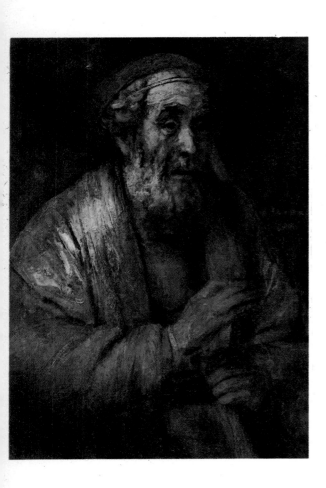

HOMER DICTATING TO TWO
SCRIBES
Fragment
Oil on canvas; 42½ × 32½ in
(108 × 82.5 cm)
Only the last letters of the signature
and the date are still visible:
... and f. 1663
The Hague, Mauritshuis (Br. 483)
This painting has been half destroyed
by fire. The original composition must
have included two other disciples; this
fact emerges from an inventory of
Count Ruffo's collection, the Count
having originally commissioned the
painting. A drawing by Rembrandt
and a painting by his pupil Aert de
Gelder are kept in Stockholm (Benesch
1066) and in Boston respectively.

how Julius Civilis swore in the guests following the enactment of barbaric
rituals, the better to shake off the effects of Roman domination. Rembrandt
follows the text closely in his usual fashion and stresses the details
mentioned by Tacitus: shown frontally, sitting behind a table, the
impressive, one-eyed Civilis towers above his fellow-conspirators, who
ominously take the oath with their swords crossed. This is contrary to the
accepted example in Tempesta's print, in which Civilis is seen in profile to
conceal his optical infirmity. This is also in keeping with Alberti's theories on
the subject. Apelles, the famous Greek painter of the fourth century BC
painted Antigonus in profile, so that his bad eye would not be visible. It was
thought that the face of a hero should be noble and perfect, and to show one
with only one eye was not therefore fitting. In Tempesta's print, the taking
of the oath is shown according to all accepted practice: by proffering the
right hand, the *junctio dextrarum*, in the Roman way, although Tacitus
describes the ceremony as being "barbaric." Rembrandt was also conscious
of the problems created by showing the figures round a table, which had
become one of the great tests of a painter since Leonardo and Tintoretto. In
his *Julius Civilis* Rembrandt finds a new, brilliant solution to the problem,
which places this painting on a par with Leonardo's *Last Supper*. Clearly,
this artistic excellence was not obvious to everybody.

It should also be noted that Rembrandt gives the scene an ominous,
monumental quality through the effect of the nocturnal light, which must
have best expressed for him the importance of the revolt. In his individual
solution to the problems of form, in his rough, direct interpretation of the
original text, Rembrandt displays an extraordinary gift for realizing the
realities of such a situation and a very rare insight. The argument which
probably weighed most heavily against this masterpiece was that it did not
follow the expected pattern for the presentation of the national hero and
thereby sinned against the principle of "propriety" or "decorum." It was
expected that the figures, composition and style of such a heroic and
important subject should also be heroic and follow the classical ideals of
beauty and proportion, as had been the case in the work of Otto Vaenius and
Tempesta. Rembrandt committed the error of representing Civilis as he was,
and not as he might have been.

Rembrandt's disregard for what was "proper" in art, which was to be a
matter for constant reproach by classical art critics, was clearly already out
of step with the increasing orientation of taste towards classical ideals
during the 1650s. And the rules were clearly expected to be followed in the
case of such official buildings as the new town hall. It is not surprising, then,
that Rembrandt's highly personal and all too convincing treatment of the
work could not be allowed to remain as an exemplary public painting.

A totally different painting is *The Sampling-Officials of the Cloth-Makers'
Guild at Amsterdam*, dated 1662, and one of the greatest achievements of
Rembrandt's later years. With *The Night Watch* it is a well-known
attraction at the Amsterdam Rijksmuseum (Bredius/Gerson 415, illus-
tration pp. 161, 162–163). The painting originally hung in the Cloth Hall, the
official building of the cloth makers. The syndics of the Cloth Hall were
responsible for the control of color and quality in the cloth industry.
Broadcloth was a finely woven, woolly material, which had a great variety of
uses, including the manufacture of clothes, for which it is now rarely used.
The cloth trade was a particularly important industry, and Leyden, like
Amsterdam, owed its prosperity to it.

The sampling-officials have been painted in such a lively and interesting
fashion that the painting has attracted many fanciful and confusing
interpretations. In a perceptive article, written in 1956, H. van de Waal did
succeed in stripping the painting of some of the layers of well-meaning, but
often erroneous, interpretation.

Since the middle of the nineteenth century, the painting of the sampling-
officials, like the group-portrait of Dr Tulp and his pupils of 1632, has been
thought of as an "eye-witness" account of an actual event. The

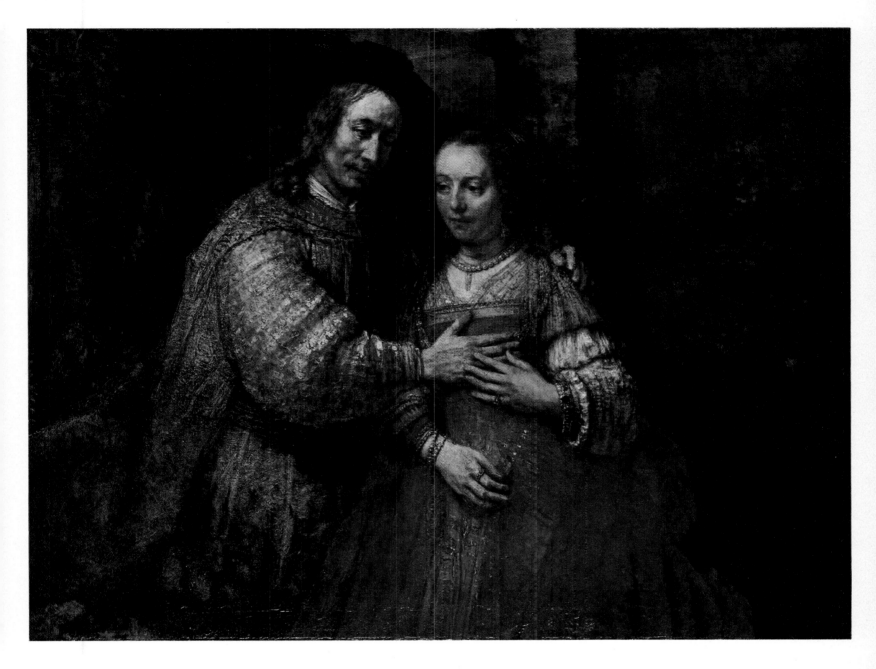

"THE JEWISH BRIDE"
Oil on canvas; 48 × 65½ in
(121.5 × 166.5 cm)
Signed and dated: Rembrandt f. 16 .
. . (probably cut on the right, with
part of the signature).
Circa 1666
Amsterdam, Rijksmuseum (Br. 416)
Given to the City of Amsterdam in
1854.
Lent to the Museum in 1885.
The scene was probably based on a
previous drawing by Rembrandt in
which Isaac and Rebecca are shown
being spied upon by Abimelech (Ben-
esch 988). The two characters are
almost certainly portraits of con-
temporaries.

interpretation of the event varies according to the period and the
circumstances of those who are describing the painting. It was thought, for
instance, that the table behind which the officials are sitting is placed on a
platform; the officials of the guild have just presented a report of their
findings to a gathering of the other members of the guild, who are not
represented in the painting, so that we, the spectators, occupy the same
place as those members; the officials are just on the point of leaving, and one
of them has already got up, when there is an interruption from the public;
the official, who has already risen, looks up, while the others react to the
question in their individual ways.

It is hardly possible that Rembrandt could have intended this frozen-
moment, snap-shot effect, since photography did not exist in the
seventeenth century and the analogy is therefore not valid. Those elements
in the painting – especially the hands and the attitudes of the officials – play
an important role in the structure of the work and are in any case susceptible
to straightforward interpretation. Even the suggestion that the table is
placed on a platform is invalidated by a reconstruction of the original
position of the painting: it would have been hanging high on a wall, whereby
the seen-from-below effect is easily explained.

Beneath all the misunderstandings of the nineteenth and twentieth
centuries, the painting is not some kind of stage set, or even the report of an
actual event. The painting of *The Sampling-Officials* is important because it
is yet another solution to the pictorial problem which Rembrandt had

confronted before in *Samson's Wedding* and *The Conspiracy of Julius Civilis*, and which he now confronts in the context of a portrait: how to present a number of people seated around a table. As we can see, his solution to the problem is both natural and lively.

The table around which the men are grouped is rectangular and is placed diagonally within the implied space of the painting, so that the unoccupied short side faces forward towards the right. The left corner of the table, over which the red oriental cloth hangs heavily is positioned about the center of the foreground. Four of the officials, who are shown wearing their hats, are seated around the table. Two are behind the open book, with the other two to the left and right of them. The pictorial problem is created by the fifth figure: if Rembrandt had shown him in the place obviously destined for him, then this official would have been seen from the back and the purpose of the portrait would have been defeated. For this reason, he is shown standing between the official on the far left and the one in the center; the vacant space thus created is emphasized by the bright light which falls upon the warm red table cloth at that point. Firstly, this brings the otherwise empty foreground space alive through the alternation of light and shade. In the second place, by having this official stand among the other cloth-makers, he introduces variety to the row of heads, which would otherwise be all on one level in the composition. The other standing figure, the hatless assistant, also helps to introduce variety. Although the figures portrayed, then, are all virtually on the same plane as the picture, Rembrandt's handling of space does create the impression that they really are seated round the table. The horizontal structure of the group portrait is further accentuated by the horizontal line of the panelling above the heads and the line of the table surface beneath; it is however broken by the diagonal and vertical elements of the two standing men, thus achieving a varied, yet dignified effect. This effect is reinforced further by the controlled but lively use of color. The red cloth, which occupies the foreground, is balanced by the predominantly dark group – especially the dark costumes of the clothmakers – in the middle ground of the canvas. The red harmonizes with the tones and colors of the rest of the painting and is picked out again here and there, as in the chair back, the faces and in the reddish tints of the predominantly brown background.

The Sampling-Officers of the Cloth-Makers' Guild demonstrates Rembrandt's domination of image, form and color and indicates how far above his pupils and contemporaries he stood. The simplicity and apparent ease of expression shown demands our deepest admiration.

The subject of Homer, the blind Greek poet recurs several times in Rembrandt's work. He is represented in *The Hundred Guilder Print* of about 1650; or at least his features are used to give added weight to the intellectual content of the etching. Rembrandt also drew a picture of Homer reading his poetry for Jan Six in 1652. It is not known whether Rembrandt or Ruffo chose the subject for the painter's first commission for the Sicilian nobleman; whatever the case, the subject was Aristotle, the official philosopher of Dutch Calvinism, but a bust of the great Homer is also included in the painting. In 1663 he painted *Homer Dictating to a Scribe* (The Hague, Mauritshius, Bredius/Gerson 483, illustration p. 164), of which only a fragment has survived.

As we have noted before, Homer's great epics, *The Iliad* and *The Odyssey* were held in very high esteem in the Northern Netherlands during the seventeenth century. Homer was considered to be the only truly original poet, who had not borrowed from other sources for his epics. Although blindness was traditionally associated with evil, Homer's blindness seems to have been an exception. It was, indeed, considered to be the means which enabled him to contemplate "inner" visions, undisturbed by the sensory perception of daily, trivial matters. It is not surprising that the *contradictio in terminis* of the blind seer fascinated Rembrandt, since the painter was always much more concerned with representing the inner motives of his human subjects than the grace of their exterior appearance and actions. This

A WOMAN HOLDING AN
OSTRICH FEATHER FAN
Oil on canvas; $39\frac{1}{4} \times 32\frac{5}{8}$ in (99.5 × 83 cm)
Signed and dated:
Rembrandt f. 166

Circa 1667
Washington, National Gallery of Art, Widener Collection (Br. 402)
This painting is a pendant to another portrait, *A Man Holding Gloves*, in the same museum.
Opposite page: Detail

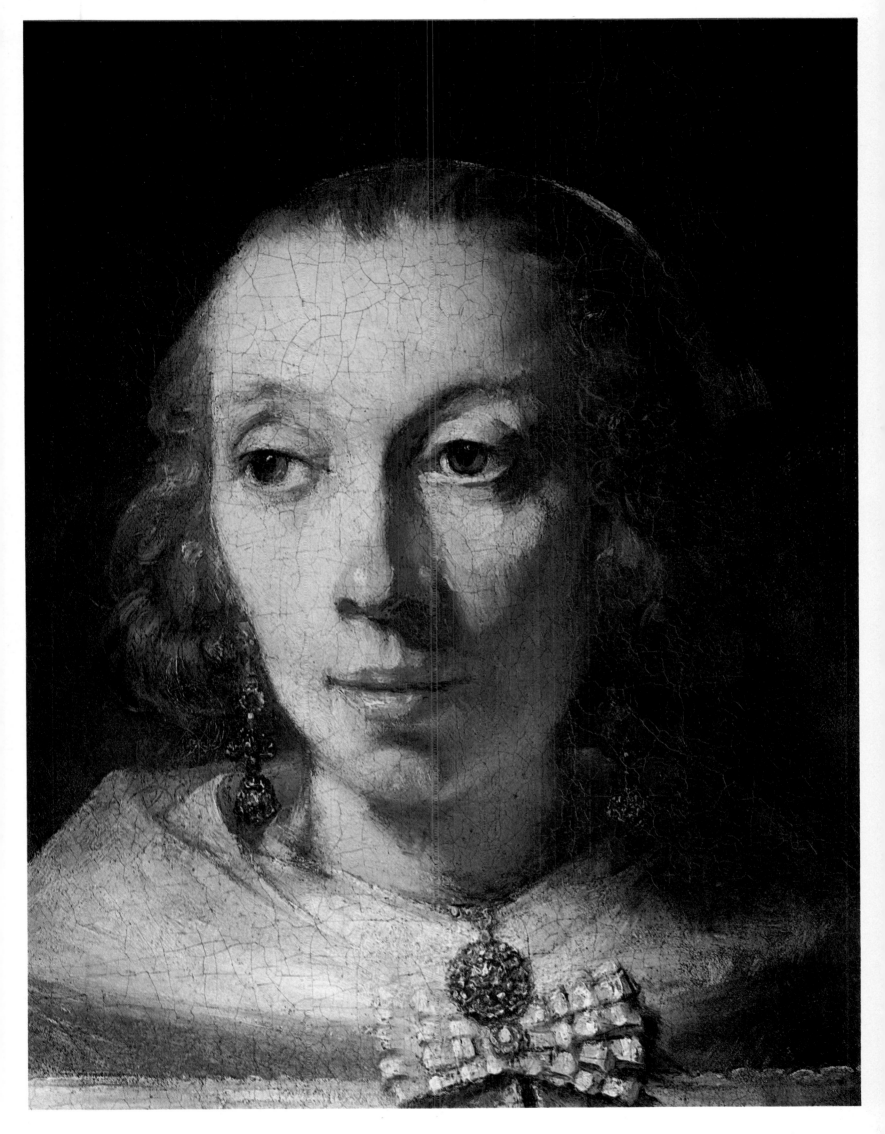

preoccupation becomes increasingly clear in Rembrandt's later work.

In 1663 a painting of Homer was commissioned from Rembrandt by Don Antonio Ruffo as a second and final pendant to the portrait of Aristotle; to add to that of Alexander the Great. It is described in the Ruffo inventory as "Homer, sitting, dictating to two pupils, half-figure, life-size" (*Omero seduto che insegna a due discepoli, mezza figura al naturale*), and had the same dimensions as the other two paintings by Rembrandt in Ruffo's possession. As in the case of the portrait of Alexander, Ruffo raised some objections to the painting, because he did not regard it as finished. It was then returned to Rembrandt, who finished it off, and it was finally approved and accepted by Ruffo in 1663. The form of the original painting is known from a drawing by Rembrandt (Stockholm, Benesch 1066) and from a copy painted by Rembrandt's pupil, Aert de Gelder, which is now in Boston.

One of Rembrandt's most mysterious, yet at the same time most expressive paintings was given the distinctly anecdotal and probably erroneous title of *The Jewish Bride* (Amsterdam, Rijksmuseum, Bredius/Gerson 416, illustration p. 165) at the beginning of the nineteenth century. The painting shows a couple against a brownish background; the man is dressed in a costume of gold brocade, with a dark hat, while, beside him, the woman is swathed in a dress of deep red. The identity of the two figures is unknown, nor do we know in what situation they are represented. It cannot be established with any certainty whether the woman is Jewish or not, let alone whether she is a "Jewish bride." Almost all the couples in the Bible have been suggested as possible subjects, but never satisfactorily, and no detail has yet been discovered to yield the key to a sound interpretation.

As Rembrandt became older, he limited himself more and more to conveying the main point of the painting, and this is very evident in this double portrait, where it is the tranquil, loving relationship between the man and the woman. This relationship is suggested to a considerable degree by the position of the hands, which is always important to Rembrandt in the expression of emotional states. If we look back for a moment to one of the earliest known paintings by Rembrandt, *The Martyrdom of St Stephen* (p. 10) and note the relatively uncoordinated expressiveness of all the various hands and the attitudes of the figures, and compare it with the simple, harmonious treatment of the couple in the late painting, we can see just how far Rembrandt's painting had developed in forty years, although his fundamental aims had remained the same. Form in the later work is indicated entirely through color, and the spectator is thus almost expected to finish off the painting himself.

Rembrandt's late technique is demonstrated especially well in the portrait of *A Woman Holding an Ostrich-Feather Fan* (Washington, National Gallery of Art, Bredius/Gerson 402, illustration pp. 166, 167), of which a detail is shown here. The portrait shows a woman of some dignity in slightly more than half-length. Although she is simply dressed, her jewels point to great prosperity. The use of color is limited to dark-brown and black for the background and dress, in which lighter accents are carefully grouped. The light falls from the upper left corner of the canvas. If the painting is divided horizontally into two equal parts, above this imaginary line which runs through the black of the dress can be seen the light area of the face and neck and the collar which falls over the shoulder. These elements stand out against the dark background and, together, form a triangle, which the spectator can complete. Below the imaginary line, the two light cuffs, the hands and the ostrich-feather form a reflection of the upper triangle. The crossed hands are repeated in detailed reflection in the butterfly-shaped brooch on the collar. The integration of these various elements into a satisfactory overall composition brings an interest to a subject which could easily have been intrinsically tedious.

In 1669, the year in which he died, Rembrandt painted a number of self-portraits, of which the half-length *Self-portrait* (London, National Gallery, Bredius/Gerson 55, illustration p. 168) is reproduced here. His sense of

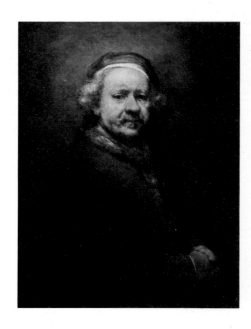

SELF-PORTRAIT (HALF-FIGURE)
Oil on canvas; $33\frac{7}{8} \times 27\frac{3}{4}$ in (86 × 70.5 cm) (a strip about 3 cm in width has been cut from the left side of the painting).
Signature almost unreadable: . . .
t(?) f. 1669
London, National Gallery (Br. 55)
Acquired in 1851.

FAMILY GROUP
Oil on canvas; $49\frac{1}{2} \times 65\frac{3}{4}$ in (126 × 167 cm)
Signed: Rembrandt f.
Circa 1667–1669
Brunswick, Staatliche Herzog-Anton-Ulrich-Museum (Br. 417)
According to W. R. Valentiner, the group is composed of Magdalena van Loo, the wife of Titus, with their children and her brother-in-law, François van Bylert.

structure and his command of his brush are just as sure in this mature portrait of a man who existed for and through his paintings.

The *Family Group* (Brunswick, Herzog Anton Ulrich Museum, Bredius/Gerson 417, illustration p. 169), which must have been painted about 1668, was probably never finished. The mother sits with her three children, one on her lap, in the foreground; all these figures are picked out in light colors. Of the man dressed in dark clothing, standing behind the foreground group, only the face is clearly distinguishable, as it stands out against the dark background. The whole family forms a tight, intimate structure, which heightens the overall sense of liveliness. All the elements which characterize Rembrandt's work are present here. The figures come forward, clear and bright, out of the dark background, although here and there they are only sketchily indicated. Red, in all its tones, is the dominant color, and determines the atmosphere of the painting.

As we have already seen, Rembrandt several times used episodes from the parable of the Prodigal Son (Luke 15, 11–32) as subjects for his works. One of his last biblical-historical works shows the decisive moment in the story: *The Return of the Prodigal Son* (Leningrad, Hermitage, Bredius/Gerson 598, illustration p. 170). The most important fragment of the painting in Rembrandt's hand is reproduced here; the other three figures were probably added by pupils. The fragment shows the totally impoverished son from the

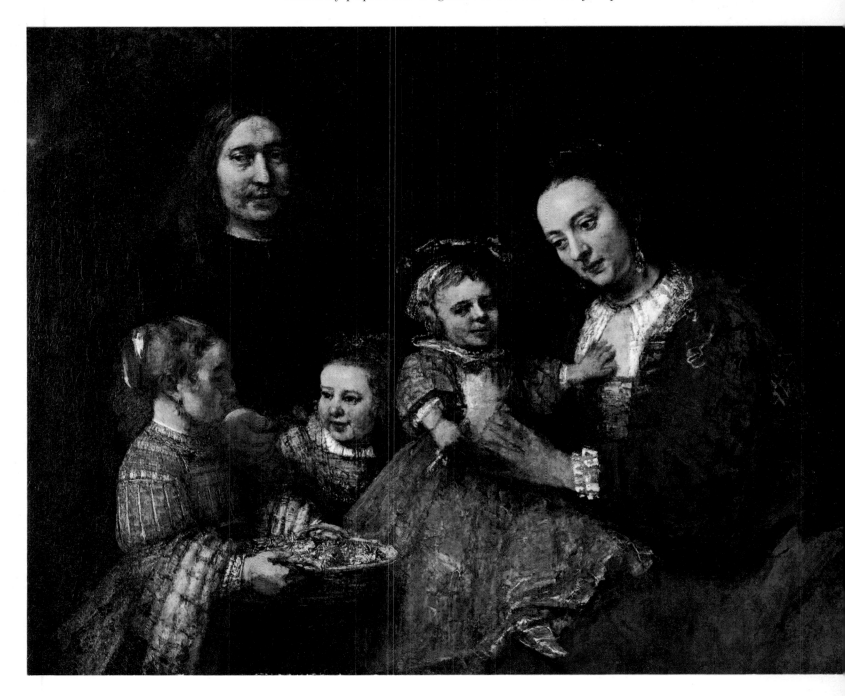

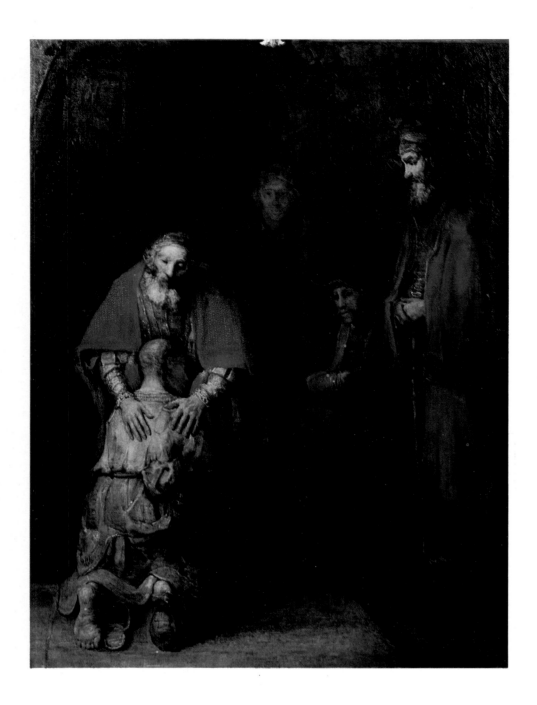

THE RETURN OF THE
PRODIGAL SON
Oil on canvas; 103 × 81 in
(262 × 206 cm)
Circa 1668?
There is some doubt as to the
authenticity of the signature: R v.
Rijn f.
Leningrad, Hermitage (Br. 598)

back, now dressed in rags and kneeling before his old father, who, according
to the text, was "moved with pity." This sentiment is translated by
Rembrandt into visual terms by the manner in which the father rests both
his hands on his son's shoulders. Rembrandt thus conveys to us the
understandably tender relationship between the father and the son who had
been assumed lost and had now returned. The painting is no longer an
illustration of the story, but a representation of a universally valid human
emotion. And that rendering of that emotion was the task which
Rembrandt, the greatest of historical painters, had always set himself.

Catalog of extant paintings

This catalog of Rembrandt's paintings is based essentially on Abraham Bredius' *The Paintings of Rembrandt*, published in 1935 and considered a classic among Rembrandt studies. It is further based on the 1968 edition, edited by Horst Gerson who collaborated with Bredius in the compiling of the first edition. In the meantime, a number of works previously attributed to Rembrandt had been shown to be those of his pupils, while others, since proved to be genuine works of the master, have come to light. The most recent of these is *The Baptism of the Eunuch*, which is reproduced on page eleven. Because in Rembrandt's case, perhaps more so than any other artist, the problems of attribution are so complex, we have listed in the table at the end of the catalog works which according to the most recent studies are accepted as authentic and those attributed to other hands. We have finally endeavored, as far as possible – given the difficulty of identifying in time the numerous undated paintings – to place the works in chronological order so as to enable the reader to follow the artistic evolution of the great Dutch master.

1

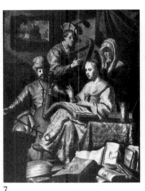

6

7

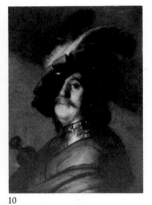

10

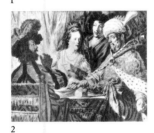

2

4

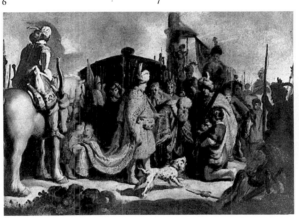

8

11

7. The Music Makers
Oil on panel; 24¾ × 19 in
(63 × 48 cm)
1626
Paris, private collection

8. David Presenting the Head of Goliath to Saul
Oil on panel; 10¾ × 15½ in
(26.5 × 38 cm)
1626(?)
Basle, Öffentliche Kunstsammlung

9. The Justice of Brutus
Oil on panel; 35¼ × 47½ in
(91 × 121 cm)
1626
Leyden, Stedelijk Museum "De Lakenhaal"

10. A Warrior
Oil on panel; 15½ × 11½ in
(39.5 × 29.5 cm)
Circa 1626–1627
Lugano, Thyssen-Bornemisza Collection

11. Diana Bathing
Oil on panel; 7 × 6½ in
(18 × 17 cm)
Circa 1626–1632
Amsterdam, Kleiweg de Zwaan Collection (from a Benesch engraving 201)

3

1. The Martyrdom of St. Stephen
Oil on panel; 35½ × 48½ in
(89.5 × 123.5 cm)
1625
Lyons, Musée des Beaux-Arts

Rembrandt and/or Jan Lievens?
2. The Wrath of Ahasuerus
Oil on canvas; 51¼ × 65 in
(130 × 165 cm)
Circa 1625
Raleigh, Museum of North Carolina

5

3. Anna Accused by Tobit of Stealing the Kid
Oil on panel; 15½ × 11¾ in
(39.5 × 30 cm)
1626
Amsterdam, Rijksmuseum, on loan from Baroness Bentinck-Thyssen Bornemisza

9

4. The Ass of Balaam
Oil on panel; 25½ × 18½ in
(65 × 47 cm)
1626
Paris, Musée Cognacq-Jay

5. The Baptism of the Eunuch
Oil on panel; 25¼ × 18¾ in
(64 × 47.5 cm)
1626 Utrecht,
Aartbisschoppelijk Museum

6. Christ Driving the Money Changers from the Temple
Oil on panel; 17 × 13 in
(43 × 33 cm)
1626
Moscow, Pushkin Museum

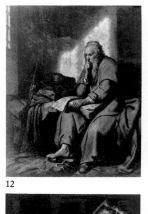

12

16

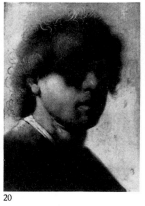

20

24

27

13

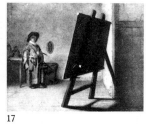

17

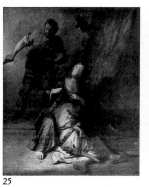

21

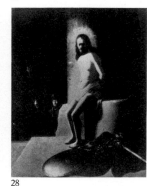

25

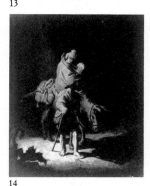

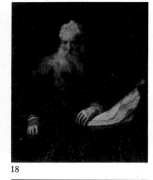

14

18

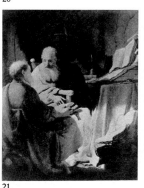

22

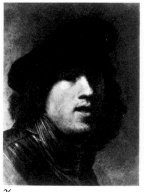

26

28

15

19

23

29

30

12. The Apostle Paul in Prison
Oil on panel; $28\frac{3}{4} \times 23\frac{3}{4}$ in
(73×60 cm)
1627
Stuttgart, Staatsgalerie

13. "The Money Changer"
Oil on panel; $12\frac{1}{2} \times 16\frac{1}{2}$ in
(32×42 cm)
1627
Berlin, Staatliche Museen
Preussischer Kulturbesitz,
Gemäldegalerie

14. The Flight of the Holy Family into Egypt
Oil on panel; $10\frac{1}{2} \times 9\frac{1}{2}$ in
(26.5×24 cm)
1627
Tours, Musée des Beaux-Arts

15. "Three Musicians"
Oil on panel; $12\frac{1}{2} \times 9\frac{3}{4}$ in
(32×25 cm)
Circa 1627–1628
Provenence: Hoevelaken,
van Aalst Collection

16. A Head Operation
Oil on panel; $12\frac{1}{2} \times 9\frac{3}{4}$ in
(32×25 cm)
Circa 1627–1628
Provenence: Hoevelaken,
van Aalst Collection

17. An Artist in his Studio ("The Easel")
Oil on panel; $10 \times 12\frac{1}{2}$ in
(25×32 cm)
Circa 1627–1628
Boston, Museum of Fine
Arts

18. The Apostle Paul
Oil on canvas; $53\frac{1}{4} \times 43\frac{3}{4}$ in
(135×111 cm)
Circa 1627–1630
Vienna, Kunsthistorisches
Museum, Gemäldegalerie

19. The Apostle Paul at his Desk
Oil on panel; $18\frac{1}{2} \times 15\frac{1}{4}$ in
(47×39 cm)
Circa 1627–1630
Nuremberg, Germanisches
Nationalmuseum

20. Self-portrait
Oil on panel; $9\frac{1}{4} \times 6\frac{3}{4}$ in
(23.5×17 cm)
Circa 1628
Kassel, Staatliche
Kunstsammlungen,
Gemäldegalerie

21. Two Scholars Disputing
Oil on panel; $28\frac{7}{8} \times 23\frac{1}{2}$ in
(71×58.5 cm)
1628
Melbourne, National
Gallery of Victoria

22. Christ at Emmaus
Paper on panel;
$15\frac{1}{4} \times 16\frac{1}{2}$ in (39×42 cm)
Circa 1628
Paris, Musée Jacquemart-André

23. A Foot Operation
Oil on panel; $12\frac{1}{2} \times 9\frac{3}{4}$ in
(31.5×24.5 cm 1628
Zurich, E. Haab-Escher
Collection

24. St. Peter Denying Christ (?)
Oil on copper; $8\frac{1}{2} \times 6\frac{1}{2}$ in
(21.5×16.5 cm)
1628
Tokyo, Bridgestone
Museum of Art, Ishibashi
Foundation

25. Samson Betrayed by Delilah
Oil on panel; $23\frac{1}{2} \times 19\frac{1}{2}$ in
(59.5×49.4 cm)
1628
Berlin, Staatliche Museen
Preussischer Kulturbesitz,
Gemäldegalerie

26. Self-portrait
Oil on panel; 17×13 in
(43×33 cm)
Circa 1628–1629
Formerly at Lemberg,
Lubomirska Collection

27. Two Scholars Disputing
Oil on panel; $15\frac{1}{4} \times 12$ in
(39×30.5 cm)
Circa 1628–1629
Dortmund, Becker
Collection

28. Christ at the Column
Oil on canvas; $29\frac{1}{4} \times 25$ in
(74.5×63.5 cm)
Circa 1628–1629
London, formerly in
private collection

29. The Presentation of Christ in the Temple
Oil on panel; $21\frac{3}{4} \times 17\frac{1}{4}$ in
(55.5×44 cm)
Circa 1628–1629
Hamburg, Kunsthalle

30. The Abduction of Proserpine
Oil on panel; $32\frac{3}{4} \times 30\frac{3}{4}$ in
(83×78 cm)
Circa 1628–1629
Berlin, Staatliche Museen
Preussischer Kulturbesitz,
Gemäldegalerie

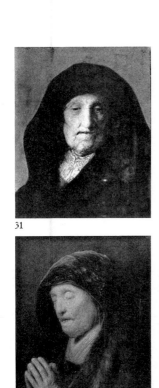

31

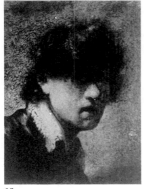

35

39

42

45

32

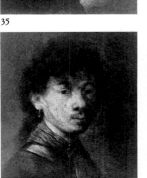

36

40

43

46

33

37

41

44

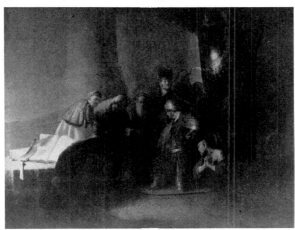

34

38

47

48

31. "Rembrandt's Mother"
Oil on panel; $13\frac{3}{4} \times 11\frac{1}{2}$ in
(35×29 cm)
Circa 1628–1629
Essen, von Bohlen und
Halbach Collection

32. "Rembrandt's Mother"
Oil on copper; 6×5 in
(15.5×13 cm)
Circa 1628–1629
Salzburg,
Residenzmuseum, on loan
from the Czernin Collection

33. A Scholar in a Lofty Room
Oil on canvas; $21\frac{11}{16} \times 18\frac{5}{16}$
in (55.5×46.5 cm)
Circa 1628–1629
London, National Gallery

34. A Scholar Writing
Oil on panel; $6 \times 5\frac{1}{4}$ in
(15.5×13.5 cm)
Circa 1628–1629
United States, private
collection

35. Self-portrait
Oil on panel; 6×5 in
(15.6×12.7 cm)
1629
Munich, Alte Pinakothek

36. Self-portrait
Oil on panel; $8\frac{1}{4} \times 6\frac{3}{4}$ in
(21×17 cm)
1629
Cambridge
(Massachusetts), Fogg Art
Museum, on loan from
James P. Warburg

37. Self-portrait
Oil on panel; 35×29 in
(89×74 cm)
1629
Boston, Isabella Stewart
Gardner Museum

38. Judas Returning the Thirty Pieces of Silver
Oil on panel; $31\frac{1}{2} \times 40\frac{1}{4}$ in
(76×101 cm)
1629
Mulgrave Castle (England),
Normanby Collection

39. The Tribute Money
Oil on panel; $16\frac{1}{2} \times 13$ in
(41×33 cm)
1629
Ottawa, National Gallery
of Canada

40. "Rembrandt's Father"
Oil on canvas; $7\frac{3}{4} \times 6\frac{3}{4}$ in
(20×17 cm)
1629
Cambridge
(Massachusetts), Fogg Art
Museum, on loan from
James P. Warburg

41. Portrait of Constantijn Huygens (?)
Oil on panel $10 \times 8\frac{1}{2}$ in
(25.5×21.5 cm)
Circa 1629
Formerly at Glasgow,
Beattie Collection

42. An Old Man Asleep at the Hearth
Oil on panel; $20\frac{1}{2} \times 16\frac{1}{4}$ in
(52×41 cm)
1629
Turin, Galleria Sabauda

43. Head of a Man
Oil on panel; $6\frac{1}{4} \times 5$ in
(16×13 cm)
Circa 1629
Oxford, Ashmolean
Museum

44 Head of an Old Man ("Rembrandt's father"?)
Oil on panel; $9\frac{1}{2} \times 8$ in
(24×20.5 cm)
Circa 1629
Wassenaar (Netherlands),
van den Bergh Collection

45. Head of an Old Man
Oil on panel; $7\frac{3}{4} \times 6\frac{1}{2}$ in
(19.5×16.5 cm)
Circa 1629
Copenhagen, Statens
Museum

46. Self-portrait (?)
Oil on panel; $16\frac{1}{4} \times 13\frac{1}{4}$ in
(41×34 cm)
Circa 1629–1630
Amsterdam, Rijksmuseum

47. Self-portrait
Oil on panel; $14\frac{3}{4} \times 11\frac{1}{2}$ in
(37.5×29 cm)
Circa 1629–1630
The Hague, Mauritshuis

48. Self-portrait
Oil on panel; $28\frac{1}{2} \times 22\frac{3}{4}$ in
(72.5×57.5 cm)
Circa 1629–1630
Liverpool, Walker Art
Gallery

49

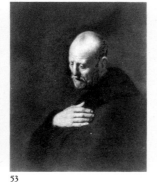

53

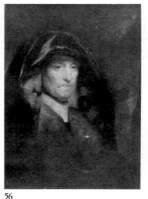

56

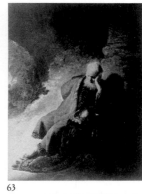

60

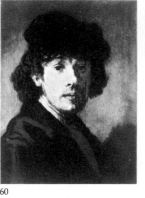

63

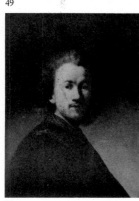

50

54

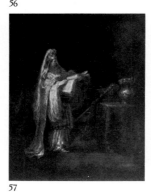

57

61

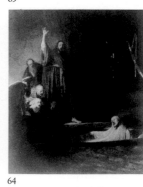

64

51

55

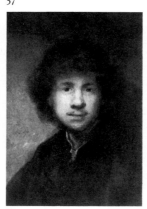

58

62

65

52

59

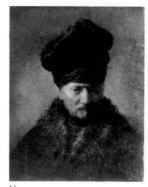

66

52. "Rembrandt's Father"
Oil on panel; 19 × 14½ in (48 × 37 cm)
Circa 1629–1630
Kassel, Staatliche Kunstsammlungen, Gemäldegalerie

53. "Rembrandt's Father"
Oil on panel; 29½ × 23½ in (74.5 × 60 cm)
Circa 1629–1630
Boston, Museum of Fine Arts

54. The Adoration of the Magi
Oil on panel; 29½ × 25½ in (75 × 65 cm)
Circa 1629–1631
Gothenburg, Konstmuseum

55. The Rest on the Flight into Egypt
Oil on panel; 30 × 25¼ in (76.5 × 64 cm)
Circa 1629–1631
Downton Castle (England), Kincaird-Lennox Collection

56. "Rembrandt's Mother"
Oil on panel; 23½ × 18 in (58.5 × 45 cm)
Circa 1629–1631
Windsor, Royal Collection

49. Self-portrait
Oil on panel; 7¾ × 6¾ in (20 × 17 cm)
Circa 1629–1630
Bindhoven, Philips-de Jongh Collection

50. Self-portrait
Oil on panel; 24 × 18½ in (61 × 47 cm)
Circa 1629–1630
Paris, private collection

51. "Rembrandt's Mother"
Oil on canvas; 29 × 24½ in (74 × 62 cm)
Circa 1629–1630
Salisbury, Wilton House, Pembroke and Montgomery Collection

57. Zacharias in the Temple
Oil on panel; 22¾ × 20½ in (58 × 47.5 cm)
Circa 1629–1631
Formerly at Amsterdam, de Boer Collection

58. Self-portrait
Oil on panel; 19¼ × 15½ in (49 × 39 cm)
1630
Aerdenhout (Netherlands), Loudon Collection

59. Self-portrait
Oil on copper; 6 × 4¾ in (15 × 12 cm)
1630 (?)
Stockholm, Nationalmuseum

60. Self-portrait
Oil on panel; 8¼ × 6¼ in (21 × 16 cm)
Circa 1630
New York, Metropolitan Museum of Art

61. David Playing the Harp Before Saul
Oil on panel; 24½ × 19¾ in (62 × 50 cm)
Circa 1630
Frankfurt, Städelsches Kunstinstitut

62. A Hermit Reading
Oil on panel; 23¼ × 18 in (59 × 46 cm)
1630
Paris, Louvre

63. The Prophet Jeremiah Mourning over the Destruction of Jerusalem
Oil on panel; 22¾ × 18 in (58 × 46 cm)
1630
Amsterdam, Rijksmuseum

64. The Raising of Lazarus
Oil on panel; 37 × 32 in (93.7 × 81.1 cm)
Circa 1630
Los Angeles, County Museum of Art

65. "Rembrandt's Mother"
Oil on panel; 6¾ × 5 in (17 × 13 cm)
Circa 1630
The Hague, Mauritshuis

66. "Rembrandt's Father"
Oil on panel; 8½ × 6¾ in (21.5 × 17 cm)
1630
Innsbruck, Tiroler Landesmuseum Ferdinandeum

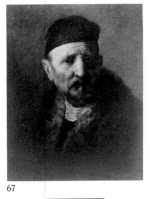

67

71

74

78

81

68

72

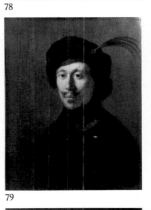

75

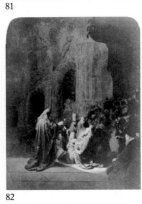

79

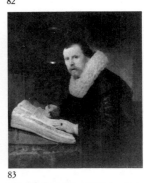

82

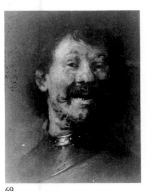

69

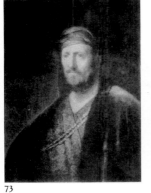

73

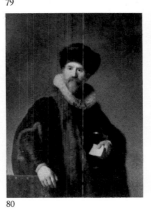

76

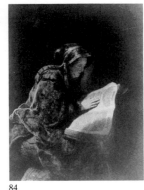

83

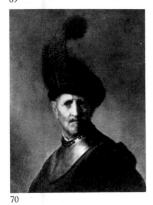

70

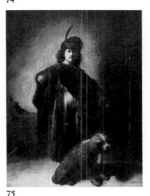

77

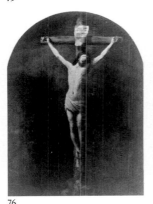

80

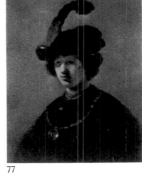

84

67. "Rembrandt's Father"
Oil on panel; 18½ × 15¼ in
(47 × 39 cm)
Circa 1630
The Hague, Mauritshuis

68. An Old Man with a Jewelled Cross
Oil on panel; 26½ × 22 in
(67.5 × 56 cm)
1630
Kassel, Staatliche Kunstsammlungen, Gemäldegalerie

69. A Man Laughing
Oil on copper; 6 × 4¾ in
(15.5 × 12.5 cm)
Circa 1630
The Hague, Mauritshuis

70. "Rembrandt's Father"
Oil on panel; 25½ × 20 in
(65 × 51 cm)
Circa 1630–1631
London, Mountain Collection

71. "Rembrandt's Father"
Oil on panel; 14¼ × 10¼ in
(35 × 26 cm)
Circa 1630–1631
Leningrad, Hermitage

72. "Rembrandt's Father"
Oil on canvas; 32⅞ × 29¾ in
(81 × 75 cm)
Circa 1630–1631
Chicago, Art Institute

73. A Man in a Turban
Oil on canvas; 32¾ × 25¼ in
(83 × 64 cm)
Circa 1630–1631
Philadelphia, Museum of Art

74. The Apostle Bartholomew
Oil on panel; 24½ × 18 in
(62 × 46 cm)
Circa 1630–1631
Worcester (Massachusetts), Worcester Art Museum

75. Self-portrait
Oil on panel; 31¾ × 21¼ in
(81 × 54 cm)
1631
Paris, Musée du Petit Palais

76. Christ on the Cross
Oil on canvas laid down on panel; 39½ × 28¾ in
(100 × 73 cm)
1631
Le Mas d'Agenais (France), Parish church

77. A Young Man in a Plumed Hat
Oil on panel 32 × 26 in
(81 × 67 cm)
1631
Toledo (Ohio), Museum of Art

78. A Young Man in a Turban
Oil on panel; 25½ × 20 in
(63.5 × 50 cm)
1631
Windsor, Royal Collection

79. A Young Officer
Oil on panel; 22 × 18 in
(55 × 45 cm)
1631
San Diego, The Fine Arts Gallery

80. The Amsterdam Merchant Nicolaes Ruts
Oil on panel; 46 × 34⅜ in
(115 × 85.5 cm)
1631
New York, Frick Collection

81. "Rembrandt's Father"
Oil on panel; 23¾ × 20¼ in
(61 × 52 cm)
1631
Birmingham (England), City Museum and Art Gallery, on loan from Mrs. Oscar Ashcroft

82. The Presentation of Jesus in the Temple
Oil on panel; 24 × 19 in
(61 × 48 cm)
1631
The Hague, Mauritshuis

83. A Young Man at a Desk
Oil on panel; 44½ × 36¼ in
(113 × 92 cm)
1631
Leningrad, Hermitage

84. "Rembrandt's Mother" as a Biblical Prophetess (Hannah)
Oil on panel; 23½ × 19 in
(60 × 48 cm)
1631
Amsterdam, Rijksmuseum

85

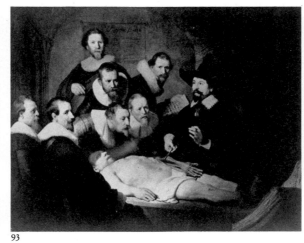

89

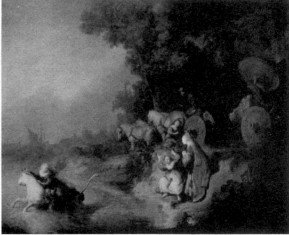

93

98

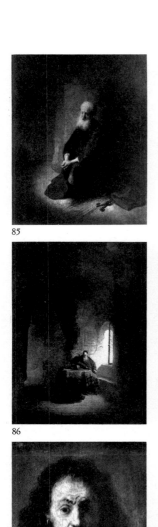

86

90

94

97

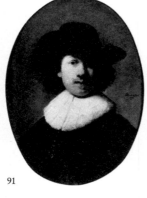

99

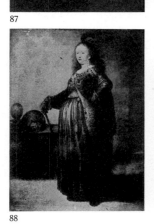

87

91

95

100

88

92

96

85. The Apostle Peter in Prison
Oil on panel; 22¾ × 19 in
(58 × 48 cm)
1631
Brussels, de Mérode-
Westerloo Collection

86. A Scholar in a Lofty Room ("St. Anastasius")
Oil on panel; 23½ × 19 in
(60 × 48 cm)
1631
Stockholm,
Nationalmuseum

87. Head of a Man
Oil on panel; 7¾ × 6¼ in
(19.5 × 16 cm)
Circa 1631
Leyden, Stedelijk Museum
"De Lakenhaal"

88. "Rembrandt's Sister"
Oil on canvas laid down on
panel; 27 × 18¾ in
(68.5 × 48 cm)
Circa 1631–1632
Formerly at Paris, de
Schickler Collection

89. The Good Samaritan
Oil on panel; 9¾ × 8¼ in
(25 × 21 cm)
Circa 1631–1633
London, Wallace
Collection

90. Andromeda Chained to the Rock
Oil on panel; 13½ × 9¾ in
(34.5 × 25 cm)
Circa 1632
The Hague, Mauritshuis

91. Self-portrait
Oil on panel; 25 × 18½ in
(63 × 48 cm)
1632
Glasgow, Art Gallery and
Museum, Burrell Collection

92. Bathsheba at her Toilet
Oil on panel; 9¾ × 8¼ in
(25 × 21 cm)
1632
Rennes (France), Musée
des Beaux-Arts

93. Doctor Nicolaes Tulp Demonstrating the Anatomy of the Arm
Oil on canvas; 66¾ × 85¼ in
(169.5 × 216.5 cm)
1632
The Hague, Mauritshuis

94. A Young Man with a Gold Chain
Oil on panel; 22¾ × 17¼ in
(56.5 × 42 cm)
1632
Cleveland, Museum of Art

95. Jan Pellicorne and his Son Caspar
Oil on canvas; 61 × 48¼ in
(155 × 123 cm)
Circa 1632
London, Wallace
Collection

96. Joris De Caullery
Oil on canvas; 40¼ × 33 in
(101 × 82.5 cm)
1632
San Francisco, M. H. de
Young Memorial Museum

97. Maerten Looten
Oil on panel; 36 ×
29½ in (93 × 76 cm)
1632
Los Angeles, County
Museum of Art

98. Maurits Huygens
Oil on panel; 12¼ × 9¾ in
(31 × 24.5 cm)
1632
Hamburg, Kunsthalle

99. The Painter Jacob De Gheyn III
Oil on panel; 11⅞ × 9⅞ in
(29.5 × 24.5 cm)
1632
London, Dulwich College
Gallery

100. The Abduction of Europa
Oil on panel; 24 × 30½ in
(70 × 77.5 cm)
1632
New York, Klotz
Collection

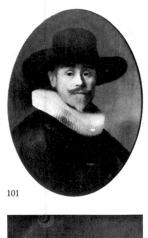

101

105

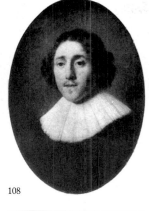

108

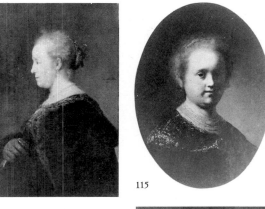

112

115

102

106

109

113

116

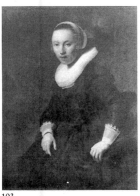

103

107

110

114

117

104

**104. Portrait of a Young
Woman**
Oil on canvas; 44 × 35 in
(110 × 87.5 cm)
1632
New York, Metropolitan
Museum of Art

**105. Portrait of a Young
Woman**
Oil on panel; 21¾ × 19 in
(55 × 48 cm)
1632
Milan, Pinacoteca di Brera

**106. A Young Woman
with a Hymnbook**
Oil on panel; 30 × 23¼ in
(76.5 × 59 cm)
1632
Nivaa (Denmark),
Malerisamlingen paa
Nivagaard

**107. A Young Man with
a Broad Collar**
Oil on canvas; 25 × 19½ in
(63.5 × 49.5 cm)
Circa 1632
New York, Fleitman
Collection

**108. Portrait of a Young
Man**
Oil on panel; 24¾ × 18 in
(63 × 46 cm)
1632
Wanas (Sweden),
Wachtmeister Collection

111

**109. A Young Man in a
Broad-brimmed Hat**
Oil on panel; 23¼ × 19 in
(60 × 48 cm)
Circa 1632
New York, private
collection

**110. Portrait of a Young
Girl**
Oil on panel; 22¼ × 17½ in
(56.5 × 44.5 cm)
Circa 1632
Philadelphia, Zimbalist
Collection

**111. "Rembrandt's
Sister"**
Oil on panel; 25¼ × 19⅜ in
(63 × 48 cm)
1632
Allentown, Art Museum
Kress Collection

**112. "Rembrandt's
Sister"**
Oil on canvas; 28¼ × 21¼ in
(72 × 54 cm)
1632
Stockholm,
Nationalmuseum

**113. "Rembrandt's
Sister"**
Oil on canvas 27 × 21 in
(68.5 × 53.5 cm)
1632
Zurich, Wiederkehr
Collection

**114. "Rembrandt's
Sister"**
Oil on panel; 22¾ × 16⅞ in
(59 × 44 cm)
1632
Boston, Museum of Fine
Arts, on loan from Richard
C. Paine

**115. "Rembrandt's
Sister"**
Oil on panel; 20½ × 15¼ in
(52 × 39 cm)
Circa 1632
Chapel Hill, University of
North Carolina

116. Portrait of a Man
Oil on canvas 44 × 35 in
(110 × 87.5 cm)
1632
New York, Metropolitan
Museum of Art

101. Aelbert Cuyper
Oil on panel; 23½ × 18½ in
(60 × 47 cm)
1632
Paris, Louvre.

102. Amalia van Solms
Oil on canvas; 27 × 21¾ in
(68.5 × 55.5 cm)
1632
Paris, Musée Jacquemart-
André

**103. Portrait of a Young
Woman**
Oil on canvas; 36¼ × 28 in
(92 × 71 cm)
1632
Vienna, Akademie der
bildenden Künste,
Gemäldegalerie

117. Portrait of a Man
Oil on panel; 29¾ × 20½ in
(72 × 52 cm)
1632
New York, Metropolitan
Museum of Art

118. Portrait of a Man
Oil on panel; 25 × 19 in
(63.5 × 48 cm)
1632
Brunswick, Staatliches
Herzog Anton Ulrich
Museum

119

123

126

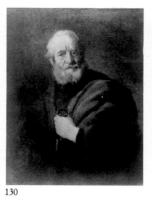

130

134

120

124

127

131

135

121

125

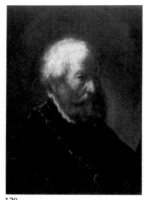

128

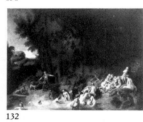

132

136

122

129

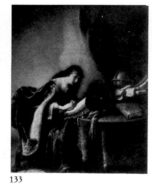

133

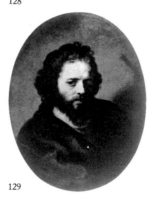

119. A Man Sharpening a Quill
Oil on canvas; 40 × 32 in
(101.5 × 81.5 cm)
Circa 1632
Kassel, Staatliche
Kunstsammlungen,
Gemäldegalerie

120. A Man in Fanciful Costume
Oil on canvas; 60⅛ × 43¾ in
(150.25 × 109 cm)
1632
New York, Metropolitan
Museum of Art

121. Portrait of a Man with Gloves
Oil on canvas; 44 × 35¾ in
(112 × 91 cm)
1632
Shelburne (Vermont),
Shelburne Museum,
Electra Havemeyer Webb
Collection

122 Portrait of a Seated Man
Oil on panel; 35½ × 27 in
(90 × 68.5 cm)
Circa 1632
Vienna, Kunsthistorisches
Museum, Gemäldegalerie

123 A Woman in a White Cap
Oil on panel; 29½ × 21¾ in
(75 × 55.5 cm)
1632
Paris, Edouard de
Rothschild Collection

124 Portrait of an Old Man
Oil on panel; 26¼ × 20 in
(66.5 × 51 cm)
1632
Cambridge (Massachusetts),
Fogg Art Museum

125 Portrait of an Old Man
Oil on panel; 22½ × 18½ in
(57 × 47 cm)
Circa 1632
London Schicht Collection

126. A Bald-headed Old Man
Oil on panel; 19¾ × 16 in
(50 × 40.5 cm)
1632
Kassel, Staatliche
Kunstsammlungen,
Gemäldegalerie

127. An Old Man with a Gold Chain
Oil on panel; 23¼ × 19¼ in
(59 × 49 cm)
1632
Kassel, Staatliche
Kunstsammlungen,
Gemäldegalerie

128. An Old Man with a Gold Chain
Oil on panel; 25¼ × 17¾ in
(64 × 45 cm)
Circa 1632
Los Angeles, Cohn
Collection

129. St. John the Baptist
Oil on panel; 25¼ × 19 in
(64 × 48 cm)
1632
Los Angeles, County
Museum of Art

130. The Apostle Peter
Oil on canvas; 28¼ × 21¼ in
(72 × 54 cm)
1632
Stockholm,
Nationalmuseum

131. Susanna van Collen with her Daughter Eva Susanna
Oil on canvas; 61 × 48¼ in
(155 × 123 cm)
Circa 1632
London, Wallace
Collection

132. Diana, with Scenes from the Stories of Actaeon and Callisto
Oil on canvas; 29 × 36¾ in
(73.5 × 93.5 cm)
Circa 1632–1633
Anholt (West Germany),
Prince von Salm-Salm
Collection

133. Minerva
Oil on panel; 17 × 13¾ in
(43.5 × 35 cm)
Circa 1632–1633
Denver, Art Museum

134. Minerva
Oil on panel; 23¼ × 19 in
(59 × 48 cm)
Circa 1632–1633
Berlin, Staatliche Museen
Preussischer Kulturbesitz,
Gemäldegalerie

135. Portrait of a Woman
Oil on panel; 35½ × 26¼ in
(90 × 67.5 cm)
Circa 1632–1633
Vienna, Kunsthistorisches
Museum, Gemäldegalerie

136. Susanna and the Elders
Oil on panel; 20 × 16¼ in
(51 × 41 cm)
Circa 1632–1633
Private collection

137

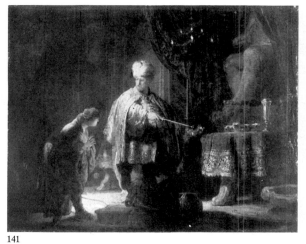

141

146

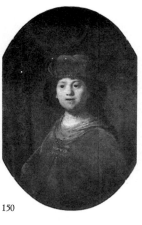

150

138

142

143

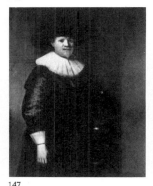

147

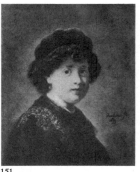

151

139

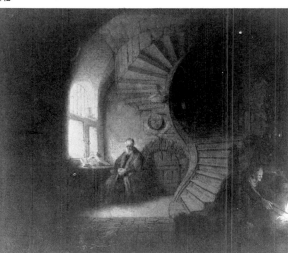

144

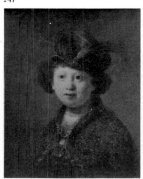

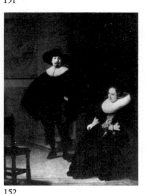

148

140

145

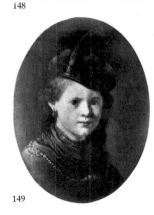

149

152

137. Self-portrait
Oil on panel; $22\frac{3}{4} \times 17\frac{3}{4}$ in
(58×45 cm)
1633
Paris, Louvre

138. Bellona
Oil on canvas; $49\frac{1}{4} \times 38$ in
(125×96.5 cm)
1633
New York, Metropolitan
Museum of Art

139. A Man in Oriental Costume
Oil on panel; $33\frac{3}{4} \times 25$ in
(85.5×63.7 cm)
1633
Munich, Alte Pinakothek

140. The Shipbuilder and his Wife
Oil on canvas; $45 \times 66\frac{1}{2}$ in
(115×165 cm)
1633
London, Buckingham
Palace

141. Daniel and King Cyrus Before the Idol of Bel
Oil on panel; $8\frac{3}{4} \times 11\frac{1}{4}$ in
(22.5×28.5 cm)
1633
England, private collection

142. Esther Preparing to Intercede with Ahasuerus
Oil on canvas; 43×37 in
(109×93 cm)
1633 (?)
Ottawa, National Gallery
of Canada

143. Esther Preparing to Intercede with Ahasuerus
Oil on panel; $21\frac{1}{2} \times 18\frac{3}{4}$ in
(54.5×47.5 cm)
Circa 1633
Formerly at Berlin,
Heilgendorff Collection

144. A Scholar in a Room with a Winding Stair
Oil on panel; $11\frac{1}{2} \times 13$ in
(29×33 cm)
1633 (?)
Paris, Louvre

145. Christ in the Storm on the Lake of Galilee
Oil on canvas; 63×50 in
(159.5×127.5 cm
1633
Boston, Isabella Stewart
Gardner Museum

146. The Preacher Johannes Uyttenbogaert
Oil on canvas; $52 \times 40\frac{1}{4}$ in
(130×101 cm)
1633
Mentmore (England),
Rosebery Collection

147. The Poet Jan Hermansz. Krul
Oil on canvas; $50\frac{1}{2} \times 39\frac{1}{2}$ in
(128.5×100.5 cm)
1633
Kassel, Staatliche
Kunstsammlungen,
Gemäldegalerie

148. A Child in Fanciful Costume
Oil on panel; $7\frac{3}{4} \times 6\frac{1}{2}$ in
(20×17 cm)
1633
London, Wallace
Collection

149. A Child in Fanciful Costume
Oil on panel; $17\frac{1}{4} \times 13\frac{3}{4}$ in
(44×35 cm)
1633
Ferrières, Edouard de
Rothschild Collection

150. A Child in Fanciful Costume
Oil on panel; $26\frac{1}{2} \times 18\frac{3}{4}$ in
(67×47.5 cm)
Circa 1633
Leningrad, Hermitage

151. A Child in Fanciful Costume
Oil on panel; $7\frac{3}{4} \times 6\frac{1}{2}$ in
(19.5×16.5 cm)
Circa 1633
Formerly at Leningrad,
Yussupoff Collection

152. Portrait of a Fashionably-Dressed Couple
Oil on canvas; $51\frac{3}{4} \times 42$ in
(131×107 cm)
1633
Boston, Isabella Gardner
Stewart Museum

179

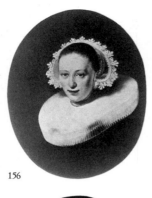

153

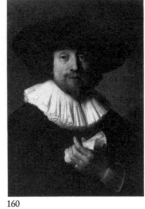

156

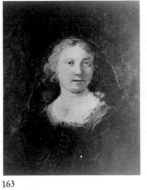

160

163

167

154

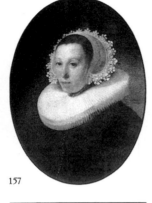

157

161

164

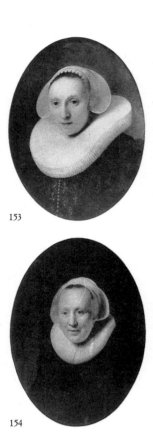

155

158

162

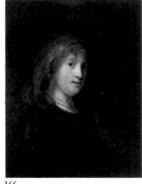

165

166

159

169

170

153. Cornelia Pronck, Wife of Aelbert Cuyper
Oil on panel; 23½ × 18½ in (60 × 47 cm)
1633
Paris, Louvre

154. Portrait of a Woman
Oil on panel; 26¾ × 19¾ in (66.5 × 49.5 cm)
1633
New York, Metropolitan Museum of Art

155. A Woman with a Lace Collar
Oil on panel; 25 × 19 in (63.5 × 47.5 cm)
1633
Santa Barbara, Converse Collection

156. Portrait of a Young Woman
Oil on panel; 24¾ × 20 in (61 × 50 cm)
1633
Formerly at Piqua (Ohio), Flesh Collection

157. Portrait of a Young Woman
Oil on panel; 25 × 19 in (63.5 × 48 cm)
1633
Brunswick, Staatliches Herzog Anton Ulrich Museum

158. A Young Woman with a Fan
Oil on canvas; 49½ × 39¾ in (127 × 101 cm)
1633
New York, Metropolitan Museum of Art

159. Magaretha van Bilderbeecq
Oil on panel; 26¾ × 21¾ in (67.5 × 55 cm)
1633
Frankfurt, Städelsches Kunstinstitut

160. Portrait of a Musician
Oil on panel; 25¾ × 18¾ in (65.5 × 47.5 cm)
1633
Washington, Corcoran Gallery of Art

161. Saskia
Oil on panel; 28¼ × 19 in (72 × 48 cm)
1633
Leeuwarden (Netherlands), Fries Museum

162. Saskia
Oil on panel; 26¼ × 19¼ in (66.5 × 49.5 cm)
1633
Amsterdam, Rijksmuseum

163. Saskia
Oil on panel; 8¼ × 6¾ in (21 × 17 cm)
Circa 1633
Richmond, Museum of Fine Arts

164. Saskia
Oil on panel; 20¾ × 17½ in (52.5 × 44.5 cm)
1633
Dresden, Staatliche Kunstsammlungen, Gemäldegalerie

165. Saskia
Oil on panel; 3¾ × 3 in (9.7 × 7.7 cm)
Circa 1633
United States, private collection

166. Saskia
Oil on panel; 23¾ × 19¼ in (60.5 × 49 cm)
Circa 1633
Washington, National Gallery of Art, Widener Collection

167. Saskia as Flora
Oil on canvas; 26¼ × 20 in (67 × 51 cm)
1633
New York, Metropolitan Museum of Art

168. "Rembrant's Sister"
Oil on canvas; 24½ × 21¾ in (62 × 55.5 cm)
1633
South America, private collection

169. "Rembrandt's Sister"
Oil on canvas; 22¾ × 18 in (58 × 45.5 cm)
1633
Richmond, Virginia Museum of Fine Arts

170. "Rembrandt's Sister"
Oil on panel; 23¼ × 17¼ in (59 × 44 cm)
Circa 1633
Stockholm, Nationalmuseum

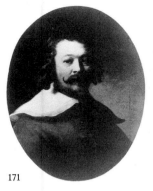

171

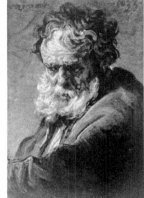

172

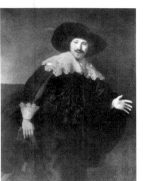

173

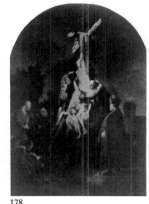

174

175

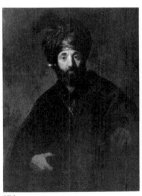

176

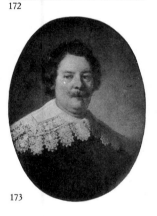

177

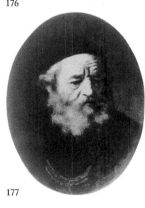

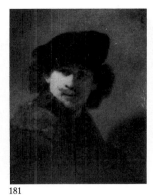

178

179

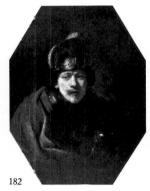

180

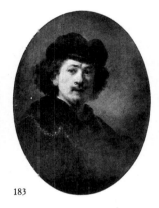

181

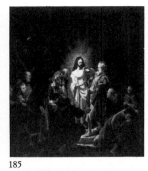

182

183

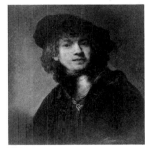

184

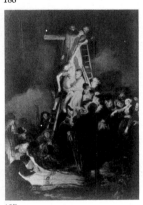

185

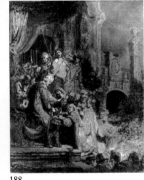

186

187

188

171. Portrait of a Man in a Red coat
Oil on panel; 25 × 20 in
(63.5 × 51 cm)
1633
Formerly at New York,
Howard Young Galleries

172. Portrait of a Fashionably-Dressed Man
Oil on canvas; 49 × 39½ in
(125 × 100 cm)
1633
Cincinnati, Taft Museum

173. Willem Burchgraeff
Oil on panel; 26½ × 20½ in
(67.5 × 52 cm)
1633
Dresden, Staatliche
Kunstsammlungen,
Gemäldegalerie

174. Study of an Old Man
Oil on panel; 3¾ × 2½ in
(9.5 × 6.5 cm)
1633
New York, Houghton
Collection

175. A Bearded Man in a Wide-Brimmed Hat
Oil on panel; 27¼ × 21½ in
(69 × 54.5 cm)
1633
Lugano, Thyssen-
Bornemisza Collection

176. A Man in Oriental Costume
Oil on canvas; 38¾ × 29⅛ in
(98 × 74 cm)
Circa 1633
Washington, National
Gallery of Art, Mellon
Collection

177. An Old Man with a Beard
Oil on panel; 25½ × 16½ in
(65 × 42 cm)
1633
Metz, Musée Central

178. The Descent from the Cross
Oil on panel; 35¼ × 25¾ in
(89.4 × 65.2 cm)
Circa 1633–1634
Munich, Alte Pinakothek

179. The Raising of the Cross
Oil on canvas; 37¾ × 28¼ in
(96 × 72 cm)
Circa 1633–1634
Munich, Alte Pinakothek

180. Saskia with a Hat
Oil on panel; 39¼ × 31 in
(99.5 × 78.5 cm)
Circa 1633–1634
Kassel, Staatliche
Kunstsammlungen,
Gemäldegalerie

181. Self-portrait
Oil on panel; 22½ × 18 in
(57 × 46 cm)
1634
Berlin, Staatliche Museen
Preussischer Kulturbesitz,
Gemäldegalerie

182. Self-portrait
Oil on panel; 31¾ × 26 in
(80.5 × 66 cm)
1634
Kassel, Staatliche
Kunstsammlungen,
Gemäldegalerie

183. Self-portrait
Oil on panel; 26¾ × 21 in
(68 × 53 cm)
163(4?)
Paris, Louvre

184. Self-portrait as a Young Man
Oil on panel; 26½ × 21¼ in
(67 × 54 cm)
Circa 1634
Florence, Uffizi

185. The Risen Christ Showing his Wound to the Apostle Thomas
Oil on panel; 20¾ × 20 in
(53 × 51 cm)
1634
Moscow, Pushkin Museum

186. Cupid
Oil on canvas; 29¼ × 36¼ in
(74.5 × 92 cm)
1634
Paris, Bentinck Collection

187. The Descent from the Cross
Oil on canvas; 62¼ × 46 in
(158 × 117 cm)
1634
Leningrad, Hermitage

188. Christ Before Pilate and the People
Monochrome on paper laid
down on panel; 21⅞ × 17½
in (54.5 × 44.5 cm)
1634
London, National Gallery

189

190

191

192

199

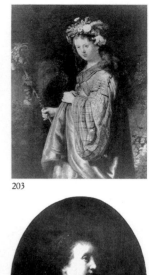

193

196

200

203

194

197

201

204

195

198

202

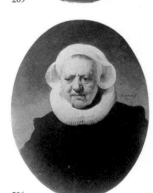

205

206

189. The Flight into Egypt
Oil on panel; $20\frac{1}{2} \times 16\frac{1}{4}$ in (52×41 cm)
1634 (?)
London, Wharton Collection

190. A Boy with Long Hair
Oil on panel; $18\frac{1}{2} \times 14\frac{1}{2}$ in (47×36.5 cm)
1634
Welbeck (England), Portland Collection

191. Portrait of a Young Man
Oil on panel; $28 \times 20\frac{1}{4}$ in (71×53 cm)
1634
Warsaw, National Museum

192. Portrait of a Young Man
Oil on panel; $26\frac{1}{4} \times 20\frac{1}{2}$ in (66.5×52 cm)
Circa 1634
Dublin, National Gallery of Ireland

193. Portrait of a Young Woman
Oil on panel; $26 \times 20\frac{3}{4}$ in (66×52.5 cm)
1634
London, private collection

194. A Young Woman with a Gold Chain
Oil on panel; $27\frac{1}{2} \times 20\frac{3}{4}$ in (68×51 cm)
Circa 1634
Boston, Museum of Fine Arts

195. A Young Woman with Flowers in her Hair
Oil on panel; 28×21 in (71×53.5 cm)
1634
Edinburgh, National Gallery of Scotland, on loan from the Duke of Sutherland

196. Portrait of a Young Man
Oil on panel; $27\frac{1}{2} \times 20\frac{1}{2}$ in (66.5×52 cm)
1634
Boston, Museum of Fine Arts

197. A Young Man with a Moustache
Oil on panel; $27\frac{1}{2} \times 20\frac{1}{2}$ in (70×52 cm)
1634
Leningrad, Hermitage

198. Maerten Soolmans
Oil on canvas; $82\frac{1}{2} \times 53$ in (210×134.5 cm)
1634
Paris, Robert de Rothschild Collection

199. Maria Bockenolle
Oil on canvas; $68\frac{3}{4} \times 48\frac{7}{8}$ in (173×125 cm)
1634
Boston, Museum of Fine Arts

200. A Member of the Raman Family
Oil on panel; $26\frac{1}{4} \times 20\frac{1}{2}$ in (67×52 cm)
1634
Wassenaar (Netherlands), Cohn Collection

201. Oopjen Coppit, Wife of Maerten Soolmans
Oil on canvas; $82\frac{1}{4} \times 52\frac{3}{4}$ in (209.5×134 cm)
1634
Paris, Robert de Rothschild Collection

202. The Preacher Johannes Elison
Oil on canvas; $68\frac{1}{8} \times 48\frac{7}{8}$ in (171×122.5 cm)
1634
Boston, Museum of Fine Arts, William K. Richardson Fund

203. Saskia as Flora
Oil on canvas; $49\frac{1}{4} \times 39\frac{3}{4}$ in (125×101 cm)
1634
Leningrad, Hermitage

204. "Rembrandt's Sister" (?)
Oil on panel; $24\frac{1}{2} \times 19\frac{1}{4}$ in (62×49 cm)
1634
Indianapolis, John Herron Art Museum

205. Portrait of an Officer
Oil on panel; $24\frac{1}{2} \times 18$ in (62×46 cm)
Circa 1634
Detroit, Wilson Collection

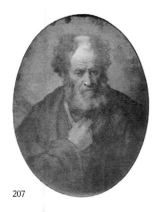

207

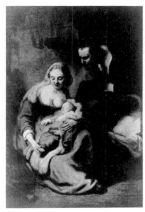

211

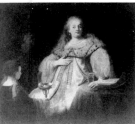

208

214

217

221

209

212

215

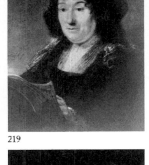

218

210

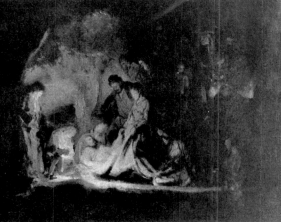

213

219

222

216

220

206. Portrait of an 83-Year-Old Woman
Oil on panel; 27 × 21 in
(68.7 × 53.8 cm)
1634
London, National Gallery

207. An Old Man with a Beard
Oil on panel; 27½ × 22 in
(70 × 56 cm)
163(4)
Paris, Louvre

208. Sophonisba Receiving the Poisoned Cup (?)
Oil on canvas; 56 × 60¼ in
(142 × 153 cm)
1634
Madrid, Prado

209. A Scholar in his Study
Oil on canvas; 55½ × 53¼ in
(141 × 135 cm)
1634
Prague, Národní Galerie

210. Self-portrait
Oil on panel; 21¾ × 18 in
(55 × 46 cm)
Circa 1634–1635
Berlin, Staatliche Museen
Preussischer Kulturbesitz,
Gemäldegalerie

211. The Holy Family
Oil on canvas; 72½ × 48½ in
(183.5 × 123 cm)
Circa 1634–1635
Munich, Alte Pinakothek

212. The Rest on the Flight into Egypt
Oil on paper laid down on
panel; 15¼ × 13½ in
(38.5 × 34 cm)
Circa 1634–1636
The Hague, Mauritshuis

213. The Entombment of Christ
Oil on panel; 16½ × 16 in
(32 × 40.5 cm)
Circa 1634–1636
Glasgow, University,
Hunterian Museum

214. Self-portrait
Oil on canvas; 36¼ × 28¼ in
(92 × 72 cm)
1635
Formerly at Vaduz,
Liechtenstein Collection

215. A Child Abducted by an Eagle (The Abduction of Ganymede)
Oil on canvas; 67¼ × 51¼ in
(171.5 × 130 cm)
1635
Dresden, Staatliche
Kunstsammlungen,
Gemäldegalerie

216. A Man in Oriental Costume
Oil on panel; 28¼ × 21½ in
(72 × 54.5 cm)
1635
Amsterdam, Rijksmuseum

217. The Diplomat Anthonis Coopal
Oil on panel; 32¾ × 26¼ in
(83 × 67 cm)
1635
Greenwich (Connecticut),
Neuman de Vegvar
Collection

218. The Feast of Belshazzar
Oil on canvas; 66 × 82⅜ in
(167.6 × 209.2 cm)
Circa 1635
London, National Gallery

219. A Young Woman with a Book
Oil on panel; 25½ × 20½ in
(65 × 52 cm)
1635
Los Angeles, University of
Southern California

220. Minerva
Oil on canvas; 54 × 45¾ in
(137 × 116 cm)
1635
London, Weitzner
Collection

221. Uzziah Stricken with Leprosy
Oil on panel; 40 × 30½ in
(101 × 79 cm)
1635
Chatsworth (England),
Devonshire Collection

222. Portrait of a Young Woman
Oil on panel; 30¼ × 25½ in
(77 × 64 cm)
1635
Cleveland, Museum of Art

223

226

230

233

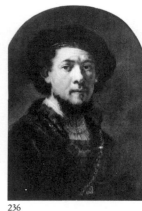

236

224

227

231

237

225

228

229

232

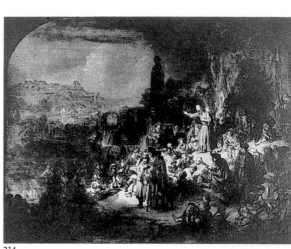

234

235

223. Petronella Buys, Wife of Philips Lucasz
Oil on panel; 29⅞ × 22⅞ in (76 × 58 cm)
1635
New York, Meyer Collection

224. Philips Lucasz
Oil on panel; 31⁵⁄₁₆ × 23³⁄₁₆ in (79.5 × 59 cm)
1635
London, National Gallery

225. Saskia
Oil on panel; 38½ × 27½ in (98 × 70 cm)
163(5? 8?)
Château de Pregny (Geneva), Edmond de Rothschild Collection

226. Saskia as Flora
Oil on canvas; 48⅝ × 38⅜ in (123.5 × 97.5 cm)
1635
London, National Gallery

227. An Old Woman Seated in an Armchair
Oil on canvas; 50⅜ × 39⅛ in (126 × 99 cm)
1635
New York, Metropolitan Museum of Art

228. A Man with Dishevelled Hair
Oil on panel; 26¼ × 20¾ in (66.5 × 53 cm)
1635
New York, Acquavella Galleries

229. A Man in a Broad-Brimmed Hat
Oil on canvas transferred from panel; 30½ × 25½ in (76 × 63.5 cm)
1635
Indianapolis, Townsend Collection

230. A Man in Fanciful Costume
Oil on panel; 27½ × 24 in (70 × 61 cm)
1635
Hampton Court Palace (England), Royal Collection

231. The Finding of Moses
Oil on canvas; 18½ × 23¼ in (47 × 59 cm)
Circa 1635
Philadelphia, Museum of Art

232. The Angel Stopping Abraham from Sacrificing Isaac to God
Oil on canvas; 76 × 52½ in (193 × 133 cm)
1635
Leningrad, Hermitage

233. Samson Threatening his Father-in-Law
Oil on canvas; 61½ × 50¾ in (156 × 129 cm)
163(5)
Berlin, Staatliche Museen Preussischer Kulturbesitz, Gemäldegalerie

234. St. John the Baptist Preaching
Grisaille on canvas laid down on panel; 24½ × 31½ in (62 × 80 cm)
Circa 1635–1636
Berlin, Staatliche Museen Preussischer Kulturbesitz, Gemäldegalerie

235. Self-portrait
Oil on panel; 25 × 19⅜ in (63.5 × 49 cm)
Circa 1635–1637
London, Wallace Collection

236 Self-portrait (?)
Oil on canvas; 22½ × 17¼ in (57.5 × 44 cm)
Circa 1635–1637
São Paolo (Brazil), Museu de Arte

237. A Man in Fanciful Costume
Oil on panel; 28¼ × 21¾ in (71.5 × 55 cm)
Circa 1635–1637
Knowsley Hall (England), Derby Collection

238

242

245

246

248

239

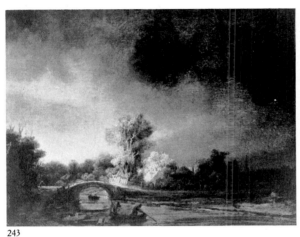

243

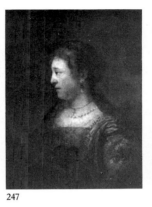

247

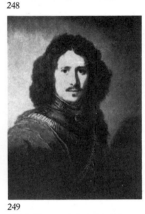

249

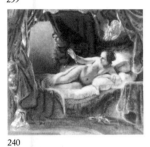

240

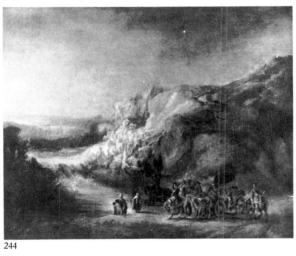

244

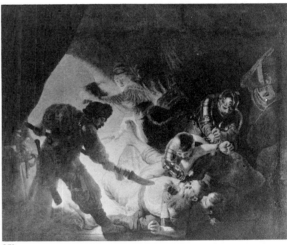

250

241

251

238. The Slaughtered Ox
Oil on panel; 28⅞ × 20⅜ in
(73.5 × 51.5 cm)
Circa 1635–1640
Glasgow, Art Gallery and
Museum

**239. The Ascension of
Christ**
Oil on canvas; 36½ × 27 in
(92.5 × 68.5 cm)
1636
Munich, Alte Pinakothek

240. Danaë
Oil on canvas; 72¾ × 80 in
(185 × 203 cm)
16(3)6
Leningrad, Hermitage

**241. A Young Woman
Holding a Carnation**
Oil on canvas; 28¼ × 23¼ in
(72 × 59 cm)
Circa 1636
Kassel, Staatliche
Kunstsammlungen,
Gemäldegalerie

**242. A Young Woman
with a Heron's Plume in
her Hair**
Oil on panel; 25½ × 20½ in
(65 × 52 cm)
1636
Formerly at Vaduz
(Liechtenstein), private
collection

**243. Landscape with a
Stone Bridge**
Oil on panel; 11½ × 16¾ in
(29.5 × 42.5 cm)
Circa 1636
Amsterdam, Rijksmuseum

**244. Landscape with the
Baptism of the Eunuch**
Oil on canvas; 33¾ × 42½ in
(85.5 × 108 cm)
1636
Hannover,
Niedersächsisches
Landesmuseum, on loan

**245. Rembrandt and
Saskia (The Prodigal Son
in the Tavern)**
Oil on canvas; 63¼ × 51½ in
(161 × 131 cm)
Circa 1636
Dresden, Staatliche
Kunstsammlungen,
Gemäldegalerie

**246. A Lady of the
Raman Family**
Oil on panel 27 × 21 in
(68 × 53 cm)
1636
Rossie Priory (England),
Kinnaird Collection

247. Saskia
Oil on canvas; 26½ × 20¾ in
(67.5 × 52.5 cm)
1636
Hartford (Connecticut),
Wadsworth Atheneum

248. Saskia
Oil on canvas; 31 × 26 in
(78.5 × 66 cm)
1636
Zurich, Mrs Emil Bührle
Collection

**249. Portrait of an
Officer**
Oil on panel; 26 × 20½ in
(66 × 52 cm)
1636
Zurich, Anca-Bührle
Collection

**250. The Blinding of
Samson**
Oil on canvas; 93 × 119 in
(236 × 302 cm)
1636
Frankfurt, Städelsches
Kunstinstitut

**251. Tobias Healing his
Father's Blindness**
Oil on panel; 18½ × 15¼ in
(48 × 39 cm)
1636
Stuttgart, Staatsgalerie

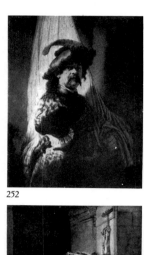

252

256

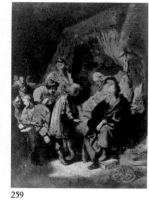

259

263

266

253

257

260

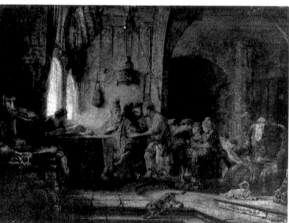

264

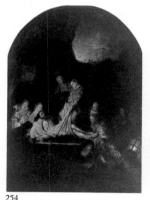

254

258

261

267

255

262

268

265

269

252. The Standard-Bearer
Oil on canvas; 49¼ × 41½ in (125 × 105 cm)
1636
Paris, Elie de Rothschild Collection

253. Child with Dead Peacocks
Oil on canvas; 57 × 53½ in (145 × 135.5 cm)
Circa 1636–1637
Amsterdam, Rijksmuseum

254. The Entombment of Christ
Oil on canvas; 36½ × 27¼ in (92.5 × 68.8 cm)
Circa 1636–1639
Munich, Alte Pinakothek

255. The Resurrection of Christ
Oil on canvas on panel; 36¼ × 26½ in (92 × 67 cm)
Circa 1636–1639
Munich, Alte Pinakothek

256. The Angel Leaving Tobias and his Family
Oil on panel; 26¾ × 20½ in (68 × 52 cm)
1637
Paris, Louvre

257. Self-portrait
Oil on panel; 31½ × 24½ in (80 × 62 cm)
1637
Paris, Louvre

258. Still Life with a Dead Bittern
Oil on canvas; 47½ × 35¾ in (120.5 × 91 cm)
163(7?)
Zurich, E. G. Bührle Collection

259. Joseph Relating his Dreams
Paper on panel (grisaille); 20 × 15¼ in (51 × 39 cm)
Circa 1637
Amsterdam, Rijksmuseum

260. The Minister Eleazar Swalmius
Oil on canvas; 54¾ × 40½ in (139 × 103 cm) 1637
Antwerp, Musée Royal des Beaux-Arts

261. The Parable of the Laborers in the Vineyard
Oil on panel; 12¼ × 16½ in (31 × 42 cm)
1637
Leningrad, Hermitage

262. St. Francis at Prayer
Oil on panel; 23¼ × 18¾ in (58 × 47 cm)
1637
Columbus (Ohio), Gallery of Fine Arts

263. Susanna Surprised by the Elders
Oil on panel; 18¾ × 15¼ in (47.5 × 39 cm)
1637(?)
The Hague, Mauritshuis

264. A Man in Polish Costume
Oil on panel; 38½ × 26 in (96 × 65 cm)
1637
Washington, National Gallery of Art, Mellon Collection

265. A Man Seated in an Armchair
Oil on canvas; 52½ × 41 in (133 × 104 cm)
1637
Mertoun (Scotland), Duke of Sutherland Collection

266. A Man Seated in an Armchair
Oil on canvas; 48¾ × 37½ in (124 × 95 cm)
Circa 1637
Washington, Corcoran Gallery of Art

267. Self-portrait (?)
Oil on panel; 24½ × 18½ in (62.5 × 47 cm)
Circa 1637–1638
The Hague, Mauritshuis

186

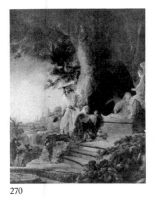

270

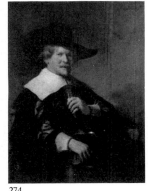

274

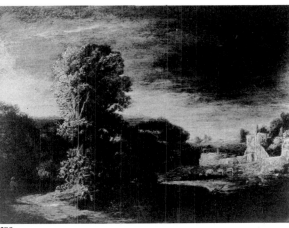

275

279

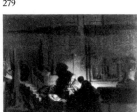

280

271

276

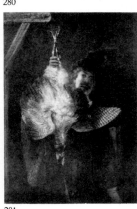

281

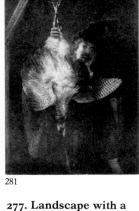

272

277

273

278

271. Landscape with an Obelisk
Oil on panel; $21\frac{3}{4} \times 28$ in (55×71.5 cm)
1638 (?)
Boston, Isabella Stewart Gardner Museum

272. Stormy Landscape, with the Good Samaritan
Oil on panel; $18\frac{1}{4} \times 26$ in (46.5×66 cm)
1638
Cracow, Muzeum Czartoryski

273. Samson Posing the Riddle to the Wedding Guests
Oil on canvas; $49\frac{1}{2} \times 69$ in (126.5×175.5 cm)
1638
Dresden, Staatliche Kunstsammlungen, Gemäldegalerie

274. A Man Seated in an Armchair
Oil on canvas; $41\frac{1}{2} \times 32$ in (105×81.5 cm)
1638
New York, Lehman Collection

268. Bathsheba at her Toilet
Oil on panel; $16\frac{1}{4} \times 12\frac{1}{4}$ in (41×31 cm)
Circa 1637–1638
Leningrad, Hermitage

269. The Lamentation over the Dead Christ (Pietà)
Oil on paper and canvas on panel (grisaille);
$12\frac{1}{2} \times 10\frac{1}{2}$ in (31.9×26.7)
Circa 1637–1638
London, National Gallery

270. The Risen Christ Appearing to the Magdalen
Oil on panel; $24 \times 19\frac{1}{2}$ in (61.5×50 cm)
1638
London, Buckingham Palace

275. Woody Landscape with Ruins
Oil on panel; $11\frac{3}{4} \times 18$ in (30×46 cm)
Circa 1638–1639
Wassenaar (Netherlands) private collection

276. Landscape with a Church
Oil on panel $16\frac{1}{2} \times 23\frac{1}{2}$ in (42×60 cm)
Circa 1638–1639
Madrid Berwick-Alba Collection

277. Landscape with a Distant Town
Oil on panel; $8\frac{3}{4} \times 11\frac{1}{2}$ in (22×29.5)
Circa 1638–1639
Lugano, Thyssen-Bornemisza Collection

278. Stormy Landscape
Oil on panel; $20\frac{1}{2} \times 28\frac{1}{4}$ in (52×72 cm)
Circa 1638–1639
Brunswick, Staatliches Herzog Anton Ulrich Museum

279. Stormy Landscape, with an Arched Bridge
Oil on panel; $11 \times 15\frac{3}{4}$ in (28×40 cm)
Circa 1638–1639
Berlin, Staatliche Museen Preussischer Kulturbesitz, Gemäldegalerie

280. The Holy Family
Oil on panel; $23\frac{1}{2} \times 30\frac{1}{4}$ in (60×77 cm)
Circa 1638–1646
Amsterdam, Rijksmuseum

281. Self-portrait, with a Dead Bittern
Oil on panel; $47\frac{1}{2} \times 35$ in (121×89 cm)
1639
Dresden, Staatliche Kunstsammlungen, Gemäldegalerie

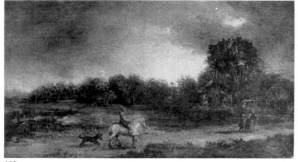

282

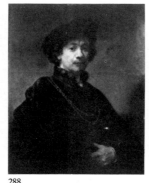

288

291

296

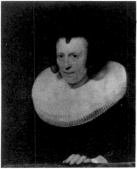

283

285

297

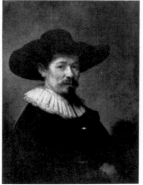

289

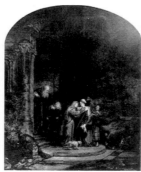

292

298

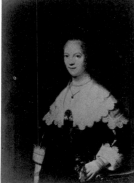

284

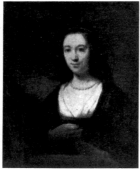

289

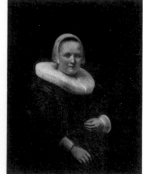

299

294

295

282. Evening Landscape with a Horseman
Oil on panel; $7\frac{3}{4} \times 14\frac{1}{4}$ in (19.5×36.5 cm)
1639
Oslo, Nasjonalgalleriet

283. Alotta Adriaensdr
Oil on panel; $25\frac{1}{2} \times 22$ in (65×56 cm)
1639
Rotterdam, Willem van der Vorm Foundation

284. Maria Trip, Daughter of Alotta Adriaensdr
Oil on panel; $42 \times 32\frac{1}{4}$ in (107×82 cm)
1639
Amsterdam, Rijksmuseum

285. "Rembrandt's Mother" (?)
Oil on panel; $31\frac{1}{4} \times 24\frac{1}{4}$ in (79.5×61.7 cm)
1639
Vienna, Kunsthistorisches Museum, Gemäldegalerie

286. A Man Standing in Front of a Doorway
Oil on canvas; $78\frac{3}{4} \times 49$ in (200×125 cm)
1639
Kassel, Staatliche Kunstsammlungen, Gemäldegalerie

287. Self-portrait
Oil on panel; $24\frac{1}{2} \times 19\frac{3}{4}$ in (62.5×50 cm)
Circa 1639–1640
Liverpool, Walker Art Gallery, on loan from Lt. Col. A. Heywood-Lonsdale

288. Self-portrait
Oil on canvas; $34\frac{1}{2} \times 28\frac{1}{2}$ in (87.5×72.5 cm)
Circa 1639–1640
Woburn Abbey (England), Duke of Bedford Collection

289. Baartjen Martens, Wife of Herman Doomer
Oil on panel; 30×22 in (76×56 cm)
Circa 1639–1641
Leningrad, Hermitage

290. Saskia at her Mirror
Oil on panel; $29 \times 37\frac{1}{2}$ in (73.5×63.5 cm)
Circa 1639–1641
Formerly at London, Davis Collection

291. Self-portrait
Oil on canvas; $40\frac{1}{8} \times 31\frac{1}{2}$ in (102×80 cm)
1640
London, National Gallery

292. The Frame Maker Herman Doomer
Oil on panel; $29\frac{5}{8} \times 21\frac{3}{4}$ in (74×53 cm)
1640
New York, Metropolitan Museum of Art

293. The Meeting of Mary and Elizabeth (The Visitation)
Oil on panel; $22\frac{1}{4} \times 18\frac{7}{8}$ in (57×48 cm)
1640
Detroit, Institute of Arts

294. Landscape with a Castle
Oil on panel; $17\frac{1}{2} \times 27\frac{1}{2}$ in (44.5×70 cm)
Circa 1640
Paris, Louvre

295. The Holy Family
Oil on panel; $16 \times 13\frac{1}{2}$ in (41×34 cm)
1640
Paris, Louvre

296. The Departure of the Shunamite Wife
Oil on panel; $15\frac{1}{4} \times 21$ in (39×53 cm)
1640
London, Victoria and Albert Museum

297. Landscape with a Coach
Oil on panel; $18 \times 25\frac{1}{8}$ in (46×64 cm)
Circa 1640–1641
London, Wallace Collection

298. The Concord of the State
Oil on panel; $29\frac{1}{2} \times 39\frac{3}{4}$ in (74.5×101 cm)
1641
Rotterdam, Boymans-van Beuningen Museum

299. Anna Wijmer (?)
Oil on panel; $37\frac{3}{4} \times 31\frac{1}{2}$ in (96×80 cm)
1641
Amsterdam, The Six Foundation

300

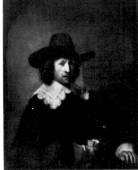

301

302

303

304

305

306

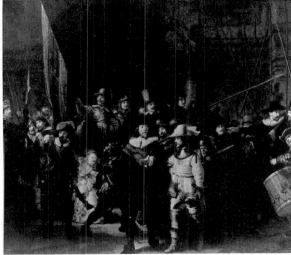

307

308

309

310

311

312

313

314

315

316

300. The Angel Ascending in the Flames of Manoah's Sacrifice
Oil on canvas; 95¼ × 111¼ in (242 × 283 cm)
1641
Dresden, Staatliche Kunstsammlungen, Gemäldegalerie

301. Nicolaas van Bambeeck
Oil on canvas; 41½ × 33 in (105.5 × 84 cm)
1641
Brussels, Musée des Beaux-Arts

302. The Mennonite Minister Cornelis Claesz. Anslo with his Wife
Oil on canvas; 69¼ × 82¾ in (172 × 209 cm)
1641
Berlin, Staatliche Museen Preussischer Kulturbesitz, Gemäldegalerie

303. Agatha Bas, Wife of Nicolaas van Bambeeck
Oil on canvas; 41½ × 33 in (104.5 × 85 cm)
1641
London, Buckingham Palace

304. A Young Girl Resting her Hands on a Sill
Oil on panel; 41 × 30 in (104 × 76 cm)
1641
Formerly at Vienna Lanckoronski Collection

305. Saskia with a Flower
Oil on panel; 38¾ × 32½ in (98.5 × 82.5 cm)
1641
Dresden, Staatliche Kunstsammlungen, Gemäldegalerie

306. A Scholar at his Desk
Oil on panel; 41 × 30 in (104 × 76 cm)
1641
Formerly at Vienna, Lanckoronski Collection

307. The Militia Company of Captain Frans Banning Cocq ("The Night Watch")
Oil on canvas; 143 × 172 in (363 × 437 cm)
1642
Amsterdam, Rijksmuseum

308. The Reconciliation of David and Absalom
Oil on panel; 28¾ × 24¼ in (73 × 61.5 cm)
1642
Leningrad, Hermitage

309. An Old Man at his Study Table
Oil on panel; 27½ × 21 in (70.5 × 53.5 cm)
1642
Budapest, Szépmüvészeti Múzeum

310. Study of an Old Man
Oil on panel; 8 × 6¾ in (20.5 × 17 cm)
Circa 1642–1643
New York, Goldman Collection

311. Self-portrait
Oil on canvas; 24 × 19 in (61 × 48 cm)
1643
Weimar, Stadtmuseum

312. Self-portrait
Oil on panel; 28½ × 23 in (71 × 57 cm)
Circa 1643 (?)
Boston, Museum of Fine Arts, on loan from R. W. Hoos

313. Bathsheba at her Toilet Seen by King David
Oil on panel; 22½ × 30 in (57 × 76 cm)
1643
New York, Metropolitan Museum of Art

314. Portrait of a Woman in a Velvet Dress
Oil on canvas; 46¾ × 38 in (119 × 96.5 cm)
1643
New York, Metropolitan Museum of Art

315. Portrait of a Woman with a Fan
Oil on canvas; 45 × 38½ in (114.5 × 98 cm)
1643
London, Duke of Westminster Collection

316. Saskia (posthumous portrait)
Oil on panel; 28¼ × 23¼ in (72 × 59 cm)
1643
Berlin, Staatliche Museen Preussischer Kulturbesitz, Gemäldegalerie

317

321

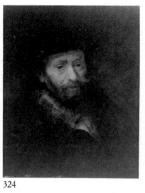

324

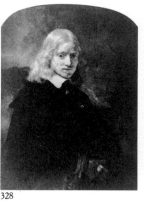

328

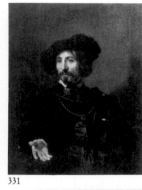

331

318

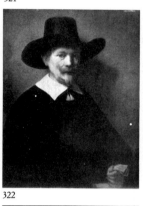

322

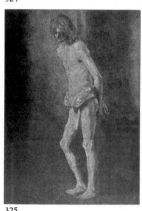

325

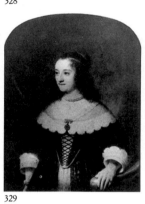

329

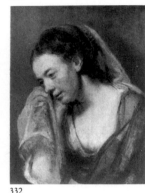

332

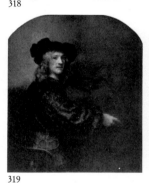

319

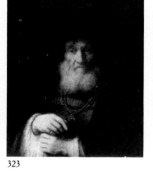

323

326

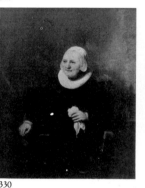

330

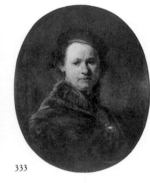

333

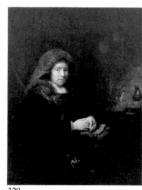

320

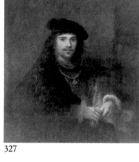

327

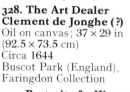

334

317. Portrait of a Man
Oil on canvas; 41 × 30 in
(104 × 76 cm)
1643
Tisbury (England),
Margadale Collection

318. Portrait of a Man
Oil on canvas; 47¾ × 38¾ in
(121.5 × 98.5 cm)
Circa 1643
New York, Metropolitan
Museum of Art

319. Portrait of a Man with a Falcon
Oil on canvas; 45 × 38½ in
(114.5 × 98 cm)
1643
London, Duke of
Westminster Collection

320. An Old Woman in Fanciful Costume
Oil on panel; 24 × 19¼ in
(61 × 49 cm)
1643
Leningrad, Hermitage

321. An Old Man Wearing a Beret
Oil on panel; 8¼ × 6¾ in
(21 × 17 cm)
1643
Richmond, Museum of
Fine Arts

322. A Man Holding a Glove
Oil on panel; 31¾ × 26½ in
(81 × 67 cm)
1643 (?)
New York, Metropolitan
Museum of Art

323. An Old Man in Rich Costume
Oil on panel; 29 × 23½ in
(72.5 × 58.5 cm)
1643
Woburn Abbey (England),
Duke of Bedford Collection

324. An Old Man Wearing a Beret
Oil on panel; 20 × 16½ in
(51 × 42 cm) (originally
18½ × 14½ in –47 × 37 cm)
Circa 1643–1644
Leningrad, Hermitage

325. Christ at the Column
Oil on panel; 13 × 11 in
(33 × 28 cm)
Circa 1644
Cologne, Wallraf-Richartz
Museum, von Carstanjen
Bequest

326. Christ and the Woman Taken in Adultery
Oil on panel; 33 × 25¾ in
(83.8 × 64.5 cm)
1644
London, National Gallery

327. A Young Man Holding a Sword
Oil on canvas; 40½ × 34 in
(102 × 85.5 cm)
1644
Brunswick (Maine),
Bowdoin College Museum
of Art, on loan from
Eunice, Lady Oakes

328. The Art Dealer Clement de Jonghe (?)
Oil on canvas; 37 × 29 in
(92.5 × 73.5 cm)
Circa 1644
Buscot Park (England),
Faringdon Collection

329. Portrait of a Woman
Oil on canvas; 36½ × 29 in
(93 × 73.5 cm)
1644
Buscot Park (England),
Faringdon Collection

330. A Woman Seated in an Armchair
Oil on canvas; 49 × 39½ in
(124.5 × 100 cm)
1644
Toronto, Art Gallery of
Ontario

331. A Man Wearing a Gorget-Plate
Oil on canvas; 37¼ × 30 in
(94.5 × 78 cm)
1644
New York, Metropolitan
Museum of Art

332. Study of a Woman Weeping
Oil on panel; 8½ × 6¾ in
(21.5 × 17 cm)
Circa 1644–1645
Detroit, Institute of Arts

333. Self-portrait
Oil on panel; 27 × 22 in
(69 × 56 cm)
Circa 1645
Karlsruhe, Staatliche
Kunsthalle

334. Self-portrait
Oil on panel; 26½ × 22½ in
(67.5 × 57.5 cm)
Circa 1645
Windsor, Royal Collection

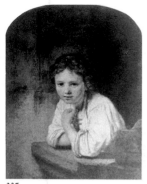

335

339

336

340

342

343

344

337

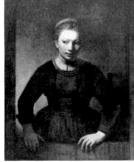

338

341

345

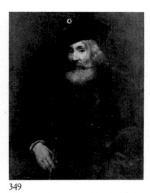

346

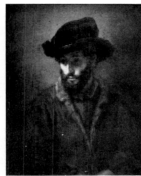

347

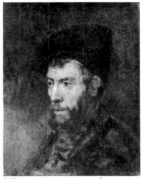

348

349

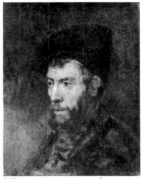

350

351

352

335. A Young Girl Leaning on a Windowsill
Oil on canvas; $32\frac{1}{8} \times 26$ in
(81.5×66 cm)
1645
London, Dulwich College Gallery

336. The Raising of the Cross
Oil on panel; $15\frac{1}{4} \times 11\frac{3}{4}$ in
(39×30 cm)
Circa 1645
The Hague, Bredius Museum

337. Landscape with Two Bridges
Oil on canvas; $15 \times 24\frac{1}{2}$ in
(38×62 cm)
1645 (?)
Eindhoven, Philips-de Jongh Collection

338. A Young Woman at a Door
Oil on canvas; $40\frac{1}{8} \times 33\frac{1}{8}$ in
(102×84 cm)
1645
Chicago, Art Institute

339. Portrait of a Man Reading
Oil on canvas; $26\frac{1}{4} \times 22\frac{3}{4}$ in
(66.5×58 cm)
1645
Williamstown (Massachusetts), The Sterling and Francine Clark Art Institute

340. The Holy Family with Angels
Oil on canvas; $46 \times 35\frac{3}{4}$ in
(117×91 cm)
1645
Leningrad, Hermitage

341. Joseph's Dream in the Stable at Bethlehem
Oil on panel; $8 \times 10\frac{3}{4}$ in
(20×27 cm)
1645
Berlin, Staatliche Museen Preussischer Kulturbesitz, Gemäldegalerie

342. A Scholar at his Desk
Oil on canvas; $51 \times 39\frac{1}{2}$ in
(129.5×100.5 cm)
1645
Cologne, Wallraf-Richartz Museum

343. Anna Accused by Tobit of Stealing the Kid
Oil on panel; $8 \times 10\frac{3}{4}$ in
(20×27 cm)
1645
Berlin, Staatliche Museen Preussischer Kulturbesitz, Gemäldegalerie

344. A Bearded Man
Oil on panel; $8 \times 6\frac{1}{4}$ in
(20×16 cm)
Circa 1645 (?)
Kassel, Staatliche Kunstsammlungen, Gemäldegalerie

345. An Old Man in a Fur-Lined Coat
Oil on canvas; $43\frac{1}{4} \times 32\frac{1}{4}$ in
(110×82 cm)
1645
Berlin, Staatliche Museen Preussischer Kulturbesitz, Gemäldegalerie

346. An Old Man in Fanciful Costume Holding a Stick
Oil on canvas; $50\frac{1}{4} \times 43\frac{3}{4}$ in
(128×112 cm)
1645
Lisbon, Museu de Arte, Gulbenkian Collection

347. A Young Man with a Beard
Oil on canvas; $32\frac{3}{4} \times 26\frac{3}{4}$ in
(83×68 cm)
Circa 1645–1647
Cleveland, Museum of Art

348. Head of a Bearded Man
Oil on panel; 8×6 in
(20×15 cm)
Circa 1645–1647
London, Ellesmere Collection

349. An Old Man with a Beard
Oil on canvas; $37\frac{1}{2} \times 31\frac{3}{4}$ in
(95.5×80.5 cm)
Circa 1645–1647
Dresden, Staatliche Kunstsammlungen, Gemäldegalerie

350. An Old Man with a Beard
Oil on panel; $29\frac{1}{2} \times 24$ in
(75×61 cm)
Circa 1645–1647
San Antonio, Urschel Collection

351. An Old Man Wearing a Beret
Oil on panel; $9\frac{1}{4} \times 7\frac{1}{4}$ in
(23.5×18.5 cm)
Circa 1645–1647
New York, Zedwitz Collection

352. Christ
Oil on panel; $10 \times 7\frac{3}{4}$ in
(25×20 cm)
1645–1650 (?)
Cambridge (Massachusetts), Fogg Art Museum

353

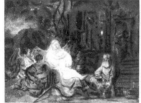

354

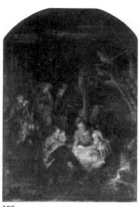

355

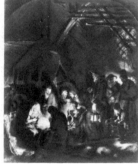

356

357

358

359

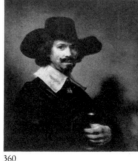

360

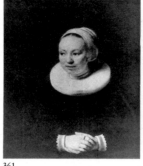

361

362

363

364

365

366

367

368

353. Hendrickje Stoffels in Bed
Oil on canvas; 32 × 26½ in
(80 × 66.5 cm)
Circa 1645–1650
Edinburgh, National
Gallery of Scotland

354. Abraham Serving the Three Angels
Oil on panel; 6¼ × 8¼ in
(16 × 21 cm)
1646
Rotterdam, Boymans-van
Beuningen Museum

355. The Adoration of the Shepherds
Oil on canvas; 38¼ × 28 in
(97 × 71 cm)
1646
Munich, Alte Pinakothek

356. The Adoration of the Shepherds
Oil on canvas; 25¾ × 21⅝ in
(65.5 × 55 cm)
1646
London, National Gallery

357. Winter Landscape with Skaters
Oil on panel; 6¾ × 9 in
(17 × 23 cm)
1646
Kassel, Staatliche
Kunstsammlungen,
Gemäldegalerie

358. The Holy Family
Oil on panel; 18¼ × 27 in
(46.5 × 68.5 cm)
(with painted frame and
curtain)
1646
Kassel, Staatliche
Kunstsammlungen,
Gemäldegalerie

359. The Rest on the Flight into Egypt
Oil on panel; 13½ × 19 in
(34 × 47 cm)
1647
Dublin, National Gallery of
Ireland

360. The Painter Hendrick Martensz. Sorgh
Oil on panel; 29¼ × 26½ in
(74 × 67 cm) 164(7?)
London, Duke of
Westminster Collection

361. Adriaentje Hollaer, Wife of the Painter Hendrick Martensz. Sorgh
Oil on panel; 29¼ × 26½ in
(74 × 67 cm) 1647
London, Duke of
Westminster Collection

362. The Jewish Physician Ephraïm Bueno
Oil on panel; 7½ × 6 in
(19 × 15 cm)
Circa 1647
Amsterdam, Rijksmuseum

363. An Old Woman with a Book
Oil on canvas; 43 × 36 in
(109 × 91.5 cm)
164(7)
Washington, National
Gallery of Art, Mellon
Collection

364. Susanna Surprised by the Elders
Oil on panel; 30 × 35¾ in
(76 × 91 cm)
1647
Berlin, Staatliche Museen
Preussischer Kulturbesitz,
Gemäldegalerie

365. An Old Man Wearing a Fur Cap
Oil on panel; 10 × 8¾ in
(25 × 22.5 cm) 1647
Rotterdam, Boymans-van
Beuningen Museum

366. Portrait of a Young Jew
Oil on panel; 9¾ × 8 in
(24.5 × 20.5 cm)
Circa 1647–1648
Berlin, Staatliche Museen
Preussischer Kulturbesitz,
Gemäldegalerie

367. A Young Girl
Oil on panel; 8¾ × 7½ in
(22 × 19 cm)
Circa 1647–1651
England, private collection

368. Head of a Girl
Oil on panel; 8¼ × 7 in
(21 × 17.5 cm)
Circa 1647–1651
Wassenaar (Netherlands),
van den Bergh Collection

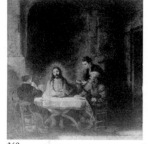

369

370

371

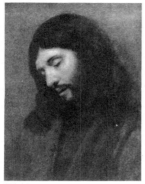

373

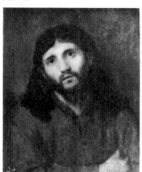

374

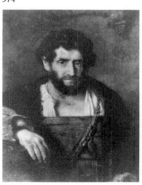

375

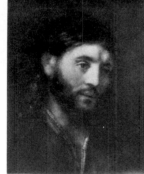

376

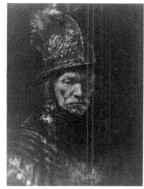

377

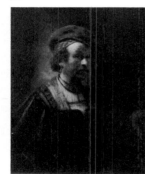

378

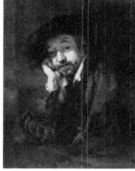

379

380

381

382

383

384

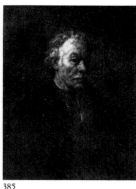

385

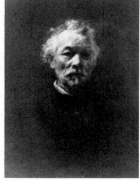

386

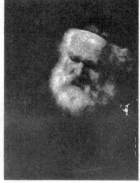

387

369. Christ at Emmaus
Oil on panel; 26¾ × 25¼ in
(68 × 65 cm)
1648
Paris, Louvre

370. Christ at Emmaus
Oil on canvas; 35¼ × 44 in
(89.5 × 111.5 cm)
1648
Copenhagen, Statens
Museum for Kunst

371. Christ
Oil on panel; 10 × 8¼ in
(25.5 × 21 cm)
Circa 1648
The Hague, Bredius
Museum

372. Christ
Oil on panel; 10 × 8 in
(25.5 × 20 cm)
Circa 1648
Formerly at Amsterdam,
de Boer Collection

373. Christ
Oil on panel; 9½ × 7½ in
(24 × 19 cm)
Circa 1648
Private collection

374. Christ
Oil on panel; 10 × 9 in
(25 × 23 cm)
Circa 1648
Detroit, Institute of Arts

**375. A Man With a Gold
Chain**
Oil on canvas; 35 × 26 in
(89 × 66 cm)
1648
London, Weitzner
Collection

376. Christ
Oil on canvas; 18⅝ × 14⅝ in
(47 × 37 cm)
Circa 1648–1650
New York, Metropolitan
Museum of Art

**377. "The Man with the
Golden Helmet"**
Oil on canvas; 26½ × 19¾ in
(67 × 50 cm)
Circa 1648–1650
Berlin, Staatliche Museen
Preussischer Kulturbesitz,
Gemäldegalerie

378. Self-portrait
Oil on canvas; 34¾ × 28 in
(88.5 × 71 cm)
1650
Washington, National
Gallery of Art, Widener
Collection

379. Self-portrait (?)
Oil on canvas; 32¼ × 27 in
(82 × 68.5 cm)
1650
Cincinnati, Taft Museum

380. Self-portrait
Oil on panel; 10¼ × 8½ in
(26 × 21.5 cm)
Circa 1650
Leipzig, Museum der
Bildenden Kunste

**381. Hannah in the
Temple (?)**
Oil on panel; 16 × 12½ in
(40.5 × 31.5 cm)
Circa 1650 (?)
Edinburgh, National
Gallery of Scotland, on
loan from the Duke of
Sutherland

382. The Lamentation
Oil on canvas; 69¾ × 77¼ in
(177.5 × 196.5 cm)
1650
Sarasota, John and Mabel
Ringling Museum

**383. River Landscape
with Ruins**
Oil on panel; 26½ × 34½ in
(67 × 87.5 cm)
Circa 1650
Kassel, Staatliche
Kunstsammlungen,
Gemäldegalerie

**384. A Woman in
Fanciful Costume**
Oil on panel; 54 × 40 in
(137 × 101.5 cm)
1650 (?)
Sarasota, John and Mabel
Ringling Museum

**385. "Rembrandt's
Brother"**
Oil on canvas; 31¼ × 26½ in
(80 × 67 cm)
1650
The Hague, Mauritshuis

**386. "Rembrandt's
brother"**
Oil on canvas; 28 × 21¾ in
(71 × 55 cm)
Circa 1650
Paris, Louvre

**387. Portrait of an Old
Jew**
Oil on panel; 24½ × 18 in
(62 × 45.5 cm)
Circa 1650
Dublin, National Gallery of
Ireland

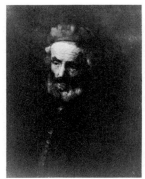

388

392

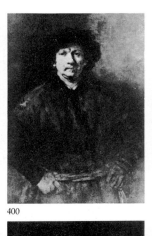

396

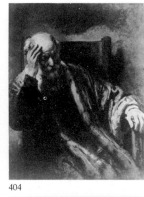

404

389

393

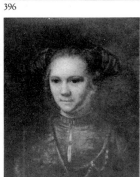

400

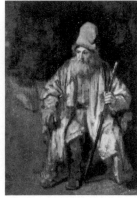

400

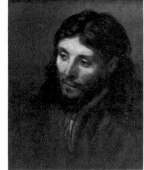

390

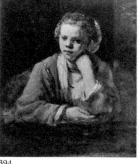

394

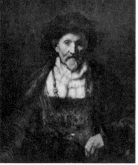

397

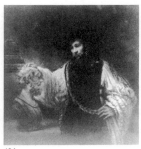

401

391

395

397

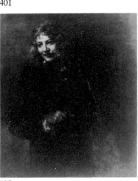

401

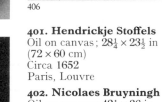

405

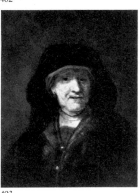

398

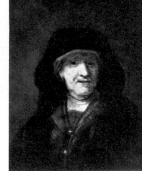

399

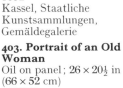

402

403

406

388. A Man Wearing a Beret
Oil on canvas; 26¾ × 22 in
(68 × 56 cm)
1650
Baltimore, Museum of Fine
Arts

389. A Man in Fanciful Costume Holding a Large Sword
Oil on panel; 50⅜ × 40⅞ in
(126 × 103 cm)
1650
Cambridge, Fitzwilliam
Museum

390. The Vision of Daniel
Oil on canvas; 37¾ × 45¾ in
(96 × 116 cm)
Circa 1650
Berlin, Staatliche Museen
Preussischer Kulturbesitz,
Gemäldegalarie

391. Christ
Oil on panel; 9¾ × 8 in
(25 × 20 cm)
Circa 1650–1656
Berlin, Staatliche Museen
Preussischer Kulturbesitz,
Gemäldegalerie

392. The Risen Christ Appearing to the Magdalen
Oil on canvas; 25½ × 31 in
(65 × 79 cm)
1651
Brunswick, Staatliches
Herzog Anton Ulrich
Museum

393. The Descent from the Cross
Oil on canvas; 56 × 41¾ in
(142 × 106 cm)
165(1)
Washington, National
Gallery of Art, Widener
Collection

394. A Young Girl at a Window
Oil on canvas; 30¾ × 24¾ in
(78 × 63 cm)
1651
Stockholm,
Nationalmuseum

395. A Young Girl Holding a Broom
Oil on canvas; 42¼ × 36 in
(107.5 × 91.5 cm)
1651 (?)
Washington, National
Gallery of Art, Mellon
Collection

396. King David
Oil on panel; 12 × 10¼ in
(30 × 26 cm)
1651
New York, Kaplan
Collection

397. A Young Girl
Oil on canvas; 22¾ × 19 in
(58 × 48 cm)
1651
New York, Linsky
Collection

398. An Old Man in Fanciful Costume
Oil on canvas; 32 × 31 in
(78.5 × 76.5 cm)
1651
Chatsworth (England),
Devonshire Collection

399. An Old Man Wearing a Linen Headband
Oil on canvas; 30¼ × 26 in
(77 × 66 cm)
1651
Wanas (Sweden),
Wachtmeister Collection

400. Self-portrait
Oil on canvas; 44 × 32 cm
(112 × 81.5 cm)
1652
Vienna, Kunsthistorisches
Museum, Gemäldegalerie

401. Hendrickje Stoffels
Oil on canvas; 28¼ × 23½ in
(72 × 60 cm)
Circa 1652
Paris, Louvre

402. Nicolaes Bruyningh
Oil on canvas; 42¼ × 36 in
(107.5 × 91.5 cm)
1652
Kassel, Staatliche
Kunstsammlungen,
Gemäldegalerie

403. Portrait of an Old Woman
Oil on panel; 26 × 20½ in
(66 × 52 cm)
165(2?)
Cincinnati, Taft Museum

404. An Old Man in an Armchair
Oil on canvas;
43⅝ × 34⅝ in (111 × 88 cm)
1652
London, National Gallery

405. An Old Man in an Armchair (Biblical figure?)
Oil on canvas; 20 × 14½ in
(51 × 37 cm)
Circa 1652
Berlin, Staatliche Museen
Preussischer Kulturbesitz,
Gemäldegalerie

406. Aristotle Contemplating a Bust of Homer
Oil on canvas; 56½ × 53¾ in
(143.5 × 136.5 cm) 1653
New York, Metropolitan
Museum of Art

407

408

409

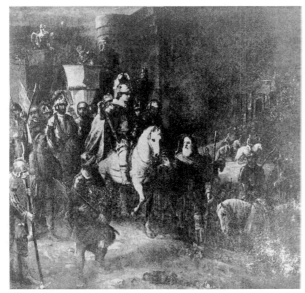

410

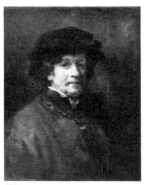

411

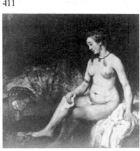

412

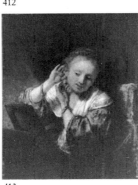

413

414

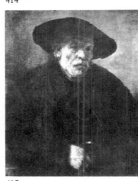

415

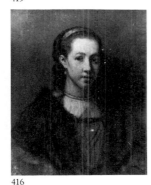

416

417

418

419

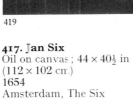

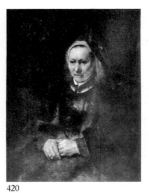

420

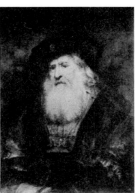

421

422

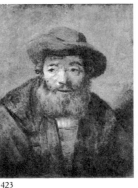

423

407. Self-portrait
Oil on canvas; 29¼ × 24 in
(74.5 × 61 cm)
1653 (?)
San Francisco, M. H. de
Young Memorial Museum

408. Self-portrait
Oil on canvas; 29½ × 24¾ in
(75 × 63 cm)
Circa 1653–1654
Rousham (England),
Cottrell Dormer Collection

409. Titus (?)
Oil on canvas; 25½ × 22 in
(65 × 56 cm)
Circa 1653–1654
Fullerton (California),
Norton Simon Foundation

410. Quintus Fabius
Maximus
Oil on canvas; 70½ × 77½ in
(179 × 197 cm)
165(3? 5?)
Formerly at Belgrade,
Royal Collections

411. Self-portrait
Oil on canvas; 28¾ × 23½ in
(73 × 60 cm)
165(4)
Kassel, Staatliche
Kunstsammlungen,
Gemäldegalerie

412. Bathsheba with
King David's Letter
Oil on canvas; 56 × 56 in
(142 × 142 cm)
1654
Paris, Louvre

413. A Young Woman at
her Mirror
Oil on panel; 15½ × 12¾ in
(40 × 33 cm)
165(4?)
Leningrad, Hermitage

414. Evening Landscape
with Cottages
Oil on panel; 10 × 15½ in
(25.5 × 39.5 cm)
1654
Montreal, Museum of Fine
Arts

415. "Rembrandt's
Brother"
Oil on canvas; 29 × 25½ in
(74 × 65 cm)
1654
Moscow, Pushkin Museum

416. Hendrickje Stoffels
Oil on canvas; 25¾ × 21¼ in
(65.5 × 54 cm)
Circa 1654
Fullerton (California),
Norton Simon Foundation

417. Jan Six
Oil on canvas; 44 × 40½ in
(112 × 102 cm)
1654
Amsterdam, The Six
Foundation

418. An Old Woman in a
Hood
Oil on canvas; 29 × 24¾ in
(74 × 63 cm)
1654
Moscow, Pushkin Museum

419. An Old Woman in
an Armchair
Oil on canvas; 43 × 33 in
(109 × 84 cm)
1654
Leningrad, Hermitage

420. An Old Woman
Seated
Oil on canvas; 32½ × 28¼ in
(82 × 72 cm)
Circa 1654
Moscow, Pushkin Museum

421. An Old Man in
Fanciful Costume
Oil on panel; 40¼ × 30¾ in
(102 × 78 cm)
1654
Dresden, Staatliche
Kunstsammlungen,
Gemäldegalerie

422. An Old Man in an
Armchair
Oil on canvas; 42½ × 33¾ in
(108 × 86 cm)
Circa 1654 (?)
Leningrad, Hermitage

423. A Bearded Man
Oil on panel; 10 × 8¼ in
(25.5 × 21 cm)
1654
Groningen, Museum voor
Stad en Lande

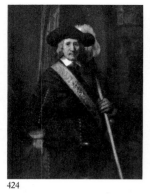

424

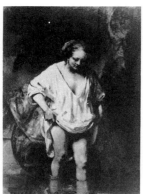

428

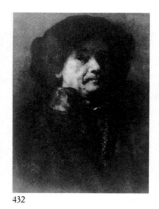

432

436

439

425

429

440

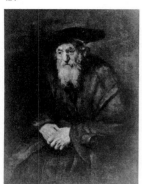

437

426

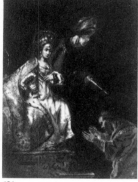

430

433

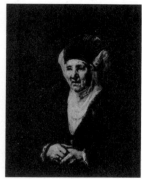

441

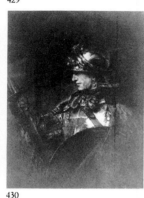

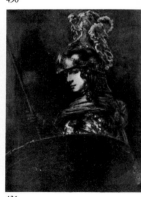

434

438

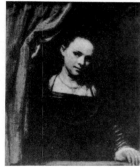

427

431

435

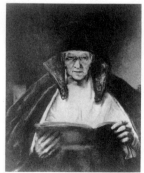

442

424. The Standard-Bearer
Oil on canvas; 55¼ × 45¼ in (138 × 113 cm)
1654
New York, Metropolitan Museum of Art

425. An Old Man in an Armchair
Oil on canvas; 43 × 33½ in (109 × 84 cm)
1654
Leningrad, Hermitage

426. The Condemnation of Haman
Oil on canvas; 102½ × 74¾ in (235 × 190 cm)
Circa 1654–1655
Bucharest, Muzeul de Arta

427. A Woman in Fanciful Costume
Oil on canvas; 33½ × 28 in (85 × 71 cm)
Circa 1654–1655
Baltimore, The Walters Art Gallery

428. A Woman Bathing
Oil on panel; 24¼ × 18½ in (61.8 × 47 cm)
1654 or 1655
London, National Gallery

429. Portrait of an Old Woman
Oil on canvas; 28¼ × 24 in (72 × 61 cm)
Circa 1654–1655
Copenhagen, Statens Museum

430. Alexander the Great
Oil on canvas; 54¼ × 41⅛ in (137.5 × 104.5 cm)
Circa 1655
Glasgow, Art Gallery and Museum

431. Alexander the Great
Oil on canvas; 46½ × 35¾ in (118 × 91 cm)
Circa 1655
Lisbon, Gulbenkian Foundation

432. Self-portrait
Oil on panel; 26 × 21 in (66 × 53 cm)
1655
Vienna, Kunsthistorisches Museum, Gemäldegalerie

433. The Slaughtered Ox
Oil on panel; 37 × 26½ in (94 × 67 cm)
1655
Paris, Louvre

434. "The Polish rider"
Oil on canvas; 46 × 53⅛ in (116.8 × 134.9 cm)
Circa 1655
New York, Frick Collection

435. Christ and the Woman of Samaria at the Well
Oil on panel; 18¼ × 15¼ in (46.5 × 39 cm)
1655
Berlin, Staatliche Museen Preussischer Kulturbesitz, Gemäldegalerie

436. Christ and the Woman of Samaria at the Well
Oil on panel; 25 × 19¼ in (62 × 49.5 cm)
1655
New York, Metropolitan Museum of Art

437. Joseph Accused by Potiphar's Wife
Oil on canvas; 41⅝ × 38½ in (106 × 98 cm)
1655
Washington, National Gallery of Art, Mellon Collection

438. Joseph Accused by Potiphar's Wife
Oil on canvas; 43¼ × 34¼ in (110 × 87 cm)
1655
Berlin, Staatliche Museen Preussischer Kulturbesitz, Gemäldegalerie

439. The Tribute Money
Oil on canvas; 24¾ × 33 in (63 × 84 cm)
1655
Bywell (England), Allendale Collection

440. Titus
Oil on canvas; 31 × 23¼ in (79 × 59 cm)
1655
New York, Metropolitan Museum of Art

441. Portrait of an Old Woman
Oil on canvas; 34¼ × 28¼ in (87 × 73 cm)
1655
Stockholm, Nationalmuseum

442. An Old Woman Reading
Oil on canvas; 31½ × 26 in (79 × 65 cm)
1655
Drumlanrig Castle (Scotland), Buccleuch Collection

443

444

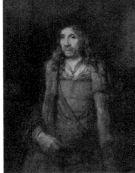
445

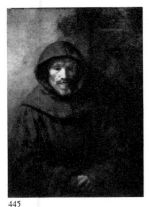
446

447

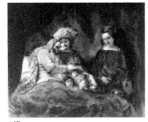
448

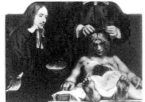
449

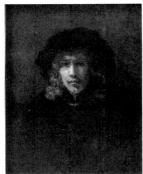
450

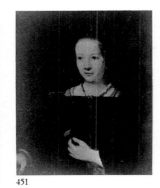
451

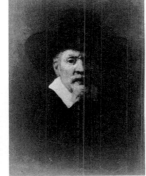
452

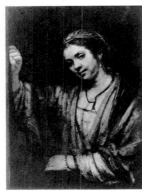
453

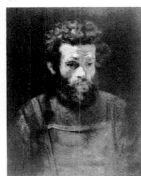
454

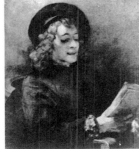
454

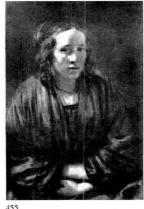
455

456

457

458

459

460

461

443. An Old Man with a Stick
Oil on canvas; 35 × 28¾ in (89 × 73 cm)
1655
Stockholm, Nationalmuseum

444. Titus
Oil on canvas; 30¼ × 24¾ in (77 × 63 cm)
1655
Rotterdam, Boymans-van Beuningen Museum

445. A Franciscan Monk
Oil on canvas; 35 1/16 × 26 3/16 in (89 × 66.5 cm)
Circa 1655–1656
London, National Gallery

446. A Man in a Fur-Lined Coat
Oil on canvas; 45 × 34¼ in (114 × 87 cm)
1655–1660
Boston, Museum of Fine Arts, on loan from The Fuller Foundation

447. Christ
Oil on panel; 9¾ × 7⅞ in (21.5 × 20 cm (later enlarged to 14 × 12⅓ in – 35.7 × 31.5 cm)
1656 (?)
Philadelphia, John G. Johnson Art Collection

448. Jacob Blessing the Children of Joseph
Oil on canvas; 69 × 82¾ in (175.5 × 210.5 cm)
1656
Kassel, Staatliche Kunstsammlungen, Gemäldegalerie

449. The Anatomy Lesson of Doctor Joan Deyman
Fragment
Oil on canvas; 39½ × 52¾ in (100 × 134 cm)
1656
Amsterdam, Rijksmuseum

450. A Young Man with a Beret
Oil on canvas; 30 × 24 in (76 × 61 cm)
Circa 1656
New York, Payson Collection

451. A Young Woman with a Carnation
Oil on canvas; 30¾ × 27 in (78.5 × 68.5 cm)
1656
Copenhagen, Statens Museum for Kunst

452. A Young Woman with a Carnation
Oil on canvas; 40½ × 33¾ in (103 × 86 cm)
1656
Washington, National Gallery of Art, Mellon Collection

453. The Amsterdam Physician Arnout Tholinx
Oil on canvas; 30 × 24¾ in (76 × 63 cm)
1656 (?)
Paris, Musée Jacquemart-André

454. Titus Reading
Oil on canvas; 27¾ × 25¼ in (70.5 × 64 cm)
Circa 1656
Vienna, Kunsthistorisches Museum, Gemäldegalerie

455. Hendrickje Stoffels
Oil on panel; 28½ × 20¼ in (72.5 × 51.5 cm)
Circa 1656–1657
Frankfurt, Städelsches Kunstinstitut

456. Hendrickje Stoffels Leaning against a Door
Oil on canvas; 34 × 25½ in (86 × 65 cm)
Circa 1656–1657
Berlin, Staatliche Museen Preussischer Kulturbesitz, Gemäldegalerie

457. A Bearded Man
Oil on canvas; 27¾ × 23 in (70.5 × 58.5 cm)
Circa 1656–1657
Berlin, Staatliche Museen Preussischer Kulturbesitz, Gemäldegalerie

458. A Bearded Man in a Cap
Oil on canvas; 30¾ × 26¼ in (78 × 66.5 cm)
Circa 1656–1657
London, National Gallery

459. A Bearded Man in a Cap
Oil on canvas; 32¼ × 26 in (82 × 65 cm) Circa 1656–1657
Kenosha (Wisconsin), Whitacker Collection

460. Titus
Oil on canvas; 26½ × 21¾ in (67.5 × 55 cm) Circa 1656–1658
London, Wallace Collection

461. The Adoration of the Magi
Oil on panel; 48½ × 40½ in (123 × 103 cm) 1657
London, Buckingham Palace

197

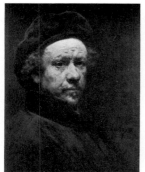

462

466

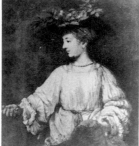

467

470

474

463

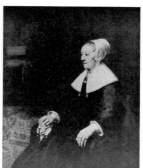

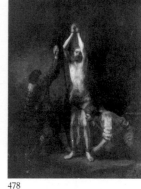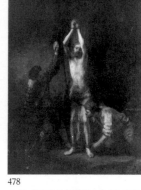

468

471

475

477

464

469

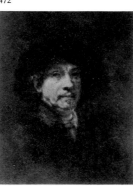

472

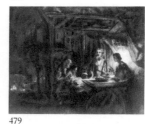

476

478

479

465

473

480

462. Self-portrait
Oil on canvas; 20 × 17 in
(50 × 42.5 cm)
1657
Edinburgh, National
Gallery of Scotland, on
loan from the Duke of
Sutherland

463. Self-portrait
Oil on canvas; 33¾ × 25½ in
(85.5 × 65 cm) 1657
Dresden, Staatliche
Kunstsammlungen,
Gemäldegalerie

464. Self-portrait
Oil on panel; 19½ × 16¼ in
(49 × 41 cm)
Circa 1657
Vienna, Kunsthistorisches
Museum, Gemäldegalerie

465. Christ on the Cross
Oil on panel; 12½ × 11½ in
(32 × 29 cm)
1657
Williamstown
(Massachusetts), The
Sterling and Francine
Clark Art Institute

**466. David Playing the
Harp Before Saul**
Oil on canvas; 51¼ × 64½ in
(130.5 × 164 cm)
Circa 1657
The Hague, Mauritshuis

**467. Hendrickje Stoffels
as Flora**
Oil on canvas; 39⅜ × 36⅛ in
(100 × 92 cm)
Circa 1657
New York, Metropolitan
Museum of Art

**468. Catharina
Hooghsaet**
Oil on canvas; 49½ × 38 in
(123.5 × 95 cm)
1657
Penrhyn Castle (England),
Douglas-Pennant
Collection

469. A Man with a Stick
Oil on canvas; 32¾ × 26 in
(83 × 66 cm)
1657
Paris, Louvre

**470. The Apostle
Bartholomew**
Oil on canvas; 64¾ × 53¾ in
(126.5 × 100.5 cm)
1657
San Diego, Timken Art
Gallery

**471. Head of an Old
Woman**
Oil on panel; 8¼ × 6¾ in
(21 × 17 cm)
1657
Washington, National
Gallery of Art, Widener
Collection

**472. An Old Man with a
Gold Chain**
Oil on canvas; 31 × 25½ in
(78.5 × 65.5 cm)
1657
San Francisco, California
Palace of the Legion of
Honor

473. Self-portrait
Oil on canvas; 28¼ × 22¾ in
(71.5 × 57.5 cm)
Circa 1657–1658
Florence, Uffizi

**474. A Man in a Pearl-
Trimmed Cap**
Oil on canvas; 30½ × 26¼ in
(77.5 × 66.5 cm)
Circa 1657–1658
Copenhagen, Statens
Museum for Kunst

**475. The Writing Master
Lieven Willemsz. van
Coppenol**
Oil on panel; 14¼ × 11 in
(36 × 28 cm)
Circa 1657–1658
New York, Metropolitan
Museum of Art

**476. The Apostle Paul at
his Desk**
Oil on canvas; 50¾ × 40⅛ in
(129 × 102 cm)
Circa 1657 or 1659
Washington, National
Gallery of Art, Widener
Collection

477. Self-portrait
Oil on canvas; 52⅝ × 40⅞ in
(131 × 102 cm)
1658
New York, Frick
Collection

**478. Christ at the
Column**
Oil on canvas; 36½ × 28¼ in
(93 × 72 cm)
1658
Darmstadt, Hessisches
Landesmuseum

**479. Jupiter and
Mercury Visiting
Philemon and Baucis**
Oil on panel; 21½ × 27 in
(54.5 × 68.5 cm)
1658
Washington, National
Gallery of Art, Widener
Collection

**480. Hendrickje Stoffels
as Venus**
Oil on canvas; 43¼ × 34¾ in
(110 × 88 cm)
Circa 1658
Paris, Louvre

481

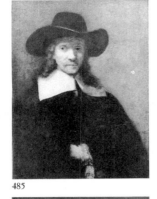

485

489

492

496

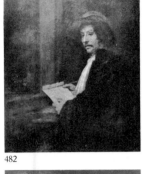

482

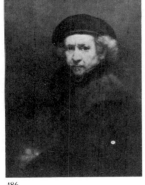

486

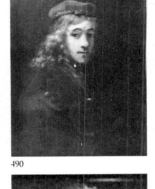

490

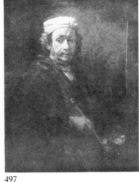

493

497

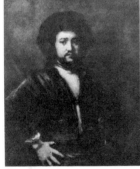

483

487

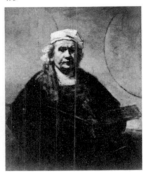

494

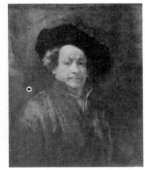

498

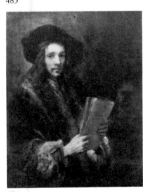

484

488

491

495

499

481. Portrait of a Young Man
Oil on canvas; 28¾ × 24 in
(73 × 61 cm)
1658
Paris, Louvre

482. A Man Holding a Letter
Oil on canvas; 44½ × 37½ in
(113 × 95.5 cm)
Château de Pregny
(Geneva), Edmond de
Rothschild Collection

483. A Man with Arms Akimbo
Oil on canvas; 42 × 34½ in
(106.5 × 87.5 cm)
1658
New York, Columbia
University

484. A Man Holding a Manuscript
Oil on canvas; 42¾ × 34 in
(109 × 86 cm)
1658
New York, Metropolitan
Museum of Art

485. Portrait of a Man
Oil on canvas; 32⅞ × 25⅜ in
(83.5 × 64.5 cm)
Circa 1658–1660
New York, Metropolitan
Museum of Art

486. Self-portrait
Oil on canvas; 33¼ × 26 in
(84.5 × 66 cm)
1659
Washington, National
Gallery of Art, Mellon
Collection

487. Christ and the Woman of Samaria at the Well
Oil on canvas; 23½ × 29½ in
(60 × 75 cm)
1659
Leningrad, Hermitage

488. Moses with the Tables of the Law
Oil on canvas; 65¾ × 53 in
(167 × 135 cm)
1659
Berlin, Staatliche Museen
Preussischer Kulturbesitz,
Gemäldegalerie

489. Young Man in a Red Cloak
Oil on panel; 15 × 12¼ in
(38 × 31 cm)
1659
New York, Metropolitan
Museum of Art

490. Titus
Oil on canvas; 28¼ × 22 in
(72 × 56 cm)
Circa 1659
Paris, Louvre

491. An Old Man
Oil on panel; 14¾ × 10½ in
(37.5 × 26.5 cm)
1659
Birmingham (England),
Cotton Collection

492. An Old Man as the Apostle Paul
Oil on canvas; 40⅛ × 33⅝ in
(102 × 85.5 cm)
1659(?)
London, National Gallery

493. Tobit and his Wife
Oil on panel; 15¾ × 21¼ in
(40.5 × 54 cm)
1659 (?)
Rotterdam, Willem van
der Vorm Foundation

494. Self-portrait with Palette and Two Circles
Oil on canvas; 45 × 37½ in
(114 × 94 cm)
Circa 1659–1660
London, Kenwood House,
The Iveagh Bequest

495. Jacob Wrestling with the Angel
Oil on canvas; 54 × 45¾ in
(137 × 116 cm)
Circa 1659–1660
Berlin, Staatliche Museen
Preussischer Kulturbesitz,
Gemäldegalerie

496. Haman and Ahasuerus at the Feast of Esther
Oil on canvas; 28¾ × 37 in
(71.5 × 93 cm)
1660
Moscow, Pushkin Museum

497. Self-portrait
Oil on canvas; 43¾ × 33½ in
(111 × 85 cm)
1660
Paris, Louvre

498. Self-portrait
Oil on canvas; 31⅝ × 26½ in
(77.5 × 66 cm)
1660
New York, Metropolitan
Museum of Art

499. Self-portrait
Oil on canvas; 30 × 24 in
(76.5 × 61 cm)
1660
Melbourne, National
Gallery of Victoria

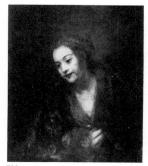

500

504

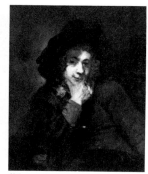

507

511

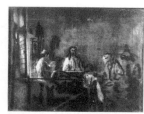

515

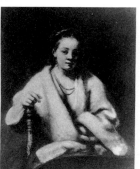

501

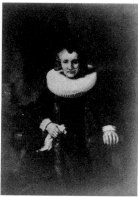

505

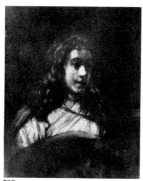

508

512

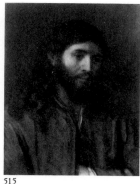

516

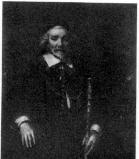

502

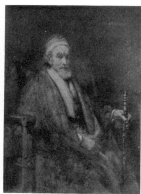

505

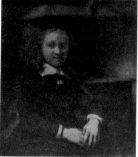

506

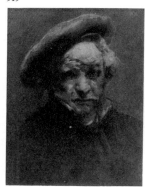

509

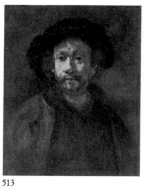

513

517

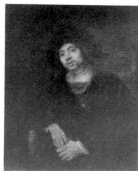

503

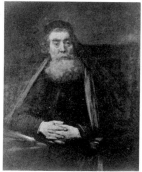

510

514

518

500. Hendrickje Stoffels
Oil on canvas; $30\frac{7}{8} \times 27\frac{1}{8}$ in
$(76 \times 67$ cm$)$
1660
New York, Metropolitan
Museum of Art

501. Hendrickje Stoffels
Oil on canvas; $39\frac{1}{2} \times 32\frac{3}{4}$ in
$(100 \times 83.5$ cm$)$
Circa 1660
Sudeley Castle (England),
Morrison Collection

502. Dirk van Os
Oil on canvas; $40\frac{3}{4} \times 34$ in
$(101 \times 85$ cm$)$
Circa 1660
Omaha (Nebraska), Joslyn
Art Museum

**503. Portrait of a Young
Man**
Oil on canvas; $36\frac{1}{4} \times 32\frac{1}{4}$ in
$(91.5 \times 81.5$ cm$)$
1660
Rochester, George
Eastman Collection of the
University of New York

504. A Young Girl seated
Oil on canvas; $30\frac{1}{2} \times 25\frac{1}{2}$ in
$(77.5 \times 65$ cm$)$
1660
London, private collection

**505. Margaretha de
Geer, Wife of Jacob Trip**
Oil on canvas; $51\frac{3}{8} \times 38\frac{3}{8}$ in
$(130.5 \times 97.5$ cm$)$
Circa 1660
London, National Gallery

**506. The Dordrecht
Merchant Jacob Trip**
Oil on canvas; $51\frac{3}{8} \times 38\frac{1}{4}$ in
$(130.5 \times 97$ cm$)$
Circa 1660
London, National Gallery

507. Titus
Oil on canvas; $31 \times 26\frac{1}{4}$ in
$(78.5 \times 67$ cm$)$
1660 (?)
Baltimore, Museum of Art

508. Titus
Oil on panel; $15\frac{3}{4} \times 13\frac{1}{2}$ in
$(40 \times 34.5$ cm$)$
Circa 1660
Detroit, Fisher Collection

**509. A Man Seated
before a Stove**
Oil on panel; 19×16 in
$(48 \times 41$ cm$)$
Circa 1660
Winterthur, Sammlung
Oskar Reinhart

**510. An Old Man in an
Armchair**
Oil on canvas; $41\frac{1}{4} \times 34$ in
$(104.5 \times 86$ cm$)$
Circa 1660
Florence, Uffizi

**511. The Apostle Peter
Denying Christ**
Oil on canvas; $60\frac{1}{2} \times 66\frac{1}{2}$ in
$(154 \times 169$ cm$)$
1660
Amsterdam, Rijksmuseum

**512. A Young Capuchin
Monk (Titus)**
Oil on canvas; $31\frac{1}{4} \times 26\frac{3}{4}$ in
$(79.5 \times 67.7$ cm$)$
166(0)
Amsterdam, Rijksmuseum

513. Self-portrait
Oil on canvas; $29 \times 23\frac{1}{4}$ in
$(73.7 \times 59$ cm$)$
Circa 1660–1661
Montreal, Bronfman
Collection

514. Self-portrait
Oil on panel; $11\frac{3}{4} \times 9$ in
$(30 \times 23$ cm$)$
Circa 1660–1661
Aix-en-Provence, Musée
Granet

515. Christ
Oil on panel; $24\frac{1}{2} \times 19\frac{1}{4}$ in
$(62 \times 49$ cm$)$
Circa 1660–1661
Milwaukee, John Collection

516. Christ at Emmaus
Oil on canvas; $19 \times 25\frac{1}{4}$ in
$(48 \times 64$ cm$)$
Circa 1660–1661
Paris, Louvre

**517. Head of an Old Man
(Study for the Apostle
Matthew)**
Oil on panel; $9\frac{3}{4} \times 7\frac{1}{2}$ in
$(25 \times 19.5$ cm$)$
Circa 1660–1661
Washington, National
Gallery of Art, Widener
Collection

**518. Head of an Old Man
(Study for the Apostle
Matthew)**
Oil on panel; $9\frac{3}{4} \times 8\frac{3}{4}$ in
$(25 \times 22$ cm$)$
Circa 1660–1661
Bayonne, Musée Léon
Bonnat

519

520

521

522

523

524

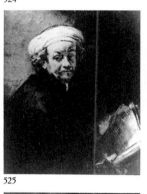

525

526

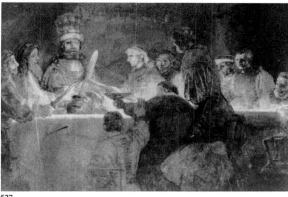

527

528

529

530

531

532

533

534

535

536

537

519. Head of an Old Man (Study for the Apostle Matthew)
Oil on panel; 9¾ × 7¾ in (24.5 × 20 cm)
Circa 1660–1661
England, private collection

520. Head of an Old Man (Study for the Apostle Matthew)
Oil on panel; 10½ × 8¾ in (27 × 22 cm)
Circa 1660–1661
Detroit, McAneeny Collection

521. Study of the Head of an Old Man
Oil on panel; 9½ × 7½ in (24 × 19 cm)
Circa 1660–1663
New York, Whitney Collection

522. The Apostle James
Oil on canvas; 35½ × 30¾ in (90 × 78 cm)
1661
New York, Metropolitan Museum of Art, on loan

523. An Apostle Praying
Oil on canvas; 32¾ × 26½ in (83 × 67 cm)
1661
Cleveland, Museum of Art

524. The Apostle Simon
Oil on canvas; 38¾ × 31 in (98.5 × 79 cm)
1661
Zurich, Kunsthaus, Ruzicka Stiftung

525. Self-portrait as the Apostle Paul
Oil on canvas; 35¾ × 30¼ in (91 × 77 cm)
1661
Amsterdam, Rijksmuseum

526. The Circumcision of Christ
Oil on canvas; 22¼ × 29½ in (56.5 × 75 cm)
1661
Washington, National Gallery of Art, Widener Collection

527. The Conspiracy of the Batavians (The Conspiracy of Claudius Civilis: the Oath)
Fragment
Oil on canvas; 77¼ × 121¾ in (196 × 309 cm)
1661
Stockholm, Nationalmuseum

528. Christ
Oil on canvas; 42½ × 35 in (108 × 89 cm)
Circa 1661
Glens Falls (New York), Hyde Collection

529. Christ
Oil on canvas; 37½ × 32⅓ in (94.5 × 81.5 cm)
1661
New York, Metropolitan Museum of Art

530. The Risen Christ
Oil on canvas; 31 × 24¾ in (78.5 × 63 cm)
1661
Munich, Alte Pinakothek

531. Two Negroes
Oil on canvas; 30½ × 25¼ in (78 × 64.5 cm)
1661
The Hague, Mauritshuis

532. An Evangelist Writing
Oil on canvas; 40¼ × 33 in (105 × 82 cm)
Circa 1661
Boston, Museum of Fine Arts

533. The Evangelist Matthew Inspired by the Angel
Oil on canvas; 37¾ × 32 in (96 × 81 cm)
1661
Paris, Louvre

534. Portrait of a Young Jew
Oil on canvas; 25¼ × 22½ in (64 × 57 cm)
1661
Montreal, Van Horne Collection

535. Margaretha de Geer
Oil on canvas; 29⅝ × 25⅛ in (76.5 × 64 cm)
1661
London, National Gallery

536. A Nun (The Madonna?)
Oil on canvas; 42 × 32 in (107 × 81 cm) 1661
Epinal, Musée des Vosges

537. A Capuchin Monk Reading
Oil on canvas; 32¼ × 26 in (82 × 66 cm) 1661
Helsinki, Ateneumin Taidemuseo

538

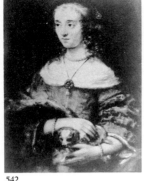

542

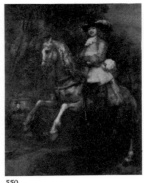

546

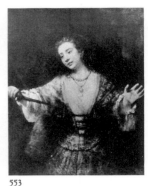

550

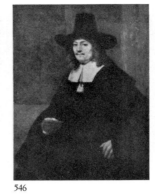

553

539

543

547

551

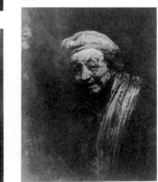

554

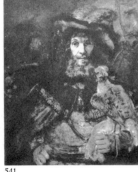

540

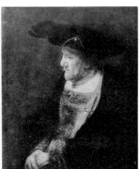

544

551

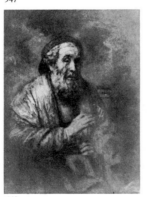

548

552

541

545

549

555

556

538. A Bearded Man
Oil on canvas; 28 × 24 in
(71 × 61 cm)
1661
Leningrad, Hermitage

539. Portrait of an Old Woman
Oil on canvas; 30¼ × 25¼ in
(77 × 64 cm)
1661
New York, Straus
Collection

540. The Apostle Bartholomew
Oil on canvas; 34½ × 29½ in
(87.5 × 75 cm)
1661
Sutton Place (England),
Getty Collection

541. "The falconer"
Oil on canvas; 38½ × 31 in
(98 × 79 cm)
Circa 1661–1662
Gothenburg,
Konstmuseum

542. A Woman with a Lapdog
Oil on canvas; 32 × 25¼ in
(81 × 64 cm)
Circa 1662
Toronto, Art Gallery of
Ontario

543. Portrait of a Young Man
Oil on canvas; 35⅜ × 27⅞ in
(85 × 70 cm)
166(2?)
St Louis, City Art Museum

544. Portrait of a Man in a Pearl-Trimmed Hat
Oil on canvas; 32¼ × 28¼ in
(82 × 71 cm)
Circa 1662 (?)
Dresden, Staatliche
Kunstsammlungen,
Gemäldegalerie

545. The Sampling Officials of the Cloth-Makers' Guild at Amsterdam ("De Staalmeesters")
Oil on canvas; 75¼ × 110 in
(191 × 279 cm)
1662
Amsterdam, Rijksmuseum

546. A Man in a Tall Hat
Oil on canvas; 47¾ × 37 in
(121 × 94 cm)
Circa 1662–1663
Washington, National
Gallery of Art, Widener
Collection

547. An Evangelist Writing
Oil on canvas; 40¼ × 31½ in
(102 × 80 cm)
Circa 1663
Rotterdam, Boymans-van
Beuningen Museum

548. Homer Dictating to Two Scribes
Fragment
Oil on canvas; 42½ × 32½ in
(108 × 82.5 cm)
1663
The Hague, Mauritshuis

549. Portrait of a Young Man
Oil on canvas; 43¼ × 35¼ in
(110 × 90 cm)
1663
Washington, National
Gallery of Art, Mellon
Collection

550. Portrait of a Man on Horseback (Frederick Rihel?)
Oil on canvas; 116 × 95 in
(294.5 × 241 cm)
1663 (?)
London, National Gallery

551. Portrait of a Young Man (Titus?)
Oil on canvas; 32½ × 26½ in
(81 × 65 cm)
Circa 1663–1665
London, Dulwich College
Gallery

552. Self-portrait
Oil on canvas; 33½ × 24 in
(85 × 61 cm)
Circa 1664
Florence, Uffizi

553. The Suicide of Lucretia
Oil on canvas; 47¼ × 39¾ in
(116 × 99 cm)
1664
Washington, National
Gallery of Art, Mellon
Collection

554. The Disgrace of Haman (Uriah Driven Out by David?)
Oil on canvas; 50 × 46 in
(127 × 117 cm)
Circa 1665
Leningrad, Hermitage

555. Self-portrait
Oil on canvas; 32¼ × 24¾ in
(82 × 63 cm)
Circa 1665
Cologne, Wallraf-Richartz
Museum

556. Juno
Oil on canvas; 50 × 42⅜ in
(127 × 106 cm)
Circa 1665
New York, Metropolitan
Museum of Art, on loan

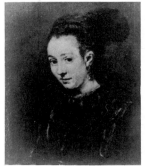

557

558

559

560

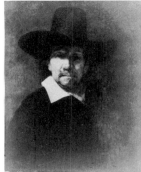

561

562

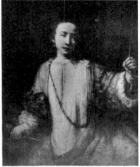

563

564

565

566

567

565

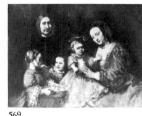

563

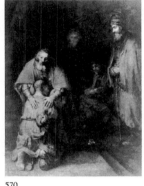

569

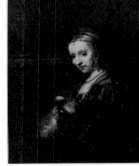

570

571

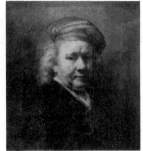

572

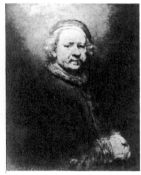

573

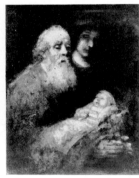

574

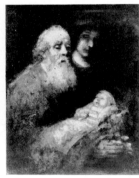

575

**557. A Young Woman
(Hendrickje Stoffels?)**
Oil on canvas; 22³⁄₁₆ × 18¹¹⁄₁₆
in (56 × 47 cm)
1665 (?)
Montreal, Museum of Fine
Arts

**558. The Painter Gerard
de Lairresse**
Oil on canvas; 44 × 34¼ in
(112 × 87 cm)
1665
New York, Lehman
Collection

559. Portrait of a Man
Oil on canvas; 28¼ × 25 in
(71 × 63.5 cm)
1665
New York, Metropolitan
Museum of Art

560. Portrait of a Youth
Oil on canvas; 31½ × 25½ in
(78 × 63 cm)
1666
Kansas City, William
Rockhill Nelson Gallery of
Art

**561. The Poet Jeremias
de Decker**
Oil on panel; 28 × 22 in
(71 × 56 cm)
1666
Leningrad, Hermitage

562. "The Jewish Bride"
Oil on canvas; 48 × 65½ in
(121.5 × 166.5 cm)
Circa 1666
Amsterdam, Rijksmuseum

**563. The Suicide of
Lucretia**
Oil on canvas; 43 × 36½ in
(111 × 95 cm)
1666
Minneapolis, Institute of
Arts

**564. A Woman Holding
an Ostrich-Feather Fan**
Oil on canvas; 39¼ × 32⅝ in
(99.5 × 83 cm)
Circa 1667
Washington, National
Gallery of Art, Widener
Collection

**565. Portrait of a Fair-
Haired Man**
Oil on canvas; 43 × 36¾ in
(107.5 × 91.5 cm)
1667
Melbourne, National
Gallery of Victoria

**566. Portrait of an
Elderly Man**
Oil on canvas; 32¼ × 26½ in
(81 × 67 cm)
1667
Cowdray Park (England),
Cowdray Collection

**567. Portrait of an Old
Man**
Oil on canvas; 27½ × 22¾ in
(70 × 58 cm)
1667
Formerly at Lugano,
Thyssen-Bornemisza
Collection

**568. A Man with a
Magnifying Glass**
Oil on canvas; 36 × 29¼ in
(90 × 73.5 cm)
Circa 1667–1668
New York, Metropolitan
Museum of Art

569. Family Group
Oil on canvas; 49½ × 65¾ in
(126 × 167 cm)
Circa 1667–1669
Brunswick, Staatliches
Herzog Anton Ulrich
Museum

**570. The Return of the
Prodigal Son**
Oil on canvas; 103 × 81 in
(262 × 206 cm)
Circa 1668 (?)
Leningrad, Hermitage

**571. A Woman Holding
a Carnation**
Oil on canvas; 36¼ × 29⅜ in
(91 × 73.5 cm)
Circa 1668
New York, Metropolitan
Museum of Art

**572. A Man Holding
Gloves**
Oil on canvas; 39⅛ × 32½ in
(99.5 × 82.5 cm)
1668 (?)
Washington, National
Gallery of Art, Widener
Collection

573. Self-portrait
Oil on canvas; 23¼ × 20 in
(59 × 51 cm)
1669
The Hague, Mauritshuis

**574. Self-portrait (half-
figure)**
Oil on canvas; 33⅞ × 27¾ in
(86 × 70.5 cm)
1669
London, National Gallery

**575. Simeon with the
Christ Child in the
Temple**
Oil on canvas; 38¼ × 31 in
(99 × 78.5 cm) 1669
Stockholm,
Nationalmuseum

Comparative Table

The table below lists the works included in the catalog to this volume (bold type) and their corresponding numeration in the most recent compilations of the Rembrandt *corpus*: *Rembrandt: The Complete Edition of the Paintings* by A. Bredius, revised by H. Gerson, London 1969 (Br./G.); Kurt Bauch, *Rembrandt Gemälde*, Berlin 1966 (B.); H. Gerson, *Rembrandt Paintings*, New York 1968 (G.). A dash indicates that the cataloguer does not acknowledge the work as authentic.

	Br./G.	B.	G.		Br./G.	B.	G.		Br./G.	B.	G.		Br./G.	B.	G.		Br./G.	B.	G.
1	531A	41	2	**65**	67	—	—	**129**	608	140	102	**193**	344	480	150	**257**	29	310	—
2	631	A1	—	**66**	76	124	42	**130**	609	139	—	**194**	346	482	160	**258**	455	559	—
3	486	2	4	**67**	77	116	36	**131**	407	534	177	**195**	345	479	167	**259**	504	19	86
4	487	1	6	**68**	141	128	50	**132**	472	103	61	**196**	197	369	159	**260**	213	380	—
5	—	—	—	**69**	134	113	—	**133**	465	—	—	**197**	196	371	166	**261**	558	65	83
6	532	42	5	**70**	79	130	47	**134**	466	253	90	**198**	199	373	164	**262**	610	175	97
7	632	97	18	**71**	80	117	49	**135**	332	470	154	**199**	347	477	163	**263**	505	18	84
8	488	3	3	**72**	81	129	46	**136**	493	10	—	**200**	194	374	168	**264**	211	174	186
9	460	96	1	**73**	133	133	—	**137**	18	303	129	**201**	342	478	165	**265**	214	381	187
10	132	109	28	**74**	606A	154	—	**138**	467	257	—	**202**	200	372	162	**266**	212	382	—
11	461	—	—	**75**	16	301	—	**139**	178	155	152	**203**	102	258	92	**267**	24	311	189
12	601	111	22	**76**	543A	54	56	**140**	408	532	139	**204**	100	483	—	**268**	506	—	—
13	420	110	19	**77**	143	138	52	**141**	491	11	59	**205**	192	158	—	**269**	565	69	89
14	532A	43	8	**78**	142	136	106	**142**	494	—	58	**206**	343	476	156	**270**	559	66	82
15	421	—	—	**79**	144	137	51	**143**	495	255	—	**207**	182	152	—	**271**	443	546	198
16	421A	—	—	**80**	145	348	53	**144**	431	156	—	**208**	468	101	69	**272**	442	545	199
17	419	112	20	**81**	82	131	48	**145**	547	58	60	**209**	432	162	93	**273**	507	20	85
18	603	A9	—	**82**	543	52	17	**146**	173	361	137	**210**	23	304	133	**274**	215	383	—
19	602	120	23	**83**	146	349	54	**147**	171	363	138	**211**	544	53	63	**275**	444	548	201
20	1	288	30	**84**	69	252	27	**148**	188	149	—	**212**	556	50	—	**276**	446	549	265
21	423	5	11	**85**	607	134	25	**149**	190	150	145	**213**	554	74	217	**277**	447	—	—
22	539	49	14	**86**	430	135	26	**150**	186	151	131	**214**	25	309	171	**278**	441	547	200
23	422	98	—	**87**	135	132	—	**151**	187	140	—	**215**	471	102	73	**279**	445	544	197
24	533	44	7	**88**	83	450	—	**152**	405	531	130	**216**	206	163	170	**280**	568	—	—
25	489	4	9	**89**	545	55	—	**153**	336	471	126	**217**	203	377	183	**281**	31	312	191
26	3	289	—	**90**	462	254	55	**154**	335	462	123	**218**	497	21	77	**282**	448	556	—
27	424	6	—	**91**	17	302	99	**155**	340	475	146	**219**	351	260	—	**283**	355	497	193
28	534	45	—	**92**	492	8	—	**156**	337	472	155	**220**	469	259	94	**284**	356	498	194
29	535	46	10	**93**	403	530	100	**157**	338	465	—	**221**	179	164	70	**285**	71	262	190
30	463	99	57	**94**	156	142	101	**158**	341	469	141	**222**	350	485	181	**286**	216	384	192
31	64	249	35	**95**	406	533	176	**159**	339	466	148	**223**	349	486	179	**287**	32	313	229
32	63	250	—	**96**	170	359	124	**160**	174	362	—	**224**	202	376	178	**288**	33	314	236
33	427	119	21	**97**	166	358	110	**161**	634	467	—	**225**	104	490	184	**289**	357	499	231
34	426	—	—	**98**	161	352	104	**162**	94	473	132	**226**	103	261	96	**290**	107	263	—
35	2	290	32	**99**	162	353	105	**163**	92	487	—	**227**	348	491	185	**291**	34	316	238
36	4	291	—	**100**	464	100	62	**164**	97	474	134	**228**	205	167	173	**292**	217	385	230
37	8	292	38	**101**	165	356	125	**165**	93	484	—	**229**	201	375	180	**293**	562	70	203
38	539A	47	12	**102**	99	456	112	**166**	96	488	174	**230**	207	166	172	**294**	450	553	268
39	536	48	15	**103**	330	460	128	**167**	98	256	—	**231**	496	12	—	**295**	563	71	205
40	74	114	—	**104**	331	459	121	**168**	95	468	143	**232**	498	13	74	**296**	508	22	202
41	139	346	—	**105**	87	454	117	**169**	90	464	—	**233**	499	14	78	**297**	451	550	266
42	428	121	—	**106**	334	458	—	**170**	91	—	—	**234**	555	63	71	**298**	476	105	206
43	138A	115	—	**107**	154	350	113	**171**	176	364	151	**235**	27	315	237	**299**	358	500	235
44	633	343	29	**108**	155	355	108	**172**	172	366	140	**236**	26	172	188	**300**	509	23	204
45	136	345	—	**109**	153	—	—	**173**	175	368	147	**237**	208	169	—	**301**	218	386	232
46	5	298	33	**110**	329	457	—	**174**	183	153	136	**238**	458	561	290	**302**	409	536	234
47	6	295	39	**111**	86	453	116	**175**	177	365	149	**239**	557	64	80	**303**	360	501	233
48	12	297	41	**112**	85	455	118	**176**	180	170	182	**240**	474	104	270	**304**	359	265	224
49	13	296	—	**113**	84	451	114	**177**	181	147	135	**241**	353	494	—	**305**	108	264	226
50	7	294	40	**114**	89	452	115	**178**	550	56	65	**242**	352	496	—	**306**	219	176	225
51	68	—	34	**115**	88	463	—	**179**	548	57	64	**243**	440	543	196	**307**	410	537	239
52	78	347	31	**116**	167	360	120	**180**	101	489	175	**244**	439	542	195	**308**	511	24	207
53	73	123	43	**117**	160	357	122	**181**	21	308	158	**245**	30	535	79	**309**	435	177	222
54	541	—	—	**118**	159	354	119	**182**	22	307	157	**246**	354	492	169	**310**	244	180	—
55	540	—	—	**119**	164	351	111	**183**	19	305	142	**247**	105	493	—	**311**	35	318	—
56	70	251	37	**120**	169	141	103	**184**	20	306	144	**248**	106	495	—	**312**	36	317	240
57	542	—	—	**121**	168	—	—	**185**	552	60	67	**249**	204	378	—	**313**	513	25	213
58	9	300	45	**122**	163	367	153	**186**	470	157	—	**250**	501	15	76	**314**	364	504	—
59	11	299	44	**123**	333	461	127	**187**	551	59	66	**251**	502	16	75	**315**	363	502	—
60	10	293	—	**124**	147	A8	—	**188**	546	62	72	**252**	433	171	95	**316**	109	503	241
61	490	7	13	**125**	150	145	—	**189**	552A	61	68	**253**	456	558	98	**317**	222	390	246
62	605	126	—	**126**	148	143	107	**190**	191	159	161	**254**	560	68	87	**318**	223	389	—
63	604	127	24	**127**	152	146	109	**191**	195	370	—	**255**	561	67	88	**319**	224	388	—
64	538	51	16	**128**	149	144	—	**192**	198	—	—	**256**	503	17	81	**320**	361	267	—

	Br./G.	B.	G.		Br./G.	B.	G.		Br./G.	B.	G.		Br./G.	B.	G.		Br./G.	B.	G.
321	232	181	—	372	625	197	256	423	271	209	—	474	287	416	—	525	59	338	403
322	221	387	245	373	623	198	—	424	275	408	317	475	291	424	—	526	596	93	350
323	185	165	243	374	621	195	257	425	270	210	313	476	612	221	295	527	482	108	354
324	229	183	242	375	253	193	—	426	522	40	—	477	50	329	343	528	628	229	368
325	591	192	—	376	626	196	258	427	386	—	—	478	593	90	—	529	629	241	369
326	566	72	208	377	128	199	261	428	437	278	289	479	481	106	278	530	630	240	360
327	235	184	244	378	39	321	—	429	384	276	—	480	117	107	—	531	310	539	390
328	265	391	250	379	41	399	301	430	480	280	294	481	292	420	—	532	619	238	364
329	365	505	—	380	40	—	—	431	479	281	293	482	295	423	341	533	614	231	359
330	369	506	249	381	577	81	223	432	44	325	320	483	290	421	342	534	300	435	392
331	234	393	—	382	582	—	—	433	457	562	291	484	294	422	340	535	395	524	385
332	366	—	—	383	454	554	344	434	279	211	287	485	277	425	338	536	397	283	367
333	38	320	262	384	380	510	281	435	588	86	272	486	51	330	376	537	307	232	386
334	37	319	253	385	130	400	304	436	589	87	273	487	592A	91	349	538	309	239	402
335	368	268	228	386	129	401	—	437	523	33	275	488	527	226	347	539	396	526	388
336	564	75	—	387	231	200	—	438	524	32	274	489	296	426	—	540	615	235	366
337	449	551	—	388	258	201	—	439	586	85	276	490	126	427	375	541	319	242	370
338	367	507	248	389	256	398	280	440	121	412	—	491	295A	225	379	542	398	527	398
339	238	—	—	390	519	29	—	441	388	514	—	492	297	224	298	543	311	438	397
340	570	73	211	391	622	217	323	442	385	279	292	493	520	30	348	544	324	247	—
341	569	76	210	392	583	83	269	443	280	414	—	494	52	331	380	545	415	540	404
342	237	392	—	393	584	84	—	444	120	411	325	495	523	36	346	546	313	437	401
343	514	26	209	394	377	269	285	445	308	205	300	496	530	37	351	547	618	248	363
344	230	187	—	395	378	270	284	446	278	409	316	497	53	333	389	548	483	244	371
345	236	190	254	396	611	202	282	447	624	212	321	498	54	332	381	549	312	439	405
346	239	185	247	397	379	511	—	448	525	34	277	499	55	335	—	550	255	440	410
347	246	—	—	398	266	204	299	449	414	538	326	500	118	522	382	551	289	434	406
348	247	189	—	399	263	402	306	450	293	417	328	501	113	521	396	552	60	340	399
349	240	191	—	400	42	322	308	451	389	516	331	502	315	428	400	553	484	284	373
350	245	—	—	401	111	512	311	452	390	515	—	503	299	433	394	554	531	39	357
351	242	168	—	402	268	404	307	453	281	415	327	504	393	525	—	555	61	341	419
352	624A	213	322	403	382	271	—	454	122	418	335	505	394	523	384	556	639	285	374
353	110	266	227	404	267	206	305	455	115	517	—	506	314	429	383	557	400	520	337
354	515	27	214	405	269	203	283	456	116	518	339	507	124	430	—	558	321	441	407
355	574	79	215	406	478	207	286	457	284	216	297	508	125	230	—	559	317	—	—
356	575	78	216	407	47	—	—	458	283	218	334	509	298	432	393	560	322	443	408
357	452	552	267	408	47A	323	—	459	282	220	333	510	285	431	391	561	320	442	413
358	572	77	212	409	119	410	319	460	123	419	330	511	594	92	353	562	416	38	356
359	576	80	220	410	477	—	—	461	592	88	—	512	306	227	377	563	485	286	372
360	251	394	251	411	43	324	310	462	48	327	329	513	57	334	—	564	402	528	412
361	370	509	252	412	521	21	271	463	46	—	—	514	58	336	—	565	323	445	414
362	252	397	263	413	387	272	279	464	49	326	324	515	627	228	378	566	323A	444	409
363	362	508	264	414	453	555	345	465	590	89	—	516	597	—	352	567	325	246	—
364	516	28	221	415	131	406	302	466	526	35	—	517	302	—	—	568	326	447	417
365	249	395	259	416	112	513	318	467	114	282	288	518	303	—	—	569	417	541	416
366	250	396	260	417	276	405	309	468	391	519	336	519	304	233	387	570	598	94	355
367	374	—	—	418	383	275	303	469	286	222	—	520	305	—	—	571	401	529	418
368	373	—	—	419	381	274	312	470	613	217	296	521	261	245	395	572	327	446	411
369	578	82	218	420	371	277	315	471	392	273	—	522	617	236	361	573	62	342	420
370	579	—	219	421	272	208	—	472	259A	219	332	523	616	234	365	574	55	339	415
371	620	194	255	422	274	407	314	473	45	328	—	524	616A	237	362	575	600	95	358

Photographic sources

a = above; b = below; c = center; r = right; l = left

Bibliography

Ph. Angel, *Lof der Schilder-konst*, Leiden 1642; anastatic reprint, Amsterdam 1972

K. Bauch, *Der frühe Rembrandt und seine Zeit, Studien zur geschichtlichen Bedeutung seines Frühstils*, Berlin 1960

J.H. van den Berg, *Het menselijk lichaam, een metabletisch onderzoek*, Nijkerk 1960[3]

J. Bialostocki, *Rembrandt and posterity*, «Nederlands Kunsthistorisch Jaarboek,» 23 (1972), p. 131 ff.

A. Bredius – H. Gerson, *Rembrandt: the complete edition of the paintings*, London 1971

J. Bruyn, *Rembrandt keuze van Bijbelse onderwerpen, voordracht gehouden voor het Koninklijk Oudheidkundig Genootschap te Amsterdam op 11 november 1958*, Utrecht 1959

J. Bruyn, *Rembrandt and the Italian Baroque*, «Simiolus, Kunsthistorisch tijdschrift» 4 (1970), p. 28 ff.

C.G. Campbell, *Studies in the formal sources of Rembrandt's figure compositions*, London 1971, unpublished essay

Exhibition catalog «Rembrandt 1669–1969,» Amsterdam (Rijksmuseum, 1969)

H. von Einem, *Rembrandt und Homer* «Wallraf-Richartz Jahrbuch,» 14 (1952), p. 182 ff.

J.A. Emmens, *Reputatie en betekenis van Rembrandts "Geslachte Os,"* «Museum-journal,» 12 (1967), p. 81

J.A. Emmens, *Rembrandt en de regels van de kunst*, Utrecht 1968

K. Freise, *Pieter Lastman, sein Leben und seine Kunst*, Leipzig 1911

R.H. Fuchs, *Rembrandt en Amsterdam*, Rotterdam 1968

R.H. Fuchs, *Rembrandt en Italiaanse kunst: opmerkingen over een verhouding*, «Neue Beiträge zur Rembrandt Forschung,» Berlin 1913

H. Gerson, *De schilderijen van Rembrandt*, Amsterdam 1969

W.S. Heckscher, *Rembrandt's Anatomy of Dr. Nicolaes Tulp, an iconological study*, New York 1958

S. Heiland-H. Lüdecke, *Rembrandt und die Nachwelt*, Leipzig 1960

J. S. Held, *Rembrandt's Aristotle and other Rembrandt studies*, Princeton N.J. 1969

W. Gs Hellinga, *Rembrandt fecit 1642, de Nachtwacht, Gysbrecht van Aemstel*, Amsterdam 1956

A. Henkel-A. Schöne, *Handbuch zur Sinnbildkunst des XVI. und XVII. Jahrhunderts*, Stuttgart 1967

C. Hofstede de Groot, *Die Urkunden über Rembrandt, 1575–1721*, The Hague, 1906

Th. Kellerhuis, *Uitbeelding van antieke themata in de Noord-Nederlandse schilderkunst van de 17de eeuw* (provisional title) unpublished essay

J.I. Kuznetzow, *Nieuws over Rembrandts Danaë*, «Oud Holland,» 82 (1967), p. 225 ff.

Th. H. Lunsingh Scheurleer, *Un Amphithéâtre d'anatomie moralisée*, «Leiden University in the seventeenth century, an exchange of learning,» Leiden 1975, p. 216

W. Martin, *De Hollandsche schilderkunst in de 17de eeuw*, 2 vols., Amsterdam 1935

F. Petri, *Die historische Umwelt Rembrandts*, «Neue Beiträge zur Rembrandt-Forschung,» Berlin 1973

J. e A. Romein, *De lage landen bij de zee*, 4 vols., Zeist 1961

A. Rosenberg, *P. P. Rubens, des Meisters Gemälde in 551 Abbildungen*, (Klassiker der Kunst), Stuttgart-Leipzig 1905

J. Rosenberg, *Rembrandt, life and work*, London 1964

J. L. A. A. M. van Rijckevorsel, *Rembrandt en de traditie*, Rotterdam 1932

E.K. Sass, *Comments on Rembrandt's passion paintings and Constantijn Huygens's iconography*, «Det kongelige Danske videnskabernes selskap historisk-filosofiske skrifter,» 5, 3, Copenhagen 1971

R.W. Scheller, *Rembrandts reputatie van Houbraken tot Scheltema*, «Nederlands Kunsthistorisch Jaarboek,» 12 (1961), p. 81 ff.

S. Slive, *Rembrandt and his critics, 1630–1730*, The Hague 1953

A. Vels Heijn, *Rembrandt*, Hannover 1973

D. Vis, *Rembrandt en Geertje Dircx*, Haarlem 1965

H. van de Waal, *Drie eeuwen Nederlandse geschied-uitbeelding 1500–1800, een iconologische studie*, 2 vols., The Hague 1952

H. van de Waal, *Rembrandt 1956*, «Museum, tijdschrift voor filologie en geschiedenis,» 61 (1956), p. 193 ff.

H. van de Waal, *Steps towards Rembrandt, collected articles 1937–1973*, Amsterdam-London 1974

Ch. White-K. Boon, *Rembrandt's etchings, a new critical catalogue*, 2 vols., Amsterdam-London-New York 1969

Abbreviations

Bartsch: Adam von Bartsch, *Le peintre graveur*, Vienna 1803

Benesch: Otto Benesch, *The drawings of Rembrandt*, London (Phaidon) 1973[2]

Index